Making Sense

Also available from Bloomsbury

20th Century Aesthetics, Bernard Stiegler
Aesthetics and Morality, Elisabeth Schellekens
Eco-Aesthetics, Malcolm Miles

Making Sense

Art Practice and Transformative Therapeutics

Lorna Collins

BLOOMSBURY

LONDON · NEW DELHI · NEW YORK · SYDNEY

Bloomsbury Academic

An imprint of Bloomsbury Publishing Plc

50 Bedford Square	1385 Broadway
London	New York
WC1B 3DP	NY 10018
UK	USA

www.bloomsbury.com

Bloomsbury is a registered trade mark of Bloomsbury Publishing Plc

First published 2014

© Lorna Collins, 2014

Lorna Collins has asserted her right under the Copyright, Designs and Patents Act, 1988, to be identified as Author of this work.

British Library Cataloguing-in-Publication Data
A catalogue record for this book is available from the British Library.

ISBN: HB: 978-1-47257-318-6
ePDF: 978-1-47257-320-9
ePub: 978-1-47257-319-3

Library of Congress Cataloging-in-Publication Data
A catalog record for this book is available from the Library of Congress.

Typeset by Integra Software Services Pvt. Ltd.
Printed and bound in Great Britain

Contents

List of Illustrations

Preface

The project that lies behind this book has the specific intention of founding a communitarian practice, through art, that provides a restorative social act.

By showing people how they can engage with art, I wish to open a way of being in the world and making sense of it for those who are petrified or oppressed (as so many are, in truth). *Then we can take delight in existence and live together.* This is the essence of transformative therapeutics.

I want to show people how they can make sense through an art practice. This will demonstrate how an art practice is a restorative and replenishing social act: by being creative and making art, people can build a community and share it, whilst having a voice and place to express their needs, opinions, desires and dreams.

An 'art practice' is the opening of a space where people can be free, and inspired, to act naturally and creatively. By experimenting, playing and being creative together, the things people make can testify to and preserve this free space.

Here life begins.

I want to open a platform whereby this practice can be actualized and then utilized in different localities, so that people have the chance to put it into place themselves, when they make art together. This requires no specialist artistic talent, but the courage and the need to question the way things are, and to dare to think how they might be different. *Anything is possible.*

To do this requires practical activities in different localities, through workshops and exhibitions in the local community, speaking at events and debates and making connections with artists, students, academics and innovators across the world to find new contacts, new material and extend the practice. It needs a manifesto that will 'make sense' to a broad range of people in diverse constituencies and communities.

What I need, most of all, is to connect with people who really care about life and the world, and who wish that they could be true to themselves (rather than coerced and composed by the system). I wish to connect with people who dare to step outside the box, who want to go into the world and make a difference for those who really need it.

We all need it. The free space provided by art is opened for everyone. Let us make sense together.

Acknowledgements

I would like to thank the artists and thinkers who have inspired and fed this book. Vera Frenkel invited me to stay several times at her studio in Toronto, where I enjoyed very long and stimulating conversations. Frenkel describes herself as the yellow canary of the art world and in society: someone who goes down to the depths of the real and crosses disciplines and boundaries that are dangerous, threatening and hard to access, where she emerges with sense and a political art that provides a means of declaring and fighting for our fundamental rights as human beings. A chance encounter with Jean-Bernard Chardel has led to continued stimulation based on the ways that art practice has provided for both of us a way of making sense from hard times in the world. His paintings have a depth and tactility that softly saturate my sense-buds and continue to provide a nourishing sense of beauty and pleasure. I was so inspired by Kyle Reynolds's paintings, which I first saw on his website, that I wrote to him. His continued generosity of spirit and conversation has been an inspiration for this book. I am very grateful also to Caroline Rannersberger, whose passion for paint and Deleuzian ethos continue to inspire my own painting practice. Conversations with Sophie Calle, and Yves-Marie L'Hour from Hierophantes, have also been central in my efforts to make sense of why I find their works so profoundly moving and informative about who we are and how we exist. Thank you to all the artists who have let me print images of their works in this book.

I would also like to thank Jean-Luc Nancy for writing his essay on 'Making Sense' in response to my project. It has been an honour and privilege to work so closely with this brilliant thinker. I am grateful also to Bernard Stiegler, whose ongoing scholarship presents such a clear vision of the contemporary world, and whose activities with Ars Industrialis present an agency that actually moves this world. Stiegler's presence at the second Making Sense colloquium at the Centre Pompidou in Paris has developed into continued engagements and lessons, for which I am very grateful.

The influence, guidance and encouragement of my doctoral supervisor, Dr Martin Crowley, at Cambridge University was a rock during the sometimes fraught and antagonizing, but always deeply meaningful, three years I spent

doing my PhD. My thesis then developed into this book. It also grew into an expanding group of artists and thinkers who assembled under the concept of Making Sense, with the intention of founding a communitarian practice, through art, which would provide a restorative social act. This led to the organization of five annual colloquia, held around the world in places such as the Centre Pompidou, Paris, and the Metropolitan Museum, New York. These events stimulated the senses and created new ways of collaborative participation and thinking together, engaged by art practice. I would like to thank everyone who collaborated to help me organize these events, and all of those who participated in them.

Joy Schaverien's work in and beyond *Analytical Art Psychotherapy* has continued to be an inspiration, and I am very grateful for her advice about the controversies raised by my decision to include my own personal experiences of the arts therapies, in Chapter 2. Opening out these episodes from my psychiatric history is a potentially dangerous approach, in relation to how it may be perceived and criticized by an academic audience. But it proves my central thesis of Making Sense, and shows how art practice can initiate transformative therapeutics, which helps me make sense of myself and the world. I'd like to thank all the doctors, nurses and therapists who supported my artistic endeavours and helped me through these troubling times.

Introduction

This book considers how art practice helps us make sense of the world, by extrapolating the central thesis of 'transformative therapeutics'. This notion of transformative therapeutics evolves through and into the central process of making sense; the two are intertwined and symbiotic. When the process of making an artwork provides a method that is transformative because it is therapeutic (and vice versa, hence 'transformative therapeutics') it simultaneously creates a sensuous, sensitive, sensible or comprehensive connection and understanding of the world. This understanding is a method of either *being* in the world (or the self) or discovering one's place therein. These affects will be grasped, both through the lens of psychopathology and the individual case study – seen through psychoanalysis, or more specifically, different forms of arts therapies – and also in the larger socio-political context of thinking and existence in the world, per se.

The book develops an understanding of how we can use art as a method of healing and as a critical method of research (the two ways by which I define 'transformative therapeutics'). First, this is considered in relation to the subject, and an individual's healing, which can take place both inside and outside of the clinic. I begin by using specific cases of arts therapy, with examples where making art has been therapeutic in a clinical, psychiatric setting. I then consider the therapeutic agency of art practice *outside* the clinic, via Deleuze and Guattari's notion of schizoanalysis, which *contests* the clinic (although I question this) and open out how art practice provides an agency of transformative therapeutics on a larger scale that can instigate social change. At this point I develop *Making Sense* through utilizing art practice as a critical method of 'material' thinking that provides a sense of politics, territory and an epistemology, beyond the subject who performs the act of creating or viewing an artwork.

Thus, this book is divided into two halves: the first considers how art practice provides an agency of transformative therapeutics in a *clinical* sense (i.e. either inside or outside of the psychiatric clinic) and in terms of healing for the individual subject. The second part of the book considers how art practice

provides an agency of transformative therapeutics in a larger, social context, as a critical method of thinking and epistemology about the world we inhabit. Both of these viewpoints then define how art helps us to make sense of the world.

Throughout the book (and particularly in the first half) I discuss the ways that art practice has an effect that can be called *healing*. This does not necessarily or exclusively apply to those of us who suffer from some form of illness (although we all may do at times). I will develop my definition of healing as I find it, through the agency of transformative therapeutics that I discover from art practice. At the beginning I utilize Shaun McNiff, a founder and leading figure in the field of arts and healing, from his perspective of *Art Heals: How Creativity Cures the Soul* and *Art as Medicine*. McNiff says that: 'Healing can be defined as making whole, as transforming tensions and problems into affirmations of life, as doing the best we can with the conditions of our lives, and as living in sync with the larger movements of nature' (McNiff 2004: 211). To be more specific, healing concerns not only the alleviation of symptoms (although I will engage with this) but also the transformation of energy, the production of new forms of attention and a liberalized sense of being in time. These factors dilate (rather than dilute) my notion of transformative therapeutics.

My particular definition of 'therapeutics' evolves through various sources. It is important to situate this notion in relation to psychoanalysis and psychotherapy, as two comparable but different methods of building an evaluative or ameliorative science of the psyche. An individual case study may approach psychoanalysis or psychotherapy from the same point of view of a therapeutic modality, symptom relief or the cathartic interpretation of 'dark' or treacherous material from the unconscious (which leads to enlightenment and then relief). Whilst neither psychoanalysis nor psychotherapy is defined solely or definitively by pursuing symptom eradication or from a surgical model of treatment, my definition of therapeutics, through art practice, is largely concerned with generating a productive method or technique of being in the world, in relation to the onset of suffering or a clinical situation, and there *making sense* of oneself and one's situation in this world. It is thus definitively *transformative* because it has the capacity to create psychological change. From a psychoanalytic viewpoint, transformative therapeutics takes into account Thomas Ogden's notion of the 'analytic third', alongside David Winnicott's 'transitional object'. Both of these ideas are interpreted through the operative artwork and the creative process of art-making, which becomes the mediating and operative agent between the analyst and the patient, or the artist and their audience (in the world).

In the second half of the book my definition of therapeutics moves towards a broader picture beyond psychological change for the individual and onto the expanded viewpoint of making sense of the world at large. This still relates to the individual (artist or viewer) involved in the aesthetic experience of making or viewing art, and so psychoanalytic and psychotherapeutic ideas remain relevant. But the picture is expanded to take into account the implications and connotations that the creative process has in relation to the forthcoming social, political and epistemological sense that is made of the world.

To establish the critical and practical position for *Making Sense* I pave a path between contemporary art practitioners and post-structuralist aesthetic theories, through psychoanalysis. The aim for this project is to instigate a process of (and *desire* for) discovery and healing (or 'transformative therapeutics'), which is applicable to readers who connect with and learn about themselves and the world by engaging with the investigative and critical approach, through the agency of art practice, that forms and fuels the content of this book.

The artistic practices I develop in this book (situated in an artist's studio, public performance or museum, and the clinical situation of different forms of arts therapies) include painting, dance, music, installation, performance and a combination of different mediums and settings. I find my source material for this enquiry from the creative processes and artworks of a selection of contemporary artists, which include Jean-Bernard Chardel, Caroline Rannersberger, Vera Frenkel, Sophie Calle, Bill Viola and Hierophantes. I also refer to artists who do not 'fit' into the mainstream category of the art world, and exist *outside* art, and my own creative process, which is equally healing and restorative. I analyse and juxtapose these processes of creation and the consequent affective artworks in relation to some key philosophical and psychoanalytic ideas and concepts, in order to build my understanding of transformative therapeutics.

I choose to write about these artists, practices and artworks because their works have been particularly moving and instructive, and a selection of psychoanalysts and post-structuralist philosophers whose ideas help us understand how and why this happens; by intertwining them together I hope to bring forward a study of how art practice helps make sense of the world by opening the agency of transformative therapeutics.

The main philosophical corpus I use is situated in contemporary French thought, with the thinkers Deleuze and Guattari, Jean-Luc Nancy, Jacques Rancière and Bernard Stiegler. The main psychoanalytic and psychotherapeutic corpus I use comes from Joy Schaverien (who draws from Jung), Lacan, Freud,

Winnicott, Ogden and schizoanalyst Suely Rolnik. Juxtaposing psychoanalytic or schizoanalytic concepts with constructivist or deconstructivist critical theory poses an impasse at times, when the philosopher contests the clinic (as is the case with Deleuze and Guattari, in relation to Freud), but both viewpoints play an essential role in the central task of answering the questions about 'how' and the 'why' an art practice has affect and agency.

I pave the path between art and theory through psychoanalysis. Psychoanalytic theory generally establishes its arguments with emphasis on case studies, referring to clinical accounts of particular clients' and analysands' personal situations and reactions to the process of therapy or analysis. I engage with these examples, but also approach this theory from the other side of the fence, not as a psychoanalyst or a psychotherapist, but as a (former) client and patient. I use clinical episodic and philosophical experiences of using art practice as a nourishing and healing method of being-in-the-world, as well as a critical method of research. I apply these experiences of creating art and viewing art, during incidents of art therapy and independent aesthetic encounters, to demonstrate how certain theories from post-structuralist philosophy and psychoanalysis *make sense*. I then apply this to a larger context and develop how art makes sense beyond singular subjective experiences (either my own or the other artists I work with) in a broader political and social context.

At the outset, Griselda Pollock helps me theorize the making sense of art *practice*, and establish the path between art and theory through psychoanalysis, to build my notion of transformative therapeutics. She writes about how 'the seeds of ideas can emerge inside an art practice', which can then be addressed, written about and used as a transformative method of research: 'This does return us to writing, not as alien other to the artistic form, but as a space for self-theorization that is psychoanalysis as the culturally generated mirror to the search for understanding of the predicaments of subjectivity: sexed, speaking human subjects' (Pollock 2011: 27). This remains one of the aims of my book: to instigate a process of (and *desire* for) discovery and healing, which is applicable to readers who connect with and learn about themselves and the world by engaging with the tools I propose for Making Sense.

It is very important to establish my own particular position in terms of the suffering, illness or pain, which art is said to alleviate, heal or cure. Defining *cure* does not involve a teleological (mis)understanding of progress, but a *neurodiverse* understanding of self-awareness, and a politics of care. Pharmacologically, the harm can also be the cure. I develop this idea through Bernard Stiegler and D. W. Winnicott in my chapter on the pharmakon. My position on cure is

unique: I'm not approaching cure as a clinician (although I do take into account the clinical situation). I do not want to impose psychological normativity, or set a fixed standard for an idealized way of being-in-the-world that might be 'magically' obtained through art-making. As psychoanalyst Lucille Holmes says, any imposition of normativity 'refuses the invitation from an extensive range of art to confront the polymorphous, contradictory experience of human desire in relation to the aesthetic experience' (Holmes 2012: 9).

My definition of cure evolves through Hanna Segal's 'The Curative Factors in Psychoanalysis', where 'Cure does not mean conformity with any stereotyped pattern of normality prejudged by the analyst. It means restoring to the patient access to the resources of his own personality, including the capacity to assess correctly internal and external reality' (Segal 1986: 70).

Approaching 'cure' from the viewpoint of psychoanalysis is potentially problematic, however, since obtaining cure is not always the intent of undergoing this lengthy procedure. There are two sides to the point and purpose of psychoanalysis. First, there are those who approach it clinically, using a medical model of 'treatment'. Segal's understanding of cure would seem to fit into this interpretation of psychoanalysis. So there's something wrong with you, and you enter analysis in order to be healed (as though from a physical wound or ailment). On the other hand, another form of psychoanalysis has nothing to do with a cure. It's a way of thinking or understanding about yourself and your being in the world. This approach to analysis doesn't fix the symptoms so you feel better, that's the task of psychotherapy (and medication). It concerns the production of self-knowledge, which is a process that can often cause trauma or pain in itself. Freud acknowledged (to one of his hysterical patients) that psychoanalysis was not concerned with removing suffering, but rather working on its causality and depth of field in order to gain insight: 'I do not doubt that it would be easier for fate to take away your suffering than it would for me. But you will see for yourself that much has been gained if we succeed in turning your hysterical misery into common unhappiness' (Freud 2004).

Since I am arguing that the transformative therapeutics of art practice *does* result in the alleviating of suffering (to some extent), and that it can be instrumental in providing relief, my definition of cure needs to take into account a psychotherapeutic rather than strictly psychoanalytic model of thought. As we will see, Joy Schaverien's notion of *Analytical Art Psychotherapy* bridges the gap between psychoanalysis and psychotherapy, through arts therapy. I also include references to my own experiences of different forms of arts therapies, to supplement and enhance the threads of psychoanalytic thought that are

interwoven to create the methodology of Making Sense, via transformative therapeutics. Engaging with arts therapy, and also schizoanalysis, helps me define what I mean by cure, which is not always covered by purely psychoanalytic thought.

I explore this in particular in Chapter 3, which focuses on schizoanalysis. Here I address the synonyms of cure, heal, restore and transform with a questioning and critical approach. I take an explorative, cautious approach towards the premise that certain art practices, philosophies and theories are intrinsically therapeutic and remedial. The transformative therapeutics I am arguing for means production of the new. If an argument or practice provides a transformative therapeutics, this is not a matter of restoring or regaining a previous sense of being, nor does it indicate a teleological amelioration according to a standard of progress, but it offers replenishment, nourishment and new ways of being. This is an ethics that does not focus on a pseudo 'cure', condescending those for whom existence is fundamentally different, and nor does it assume that the normopathic genre is the best and only point of departure for a full life. Rather, the ethics of transformative therapeutics produces a new way of being where difference is nurtured and replenished. Sourcing this ethics through creativity and art can, as philosopher/artist Simon O'Sullivan hypothesizes, 'allow us to produce/transform, and perhaps even go beyond, our habitual selves' (O'Sullivan 2006: 238–244).

In this context, my use of arts therapy does not 'cure' or judge mental illnesses such as schizophrenia as an inferior way of being, and nor does it degrade or slur the 'schizo' and condone any conformity to a neurotypical stereotype. Rather, it enables patients who suffer to cope with, understand and talk about the symptoms of their illness. Arts therapy from this Deleuzian viewpoint is not necessarily meant to restore a patient-cum-participant to a previous state of being, nor a teleology of perfect health. It does not supply a superior state that involves the politics of the 'cure', since cure is not the only path to existence. But art can nurture a new way of being where existence is replenished and suffering is counter-actualized, not to achieve or judge a 'better' state, but to open a way by which individuals can accept their circumstances, and so create something new from them: to be able to *will* and make a world from them.

But this process extends beyond pathology. We need not have a defined illness in order to benefit from art-making. Indeed, art practice constructs a 'place of healing' for people who are suffering, and it is something we can all benefit from. The involvement of (or a reliance on) the therapist is controversial

and potentially problematic. The object made can provide a talisman that may be interpreted and which then makes sense of an illness or disorder; it is thus (potentially) diagnostic. It can also provide a means of communicating what is inexpressible in words. These factors may require a trained professional who can make sense of the artwork made in relation to the client who made it. But in other cases the presence of the therapist is only to provide the materials with which someone can interact and make some art from, and there is no clinical interpretation of what is made beyond sharing the sense that can be made during the process of creation itself. I show instances where the therapist can help the patient make sense through the artistic process, and also how this individual can find the same effect independently. In both cases I engage with psychoanalytic and post-structuralist theories, well known and *Outsider* artists, and my own experiences, to develop how art helps us make sense of the world and ourselves. This is a process of transformative therapeutics.

Each chapter proposes various discussions and a series of questions that I explore and investigate to confirm this premise. The first chapter considers what happens when we interact with an artwork and asks the question: how and why does art affect us? The purpose of this question is to begin laying out how an artwork can stimulate the agency of transformative therapeutics, which is seen in this chapter through the ways that an aesthetic encounter nourishes the senses. I interrogate and analyse the creative process of creating an artwork, the sensory experience of looking at this artwork, and the artwork itself as an affective object. By using the sensuous example of viewing and being affected by a selection of paintings by French neo-Romantic painter Jean-Bernard Chardel, I show how *encountering* an artwork can nourish the senses and in this way provide an agency of transformative therapeutics.

I then discuss the psychology of the process of art practice, and consider what happens when, say, we paint an image. I develop the concepts of transference and countertransference, through Jungian psychoanalyst Joy Schaverien, to understand how an artwork can transfer, hold, transform and evoke attributes and states, causing growth and transformation for the person who makes this object, and for the viewer who encounters and perceives it. I consider the picture as a 'scapegoat transference' and a talisman. I then situate this as an agency of transformative therapeutics, by showing how making art can provide special attention, a new worldview, and, indeed, an ethics of *taking care* that nourishes the senses and creates a new mode of existing.

In the second chapter I situate the agency of transformative therapeutics of art practice as it may take place inside the psychiatric setting of the clinic.

This chapter is about different forms of arts therapies, which I introduce and describe to show how they can help people overcome difficulties, illness, and suffering. I do this by including vignettes of my own formal experiences of arts therapy. The personal, intimate tone that is expressed in parts of this chapter is controversial, since I lay out my own experiences *on the line* for potential (academic) critique. Despite the risk posed by this approach, I include this material because demonstrates the impetus behind the whole project of this book. I hope to demonstrate how art can provide healing and respite in relation to the agonizing trauma of mental illness (and that posed by being institutionalized in the psychiatric clinic). In this chapter art practice provides transformative therapeutics because of its remedial affect, which fundamentally changes my self-perception and fuels my recovery.

Chapter 3 discusses Deleuze and Guattari's project of schizoanalysis in *Anti-Oedipus*, and the concepts of 'counter-actualization' (which is a synonym of healing) and the 'desire machine' (the motor and fuel of counter-actualization). Deleuze and Guattari's intent with these ideas is to (vociferously) challenge the clinic, which they argue *causes* rather than *cures* psychiatric illnesses. In this chapter I define schizoanalysis, going through Freud, Klein and psychoanalysis, questioning how this is a useful or applicable practice beyond its task to destroy Freud and the clinic. Schizoanalysis wishes to source 'a place of healing', or agency of transformative therapeutics, by engaging with the schizophrenic and liberating them from their clinical detainment. There are problems with Deleuze and Guattari's argument for this position, with their dependence on (and exclusion of) the schizophrenics Artaud and Schreber. I raise these problems, and then use Deleuze's morality in *The Logic of Sense* to resolve them and source the transformative therapeutics of art practice, using the example of the schizophrenic artist Adolf Wölfli, and the movement of Art Brut. I then conclude the chapter with Guattari's schizoanalytic practice with Suely Rolnik, at La Borde. Here we see an application of schizoanalysis which engages with the process of creating an artwork to deliver the process of counter-actualization (and transformative therapeutics). This resolves the problems I raise earlier in the chapter and points towards the possibility of sourcing transformation, therapeutics and healing independently of the clinic.

Chapter 4 considers the process of art practice Making Sense, *outside* the clinic. I show how art can take the place of the analyst for the ethical treatment of the symptom. This chapter is about Lacan's concept of the 'sinthome', which he raises in his work on James Joyce. I engage with another

schizophrenic artist, Kyle Reynolds, who uses painting as a method of healing that has enabled him to evade hospitalization and manage his psychosis for over a decade, outside of the clinic (and without any formal intervention of an assigned art psychotherapist). Lacan's *sinthome* helps me to define how art practice makes sense *outside the clinic*. The inclusion and application of Lacanian theory is potentially problematic to Deleuze and Guattari (based around Lacan's defining desire as a *lack*, whilst Deleuze and Guattari define desire as inherent *production*), although Guattari was trained by Lacan and his influence is still apparent in the schizoanalytic project. I question and then resolve the difficulties of juxtaposing Lacan with Deleuze and Guattari, and continue to build the now *independent* agency of transformative therapeutics.

Now, half-way through the book, we are *outside* the clinic and can build, transfer and expand this agency of transformative therapeutics beyond providing care and healing for the individual subject. It becomes timely to establish the transformative therapeutics of art practice as a critical method of research on a larger scale, which can instigate social change and help us make sense of the world at large.

In the fifth chapter I propose art practice as a transformative method of 'material thinking' (via Paul Carter and Barbara Bolt), or a critical method of research which is informative about how the world exists and is territorialized. I show how working with different materials to create an artwork provides a form of tacit knowledge about our placement in the world, and a responsibility or caring for these materials. This results in a dynamic shift in energy, on the surface plane of the artwork made, and in the territorializing process of the world itself, from a destructive 'war machine' towards a 'creative line of flight'. This shift is another conduct of transformative therapeutics. To make this argument, I initiate a material thinking that examines and solidifies the creative process of Australian landscape painter Caroline Rannersberger, and my own experimental practice. Here transformative therapeutics is sourced from art practice as a method of thinking about and marking territory. In this chapter we use art to learn how we inhabit the world. We consider our place in the world through the *process* of making art. In this sense, meaning is practice-based and it provides an aesthetic ecology. I establish these ideas by utilizing Simon O'Sullivan's Deleuzian-inspired work on 'geoaesthetics', through the paintings of Caroline Rannersberger.

In Chapter 6 I consider how art practice provides an agency of transformative therapeutics through the technology and *politics* of play. To start, I examine a new media performance-installation by the Canadian artist Vera Frenkel.

During the creation of this work in 1974, *String Games: Improvisations for Inter-City Video*, there is a sharing of the sensible, an invention, improvisation and transmission of meaning, and a technology of play, which is how I demonstrate that the artwork makes political sense. Playing *String Games* provides inter-personal (and inter-state) healing that demonstrates topical social change. This is the political sense of art practice.

During the event of this work Frenkel choreographed space, time and the senses through playing a game of cat's cradle, via inter-city video, between two rival cities in Canada. I show how the process and installation of this performance makes substantial insight through its political sense: we learn how to improvise language, with its gaps for expressing the dissensus and difference of identity, and create a holistic sense of space that forms a 'community of sense'. In this way Frenkel's artwork provides a transformative therapeutics and a political community for its participants. The work is set in relation to the capitalist monopoly of the medium, governed by Sony's overbearing control with this elementary form of 'Skype', and also in the economic rivalry between the two cities, Toronto and Montréal, which Frenkel here engages diplomatically, on each side of *String Games*.

I use Rancière's notion of the 'partage du sensible', or the 'distribution of the sensible' to consider the boundaries of our *active participation and place within the world*. Rancière helps me think about what is fundamentally at stake in Frenkel's art performance, seeing its political sense as a sharing of the sensible and in terms of its technics – the technology of the game and of the inter-city video facility. I then show how such a technics provides transformative therapeutics, which demonstrates how this artwork offers a Making Sense of, and in, the world. The point is to find a method and way of thinking that helps us understand and extend the emancipatory potential and transformative, therapeutic power that can be gained from the political sense of Frenkel's work.

Chapter 7 poses 'Making sense at the limit'. In this chapter I show how art practice provides an agency of transformative therapeutics as a method of palliation, mourning, and 'being in the present'. Firstly, I consider how an artwork can offer us an intimate sense of the ineffable threshold of existence, or an experience at the edge of our existence, at the limit of what is real. Secondly, I demonstrate how the process of making an artwork can provide a form of therapeutic palliation, as the capacity to enable a method of 'being in the present' in relation to this limit. By examining an encounter with Sophie Calle's installation *Couldn't Capture Death*, Calle's artistic process, and then turning to American video-installation artist Bill Viola (who also works on the threshold),

through the aesthetic theory of Jean-Luc Nancy, this chapter aims to develop the ongoing hypothesis that engaging with art can provide the transformative therapeutics that defines our Making Sense of the world.

In theoretical terms this chapter aims to open and develop the dimensions of Nancy's aesthetic theory on how an encounter with an artwork presents the 'threshold of existence', and also how an artwork provides a 'technique of the present'. With critical reference to Bourriaud's *Relational Aesthetics* and by examining the enclosed space and aura of works by Calle and Viola, set in Robert Storr's curation of the 2007 Venice Biennale, this chapter thinks about how encountering these works provides a poignant sense of our finitude during and beyond their event in Venice. We gain a sense of how an encounter might provide a making sense of the world *at the limit*, *our* limit. Then I open this discussion onto how the process of making these artworks provides an ethos and *technique* of existing, or 'being in the present', by using direct interviews with Calle and Viola, and developing a discussion about technology through Jean-Luc Nancy and Heidegger. I also utilize the psychoanalytic theory of Darian Leader, which considers art in relation to mourning and the mother figure, and helps us to understand the transformative power and therapeutic sense of Calle and Viola's works. We discover how art practice can provide transformative therapeutics in the way that it offers a way of life, and here conclude with Foucault's hypothesis of seeing the artwork as a 'technique of the self'.

In the final chapter I use the term 'pharma' to account for pharmaceutics and the drug industry, and also the term 'pharmakon', which is a dual-sided concept that can indicate both a poison and a cure. Sourcing the curative pole of the pharmakon is the objective of this chapter. Stiegler partakes in this search in his *What makes life worth living: On Pharmacology*. The title of this book captures the extent of our situation: Stiegler says that the misery of the present (the 'disenchantment of the world') has led us to lose the sentiment to exist, and now we just don't know why life is worth living. This situation introduces our need for the curative pole of the pharmakon.

The search for cure leads me through D. W. Winnicott and Schaverien on the transitional object. Winnicott shows us how we can use an artwork to supply a resource for re-enchantment and the curative situation of the pharmakon. We see how art uses creativity and play to define meaning, sense and healing. Winnicott's psychoanalysis raises the clinical setting and leads us to consider the role that pharmaceutics has to play in the search for a cure. Although, by now in the narrative of the book, we are supposedly *outside* the clinic, healing and therapeutics might seem to rely to some extent on the drug industry, which can

resolve the 'chemical imbalances' that are said to cause some mental illnesses. Here I consider whether, as Stiegler argues, the use of psychiatric drugs is amplified to make people functional members of the workforce, so that 'normality' is controlled or manipulated by capitalism and consumption (via Stiegler). This continues my critical questioning of psychological normativity, healing and cure. I use Stiegler's pharmakon to build a politics of care, *Taking Care*, which employs a *neurodiverse* perspective that is fuelled (again) by art practice as a sensuous, hands-on process of transformative therapeutics. In relation to this pharmaceutics is still necessary and important, although controversial and problematic. Making Sense has limitations: it can't replace drugs, but it can still occur *outside* the clinic, independent of the professional, and be applicable for everyone.

In this book we develop an understanding of how an artwork can have an affect on us, and we consider different kinds of art psychotherapy that provide healing, psychological self-awareness and growth. We then locate therapy *outside* of the clinic, and our agency of transformative therapeutics extends beyond the individual case examples to provide a critical method of thinking about society that can affect the world at large. At the end we question the remaining disenchantment of the world, and the influence and dependence on the drug industry, which pose limitations to *Making Sense*. But we can still locate and begin to understand how art practice can provide both a method of being in the world, understanding it, and an agency of transformative therapeutics that is applicable to all.

The ultimate purpose of this book is to inspire and stimulate this accessibility and encourage the reader to experiment with art practice as research and locate this agency. The proof of its potential to offer a way of being in and transforming the world that is universally accessible depends on continued stimulation and experimentation, which is an ongoing, nascent inquiry that extends beyond the confinement of this written text.

My conclusion is that we are all artists and we can all access and stimulate the *desired-for* growth and transformation that is provided by art practice. At this point my book launches a new and equally accessible aesthetico-therapeutic paradigm. Here the world *Makes Sense*.

Part One

Transformative Therapeutics as Healing for the Individual

Making Sense of the Aesthetic Experience

At the outset of the project of *Making Sense: Art Practice and Transformative Therapeutics*, it is important to consider and understand what happens when we interact with an artwork, and ask the question: how and why does art affect us? This chapter examines the triadic structure of an aesthetic experience, in terms of the symbiotic interrelation between the artist and their creative process of art-making, the artwork as an aesthetic object, and the spectator or viewer and their aesthetic encounter. I begin from the point of view of the aesthetic experience because in this book the artwork (and art practice) always comes first, preceding any intellectual, psychoanalytic, clinical or philosophical examination of theory that seeks to make sense of this artwork and its resulting or formative experiential content. My consideration of the three elements to this experience proceeds with the intent to discover and think about how and why it can stimulate the agency of transformative therapeutics.

I do this by presenting and examining a raw account of encountering some abstract paintings by French neo-Romantic painter, Jean-Bernard Chardel. After narrating an encounter with these paintings in Chardel's studio, I then consider the experience that Chardel has whilst making them, the artworks as affective objects and my own sensory experience. These three parts concern affect and forces, which are concurrent, interchangeable and hard to think about separately. So, as I develop an understanding of the creative process, I am also talking about the artwork and my encounter (and vice versa), the point being to help me understand how and why all three are transformative.

After the narrative of my encounter with Chardel, I discuss the psychology of the process of art practice. I develop the concepts of transference and counter-transference, through Jungian psychoanalyst Joy Schaverien, to understand how an artwork can transfer, hold, transform and evoke attributes and states, causing transformation for the person who makes this object, and for the viewer who encounters and perceives it. I consider the picture

as a 'scapegoat transference' and a talisman. I then situate this as an agency of transformative therapeutics by defining how the aesthetic experience can *nourish* the senses, which provides psychic growth and healing.

To develop the various factors that are involved when we experience art, I will use elements from psychoanalytic, phenomenological and post-structuralist philosophical theories. This investigation leads me to pass swiftly through various ideas, and lay down some concepts that will provide the groundwork for consideration and criticism seen in later chapters.

Part One: Narrative of encounter

I came across the paintings of Jean-Bernard Chardel by chance, on my way to (Figure 1.1) the Centre Pompidou one day. I caught sight of some artwork in the window of a building on the other side of the road in the fourth arrondissement. I could see a few square canvasses with streaming earthy colours that attracted my eyes. These paintings had a curious weight and texture that touched me, despite my distance from them, so I crossed the road to take a closer look. The door was open, and inside two men were in discussion around one of the paintings. One of them caught my eye, saw that I was interested and beckoned me, so I entered the room. Chardel introduced himself; this was his studio.

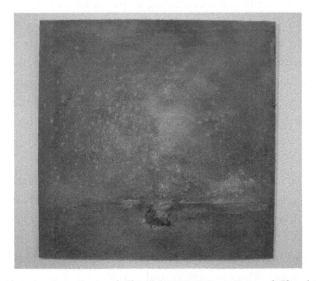

Figure 1.1 *Altamira*, Jean-Bernard Chardel 2008. © Jean-Bernard Chardel.

I entered the first room. In here there were about five rectangular blocks of canvases arranged with no particular curatorial schema on the thin white walls of the building. They bulked off these thin walls, since the fabric of each composition was made from a mixture of several layers of wood, mud, flour and sand, stuck together with the illuminated pulp of primary coloured pigments.

As though they were fodder for my thirsty sense organs, these thick paintings oozed comforting sense and offered a relief for my eyes to rest upon when I looked at them.

There was one in particular that attracted me. It was a large orange painting, which had a branch of wood lying horizontally near the bottom of the canvas. This beam of wood was deeply sunken into the composition, lying between the sprinkling of the sun, sand and soil that made up its textural surface. The painting touched me. It was the same colour as the mosquito bite on my left cheek, which I had woken up with that morning – a toasted yellow which secreted pus and had crystallized a red ochre. The painting emitted a timbre and heat like the mark on my face, but without the piquant pain. There was nourishment in this aesthetic touch: the mosquito stole my blood; the painting now regenerated my blood. As it touched my eyes I felt restored. My eyes clung to the texture and colours, which were dazzling but simultaneously soothing. The beam of wood seemed to cultivate with my looking at it, so that the painting became something like a saffron crocus compost that could reconstruct my sensitivity.

Chardel told me that the painting which had first moved me was called *Altamira*, the name of a Spanish village where there are cave paintings, like in the caves of Lascaux in France. Chardel had found this morsel of wood by the sea at the house where he was brought up. He had made this canvas, like the others, because he wanted to collect memories of his voyages around the world. He said that he had spent 20 years travelling around the world, discovering ancient civilizations that had been destroyed by war and genocide. He had left the Western world with the intention of searching a new way of life from a forgotten Oriental sensibility. Chardel assembled his art from scraps of debris that he found throughout his voyages, so that his artworks become mosaic relics of the civilizations in which minority groups of society have been slaughtered, oppressed or forgotten.

He had left his home in France because he wanted to find a true sense of beauty to take back to the modern, capitalist and hyper-industrial world of the Occident. He began his voyages after meeting a refugee from Cambodia, who had escaped from the genocide. He joined several NGOs, such as the

Enfants Réfugiés du Monde and the International Commission for the Rights of Aboriginal People, which helped refugees and minorities in the world, and soon he made his first trip to Guizho in the southeast of China. He then travelled through Europe, Africa, Senegal and Japan, in search of minority peoples and forgotten civilizations. In Japan Chardel was struck by the Buddhist temples and the culture of meditative harmony of the monastic life he encountered there. He retained the sense of Zen, and the practice of mediation that had made such a striking impression on him; it opened his eyes to a different way of being in the world.

When Chardel showed me around his studio, we went down the rickety stairs, passing behind the Japanese blind that modestly separated the exhibition in the first room and the 'kitchen for creation' behind it. Here was a grotto full of half-finished paintings and the scraps left from his working. Some piles of flour, stones, random objects and pots of pigment had accumulated on the floor.

There was a milky yellow scent of incense, which delicately filled the air of the studio. This pontifical odour filled out my nostrils as I breathed. It was a sprig from the Monastery of Jerusalem, in the fourth arrondissement. This warm ambiance became a place where the subject could dissolve in the mass (a mass so intimate and full of the mud and fragments from the earth) and be held there. So, Chardel returned to fiddling around with his current painting, whilst I wandered around his studio to look further. I wanted to see his process of creation. He mixed flour, pigment and water with a pestle in a pot and then placed the concoction on the canvas. Nothing more complicated, in fact, but between Chardel, his materials and the artwork there was such a unifying rapport, which then shone from the finished painting.

Some of these images had stamps, tokens and newspaper cuttings stuck on them, which Chardel had found and collected during those voyages that he had mentioned to me in front of *Altamira*. When I looked around the studio, I could see a cartography of these experiences and his discoveries on the surface, texture and *métissage* of these paintings. Amongst the other images, there were several thick canvases with black and white photographs of different cultures and people stuck in the centre. Like flat, faded sheets, withering away and then stuck on the corner of the painting, these photographs seemed like shadows of the past.

I looked some more. In his studio, there were canvases with bits of metal, as though remains from a shipwreck had been sunk into each composition. Marked by geometric forms like the elementary symbols of a circle, triangle, square or a star, these works imbued a sense of nourishment that was directly

touching. I asked Chardel why he used these particular symbolic forms. He told me that certain forms create a symbolic language which can directly touch the unconscious and effect different states of the soul. Circles, triangles and squares possess an expressive force that has the capacity to move us and provoke emotions that prompt a regenerative sense of well-being, whilst different colours vibrate and have the power to affect our consciousness in a therapeutic manner.

I could sense an artist who had touched an intensity of the earth and brought back remains that were ruins but still fertile when they could be transformed into an artwork. Making art became the way by which Chardel could express his frustration with the suffering, oppression and violence of the Western world, and find a sense of harmony and well-being, a new mode of living, by returning to the primary earth of Oriental civilizations. He found his 'art of living' by the equilibrium and the peace obtained from Zen Buddhism. His artistic practice continued the meditation, which seemed to resonate from his artworks.

Inside the occasional tinges of gold between the wood, flour and fabric of the canvas, these images touched me softly. They grazed my eyes so that looking became a soft, light touch. There was a weight to the materiality of these works, which also retained a sweet innocence. In looking at the crimson, scarlet, rose, azure and sunshine yellow pigments, I could sense something pure and limpid: a carnal depth and touching beauty. This terrestrial sensation is the origin of the artwork, and its work. Chardel as an artisan, with his calm and spontaneous process of creation, reminded me of the link between the earth, material things and the truth, as Heidegger wrote: Here '*The work lets the earth be the earth*' (Heidegger 1971: 46).

In this melange of pigment and sand these gorges of bark became roots for a tactile testimony of a forgotten time, which I was touching now with my eyes. In sensing this artwork I wondered about its sense of relief, its nourishment and how such contact seemed to provide me with security inside its fabric and thickness.

Chardel talked to me about the importance of the interior life, in terms of feelings and emotions, spirit or soul, in his paintings, and yet the impression of his art was very physical, and almost abrasive in its tactility. In looking at their primary sense of earth a piece of myself felt softly held there; so I stayed, gazing and held at their beauty.

Chardel showed me an essay he had written about 'Art, beauty, spirituality', in which he describes the restorative power that he believes art has. He said that

through this regenerative nourishing contact, art can open us to a new report with nature, and, in this way, art can 'save humanity':

> The crisis of the art, it is also the crisis of man and civilization. Reaching this decisive moment in history, we can legitimately say that we are in anguish. True art is certainly the highest expression of life. Beauty, dream and desire can help to change our way of thinking, it is through this that we can transform society and maybe even save humanity. (Chardel 2008)

The simple passion and need of these words resonated with my own. I was inspired because I could sense the 'beauty, dreams and desire' in his art before he had given me this manifesto. In returning there several times this art retained its affect. This was something new, but also very old, as though the weight of time had become liberated from its past anguish, and, retaining the wisdom of age, could then advance to nourish the world.

When I was leaving the studio, I saw another painting. It was a blue rectangular block, which contained a photograph of a young woman. This woman crouched down and brushed her hand on the ground of the earth. She seemed to be a ghost lurking in this old sepia photograph, and looked somewhat overwhelmed.

Whilst I was looking at this painting, I realized that I could see myself, and also my own process of looking. In this way, during this aesthetic experience, my own story seemed to intertwine with the artist's, in a chiasmus, from the flesh of these sensations which I was feeling, therein. I suddenly felt this sense as a carnal contact with the artwork, where I was able to touch the artist, the world and the primary force of desire that provided the economy and drive of this *transformative* experience.

Suddenly the mosquito bite on my left cheek began to itch – again. It had been an angry mosquito. The bite burst, and pus dripped on my skirt. I looked down, and there was a new red spot – powdered red pigment from one of Chardel's paintings, which I had brushed whilst rummaging through his studio.

I left Chardel's studio filled with wonder at the nourishing aura I sensed throughout his studio, the haptic depth and beauty of his paintings. There seemed to be a fire in his canvases, his hands and his eyes: not for destruction, but fuel for illumination and warmth, which can kindle a new way of living, so we can bloom. I felt something cultivating here: a living sacred for the present.

I will now step back from this account of experiencing Jean-Bernard Chardel's artworks and think about how they provide me with such an affect. The question of what was happening when I looked at Chardel's paintings forms the theme

for the rest of this chapter. By opening and making sense of the sensuous nourishment and affect of transformative therapeutics that can be gained from these works, I will be able to lay a base of understanding about what happens during an aesthetic experience, and how it has an effect, which we can return to in other chapters.

Part Two: Making sense of this experience

1. The creative process: Transference and transformation

Examining the creative process involves looking at the various factors that need to be taken into account in the artist's life, ethos and intent when they make an artwork; how the artwork contains or expresses these things; and whether or how the spectator/viewer is able to experience their own response during an encounter with this artwork. When I visited Chardel's studio I watched his process of creating his artworks and was able to see how therapeutic the physical effort of mixing and applying paint, with a collage of other natural materials, onto canvas, proved to be. Chardel was responding to his voyages around the world, and his art became testimonials or *talismans* of what he perceived and learned during his travels, so that the artworks he formed brought about and evoked a nourishing new sensibility. They intend to restore a feeling of well-being – for Chardel this happens during his process of making, and for me (and, potentially, other spectators), it is what I feel as a result of my sensory aesthetic experience.

We can examine this 'transmission' of feelings and affect that are involved in both Chardel and my own processes of making/viewing the artwork by looking through Jungian psychoanalyst and art therapist Joy Schaverien's work on *transference*. First developed by Freud, this is a central psychoanalytic concept that refers to the therapeutic exchange between patient and analyst, involving the transferring of emotion that occurs in a psychoanalytic setting. This exchange endows the patient's reliving stages of their psychic development – interpreting, integrating and understanding earlier stages (from their infancy and childhood) – in order to gain a conscious balanced psychic life, i.e. a cure from neuroses. The patient develops strong feelings during their sessions, which emerge as they re-live previous events in their psychological history. They project these feelings onto their analyst or therapist, who then replicates figures from the patient's past (Schaverien 1992: 13–17).

Counter-transference is the analyst's consequent emotional reaction, or counteraction, to their patient's transference. In response to the patient's disturbed or difficult emotions, the analyst can feel their own emotional stress, which they project back onto their patient. Counter-transference is 'inextricably linked' with transference, and, when the analyst examines their own reactions or feelings about their patient, it can reveal a more intimate picture of their patient's psyche. Counter-transference may involve the analyst's unconscious attitudes and also their whole behaviour towards their patient, including repressed elements which have become attached to the patient, and any dominant feelings they may have (Schaverien 1992: 17–19).

We can expand and use these notions of transference and counter-transference beyond the therapeutic relationship in the clinic. Psychologist and art theorist James Hillman says that we are in transference 'wherever a connection means something to the soul' and that the artist is 'in transference' whenever they create an artwork (Hillman 1997: 108). During the creative process, the artist's own attributes, states, feelings and emotions are transferred onto the materials they use, so the artwork they create then has the capacity to convey these (although not necessarily exactly the same) subjective states to those who encounter it. In this way, art mediates between inner and outer worlds. The artwork, specifically (in this case) a picture, produces 'an empowered form of relating which draws the artist/patient and therapist/viewer into a deep transference *to the picture itself*, and also to each other *through the picture*' (Schaverien 1992: 23, original emphasis).

As the agent of transference, the artwork is a 'scapegoat' (Schaverien 1992: 30–61). Schaverien uses this hypothesis to build her understanding of the healing effect of the creative process in *Analytical Art Psychotherapy*. A 'scapegoat' is an object that involves a mythical ritual for atoning sins and ridding a community of evil. The problems manifested in this community as evil attributes and states are transferred onto a scapegoat, which then becomes empowered. Disposing of the scapegoat results in purging the evil attributes, and so the community is cleansed, and healed. In the same way, the artwork contains and holds the negative states felt by the artist who creates it, and it becomes an empowered object or a talisman, because of the way that during the process of creating it the problematic attributes initially felt by the artist are fundamentally changed, disposed of or, rather, *sublimated*. The artist feels cleansed; the physiological materials they use to create the artwork change have an alchemical function because they transform into an *affect* of nourishment that provides a regenerative sensibility which is healing for the artist and also the spectator.

But this effect goes beyond the expression, portrayal or healing of suffering; the artwork has implications beyond the individual psyches of the artist and the viewer, who may or may not be damaged individuals. My experience of Chardel's artworks seemed to me to express a zeitgeist of the world at large. It seemed bigger than just being about Chardel or myself. As psychoanalyst Richard Kuhns says, 'Art is not simply a working through of the artists' problems and conflicts; it is a representation of universal communal conflicts in which everyone is tangled' (Kuhns 1983: 103). An artwork can be regarded not necessarily as corresponding to some aspect of the patient/artist's psyche, not just as a psychiatric diagnosis, but because of the way it reveals and expresses something fundamental about existence. This sense is both impersonal (or supra-personal) in that it does not necessarily relate to a specific individual's suffering, and yet it is universally applicable because of the way that the artwork has the capacity to affect individuals, who are moved by its tremendous power:

> Great art is intensely personal and yet it transcends the merely personal. It is the recognition of the human condition which is embodied in the work, which induces such affect. The spectator stands in some 'possessive relation' to the state which is depicted. The recognition that the artist has known this state also is an affirmation for the viewer. The picture which communicates thus, goes far beyond words in illuminating the essence of the human condition. (Schaverien 1992: 118)

Kuhns extends the psychoanalytic concept of transference to the realm of cultural objects. His argument is useful because of the way that he considers the complex procedure of interaction and affect that is involved during the creative process and the encounter with an artwork:

> We have a process that is like one of 'mirroring', reverberating and reflecting back and forth through several layers of consciousness: the 'consciousness' of the object; of the artist, who as it were makes a presentation of self through the object or in the object; and of the beholder, who responds to all the layers with an accumulation of conscious and unconscious associations which include deeply private nodal points in a unique developmental experience to which there are correspondences, but not identities, in others. (Kuhns 1983: 21)

This viewpoint is taken further by Schaverien, who argues that during the practice of arts therapies, or more specifically, what she calls *Analytical Art Psychotherapy*, the artwork as an agent of transference can operate as an agent

of self-analysis, which then induces healing for the artist, beyond or without the clinical setting of therapy:

> The picture offers an alternative external presence, it is an object which exists outside the artist, and yet a part of her or him temporarily inhabits it. A split is made between the part of the person who makes the picture (the artist part) and the part which views the picture (the viewer). These may be operating at the same time but with different priorities. For example, the artist part of the self makes the picture, during which time she or he is totally absorbed in it. Meanwhile the viewer part of the self watches, as if from a distance, intervening as little as possible. When the picture is finished the artist will stand back to view it, and now the roles are reversed. The viewer comes to the fore and the artist watches, as if from a distance, while the viewer responds to the picture. We could understand this process as the artist-self making a transference to the picture and the viewer-self, like the therapist, bringing a more objective response to the picture. (Schaverien 1992: 19)

With Chardel's paintings, his intent for his works to attune to the oriental sensibilities and meditative lifestyle that he perceived during his travels was self-evident as I looked at them. During my aesthetic encounter I felt a *connection, correspondence* and *affinity* with this intent, and enjoyed its nourishing effect. This can be seen in terms of transference, from a Kleinian object-relations framework. There are three stages here. First, in his paintings and his process of creation, Chardel was *projecting* his *paranoid-schizoid* grievances with life itself, and his need for a different way of living (which he found during his involvement in yonder, forgotten and oppressed civilizations). This exists as fragmented parts of his self and his own viewpoint is projected onto the artwork. Rather than being *represented* on the form or shape of this artwork, these fragmented parts of Chardel's self and his paranoid-schizoid grievances inspire, fuel and direct his art-making as a creative process. Second, Chardel is then *moving* from, or *splitting*, the negative thoughts and feelings about contemporary existence in the hyper-consumerist, capitalist, Western way of life. He does this by mixing and applying different materials onto canvas, which provides a process that entails a transformative therapeutics, because of the way it generates nourishment and feelings of well-being for Chardel. As a result, Chardel's process of art-making results in a feeling of *omnipotence* and cohesion, whilst creating this artwork provides a tangible transformation and symbiotic interaction with negative thoughts and their resolution. Finally, Chardel is using the artwork to grow and develop a new sensibility that is both *depressive* (in the realization at the impassable problems faced by modern life) and *restorative*, whereby the artwork is a talisman of truth that goes beyond

these difficulties and can heal, by effecting a new awareness and practice for life in the modern sense.

In this way we can see how the creative process attunes to a Kleinian understanding of the developmental sequence of an infant's growth. Psychoanalyst Anton Ehrenzweig extends Klein to demonstrate how the creative process itself can reconstitute this fundamental, universal procedure of individuation and psychic growth, so that by creating an artwork the adult, at any stage of their life, can relive and relieve this sequence and achieve psychological transformation, in the object-relations framework (Ehrenzweig 1975). Ehrenzweig will become useful to tie up the tapestry of *Making Sense: Art Practice and Transformative Therapeutics*, in the Conclusion. For now we can use his work to commence our understanding of *how* an artwork can have a transformative effect.

To do this, I present painter and psychoanalytic theorist of the creative process Stephen Newton, who follows Ehrenzweig's ideas, and argues that a genuine psychological transformation can only take place through a reconstruction of the 'embryonic pattern', and that this restructuring is possible and implicated during the process of art-making (Newton 2001). Newton uses this argument to demonstrate how art can have a transformative, healing power. Newton's painterly and theoretical œuvre is useful for our efforts to make sense of the transformative therapeutics that is made manifest by the artwork, since he argues that this is specifically the artwork's 'objective'. Like us, Newton is also trying to understand and stimulate how art can achieve this objective, so that art can provide psychic growth and healing (Newton 2008: 25).

Newton says that particularly *abstract* art has this quality and (urgent) agency (Newton 2001: 57). This is a significant position, since psychoanalysis and art therapy rely their transformative use of art almost exclusively on the *figurative* artwork, as a *representation* of some aspect of the artist or viewer's psyche:

> [...] psychoanalysis has virtually ignored modern abstract art, which deals with art's intrinsic formal language. Abstract art is pure form and doesn't provide the footholds and analogies such as condensation and displacement, on which psychoanalysis traditionally relies for its interpretation. [...] It is modern abstract painting, perhaps to a greater degree than any other art form, that unveils and exposes the inner painterly creative process. What psychoanalysis, crucially, fails to acknowledge, whether by design or not, is that this inner painterly creative process is, in effect, the *prototype* and genesis of the very procedure and clinical operational format of psychoanalytic practice itself. (Newton 2001: 17)

This is useful for our making sense of Chardel's artworks, because these are largely abstract paintings or collages, so we can use these ideas to think about how they have an affect that is transformative and therapeutic both for Chardel, whilst he is making them, and for the spectator who encounters them. I will now approach these artworks as both physical constructs and in terms of the forces they consist of and cause in the event of their being experienced.

2. Art object

Using Stephen Newton's work on the 'material facture' of the artwork, juxtaposed with thinking about the artwork as a 'monument of sensation' (via Deleuze), I will define how the artwork can exist in terms of the receptive, forceful, sensory response it causes in the spectator, whilst also being an ek-static, physical object (with colour, form, structure and spatial-temporal coordinates.

Newton defines the art *object* in terms of its transformative potential, which is accessible to artist during their creative process, and also for the receptive viewer who engages with this work. He focuses his discussion of the transformative properties of the creative process on ways that the artwork as a *material object* implicates and affects the substructure of the psyche. He begins by asking the question of how and why particularly an abstract painting, with 'inarticulate form' of non-representational marks on canvas, can cause any kind of transformative response. This involves thinking about the formal language of art, particularly in painting, which consists of: 'not only line, shape, hue, tint, composition and colour, but also texture, impasto, scratches, and striations on the painted surface; paint skin, drips, and the general *materiality* of the paint. This is the material *facture* of the painting', as distinguished from its figurative, symbolic, iconographic or narrative content (Newton 2001: 20).

From his emphasis on the materiality of the artwork, Newton then introduces the term 'ek-stasis' to define the artwork in terms of the transformative, therapeutic experience it provides for the artist. Newton uses ek-stasis to think about the ecstatic phase that an artist undergoes, as a: 'momentary, trancelike, "out of body" experience as conscious faculties are neutralized' during the aesthetic experience (Newton 2001: 101). Newton draws his particular use of the Greek word ek-stasis from Plato, and also sees it as coming through the modern psychoanalysts Klein and Kristeva, in order to develop how the creative process can lead to transformation

and transcendence. He bases this somewhat otherworldly notion on an unconscious *structure* that is embedded in the *materiality* of the painting (which he builds through Ehrenzweig). As a consequence, in Newton's view, this out-of-body experience is based on or caused by the physical construct of the artwork as an object, which then leads to psychic regeneration and healing (Newton 2001: 238–239).

Newton develops the creative process as a ritualistic *trance-formation* or even *trance-substantiation*, whereby the artist has a mystical, quasi-religious experience when they create an artwork (Newton 2008: 113). These experiences that Newton describes also apply to the viewer who encounters such an artwork. The viewer's psyche can be 'induced' into a similarly transformative trance, have an out-of-body experience and achieve a mystical one-ness or spiritual union with creation: 'the spectator, if receptive, can partake vicariously in the whole of the painter's creative process. [...] The spectator is carried momentarily though the whole ecstatic process with the potential to experience a corresponding psychic re-alignment' (Newton 2001: 237).[1]

Newton bases his argument for his spiritual, mystical viewpoint of art from his own *mystical* experiences as a painter, which he describes as: 'my soul left my body and apparently floated upwards in my studio' (Newton 2008: 80). This argument seems to take the experience of an artwork far away from the materiality on which it is (supposed to be) based. I would argue that the ek-stasis of the artwork (and its 'enactment' as a sensory event) is a tangible, heart-beating, grounding, bodily incident. Newton intends to transcend this incident, and reach a higher plane beyond it. This argument is hard to maintain, without relying on some kind of onto-theological resort to mystical faith, even though Newton is trying to base his mystical ecstasy and psychic rebirth on what he sees as the structural materiality of the unconscious, as it is expressed by the affective painting.

I set Newton's use of the term ek-stasis in contrast to Jean-Luc Nancy's use of the term, through Heidegger. Whilst Nancy is discussing the artwork, Newton is discussing the artistic process (through which he intends to define the artwork), but both of them use the term to define their own (differing) understanding about how the art object can have an affect.

Examining a Nancean account of ek-stasis will help us return to my experience of Chardel's paintings, examine what happens when I look at them (which was more of an earthy, Gaia sensation, rather than an extraterrestrial one) and understand how they exist as *objects*. When I saw *Altamira* in Chardel's studio it was propped up against the wall, standing on the ground, with a few

other paintings of roughly the same size. So the artwork is exposed to me, which means that it has been placed in a position where I can see it. The work is positioned so that it can be potentially shown off in multiple singular events of aesthetic encounter. From Nancy's perspective, the *spacing* of such a viewpoint means that the artwork ek-sists – it exists outside of itself. Nancy draws this term from Heidegger's concept 'Ekstase', meaning standing outside (Heidegger 1962: 377 §329).

Nancy thinks about how the spacing of the artwork opens time in 'The Technique of the Present: On On Kawara' (Nancy 2006: 191–206).[2] Unlike Newton, this outside does not refer to a mode of transcendence; Nancy uses the neologism 'transimmanence' to define how the affective artwork exists on these terms: 'art is the transcendence of immanence, as such the transcendence of an immanence that does not go outside itself in transcending, which is not ex-static but ek-sistent. A "transimmanence." Art exposes this. [...] Art is its ex-position' (Nancy 1996: 34–35).

In other words, the work of art moves out of its stasis as an object into the dimension of time, since it continues to remain and endures its presence – hung on the wall in front of me – for countless potential encounters. In this way, as Nancy says, the artwork opens up a space that can exist in time. Nancy argues that the work makes a form from and in the present, which means that it thus disposes or creates the present. The immanent surface of the work (which I look at, from my distance, and react to) is transcendent, since this object exists through time and opens spacing into time. This is why Nancy brings forward the concept of transimmanence, to consider how the artwork exists beyond its immediately present, singular objective form so that one can have multiple experiences of encountering it.

These experiences are transformative because they are not *out* of body, or floating somewhere indeterminate or transcendent, but *in* the body. My heartbeat quickens as I gaze at *Altamira*; the painting oscillates in my vision and there is a surge of vibrating forces as I react to this physical object that is touching and manipulating my senses. You may recall, this aesthetic experience restores the blood I had lost when that angry mosquito bit me earlier on in the day. We can describe the experience as a Heideggerian 'transfiguration' or '*radiant appearance*' that is based in the carnal matter of the painting and its event in my body (Heidegger 1987: 237). The artwork is a 'monument of sensation'.

Here we can turn to the aesthetic philosophy of Deleuze, and his collaboration with Guattari, to define how the artwork bursts through the shape or content of its material, painted composition, and directly touches

the nervous system of the viewer. Deleuze uses his concept of the 'Figure' to consider how this experience can provide a rupturous new way of thinking, which (for his purposes) provides an alternative to the dualism of binary oppositions, from and during the affectuous event of the aesthetic encounter. We can use his thinking to describe the artwork *as* an event of experience, when an electric current passes through the body and directly affects the nervous system. This affect provides a chute for accessing the bare substance and forces of the world. Sensation, from this perspective, is defined not by transference or representation, where the artwork represents and transfers the artist or patient's feelings, but by *vibration*.

The Deleuzian logic of sensation presents the hypothesis that the artwork breaks from the paradigm of representation, and stops being an image 'of something else', when it becomes a sensory experience, or a pure 'being of sensation', in the viewer.[3] This pure being of sensation is the interface between the artwork and viewer. As such, the artwork is a '*bloc of sensations, that is to say, a compound of percepts and affects*' (Deleuze and Guattari 1994: 164). It imparts a dynamic intensity of forces, which vibrate as sensory stimuli through the colour, line and form of the artwork's exposed objective figure and material facture. 'By means of the material, the aim of art is to wrest the percept from perceptions of objects and the states of a perceiving subject, to wrest the affect from affections as the transition from one state to another: to extract a bloc of sensations, a pure being of sensations' (Deleuze and Guattari 1994: 167).

The artwork's physiological qualities are affective: when they burst through the surface of its objective form to become a sensory experience in the viewer, the division or dualism between the viewer's subjective reaction and its objective form disintegrates, through the interface of bodily affect that provides a connection and equator between them. Binary forms disintegrate through the vibration, rhythm, colour and affect of the artwork.

Deleuze develops this thesis in his monograph on Francis Bacon, *Logic of Sensation*, and also in his work with Guattari, *What Is Philosophy?* There he defines sensation in terms of vibrations of the *incommensurable*, which is chaos:

> Sensation contracts the vibrations of the stimulant on a nervous surface or in a cerebral volume: what comes before has not yet disappeared when what follows appears. This is its way of responding to chaos. Sensation itself vibrates because it preserves vibrations. It is Monument. (Deleuze and Guattari 1994: 211)

Deleuze's aesthetics of force is significant in his construction of the concept of the Figure, since it is a *force* or vibration which constitutes the sensation

that defines the aesthetic encounter as an affective event. As Deleuze defines it: 'Painting's eternal object is this: to paint forces' (Deleuze and Guattari 1994: 182). Deleuze's understanding of these forces, and physiological vibrations involved in the aesthetic experience, is useful in our quest to comprehend how and why a painting can affect us and be transformative. To think further about forces, we can turn to Deleuze's writing on Nietzsche, where a force consists of dynamic quanta (or quantity of energy) in perspectival relations of tension (Deleuze 1983: 40–44). Deleuze writes about a typology of forces as a topology of difference, meaning to analyse and activate the relation *between* different and interacting forces. The Nietzschean will to power determines the differential agency of these forces, which is a relation of eternal return as the being of becoming. This 'being of becoming' is the transformation made manifest during the aesthetic encounter and the creative process. It thus defines the potential and the power of the art object.

The artwork can be seen in terms of the forces it imparts, which make something or someone's being become different; these forces have the potential to be transformative. This may not involve a Newtonian *trance-formation*, but the agency or will to power of the artwork is produced from its existence as an aesthetic object, which is an object according to a logic of *aesthesis*, or in terms of the sensations it provokes. In the case of Chardel's paintings, I was particularly struck by their radiant colours, which vibrated as I looked, so that the division and separation between their objective form and my phenomenological reaction dissolved into a pure flat plane of immanent sensation.

For Deleuze this artwork is first of all in the world. As a force, it is not relegated *to* the viewer's subjectivity (and metaphysics), but in itself is a force. When the affect provokes its reaction and becomes 'about' something, it is no longer mere affect, it has been territorialized and defined as what it is about. It is in this phase that we can speak of nourishment and transformation. This affect is a transformative force that is not in the artwork but in the work it co-activates. Deleuze and Guattari write about how affect becomes territorialized, creates a new world and can be transformative, in *What Is Philosophy?*, where the artwork: 'resonates because it makes its harmonics resonate. Sensation is the contracted vibration that has become quality, variety. That is why the brain-subject is here called *soul* or *force*, since only the soul preserves by contracting that which matter dissipates, or radiates, furthers, reflects, refracts of converts' (Deleuze and Guattari 1994: 211).

By now we can see the artwork both as a physical object and as the experience it evokes and causes. Like Winnicott's transitional object, the artwork is neither wholly external nor internal, but consists of the space between this binary, which incorporates and intertwines both whilst remaining free from the constraints of either.[4]

This idea of the intertwining of opposites brings me to examine further the aesthetic experience I had of Chardel's works, which touched me so deeply. By its capacity to *touch*, the artwork is intertwining with my sensory perception of it. I will now consider how and why this happens, and the reasons why this experience is a transformative therapeutics for me as a viewer, or *sensory participant* in this aesthetic experience.

3. The touching aesthetic experience

These paintings are immediately touching, from the primary pigments, haptic depth and the thick textural surface of their composition. This seems to prompt a primal sensation that is bare, raw and elementary, because of the effect of the composition's colours and texture touching the viewer. The painting is like a relief – it offers a thick composition for the eyes to rest upon, which immediately provides pleasure. This relief captures my attention and holds my gaze. I will now think about how the objective form of these paintings initiates my aesthetic experience of them. By considering their colour and form and the concepts of the haptic and flesh, I will try to find out how they are so affective. This investigation will lead onto seeing how my gaze is driven by desire and reveals my own process of looking.

First, the particular colour and form that compose the objective form of these works bring on their immediate affect. I will now consider how this works. The strong colours and primary pigments that Chardel uses to create such striking affects from his paintings demonstrate the influence of Kandinsky's *Concerning the Spiritual in Art*. Kandinsky says that:

> [...] color is a means of exerting a direct influence upon the soul. Color is the keyboard. The eye is the hammer. The soul is the piano, with its many strings. The artist is the hand that purposefully sets the soul vibrating by means of this or that key. Thus it is clear that the harmony of colours can only be based upon the principle of purposefully touching the human soul. (Kandinsky 1994: 160)

Chardel says that he uses Kandinsky's understanding of the ways that abstract images and colours can affect the psyche; this then enables his paintings to provide a restorative sense of nourishment for the viewer through their colour and form:

> Kandinsky became aware of the influence of colour on our soul, our moods, our psyche. 'If the colour blue is allowed to act on the soul [...] it attracts man to infinity and awakens in him the longing for pure and ultimate supersensible'. The creation of a work will be structured around the organization of coloured states, in order to 'refine the human soul'.[5]

Colours can affect because they consist of different wavelengths of light that vibrate, which causes their psychological effect on the viewer. We might call this effect *chromopathos* to define how, when I look at *Altamira*, I am moved by its bright colour. Here I use 'chromopathos' to refer to the emotive transmission of the painting, through the particular wavelengths of colours applied in Chardel's style of painting, which creates the sensuous and emotive affect of the artwork. The tone in these objects has a bright living quality that generates energy to my encounter with it. The colour gently changes with the rhythm of sunlight, as different parts of the uneven surface of the canvas catch the light, which is brought to an apex in the dashes of tone that flicker around the composition.

The pieces of wood provide a staunch weight amidst this bounding colour and they seem to be placed in a certain order to create a symbolic pattern. Chardel says that he is influenced by Paul Klee's symbolic visual language and paints symbols because certain basic forms can affect the psyche just as colours do. Recurring motifs that appear in Chardel's works are the circle, the star and the initial J, by which he marks his signature. These forms open the paintings to the viewer and provide something recognizable for the eyes to rest upon, amidst the coarse texture and bold colours of the composition. The symbols trigger psychological responses in the viewer, as do the colours, by the differing intensities of vibrations that result from making forms in certain ways.

Chardel's works are *touching*. They offer a sensory contact that is at once visual and tactile. This occurs because the canvas is coarse and thick; it has a variable surface texture that is composed of a mosaic of different materials such as tea leaves, flour, soil, old photographs and newspaper cuttings, twigs and small tree branches. These material elements are mixed with the pigments and they dry to bring off a grainy, uneven texture on the canvas, which generates a tactile sense from the looking.

Focusing on touch follows Nancy's aesthetic philosophy and his ontology, where he argues that every sense experience concerns touch. He says that sense *is* touching (Nancy 2003: 109–110).

This is a haptic sense. Haptic comes from the Greek *aptô*, which means to touch. It is a concept used by Alois Riegl to distinguish two structures of space seen in Egyptian art: optic and haptic. Riegl presents a dialectic between the haptic and the optic, as two modes of sensual experience, two types of artistic style and two extremities in a cyclical historical process. His use of the haptic, or tactile, sense remains posed in the teleological episteme of representation. Deleuze uses Riegl to apply hapticity to rupture this very kind of thinking (Riegl 2004: 395–398). Deleuze then uses hapticity to define his concept of the Figure.

In a Deleuzian logic haptic sensations have a rupturous violence akin to the tortured meat of Francis Bacon's figures. Seeing hapticity from a disruptive perspective emphasizes the chaotic rupture that seems tied in with the avant-garde accent on disorder, and the overwhelming of the subject, which is so central to the viewpoint of post-1968 French philosophy. This sets a very different tone to the hapticity I felt from Chardel. My aesthetic encounter with Chardel's works provided me with a sensual, supportive weight and relief that softly grazed my eyes and held my gaze. This is quite a different affect from that of a work by Francis Bacon, or Cézanne (another Figural artist that Deleuze discusses). We find a new critical position for the haptic, which is not shocking but nourishing. It is useful to take on the impression of the haptic sense, as emphasized by Deleuze, and also Aristotle, because it demonstrates a sense that is primal and important in helping us understand and describe the proximate intimacies of a powerful aesthetic encounter.[6]

When I look at Chardel's paintings I feel that I am sensing something primal, which has an earthy depth to it. I feel in equilibrium with this beautiful object, which resonates with bright colours in front of me and holds my gaze. 'Flesh' is a useful term to describe the process of this encounter, following Merleau-Ponty's ontology of the sensible, since the term is used to refer to the primordial fabric of being, which precedes what becomes bifurcated into opposing categories, such as subject/object, sensation/perception or haptic/optic.[7] Merleau-Ponty argues that such disjunction is superimposed *a posteriori*, whilst flesh is the carnal matter of a fundamental univocal being that precedes this division.[8] Flesh refers to the 'encroachment, thickness, *spatiality*' of a primal sense of being, meaning the raw substance or *flesh* of what there is, which is sensed during the aesthetic encounter

(Merleau-Ponty 1968: 264). The dimensionality and depth of Merleau-Ponty's concept seem to capture a sense of the haptic materiality that is involved in this encounter.

With his term flesh Merleau-Ponty wants to access a naïve sensibility of the world, and to express 'an event of the order of brute or wild being which, ontologically, is primary [...] as the unity by transgression or by correlative encroachment of "thing" and "world"' (Merleau-Ponty 1968: 200). Merleau-Ponty turns to the body to formulate his argument for the logic of flesh, which is fitting because the Deleuzian logic of sensation emphasizes our physiological response to an artwork, and it is the materiality of Chardel's paintings which seems to make them so touching, although it is important to distinguish Merleau-Ponty's harmonious flesh from the agonized meat in Deleuze's reading of Francis Bacon.[9]

Merleau-Ponty builds his logos from the reversibility of flesh. With it, he intends to refigure the dualistic ontological disjunction of subject/object. From the phenomenological experiment of the 'metonymic hand', Merleau-Ponty uses the model of touch to encompass both parts of this dichotomy. He asserts that the phenomenological experiences of touching and being touched are not necessarily or radically separated, but at the same time these two motions do not coincide – they are reversible, but do not occur simultaneously. With this hypothesis of the metonymic hand, Merleau-Ponty intends to avoid or refute dualistic and monistic ontologies and bring forth the dynamic reversibility of flesh. He then proposes flesh to be a new notion of identity in terms of intertwined difference.

I take my right hand off the computer and touch my left. I can feel my left hand with my right; then I can feel that my right hand is touching me, I can feel the sense of being touched; then again I can feel that I am the one who is doing this touching, and that it is my right hand that provides the pressure on my left. There are two differing sensations which alternate, and a sort of fuzzy gap in between them as my reflection seeks tangibility through such non-coinciding but overlapping tactile sensations. If I could feel touching and being touched simultaneously both experiences would dissolve, when in fact they remain closely linked, or somewhat intertwined, but with a fissure in their midst, as I think between them to sense their difference. The 'écart' or space of non-coincidence, between the touching and being touched, is what makes it possible for there to be such a difference that makes it possible for the experience itself to be phenomenologically felt, whilst avoiding the polarization of this difference.

The interrelation of non-coincidence but intertwining (or con-tact, proximity through distance) provides the dynamism of reversibility between the action of touching and being touched, which is grounded by the flesh that provides the medium for their encounter. In the distance and difference, yet common ground and reversibility, between touching and being touched, Merleau-Ponty brings forward the notion of identity-within-difference. From this procedure, Merleau-Ponty uses the metonymic hand to reconfigure the dualistic ontological disjunction of subject/object into the ambiguous, non-coinciding interrelation of reversibility it seems to demonstrate. He then extends this reversibility to intertwine his notion of flesh into a chiasmatic, absolute system that can account for embodied self, intersubjectivity, the world and language.[10]

The spacing of the *fuzzy gap* between touching and being touched can be used to think about the *touching* aesthetic encounter, which seems to demonstrate a primary sense of how the viewer exists as an embodied subject or 'seer' in the world, and as the vibrating force of 'seeing' in tandem with the artwork they are responding to. There is a relation or intertwining between the viewer and the artwork, just as there is between the artist and the work they create. From a psychoanalytic perspective, Schaverien talks about this relation as a 'communion', where the viewer is '*merged* with the picture' when they react to it (Schaverien 1992: 118). The viewer becomes in a '*state of reverie induced by the communion with the work*' (Schaverien 1992: 69, my emphasis).

Newton also describes a similar fusion and stupor in his work on the creative process, whereupon the artist's psyche actually *becomes at one* with the artwork they are creating. As a result of this psycho-physical synthesis, the artist's 'unconscious psychical structure is actually materialised in the "body" of the paint structure. This involves a complete psychical union with the artwork – or a *communion* [...]' (Newton 1996, original emphasis). To some extent, we can see this in Chardel's creative process, in which Chardel seemed to have such a 'unifying rapport' with the materials he was working with. Newton likens this 'unifying' relation between the artist's creative process and the structural materiality of the artwork to a religious, supernatural experience of *acheiropoietos*, or in terms of artworks of religious imagery that appear to have been made by supernatural rather than human intervention. Newton argues that this is how and why art is transformative.

The 'reverie' or supernatural qualities of the aesthetic experience are difficult to describe or theorize with any solidity. It is not possible to scientifically determine any semi-conscious state or trance. But it does help us understand

how an artwork can express and affect our psyche, and how the artist has such an intimate relation with their materials, so that the artwork formed can then have its transformative affect.

However, it must be said, the problem with arguing that an aesthetic encounter or the creative process involves a communion or merging with the artwork is that it disallows the central notion of touch: there must be some degree of distance, separation and difference to enable something to touch and thus affect or transform us. Merging can be filled by homogony, teleology, totalitarianism and thus the disallowance of spacing; it is politically dangerous and in practical terms not possible.

There is some degree by which the sensory experience of engaging with art disintegrates binary logic, so that the subject, the object and all opposing differences are opened onto a flat plane of immanence. Here these previously contesting differences are neither necessarily or structurally opposed, nor merged, but they exist as separate but touching, intertwined expressions of identity. This interrelation provides a new balance, motored by symbiosis, or *chaosmosis*, rather than fusion.

As a result, the aesthetic encounter performs a palpation on my senses, which trespasses over the boundaries of vision into the more knotty, lascivious ideas of desire, the fabric of touch and the self's growth in time. Merleau-Ponty describes the relation between the seer and the seen object (in our case, an artwork) as 'invaginating' my vision; whilst he says that it is the desire of the seer's own vision that is what 'envelops' and 'clothes' the object in the thrust of their visual encounter with it (Merleau-Ponty 1968: 131). We can use these erotic ideas to define the aesthetic encounter, which is fuelled by desire and the caducean, chiasmic intertwining of the viewer and the artwork as a sensuous object.

My interaction with Chardel's artworks attunes to Merleau-Ponty's aesthetics of the flesh because I became aware that in my gazing I could see something about myself, and this scopical experience itself, whilst the whole episode also seemed to have a libidinal economy. These arising feelings are in part due to my own process of counter-transference during the encounter. They also attune to a Lacanian account of the gaze, which draws from and significantly remodels Merleau-Ponty's reversibility thesis (Lacan 1977: 70–119). In Merleau-Ponty's phenomenological model of vision the body is both subject and object, the seeing and the seen. Thus to see implies the possibility of being seen; the subject is also an object; and the action of seeing necessitates an Other and its situation in the world. These ideas are Lacanian:

> I must, to begin with, insist on the following: in the scopic field, the gaze is outside. I am looked at, that is to say, I am a picture. This is the function that is found at the heard of the institution of the subject in the visible. What determines me, at the most profound level, in the visible, is the gaze that is outside. It is through the gaze that I enter light and it is from the gaze that I receive its effects. Hence it comes about that the gaze is the instrument through which light is embodied and through which... I am *photographed*. (Lacan 1977: 106)

Lacan's account of the gaze focuses on the schism in the visual field between what is looked at and what is seen, which dispossesses the subject of the gaze whilst giving the seer a sense of being within it. The possibility of being observed is always primary. Lacan argues that the gaze is not reducible to a sensory perception (and here he opposes Merleau-Ponty's phenomenological viewpoint), but is rather situated outside the body in the field of the Other (like desire). Since the self is always seen as an Other to itself, the subject of the gaze is always trying to make up for an inapprehensible *lack*. The scopic field is associated with the scopic *drive*, which desires visual satisfaction.

In relation to the artwork, Merleau-Ponty talks about the painter's vision having the same perceptual attributes that characterize *all* perception, but Lacan says that the frame of the painting makes the gaze of the artwork, which is the gaze of desire, different from vision itself:

> Indeed, there is something whose absence can always be observed in a picture – which is not the case in perception. This is the central field, where the separating power of the eye is exercised to the maximum in vision. In every picture, this central field cannot but be absent, and replaced by a hole – a reflection, in short, of the pupil, behind which is situated the gaze. Consequently, and in as much as the picture enters into a relation to desire, the place of a central screen is always marked, which is precisely that by which in front of the picture I am elided as subject of the geometral plane. (Lacan 1977: 108)

During the gaze, the subject identifies with itself as the *object a*, or the object of the drives. The subject is reduced to being the object of desire; during the gaze the subject identifies with this object, but in doing so becomes alienated from itself. From a Lacanian understanding of the gaze, we can see the artwork as a 'mediating object' that sometimes offers 'a direct means of access to the self' (Schaverien 1995: 13). The gaze becomes a path 'through which desire is transmitted interpersonally' (Schaverien 1995: 13). This is due to the factor of transference, as we have seen, by the affective agency produced as a result of the forces evoked and stimulated by the artwork.

Lacanian psychoanalysis can help us understand my aesthetic encounter with Chardel's paintings, and beyond this singular episode, because of the way Lacan develops and expands the notion of subjectivity – beyond Merleau-Ponty's phenomenological ontology of the flesh (which gets stuck in his grandiose, systematic attempts at metaphysics), supplemented with the explication of desire (implied but not patent in Merleau-Ponty). From Lacan we can see the *nosce teipsum* that defines the aesthetic encounter, which reveals the insight and transformative potential of the artwork.[11]

4. Conclusion

By developing the intertwining and symbiosis that occur amongst the artist's initial, creative process of art-making, the art object that is made and the encounter with it, this chapter has begun to consider the part that these three elements play in an aesthetic experience. It has become hard to distinguish between these three factors, since they are indivisible and implicate or infer each other. As a result of their reversibility and non-coincidence, these elements interact to provide the transmission of affect, breeding the forces of life *per se*. This results in transformative therapeutics for both the artist and the viewer, because of the way that the artwork is able to produce nourishment and psychic growth.

We have seen this in Chardel's paintings because of the way they have a haptic depth and a texturous luminosity. Looking becomes a tactile sensation as the viewer's eyes sink into the crevices and flicker across the undulations that make up the composition. They are relief paintings because they bulk off the walls like sculptures, and because the sensations they endow are nourishing. This affect reveals as much about the viewer's own desires and the operation of transference as it does about the intentions and process of the artist and the physical object of the artwork.

In particular, it has been argued, via Stephen Newton, that the material form of the art object can plausibly demonstrate and affect the structural architectonic of the psyche. This is important to consider because Newton argues that by constructing the artwork we can thus transform the psyche, which enables and empowers the agency of transformative therapeutics that results from engaging with this artwork. Newton claims that this involves the subject having an out-of-body experience, but we have been able to locate this affect and its will to power in the bodily sensations of the *flesh*. As a

consequence, it becomes impossible to dichotomize or oppose the subject and the object, the body and the psyche, since they are reversible and intertwined, although not fused, during an aesthetic experience.

We have seen how, as the agent *in-between* the subject and the object, we can interpret the process of creativity through Kleinian object-relations, and develop this in terms of Winnicott's transitional object. Then, moving from this psychoanalytic perspective, whereby the artwork corresponds to aspects of the individual (be they a patient's, artist's or spectator's psyche), we have become able to discuss how the artwork demonstrates *a pathology of the world*, or of the human condition, which is not dependent on a therapist's or analyst's intervention.

Psychoanalytic ideas have thus been broadened out beyond their clinical setting, in the ways that they apply to and reveal more than an individual psyche. But the transformative therapeutics of art practice still begins from this individual, and there is more to say, particularly about therapy, from a clinical viewpoint. In the next chapter I will situate the agency of transformative therapeutics of art practice as it may take place inside the psychiatric setting of the clinic, using specific episodic examples of different forms of the creative arts therapies, in response to how it is used to alleviate suffering and illness. This will develop into a discussion of psychoanalytic and philosophical resources (and limitations) with regard to healing, growth, transference, subjectivity and desire – factors that conglomerate and affect to provide our agency of transformative therapeutics.

Making Sense Inside the Clinic:
Episodes of the Arts Therapies

This chapter is written in a different tone from the rest of the book because, nestled into the theoretical and psychoanalytic elements, I include personal reflections of my own experiences of different forms of arts therapies. I do not mean to digress into uncritical or self-reflexive anecdote, whilst it remains important to reserve a critical distance between these experiences and this book, which is largely an academic text. But I present them as (further) material evidence to demonstrate that art-making has the agency of transformative therapeutics, and I show how this can have a positive, clinical effect, specifically in relation to psychiatric illness. In this chapter the integration of my own case studies advances the thesis of transformative therapeutics by showing how art practice can relieve suffering and provide a coping mechanism in relation to psychiatric illness. This is situated in the clinical situation of a patient (in this case, myself) utilizing art during their admission in a psychiatric ward.

Thus I will here examine how the agency of transformative therapeutics, which is offered by art practice, occurs from a *clinical* perspective. By describing examples of different forms of arts therapies, I will show how making art in a clinical setting (during therapy groups in the psychiatric hospital) can be seen to alleviate forms of suffering and psychiatric illness. This will show how art is therapeutic, and transformative, in the way that the creative process communicates, brings to light and then alters inner feelings or emotions and problematic behavioural patterns or attitudes.

This chapter is split into three sections: first, I lay a ground by defining art therapy, by examining the different forms of arts therapies that conglomerate under the notion of 'art therapy'. This will help me build the 'therapeutics' of 'transformative therapeutics'. Art therapy will also become particularly useful in chapters 3 and 4. Second, I recount my experiences of different forms of arts therapies, and consider how they open a method of Making Sense, inside the

clinic. This will raise critical questions about the clinic, which are considered in later, more theoretical chapters. Here I wish to generate an empathic, psychological (rather than necessarily aesthetic or theoretical) sense of the ways that participating in arts therapies can help relieve symptoms as they become manifested during periods of hospitalization in the psychiatric clinic. The third section of the chapter is concerned with the task of understanding and crystallizing the sense that has been made during these experiences. Here I utilize psychoanalytic ideas and concepts from D.W. Winnicott and Thomas Ogden, which act as theoretical cushions that help me understand why and how the experiences I have narrated have such transformative and therapeutic power.

Thus, I begin this chapter with background information to lay the psychotherapeutic ground for the arts therapies, I then present vignettes of case examples and to conclude I utilize psychoanalysis. From these three sources (arts therapy, narrated experiences and psychoanalysis) I hope to develop my main thesis of transformative therapeutics.

1. Defining the arts therapies

There are several different types of arts therapies, which include art therapy (in the singular, this refers to image-based visual arts, such as painting or drawing, or working with clay), music therapy, dance and movement therapy and drama therapy. One might object to all the arts therapies being described together, since they have developed from separate roots and have separate professional bodies with a wealth of literature associated with them, but they can still be usefully engaged with collaboratively and cooperatively. This is a definition of a multiple 'arts therapies' as a group, rather than a singular 'art therapy', following the British Association of Art Therapy's professional categorization and assembling of the different forms of art that may be utilized as therapy:

> The arts therapies group is made up of the four separate professions of Art, Dance-Movement, Drama, and Music therapies. They share a strong common feature in that all arts therapists are dual trained in both their specified art form and in psychological therapy. The arts therapies can be defined as being committed to understanding and utilising the therapeutic potentials of both psychological therapy approaches and the art form employed. In bringing together the aesthetic and psychological domains, the resulting practice is unique.[1]

By engaging with the arts therapies, in the plural, I am also working with The National Coalition of Creative Arts Therapies Associations in the United States, which is an alliance of different professional associations, dedicated to the advancement of the arts as therapeutic modalities, across the world. According to the NCCATA:

> Creative Arts Therapists are human service professionals who use arts modalities and creative processes for the purpose of ameliorating disability and illness and optimizing health and wellness. Treatment outcomes include, for example, improving communication and expression, and increasing physical, emotional, cognitive and/or social functioning.[2]

Art therapy itself (which largely concerns the therapeutic application of the visual arts, i.e. painting, drawing or working with clay) is important to define in the singular, since it forms the basis of all the different forms of arts therapies. The British Association of Art Therapists defines it in these terms:

> The use of art materials for self-expression and reflection in the presence of a trained art therapist. Clients who are referred to art therapy need not have previous experience or skill in art. The art therapist is not primarily concerned with making an aesthetic or diagnostic assessment of the client's image. The overall aim of its practitioners is to enable a client to effect change and growth on a personal level through the use of art materials in a safe and facilitating environment. (BAAT 2003, quoted in Edwards 2004: 2–3)

It is a commonly held opinion that art therapy offers remedial effects in the assessment and treatment of various illnesses and conditions, and in particular psychiatric disorders and situations involving anxiety, depression and mental or emotional problems (Pacey 1972).[3] This healing affect forms the basis for all the arts therapies. The creative process involved in artistic self-expression in this way helps people resolve conflicts and problems, develop interpersonal skills, manage behaviour, reduce stress, increase self-esteem and self-awareness and achieve insight.

All the different arts therapies are forms of psychotherapy that use the creative process of art-making as a mode of communication between the therapist and the patient. The clinical exercise of arts therapy does not require any technical know-how or specific talent on the part of the patient, who is encouraged to express their feelings by using art materials (paint, musical instruments, objects to dance with) in the safe environment of the arts therapy studio. This space is often set apart from the ward in a psychiatric hospital, as a special place for art materials and where the patient can be creative, feel

contained but also set free. Of course, arts therapy also occurs outside of the psychiatric hospital, and outside of the clinical setting, but in this chapter I focus on its usage and merits *inside* the clinic. That being so, the studio for the arts therapies seems to be a space outside (but inside) the clinical setting, because of the way it has special facilities for art-making and provides a haven for patients to go to, set apart from the usual rooms on the ward. It can in this way provide some form of relief from the (plausibly) hegemonic structure of time and space that often makes spending time on a psychiatric ward unbearable.[4]

From a psychoanalytic perspective, the arts therapies have historically been seen as a useful method of interpreting symptoms of neuroses as they are manifested in the unconscious and drawn or painted in images by the patient. Freud discusses drawing in the cases of 'Little Hans' and 'The Wolfman' (Freud 2002a: 1–121; 203–320). Here we can see how drawing plays a key role in the revealing, unravelling, understanding and integrating of repressed elements from the unconscious. The idea that dreams have meaning, which can be expressed and then interpreted through drawing images, has become one of the foundations of a psychoanalytic approach to arts therapy. Freud writes: 'we experience it [a dream] predominantly in visual images [...] part of the difficulty of giving an account of dreams is due to our having to translate these images into words. "I could draw it", a dreamer often says to us, "but I don't know how to say it"' (Freud 2012: 71). This idea, of drawing things that are impossible to put into words, provided the catalyst for the development of the different arts therapies.

The therapeutic action of the arts therapies can be understood from a psychodynamic model, where 'inner states are externalized or projected into the arts media, transformed in health-promoting ways and then re-internalized by the client' (Read Johnson 1998). In this reading of arts therapy, the patient/client's process of art-making involves the projection of aspects of the self onto the artworks that they create. As an 'attributional' process, the artwork then has a subjective or personal meaning. The psychodynamic model involves the concept of transformation, because this personal material, which is developed by artistic expression, is transferred and altered. This occurs with the externalization, representation and then expulsion of unwanted or painful aspects of the patient's self, which occurs during the creative process. In this way, non-verbal expression through making an artwork involves the symbolic 'acting out' of inner feelings. Giving them some kind of form in the artwork made alleviates their emotional pain. The creative process, and its subsequent review, then leads to the patient

developing insight into whatever is troubling them, whilst it also engenders verbal communication and plays a large part in initiating change.

We find a similar reading of arts therapy in Schaverien's work on *Analytical Art Psychotherapy*, which revolves around the concept of transference, whereby the art object transfers, holds, transforms and evokes attributes and states, causing growth and transformation for the person who makes this object (as we saw in Chapter 1). From Schaverien's clinical perspective, the picture is 'a vessel within which transformation may take place and this involves the picture as an object of transference' (Schaverien 1992: 7). Schaverien says that this happens through 'a clearly defined treatment regime', which involves the mediation of the patient's experiences, through the creation of art object, and via the art therapist's intervention, as it is takes place in a clinical setting (Schaverien 1995: 120). The picture that is made is not examined solely symptomatically or as a projection that illustrates a feeling; it is also 'a formative element in the establishment of a conscious attitude to the contents of the unconscious mind' (Schaverien 1992: 11–12). In this way, the artwork made in the context of an arts therapy session is as transformative as it is therapeutic.

The transformative affect of art-making is generated when an internal, unconscious feeling is expressed and brought to light through the creative and material process of making the artwork. The manifestation and materialization of elements in the unconscious contents of the self, during their expression in the artwork, develops a mode of thinking and a way of understanding that leads to transformation. The movement from unconscious pain to the emergence of conscious visualization, separation and mediation engenders healing, growth and change. It is a form of psychic epistemology, in that making produces an embodied and intuitive form of knowledge concerning what the artwork reveals about the person who created it. To some extent the fulfilment of this epistemology relies on the therapist's surveillance, empathic response and interpretative guidance in relation to the non-verbal communication vessel set up by the artwork. The therapist helps the patient put into words what they express in their artwork. This process develops insight and knowledge concerning their condition and state of mind.

This is a Jungian analytic psychology. Jung was interested in his patient's images of dreams, fantasies and unconscious imaginings, because of their 'endless and self-replenishing abundance of living creatures, a wealth beyond our fathoming' (Jung 1946: 14). He says that these images are impenetrable, and 'are capable of infinite variation and can never be depotentiated. The only way to get at them in practice is to try to attain a conscious attitude which

allows the unconscious to cooperate instead of being driven into opposition'
(Jung 1946: 14). The transitional process of delivering unconscious material
into consciousness is what produces healing. The artwork acts as a 'scapegoat
transference', whereby it splits off, changes and atones for the darkest elements of
the patient's psyche (Schaverien 1992: 30–61). In this way the patient's use of art
materials is an alchemical procedure: they mix and concoct different substances
and apply them to a surface, until they are transformed into an artwork that may
correspond to and then transform some aspect of the patient's psyche.

We can see this in Schaverien's psychoanalytic theory about the artwork as
a 'transactional object', or an object through which negotiation (between the
patient and the therapist) takes place (Schaverien 1995: 121–140). Schaverien
introduces the transactional object in relation to a case of anorexia in a male
patient. She interprets anorexia as:

> [...] an extreme form of denial of desire. The desire for food and so nourishment
> of the body is transformed, through a supreme effort of self-control, into
> abstinence. Desire pre-supposes an Other towards whom there is a movement;
> thus, it is to do with relationship. Anorexia is a turning away from the Other
> and, through a false sense of power, it is a movement away from life and towards
> death. (Schaverien 1995: 62)

The anorexic's restriction of food is a method of 'acting out' unconscious and
existential feelings, which are often to do with obsessive-compulsive fears of
losing control, or strong emotions such as anger or shame. They control and
restrict their intake of food to find a way to face the world and displace or
repress these feelings, which have become too hard and painful to consciously
express. It is possible to redirect this displacement and channel it through art
materials. The creative act and the artwork that the patient makes then draws
up the original feelings to consciousness, which begins the process of relieving
them. Schaverien argues that the pictures that the anorexic patient creates act
as temporary transactional objects, because they have the capacity to initiate
a movement of unconscious feelings towards their becoming conscious and
possibly transformed. As Schaverien says, 'Art offers an alternative, a way of
enacting and symbolising the inner conflict' (Schaverien 1995: 133). In this way
the anorexic's restrictive or their 'acting out' with food becomes an enactment,
which brings this behaviour to consciousness. As a consequence, 'The art process,
mediated within the transference, may facilitate a journey from a relatively
unconscious or undifferentiated state, through stages of concrete thinking, to
the beginnings of separation' (Schaverien 1995: 140). Once the patient is able to

separate the elements of the unconscious that are causing them to have difficult and painful feelings, they are then able to move forwards with insight and grow a new healthy attitude and set of behaviours.

I will now think further about the growth and transformation that are made possible by engaging with different forms of arts therapies, in relation to my own case studies of suffering (and healing) from anorexia and schizoaffective disorder.

2. Case examples: Episodes of the arts therapies

We can see illustrations of a successful use of arts therapies by looking at my own example of recovering from a complex psychiatric illness that was a combination of anorexia and schizoaffective disorder.[5] Art was instrumental in the improvement of my psychotic and neurotic symptoms because of the way it enabled me to express myself and find a new language with which I could show and share my sense of the world. More than that, creating art provided me with a safe way of being in the present so that I could accept the here and now that has caused me such distress, and learn to grow away from the illness. Art helped me build a new life. This has developed, so now I paint every day and this practice helps me take stock of myself and my experiences of reality, as I learn to flow with the drips of paint and their swift connection with the present. My own experiences do not involve an actual art therapist anymore, since I practice my art independently, and whilst I was in hospital I usually worked on my own. But my practice was opened to me by a therapist, who encouraged me to dare to express myself, and opened a safe space where I could be creative. In this space I developed my art practice until it became a coping mechanism to help me deal with the symptoms that defined my illness.

I was detained in various psychiatric hospitals numerous times over a period of 12 years. During this time I suffered from anorexia, schizoaffective disorder, depression and borderline personality disorder – diagnoses that kept on changing as the doctors attempted to label, define and pin down an illness that was largely based on my acute hypersensitivity and neurological malfunction (as a result of a chronic brain injury. That's another story). This constant mis/re-diagnosis of the psychiatrists, and the structure of the system and the timetable in the clinic, was problematic. But participating in arts therapies proved to generate healing. During this time I would paint and write to relieve my suffering. I also participated in groups of dance and movement,

music and song. These groups were facilitated by different therapists, and they all contributed to my being able to access some degree of transformation and therapy.

It might be possible to question the success of any of the arts therapies groups I attended in the different clinics I spent time in, if my illness lasted over a decade and involved repeated relapses. Clearly art, and arts therapy, have limits, and there were other important factors involved (such as medication) in my eventual recovery. But my experiences of the different kinds of arts therapies were and continue to be instrumental because they opened up a method by which I could later access the agency of transformative therapeutics from art practice, irrespective of whether or not I was in a clinic or had access to an art therapist.

My own experiences of the arts therapies, or more specifically, when they took the form of painting, do not necessarily conform to the stereotype that was discussed in the first half of this chapter, since most of the painting groups I attended were largely undirected by the therapist, who did not interfere but allowed the patients to do as they pleased. There was no interpretive discussion or review about the meaning of my artworks. The therapist's role seemed to be not to interrupt or direct me, but to provide an opening for my own self-discovery through the process of creativity.[6] By laying out a multitude of different art materials and encouraging me to choose and play with whatever I felt like, the therapist was able to simply create a calm space where I could be myself, and pause there. Pausing with the self in a safe environment, and there being creative, was cathartic and healing because of the ways that I had the opportunity to give it some kind of form in the artwork I create. Responding intuitively to the tactile materiality of the paints, pastels, paper and any other materials I could find (such as sand, wet concrete (from the building works going on in the ward), bark or bubble wrap), I found that I could express my feelings in a way that brought me an embodied sense of satisfaction and pleasure. The arts therapies studio was a safe place where I was able to bring form and living meaning to the pain and suffering I felt.

My illness was about self-destruction. I had voices in my head telling me to destroy myself, and these strange tactile hallucinations that felt like I was being throttled with barbed wire. Sometimes I would paint or draw these feelings, and my doctor would interpret the image and then gain a greater understanding of my condition. He was then able to diagnose and medicate me accordingly. In this way my art became a clinical tool that was instrumental and transformative in my recovery from psychiatric illness.[7]

Other times I would paint sheer gnashing (often dark) colours and agonizing (Figure 2.1) gestures, tearing the paper to pieces, bursting through the bounding contours of each page in my (broken) sketchpad. These works did not represent or symbolize anything; they were pure living energy from my (also broken) soul. Feeling the different materials' textures through my fingers, and being able to apply them with digital mobility enabled me to stay still with my body and somehow feel connected to it. This was particularly important, since my problems with self-harm made it very difficult to inhabit my flesh. Art helped me sit still and focus, at a time when my body was so weak and wounded from malnutrition or self-mutilation that I was simply unable to concentrate or stay with myself.

Figure 2.1 Lorna Collins, *Darkness Clings: Tactile Hallucinations*, 2009. © Lorna Collins.

Making art played a significant role in helping me recover from body dysmorphia, which is a symptom of anorexia where the patient has a heavily distorted self-image, and cannot see a true picture of their own body. A somatoform disorder, body dysmorphia manifests itself in extreme concern and preoccupation with a perceived defect of physical appearance. When I looked in the mirror I saw an obese, laden woman, whilst I was in fact extremely underweight (Figure 2.2).

What I was seeing did not in fact bear any resemblance to my true appearance (Figure 2.3). But I was able to learn how to see my body by drawing myself. With the help of physiotherapist Patricia Caddy, who asked me to look at myself in the mirror and draw what I saw, I was able to identify the difference between what I thought I was seeing and what was actually there.[8] I looked at my body as I would do a still life, and tried to draw an accurate representation of it. This exercise enlightened my self-perception. Gradually my drawings decreased in size as my vision of myself became more realistic. Life drawing in this way opened my eyes. When I learnt to see how underweight I was, it became more reasonable and justified to begin the very difficult process of gaining weight. It also helped me inhabit my body: the quiet, lengthy process of staring into a mirror and sketching my reflection slowly sharpened my perception as I learned how to see what was there. This was an embodied time and I began to feel a sense of desire to see my own, gendered form taking shape. Art enabled me to develop these new senses of my body; it was in this way transformative and therapeutic (Figure 2.4).

Figure 2.2 Untitled. © Lorna Collins.

Figure 2.3 Untitled. © Lorna Collins.

Figure 2.4 Untitled. © Lorna Collins.

I also took part in dance and movement therapy during one of my admissions at an acute general psychiatric ward. This form of therapy recognizes body movement as an evocative instrument of communication and expression, which facilitates personal growth and transformation. Beginning from the belief that bodily knowledge is core to therapeutic change within an interactive relationship, dance and movement therapy was first recognized in the United States in the 1940s, and is now represented in the United Kingdom by the Association for Dance Movement Psychotherapy. The ADMP define 'DMP' as 'a relational process in which patient/s and therapist engage together in a creative process that uses body movement and dance to integrate and embody emotional, cognitive, physical, social and spiritual aspects of the self'.[9]

In my experience of it, group sessions began by a group of fellow patients standing in a circle, when we were encouraged to think of a single gesture or movement that expressed how we were feeling at that moment. I felt locked in my head in my illness, and my body became my enemy – a war machine – because it was a place I could no longer inhabit and felt that I must destroy. So I stamped my feet and thrust a dagger to my chest, wailing at existence. Other patients curled up into a tight, foetal ball, or fled into a sprint around the room, or simply covered their eyes and sunk down onto their knees. In this single movement we got in touch with our bodies and managed to communicate our feelings to the other members of the group. This led to a sense of inhabiting the body and feeling at one with it, whilst we were able to express ourselves through these simple movements.

During this group we were asked to create another simple movement and give it to another person in the room, by dancing our movement in front of them, whereupon this other person would watch, receive and repeat your movement and create a response, then giving their movement to another person in the group. This exercise would go around the room until everyone had expressed and shared their movements with the group as a whole. This sharing developed a sense of taking care and building support so that we were no longer alone with our bodies of suffering; we collaborated and found a sense of lightness and growth in the interconnection we made by dancing individually but together.

Then the group leader brought out some props – swathes of cloth, lace, silk and blown-up fluorescent balls – and we were invited to choose one of these items to help us make another movement to express to the group. I chose a long silky cloth. I felt enamoured by touching it, pulling it through my hands and around my body. It was as though the material was asking me to hold it

closely, and I found myself dancing around the room. My movements quickly became jagged and violently sharp, as anger burst forth and I wrapped the cloth around my neck several times, pulled it taut and then fell down heavily onto my knees, as if this was the only way to break free. My theatre was tortured by the voices inside me that told me to destroy the beauty of these movements. But during this group act I could give the violence of my movement and the cloth to someone else, and they received it and took it away from me. Then they did their own movement with the cloth and through this gesture my pain was instantly transformed into a new person's own creative feelings. Not everyone danced with destructive pain, but there was visible catharsis to all of our movements. It was liberating to move the body to express ourselves, share pain or suffering and feel it recede in the caring and collaboration of the group.

My experiences of music therapy are based around the way that music triggers memory.[10] During groups of singing and percussion I found that I was able to remember words and tunes from my childhood. When the group leader asked if anyone had any songs they'd like to sing I kept quiet because I couldn't remember any songs at all. I was only doing this group because I was bored, I thought, and there was nothing else to do, locked up in this awful psych ward. I don't like singing and I've got an awful voice. But then the leader of the group began to twang her guitar and murmur through a few tunes and I found myself listening increasingly intently. I recognized some of the tunes and before I knew it I found myself singing. Words erupted from my mouth and I did not know where they had come from – I couldn't remember the words, or I could not remember remembering them, but something brought it back to me and here I was singing them, heartily now. It was fun. This distracted me from my illness as – after a while – memories grew out from these songs to distinct senses of where I had actually encountered and sung them before. This was more than mere nostalgia, since I began to feel a sense of wholeness in my hole-y soul.

Other groups of music therapy I participated in used a range of instruments.[11] One in particular was held in a large room full of different instruments and we were encouraged to choose whichever one we liked and begin to improvise. There were a lot of percussion pieces such as drums, bells or African instruments that I had never seen before, and also a piano, a guitar and some other more well-known instruments. The beauty of the group was the way the leader conducted us to improvise together. At the beginning most of the participants were too scared and shy to dare to make much noise, but gradually we began to tinkle with sound. We created together a cacophony that was at times sheer, ugly, loud noise, which was awful to hear, but then

this developed into peaceful tingling and a communal sense of rhythm, companionship and harmony. All this was entirely improvised, since we had no music. It was the group leader who held us all together, the sound that built this 'together' and there we shared a moment of freedom. This moment was beautiful.

These experiences of arts therapies provided me with ways to inhabit my body during times of desperation and suffering. They enabled me to communicate and share my way of being with the other patients in the group and the therapist, which lightened the agonizing load that I carried with my illness. Arts therapy in the clinical setting was instrumental in my recovery, because of the ways it set me free from my symptoms, whilst enabling me to express and understand them. Creating different forms of art during my detainment(s) evoked an agency of transformative therapeutics that enabled me to grow and fundamentally change my sense of self and the world. As McNiff says: 'Art is alchemy. It makes one thing from something else. It takes the worse experiences and turns them into life-enhancing expressions' (McNiff 2004: 232).

3. Making Sense of these episodes

In this section I will look through the psychoanalytic lens of Winnicott's 'holding environment' and Ogden's 'analytic third' to make sense of these episodes of arts therapies, and show how they provide an agency of transformative therapeutics.

From my narrative, we can immediately see how cathartic and reparative creating art proves to be, to the extent that it provides a clear medical instrument to improve my state of mind and my bodily awareness, in relation to (and beyond) psychiatric illness. I am able to express my emotions through my body. This *alters* my feelings and my relationship with my body. In this way creativity is to some extent a homeostatic procedure, which means that it has a regulating, stabilizing mechanism that gives me a clearer view of myself. As neuro-psychoanalyst Lois Oppenheim argues, '*the primary impulse of creativity is homeostatic inasmuch as creativity serves to augment self-awareness and it is on awareness of self that homeostasis depends*' (Oppenheim 2005: 6, original emphasis). Oppenheim argues for a homeostasis that is as much biological or embodied as psychic, cultural and social. As we can see from the drawings I made in relation to my body dysmorphia, art-making changes the artist by

providing them a clearer view of themselves. In this way the artwork activates a process of transformative therapeutics.

This homeostatic capacity of the creative procedure, during (and beyond) these episodes of arts therapies, provides a nourishing or alleviating process that seems to echo Winnicott's understanding of a 'holding environment', which is provided by a mother to her child. We can relate this holding environment to the situation of Making Sense *inside the clinic*, since the psychiatric hospital would seem to present a comparable, extreme form of 'holding' – particularly (as I experienced) in relation to the acute form of holding, which is being 'sectioned', or detained in hospital against one's will. There are clear problems with the panoptic power struggle that clinical detainment involves. But I am arguing that the psychiatric clinic can also provide a holding environment, through its provision of arts therapies, which can lead to healing and growth. This facility can be developed by utilizing Winnicott's psychoanalytic theory on the child's development.

Winnicott discusses the child's sense of being and time, and their developmental process of being in time, in a holding environment (Winnicott 1960: 585–595). Holding is an environmental provision provided for the child by the mother's care and empathy. It leads to the child's growth, eventual separation from the mother and their ongoing development. The context of this holding environment is an activation of the child's sense of their own being in time. It is a dynamic, pre-subjective process of 'going on being' (Winnicott 1956: 303). This engenders a mobility of feeling that concerns the experience of being alive. At this moment the mother protects and insulates the child from the disruptive tarnishing of 'man-made time' (on the clock), which is involved in the organization, degradation and running of the daily life of being-in-the-world. The mother transforms the impact of this pressurized formation of time and creates an illusion of a world where time is measured entirely in terms of the child's physical and psychological rhythms and needs. The holding environment protects the fabric of the child's 'going on being', by holding or sustaining over time the child's developmental process of being alive. Holding in this way involves the provision of a 'place' or psychological state in which the child (or, in psychoanalytic/arts therapies cases, the patient, or, outside the clinic (and in all these cases), the artist) may gather, collect or hold themselves together.

In a similar way, the studio for the arts therapies provides a safe space where I can pause with my (agonized) self. Through my creative procedure I can access a liberal sense of time (whereby the hammer of the clock dissolves during the

experience of art-making), and I can grow into a new way of being alive. My relation with the therapist, or with the other patients in the group, circulates around care and empathy, in a similar way to the relation between a mother and child. It is an intimate activity.

Ogden discusses Winnicott's holding environment in the context of the clinical interpretation of a patient's thoughts, feelings, dreams or symptoms. Ogden says that in the holding environment, interpretation means: 'to generate that human place in which the patient is becoming whole. This type of holding is most importantly an unobtrusive state of "coming together in one place" that has both a psychological and a physical dimension. There is a quiet quality of self and of otherness in this state of being in one place [...]' (Ogden 2004: 1352).

We can see this dynamic space of caring, nurturing and growth in the studio for the arts therapies (or any artist's studio) during the process of art-making, or during any episodes of the arts therapies. Participating in these groups, at the psychiatric clinic, enables me to continue in the face of the torturous suffering of my illness and provides me with a method of being here – in time, and in my body.

In this way, the studio for the arts therapies, such as painting, dance or music, opens a protective place that leads to my becoming and progression over time. As with the child and their mother in the holding environment, this is a psychological and physiological development, which involves maintaining the continuity of the experience of being alive. This is a process of individuation and maturation, which replicates the child's process of growth. Their process, which is also mine, 'entails the development of the infant's or child's capacity to generate and maintain for himself a sense of the continuity of his being over time – time that increasingly reflects a rhythm that is experienced by the infant or child as outside of his control' (Ogden 2004: 1362).

Winnicott's holding environment helps us understand how art practice, specifically situated, in this chapter, with the arts therapies, provides an affect that initiates an agency of transformative therapeutics, which leads to growth, healing, a sense of being and *making sense*, over time. Winnicott says that creativity is 'the doing that arises out of being' (Winnicott 2005: 39). It is the osmotic proximity between creative expression and the fundamentals of existence that enables art to have the capacity to 'resolve situations, and allow for new possibilities' (Winnicott 1986: 36). Here is the potential for art practice to initiate an agency of transformative therapeutics.

To further crystallize this agency that is produced by the creative process I will now consider and apply psychoanalyst Thomas Ogden's concept of the

'intersubjective analytic third', in relation to the healing affect that art-making has been seen to provide the patient inside the clinic. The 'analytic third' is a psychoanalytic concept, which involves the analytic and specifically therapeutic (clinical) relationship between the analysand and the analyst. This relationship is comparable to the holding environment and relation, which we have just considered, between the mother and child. It is 'designed to facilitate the patient's efforts to make psychological changes that will enable him to live his life in a more fully human way' (Ogden 1999). We can apply Ogden's analytic third to the relation between the patient and the therapist, or the artist (who may or may not be a patient) and the world (the situation they are reacting to and the viewers of their paintings). In this way, we can interpret the artwork as an analytic third, because it provides an intermediate meeting point, and paves a path between a patient and their therapist/analyst, or an artist and their reaction to the world or the viewers of their artworks.

The analytic third is defined as a tertiary subject that exists as the generative space *between* analyst and analysand. In this way it bears some resemblance to Winnicott's transitional object (which develops from his holding environment, which we will return to in Chapter 8), but Ogden's notion is based around an active *process* of doing, rather than any static or constitutive space or entity. It is a verbal dynamic that involves an 'ever-changing conscious third subject', i.e. the intersubjective analytic third, which bridges the thoughts, feelings, sensations, fantasies and actions that occur *between* the analyst and the analysand.

The activation of this *between* is important when it is applied to the arts therapies, where the artwork (painting, drawing, performance or play) provides the go-between and a medium for *Making Sense* that stands between the patient and their contact with the world. The proactive process of *making* defines both Ogden's concept and the agency of the artwork. It is this performing action that produces the resultant agency of transformative therapeutics.

The analytic third idea goes beyond the psychoanalytic notions of transference and counter-transference, which were so important in Chapter 1, and develops into generative experiential *shapes* that emerge from the interaction of the analyst and the analysand – or the patient and the world. Here we can see a clear link to the artwork, which exists as a reactive medium that holds and expresses the rapport between the artist and the world, or the patient and the analyst or therapist. The artwork is a testament to the relation between the artist and the world, or the patient and the analyst/therapist; it exists as an active thing in itself that evolves from their interaction and consequent process of

sense-making. The artwork in this way bears resemblance to Ogden's analytic third, although it can embody this notion without the analyst and in relation to the artist and the world they are reacting to.

Ogden says that the analytic third is at first an unconscious phenomenon, and the analyst and analysand should use indirect, intuitive methods to 'catch the drift' of the unconscious co-creation that it results in (Freud 1955: 239). The process of the analytic third, which takes place in both of the analysand and the analyst's minds during analysis, involves a 'reverie experience', which includes the expression and enactment of inarticulate or mundane ruminations, bodily sensations and apparently directionless or disorientated states of being in the world. We saw a similar 'reverie' (or 'ek-static') experience through Stephen Newton in Chapter 1. Ogden's work on reverie is important for our purposes because it involves, he argues, *Sensing Something Human* (Ogden 1999a). So the analytic third involves a creative experience (either in analysis or in the art therapist's or artist's studio) that generates insight into who we are and our being-in-the-world. Ogden uses it to talk about psychoanalysis *as an art*, which confirms its relevance to helping us make sense of the transformative, therapeutic affect of art practice.

There is a forthcoming *shift*, when the enactment of this reverie experience of the analytic third is analysed. It then provides a medium to recognize and name the contents of the reverie that happens between the analyst and the analysand. This experience results in a process of individuation. It is, as Ogden says, 'the experience of coming into being as an individual with one's own distinct and unique qualities' (Ogden 1999). In this way, when applied to the creative process and making an artwork (in therapy or independently), we can interpret the analytic third as a process of *Making Sense*, and an agent of transformative therapeutics.

4. Conclusion

Although we have used psychoanalytic ideas to help us understand the transformative therapeutics that results from the group of arts therapies, these therapies still seem a long way from the stereotypical understanding of psychoanalysis, of the patient reclining on a couch, along with their Oedipus complex. There are clear differences between psychotherapy (and its engagement through the arts therapies) and psychoanalysis, based around the idea that the former is more often concerned with cognitive behavioural methods of solving

problems or offering ways of managing symptoms, whilst the latter concerns self-discovery, or locating the 'why' that explains a certain behaviour, by conducting a genealogy of the unconscious mind. My experiences of arts therapies were in groups, rather than one-to-one sessions, and these groups were incorporated into the strict timetable of the daily routine on the ward. Participating in arts therapies provided some relief and distraction during the intense stress that was involved in conforming to this timetable, being a part of the patient community, and in the agonizing suffering that led to this being necessary.

There were indeed problems raised by the power structure and division of time and occupation in the clinic, but the arts therapies were to a certain extent autonomous from these logistical, practical and psycho-philosophical issues. We will encounter Deleuze and Guattari's contestation of the clinic in Chapter 3. Their antagonism towards the clinic is based on the (en)closure Freudian psychoanalysis, which (they argue) *causes*, rather than *cures* psychiatric illnesses such as schizophrenia. In this chapter we have seen how activities in the clinic, by participating in different arts therapies, have countered the problematic elements of clinical practice, by providing *a place of healing* for the patient. I will advance this hypothesis further in the following chapter.

To conclude this chapter it is important to assess how our excursion through arts therapies (theorized and narrated) and psychoanalytic ideas has developed our understanding and the application of transformative therapeutics. The episodes of arts therapies demonstrate the remedial benefits of art practice as it takes place in the clinical situation of the psychiatric hospital. In these examples we have seen how art-making in groups and individually enables transformation of symptoms, growth and development. It becomes instrumental for the diagnosis and recovery of mental illness; it is thus clearly *transformative*. The *therapeutics* of this transformation evolves through the means of cathartic expression that art-making provides, which can communicate matters and feelings that are impossible to put into words. Communication begins the process of insight, which is central to the process of recovery. The psychoanalytic ideas of Winnicott's holding environment and Ogden's analytic third have also helped develop the notion of therapeutics, because they have shown how the process of art-making in episodes of arts therapies engenders and supports the processes of being and becoming, growth and individuation, which lie at the heart of the human condition (inside and outside of the clinic). This has broadened transformative therapeutics, beyond the clinical case study, or the patient and the analyst, to the relation between the mother and child, or the artist and the world itself. From this

viewpoint, the transformative therapeutics of art practice, as it takes place *in the clinic*, demonstrates a method of making sense of the world, thus furthering the demands of this book.

Now is the time for more critique. The clinic is problematic, and there is more to do with and say about the arts therapies. In the next chapter I engage with Deleuze and Guattari's contestation of the clinic, again turning to one particular form of the arts therapies, specifically in relation to opening a schizoanalytic and ethical model, which will expand the ongoing thesis of transformative therapeutics.

Contesting the Clinic:
Art, Therapy and the Schizophrenic

Moving on from the case examples showing the application of different arts therapies, which we discussed in the previous chapter, this new chapter critiques this clinical perspective, by opening Deleuze and Guattari's project of schizoanalysis. Here, I intend to lay out how Deleuze and Guattari formulate schizoanalysis in *Anti-Oedipus*, in relation (and opposition) to psychoanalysis. I will discuss their initially destructive intent to critique the psychiatric clinic. This intent is based upon their hypothesis that the implications of the clinic actually *cause* rather than *cure* psychiatric illnesses, which I will examine. As a consequence, I will question whether or how their alternative, schizoanalysis, is a viable response to these illnesses and for considering (or liberating) subjectivity at large. As the book progresses, we will begin to discover whether or how schizoanalysis can then be utilized in response to the clinical case studies that arise in the first half of this book.

Schizoanalysis is interesting for this book because with it Deleuze and Guattari want to source an ethical 'place of healing', which – when we activate it via art practice – we can take as an agency of transformative therapeutics. They mean to do this by engaging with the schizophrenic *process* and liberating them from their clinical detainment and diagnosed *illness*. I locate problems with Deleuze and Guattari's argument for this position in *Anti-Oedipus*, with their dependence on (and exclusion of) the schizophrenic individuals, Artaud and Schreber. I also examine another term that Deleuze and Guattari utilize in their schizoanalytic project, counter-actualization, which – as a synonym of healing – relates to our efforts to source and apply the transformative therapeutics of art practice. I will critique whether the process of counter-actualization (which is transformative therapeutics) is accessible in *Anti-Oedipus*.

However, using Deleuze and Guattari's (separate, rather than collaborative) thinking in other works shows an application of schizoanalysis that plausibly

resolves these problems. We learn that Deleuze and Guattari do not so much want to destroy but *reform* the clinic; not get rid of psychoanalysis *per se*, but re-engineer it. I propose generating this productive application of schizoanalysis, and source the 'place of healing' and process of counter-actualization promised but unobtainable from *Anti-Oedipus*, by engaging with art.

I present this argument by utilizing Deleuze's morality in *The Logic of Sense* to locate an ethical model of counter-actualization that has an aesthetic motor. Then I demonstrate how art therapy (in the singular, referring to visual art practice, i.e. painting and drawing) and Art Brut offer a means to effect this counter-actualization, thus building the agency of transformative therapeutics that defines our making sense of the world. To conclude I turn to Guattari's solo schizoanalytic practice, and Deleuze's own informal interventions as a schizoanalyst (with Suely Rolnik), where (in both cases) art-making fuels a new way of living and provides therapy and healing.

1. Schizoanalysis: Exposition[1]

Before beginning our immersion into schizoanalysis it is important to define the schizophrenic.[2] According to the psychiatric systems Deleuze and Guattari are challenging, schizophrenia is a psychiatric disorder characterized by hallucinations, delusions and impairment in the perception or expression of reality. People who find themselves in the position to be diagnosed as schizophrenic have trouble knowing how to differentiate the real from the imaginary, because the boundaries that demarcate the ego or self are distorted. They often experience multiple senses of self, which invade the mind through psychotic hallucinations of visions or voices. It often seems as though several different characters inhabit a schizophrenic individual's mind. A person diagnosed with schizophrenia has paranoid or bizarre delusions, disorganized speech and thinking, with significant social dysfunction. Normal capacities of communication are severely impaired. These symptoms are involuntary and uncontrollable, so the schizophrenic's subjectivity is defined by psychotic delirium.[3]

The etymology of 'schiz' in schizophrenia and schizoanalysis comes from skhizein, or σχίζειν, meaning to split, break, separate or divide. With schizophrenia, this refers to the 'split' in the mind, or the multiple, broken up experiences of reality that an individual with schizophrenia has during a psychotic episode. Schizoanalysis is trying to locate exactly where and how

these breaks in reality arise, and then mobilize them to manufacture a new production of subjectivity. By contrast, Freudo-Lacanian psychoanalysis is concerned with dampening these breaks, to flatten or resolve any divide and eliminate any possible entry or exit points into the turmoil of this splitting. In this way the consequent mental health profession instils its hegemony onto the psyche, since, as Deleuze and Guattari argue, the psychoanalytic dam (with its singular oedipal constriction) curbs the machinic flow of desire that defines subjectivity, thus detaining it. By contrast, they want to release and liberate the schizo's split/multiple senses of subjectivity and the world.

Deleuze and Guattari's project of schizoanalysis drives the economy and logos of their magnum opus, *Anti-Oedipus: Capitalism and Schizophrenia*. In this work they position schizoanalysis to search for what they describe as 'the new earth', or a new understanding of subjectivity and desire, which will provide, as they argue, 'a place of healing' (Deleuze and Guattari 2004: 417). By offering this as the conclusion of *Anti-Oedipus*, Deleuze and Guattari imply an ethics to their schizoanalytic project. As Mark Seem argues, *Anti-Oedipus* 'develops an approach that is decidedly *diagnostic* [...] and profoundly *healing* as well' (Deleuze and Guattari 2004: xix). They are not looking for a *cure* for the schizophrenic, but a cure from the system that causes and detains this illness: 'the schizophrenization that must cure us of the cure' (Deleuze and Guattari 2004: 76/80).

However, despite these constructivist, ethical intentions, in *Anti-Oedipus* schizoanalysis is more accurately described by the ongoing dynamic of 'Destroy, destroy' than anything that brings healing. As a self-described violent, brutal and 'malevolent activity', schizoanalysis seems to be waging war. This punitive dynamic is directed towards Freudian psychoanalysis, and its implications (that Deleuze and Guattari read) on the social field and subjectivity (Deleuze and Guattari 2004: 342, 417).

And yet, any singular reading of Deleuze and Guattari's intentions in *Anti-Oedipus* is misleading. Although they seem to pronounce a catastrophic war on psychoanalysis, they do not in fact reject it completely. By contrast, they retain some key psychoanalytic concepts (such as the unconscious, repression or the ego) and even say that: 'We refuse to play "take it or leave it"' games with psychoanalysis and accept the edict that 'one cannot challenge the process of the "cure" except by starting from elements drawn from this very cure' (Deleuze and Guattari 2004: 128). They still wish to bring about fundamental systematic change to the system of psychoanalysis, its power holding and its oedipalization of the unconscious, but they say that this change will not happen 'only outside

psychoanalysis. We believe, on the contrary, in the possibility of an internal reversal that would make the analytic machine into an indispensible part of the revolutionary machinery. What is more, the objective conditions for such a practice appear to be already present' (Deleuze and Guattari 2004: 90). Thus their challenge to psychoanalysis is ambiguous, because on the one hand they are very critical indeed, and seem to want to destroy it completely; whilst on the other hand they are continuing to apply and utilize psychoanalytic concepts in the very system that they are challenging.

The reason why *Anti-Oedipus* opposes the authority and dominion of the mental health profession, as it is imposed in the psychiatric clinic (and on the couch), is because of the ways that its structure and power in fact operate and affect the social field and our existence at large. This is why it is such a big deal to argue against psychoanalysis: its problematic logic and symbolic order relates to and affects all of us. So schizoanalysis apparently begins as a fervent critique of psychoanalysis, and develops (beyond *Anti-Oedipus*) into a reworking or, as Guattari develops in his own, later work, a 'metamodeling' of its systematic mal/function in society (Guattari 1995: 58–76; Guattari 1996: 122).

In *Anti-Oedipus* Deleuze and Guattari argue that the schizophrenic illness is caused by the psychoanalytic system (Deleuze and Guattari 2004: 74–76). This is partly due to the hegemonic, restrictive use of the Oedipus complex as a starting point for all analysis, and the authoritarian role of the psychoanalyst in relationship to the patient.[4] Deleuze and Guattari then use the schizophrenic to source both a new interpretation of the unconscious, a new definition of subjectivity, to activate their new definition of desire and to break up this psychoanalytic system. They claim to do this by separating the schizophrenic process from the illness and then using this process to disrupt what they believe has caused the illness:

> Wouldn't it be better to schizophrenize – to schizophrenize the domain of the unconscious as well as the sociohistorical domain, so as to shatter the iron collar of Oedipus and rediscover everywhere the force of desiring-production: to renew, on the level of the Real, the tie between the analytic machine, desire and production? For the unconscious itself is no more structural than personal, it does not symbolize any more than it imagines or represents; it engineers, it is machinic. Neither imaginary nor symbolic, it is the Real in itself, the 'impossible real' and its production. (Deleuze and Guattari 2004: 60)

In the conclusion of *Anti-Oedipus* Deleuze and Guattari say that although schizoanalysis is a destructive undertaking, 'at the same time the process is

liberated' by their new interpretation of desire, so that their schizoanalytic system presents a 'new earth' for us all (Deleuze and Guattari 2004: 417). They assert that this new earth: 'is not to be found in the neurotic or perverse reterritorializations that arrest the process or assign it goals' (Deleuze and Guattari 2004: 417). By this they mean to say that their new way of thinking does not rely upon cases of psychiatric illness, or the clinical detainment of 'neurotic or perverse reterritorializations', and that such detainment or reterritorialization blocks the process of 'desiring-production', which defines their new system. They argue that the new system or 'the new earth' created by schizoanalysis is *not* defined by neurotic or perverse clinical entities in terms of a diagnosed illness. Such diagnosis blocks the process of desiring-production that Deleuze and Guattari wish to activate. They argue that the new system of schizoanalysis does not depend upon illness, whilst the system that diagnoses this illness is exactly what they challenge in *Anti-Oedipus*. They intend to 'liberate' the schizophrenic process – to free the process of desiring-production, to release its clinical detainment. As we will see later on in this chapter, such liberation involves a counter-actualization of suffering, which can be obtained through the transformative therapeutics of art practice (although it appears to be elusive in *Anti-Oedipus*).

Deleuze and Guattari argue that the desiring-machines activated by the schizophrenic process, once separated and liberated from the illness, operate as lines of escape from the system of psychoanalysis. The implications of schizoanalysis, from this point of view, as Foucault says, intend to 'break the holds of power and institute research into a new collective subjectivity and a revolutionary healing of mankind' (Deleuze and Guattari 2004: xxiii). Foucault accordingly calls this work a 'book of ethics' (Deleuze and Guattari 2004: xv). It is thus an appropriate notion to consider in our efforts to source an agency of transformative therapeutics that can help us make sense of the world.

Schizoanalysis is 'at once a transcendental and a materialist analysis', seeking the transcendental conditions of experience and then defining these conditions according to a materialist immanence, which demonstrates Deleuze and Guattari's challenge to Freud and Kant (Deleuze and Guattari 2004: 132).[5] At the same time, they assert that it means to provide 'practical principles as directions for the "cure"' (Deleuze and Guattari 2004: 120). By this they do not necessarily want to cure the schizophrenic, and their schizoanalytic project remains characterized by the ongoing violent dynamic of 'Destroy, destroy' (Deleuze and Guattari 2004: 342). And yet, with schizoanalysis Deleuze and Guattari intend to source a new and benevolent way of thinking about being, which can provide a 'cure', 'liberation' or 'healing' from the systematic

problems that they diagnose as the after-effects of psychoanalysis. This is why Foucault says that *Anti-Oedipus* offers the reader a 'guide to everyday life' or a practical '*Introduction to the Non-Fascist Life*' by its machinic reinterpretation of schizophrenia and desire (Deleuze and Guattari 2004: xv). As such we are encouraged to read and apply *Anti-Oedipus* to help us make sense of the present, i.e. diagnosis, and also to make a new present, i.e. remedy.

Although they say that they are not interested in the schizophrenic entity, the argument of Deleuze and Guattari implies that once 'freed' from the psychoanalytic detainment and classification of schizophrenia, schizophrenic individuals could free the schizophrenic process and release their desiring-production, escaping the system (i.e. its theatre of Oedipus and 'The Holy Family') that has suppressed them (Deleuze and Guattari 2004: 58). Deleuze and Guattari are interested in breaking and escaping the system and commencing a new way of thinking, rather than considering the subjective implications that their schizoanalytic process may have on the individual: '[…] the revolutionary knows that escape is revolutionary – *withdrawal, freaks* – provided one sweeps away the social cover on leaving, or causes a piece of the system to get lost in the shuffle. What matters is to break through the wall, even if one has to become black like John Brown' (Deleuze and Guattari 2004: 305).

Deleuze and Guattari's *Anti-Oedipus* opens with three famous schizophrenic cases – Schreber, Lenz and Malone[6] – and has three aims: to distinguish between schizophrenia as process and schizophrenia as illness, to identify the operative elements or transcendental conditions of the schizophrenic process and to show how the schizophrenic process is the basic model for the unconscious. From these aims Deleuze and Guattari want to use schizophrenia to produce an entirely new logic. They argue that the schizophrenic illness exemplifies and responds to the state of the world, and then they use it to comment on the society and environment that they believe lead to its manifestation (and detainment) as an illness: 'the schizo [is] as close as possible to matter, to a burning, living center of matter' (Deleuze and Guattari 2004: 21).[7]

By separating and schizoanalytically mechanizing the schizophrenic *process*, they intend to emancipate desire and henceforth entirely destroy what withheld it to cause the breakdown of the schizophrenic *illness*. Deleuze says that 'we are not saying that the revolutionary is a schizo. We are saying that there is a schizophrenic process, of decoding and deterritorialization, which is the only revolutionary activity against the rotation of the production of schizophrenia' (Deleuze 1972: 54–55). This 'production of schizophrenia' results in the hospitalized schizo 'entity', which is what Deleuze and Guattari are so keen to prevent.

Before we go on to see whether schizoanalysis can provide liberation for the schizo entity, or anyone else, it is important to understand Deleuze and Guattari's interpretation and use of desire. Their whole project revolves around redefining desire as productive. The main intention of *Anti-Oedipus* is to critique Freud's interpretation of desire as coming from a lack, and his system of psychoanalysis. Deleuze and Guattari use Freud's *Schreber Case* to plot their polemic against Freud's psychoanalytic analysis of Schreber's schizophrenic 'insanity', as narrated in his *Memoirs*. Deleuze and Guattari use the example of Schreber to dispute Freud's system of psychoanalysis, and build a new, schizoanalytic logic, based on the schizophrenic process they see recounted throughout Schreber's *Memoirs*.

Deleuze and Guattari employ the schizophrenic Schreber to redefine desire and the unconscious field. They wish to challenge the Freudian notion of desire, which is an idealist, transcendent, metaphysical fantasy based on lack. In Freud desire is the production of *wishes* or *phantasies,* which *represent* the object desired; its true cause is a primal *lack.* His clearest elucidation of desire as 'wish-fulfilment' is in the theory of dreams (Freud 1991a: 200–213). A dream 'can represent a wish as fulfilled' (Freud 1991a: 201). A 'day-dream' is an instance of the daytime relaxation of consciousness, which brings forward 'unconscious phantasies', or repressed, censored desires about things a person wants to obtain, but lacks (Freud 1991a: 632–636). Desire is bivalent, having two poles: eros and thanatos, or the desire for life and reproduction (which then invests the social field and culture through sublimation) and the desire for death and destruction (which stays in the unconscious and produces fantastic signs of its satisfaction). In Freud the *unconscious* drives constitute the transcendental field of the subject.[8] Desire is the production of phantasies as a result of repressed (and so unconscious) desires.[9] This system pivots around the Oedipus complex. Deleuze and Guattari wish to break the system of representation that Freudian desire fosters, and destroy the 'social production' that it antagonistically conditions through 'the holy family' (of 'daddy-mommy-me') and the singular (repressive) problem of Oedipus (Deleuze and Guattari 2004: 60).[10]

According to Deleuze and Guattari, the process of desiring has a material and economic reality, not a psychic power or fantasy. Desire is a primary active power, not derived from a desiring subject who lacks an absent object. One of the aims of *Anti-Oedipus* is to formulate an *immanent* conception of desire, thinking of the unconscious as not a theatre or system of representation but as a factory, i.e. a locus of production. Desire is not produced because of a lack, and the desired thing is not desired because it is absent; it is real because it is desired.

This is a machinic and productive conception of desire, as differentiated from the desiring subject or transcendent object desired.

Schizoanalysis has three tasks. These are flavoured by the dominant destructive energy of the first task, which is categorized by 'Destroy, destroy, wanting to 'cleanse' and reboot the unconscious (Deleuze and Guattari 2004: 342). Despite the ongoing destruction and dis-ease that permeates *Anti-Oedipus*, the thesis of schizoanalysis is nonetheless inherently productive, as Deleuze and Guattari say: 'desire is a machine, a synthesis of machines, a machinic arrangement – desiring-machines. The order of desire is the order of *production*; all production is at once desiring-production and social production' (Deleuze and Guattari 2004: 325). To infiltrate this new interpretation of desire across the whole social field, schizoanalysis has two 'positive tasks', which build and differentiate the desiring-machines, preconscious investments and unconscious desires. From its three tasks schizoanalysis presents a four-fold thesis, which embarks in opposition to Freud's Oedipus complex: every investment is social and molar (rather than familial), preconscious investment of interest differs from the unconscious investment of desire, the libidinal investment of the social field is primary in relation to familial investments and there are two poles of libidinal social investment – the paranoiac and the schizoid.

Although their whole project is characterized by *destruction*, since they want to uproot all notions of desire and the unconscious as supposedly misinterpreted by Freud, schizoanalysis remains a *constructivist* enterprise, since they want to integrate and affect the whole social field in a productive or replenishing sense. They don't want to initiate a devastating enterprise that will annihilate psychoanalysis for the sake of it, but, rather, they want to critique psychoanalysis and, in so doing, create new ways of thinking about desire and the unconscious, through their schizophrenization of subjectivity.

To materialize this revolution Deleuze and Guattari mobilize the 'sick schizo' to source their key concept, the 'body without organs' (BwO) (Deleuze and Guattari 2004: 397). The BwO is introduced via a Kantian paralogism that falsifies Freud's notions of the unconscious, desire as a lack and the closure of his system to 'the holy family' (Deleuze and Guattari 2004: 58ff.). Deleuze and Guattari argue that although the psychiatric institution is not the *sole* cause of pathology, its closure *produces* rather than *cures* the Oedipal complex and 'madness' that patients like Schreber are incarcerated for: 'Oedipal homosexuality – the qualitative aptitude for conflict – is rather the effect of oedipalization, which the treatment does not invent, but precipitates and accentuates within the artificial conditions of its exercise (transference)' (Deleuze and Guattari 2004: 74).

This is why Deleuze and Guattari wish to challenge the system rather than cure the individual. They want to cure us of the *cure*: 'in any case the harm has been done, the treatment has chosen the path of oedipalization, all cluttered with refuse, instead of the schizophrenization that must cure us of the cure' (Deleuze and Guattari 2004: 76). Such contradiction provides a double bind in Deleuze and Guattari's reading of Freud's system, which they attempt to move from with their new conceptualization of desire, as figured by the BwO.

The BwO derives, in part, from Kleinian psychoanalysis. Deleuze talks about the BwO in relation to Klein's 'urinal object' in the series 'of Orality' in *The Logic of Sense*. In this chapter Deleuze is talking about orality – or speaking and eating – as the surface of expression. He uses Klein's distinction between the paranoid-schizoid position and the depressive position to think about our oral-anal constituency, in terms of our body's input and output, its surface and depth. Deleuze is thinking about urine and faeces as liquid and solid excrement. It is from the liquid, through Klein, that Deleuze sources his concept of the BwO. The BwO is the liquid or urinal object, as opposed to the anal object: it absorbs desire: '[...] body without organs and liquid specificity are bound together, in the sense that the liquid principle ensures the soldering of the pieces into one block, even if this were a mass of water' (Deleuze 2004: 223 n. 3).

With their concept of the BwO Deleuze–Guattari intend to lay bare the material processes of the unconscious and engage them in a factory of desiring-production. The BwO itself originates from the poet – infamous for his schizophrenia – Artaud, who formulated it to suggest the 'true' condition of a body freed from God (Artaud 1988: 570–557). It presents a field of immanence of desire, rather than its surfaces of stratification, where, in Artaudian terms, the judgement of God dictates organization, signification and subjectivation. By contrast, the BwO is a site of non-coded flows. Deleuze and Guattari then use Artaud's BwO to release desire from Freudian fantasy.

They picture this release using the schizophrenic discourse or '*nerve-language*' of Schreber, as presented in his *Memoirs* (Schreber 1988: 69). From his hallucinatory experiences Schreber believes that he can communicate with God – as 'divine rays' inflect his nerve endings, fragment his body and erupt into thousands of 'little men' (Deleuze and Guattari 2004: 334). In citing Schreber's delirium (motivated by its machinic intensity, 'haeccic' flux and libidinal economy) Deleuze and Guattari intend to dissolve the representative being fascistically enclosed by the 'organism' and emancipate pure living energy.[11] In this way, with schizoanalysis Deleuze and Guattari intend to *liberate* 'madness' from its denotation and detonation as an illness, so that

'madness world no longer exist as madness, not because it would have been transformed into "mental illness", but on the contrary because it would receive the support of all the other flows, including science and art [...]' (Deleuze and Guattari 2004: 353).

They use the schizo discourse of Schreber and Artaud to access and define the 'full' BwO and the schizophrenic process of de-territorialization, as uncoded flow of desire that will produce a 'new earth' for all of us. The concept of the BwO provides Deleuze and Guattari with a boundless, mechanical plane on which they can lay out the libidinal immanence of this new earth, which constitutes and galvanizes monadic sensation, erupting intensities from the unconscious to condition and effect living conscious matter in the world.

By now we have seen how Deleuze and Guattari condemn Freud and psychoanalysis in *Anti-Oedipus*, and how they build their alternative practice of schizoanalysis. But this raises questions about how they utilize the schizo (or the schizo 'process') to build their new definitions of desire and subjectivity, and how schizoanalysis can provide any sort of liberation for this schizo (or their process) and for the rest of us. We seem to be quite a long way from making sense, transformative therapeutics and art practice. Now it's time to criticize the schizoanalysis we see in *Anti-Oedipus*, and then move on to seeing how art practice (and art therapy) can realize our thesis of transformative therapeutics (which then becomes a more *liberating* application of schizoanalysis).

2. Schizoanalysis: Critique

Despite the apparent conceptual production of 'desiring-machines', Deleuze and Guattari's engagement with schizophrenia to drive their system remains not just controversial but tenuous. They try to distinguish the schizophrenic *process* from the *disease* of the clinical entity, using this as a modal dynamic, differentiated from the 'sick schizo', to destroy (and heal) the causes of his detainment and 'Oedipalization'. Although they argue that the schizophrenic process (when emancipated from its clinical detainment) can provide the needed breakthrough and revolution, rather than the breakdown of the illness, Deleuze and Guattari define the central figure of their system, the BwO, directly from the schizophrenic cases of Artaud and Schreber – both infamous 'madmen'. Deleuze and Guattari use the examples of Artaud and Schreber to demonstrate how the force of desire can explode and exceed the psychiatric constraints of oedipalization to offer a process that provides a form of 'schizo resistance'.

This distinction between illness and process raises problems. It is unclear exactly how we can extract and motivate the schizophrenic process, and how this process can be the 'inverse' of the illness, whilst still being schizophrenic. *Who* is to do the accessing? If they mean the actual schizos, then *how* do they extract the process from their illness? How can one access the process of schizophrenia, differentiate it from the illness and then use it to provide restorative sense in relation to being *per se*?

Deleuze and Guattari do state that although they want to mobilize the schizophrenic process, which involves a disrupted sense of subjectivity, the intent is to retain *some* sense of the subject and lay out a transcendental plane of consistency for thought, rather than to destroy or deconstruct being entirely. When describing the BwO, Deleuze and Guattari advise caution with the explicit destruction that they argue is necessary. We must retain a *small* sense of subjectivity:

> Dismantling the organism has never meant killing yourself, but rather opening the body to connections that presuppose an entire assemblage [...] You have to keep enough of the organism for it to reform each dawn; and you have to keep small supplies of significance and subjectification if only to turn them against their own systems when the circumstances demand it, when things, persons, even situations, force you to; and you have to keep small rations of subjectivity in sufficient quantity to enable you to respond to the dominant reality. (Deleuze and Guattari 2004a: 177–178)

This raises the question of just how much subjectivity is enough to hold together the particular individual that we are, but not too much to curtail the continuous flux of our identity? As the authors themselves say it, there is 'a very fine file' between what is sufficient destruction or experimentation to liberate the subject and what is too much and so dangerous (Deleuze and Guattari 2004a: 177).

Deleuze and Guattari do question the violence and pathology involved in their own thinking. They advise that we should all take 'prudence' when we follow the schizoanalytic direction and adopt the mental processing of the drug addict, anorexic, masochist, etc.: 'Were you cautious enough? Not wisdom, caution. In doses. As a rule immanent to experimentation: injections of caution' (Deleuze and Guattari 2004a: 167). But their methodology of utilizing these cases as figures of thought neither defines nor follows such prudence (Deleuze and Guattari 2004a: 178). They do say that it would be *better* if we could gain the thought process of the drug addict or alcoholic, *without* relying on drugs

or drink, but their argument affirms a state of mind that depends upon these pathological behaviours.[12] They assert the need for caution, but offer no way of judging how to be cautious, whilst their argument still flirts with a fantasy of disease and depends upon the pathological individual.

It is easy, then, to question whether we must suffer from a debilitating illness, entertain potentially destructive behaviours or take illegal substances, in order to create a new way of thinking. As we have seen, Deleuze and Guattari state that their philosophy involves becoming a *little* bit schizo. It is difficult to ascertain what dosage would be sufficient or appropriate to attain the liberation and restorative sense offered by their thinking, whilst they do not counsel how we can raise or then control it. John Sellars discusses the necessity of holding on to 'small rations of subjectivity' in Deleuze and Guattari's efforts to dismantle the organism: 'Deleuze and Guattari suggest that this task is actually something very easy, something that we all do everyday. However, to do it successfully requires skill and caution' (Sellars 1999: 6). The necessity of requiring skill and caution, keeping just a little bit of subjectivity, and only getting a little bit schizophrenic, then excludes the actual schizos, since the process depends upon a quantum of subjective control. By confiscating the schizo *process* from the actual schizos, Deleuze and Guattari then have to abandon these actual schizos, who cannot access 'just a little bit' of their schizophrenia to counter-actualize their illness. The schizo, then, does not apply to schizoanalysis, since they cannot access a certain amount of their 'process', or counter-actualize the suffering that is involved in their 'illness'.

This poses a contradiction, or at least an inconsistency in Deleuze and Guattari, whereby schizophrenia remains the wished-for state of mind of an (ill) Other, which is Deleuze and Guattari's transcendent fantasy, rather than any accessible, restorative or immanent process that can be accessed to create a new way of being. As Hallward argues, Deleuzian philosophy 'is oriented by lines of flight that lead out of the world; though not other-worldly, it is *extra-worldly*' (Hallward 2006: 3). We can see this when we look at how the desiring-machine is manufactured by the BwO, via the schizo. It sounds like an idealist, evanescent entity, when described as 'Nothing but bands of intensity, potentials, thresholds, and gradients. A harrowing, emotionally overwhelming experience' (Deleuze and Guattari 2004: 21). Deleuze and Guattari then quote the mysterious passion of Artaud's madness to demonstrate that it is the schizophrenic *entity* (not clearly differentiated from process) who is the model here: 'this emotion, situated outside of the particular point where the mind is searching for it ... one's entire soul flows into this emotion that makes the mind aware of the terribly

disturbing sound of matter, and passes through its white-hot flame' (Artaud in Deleuze and Guattari 2004: 21).

As Sass argues, schizophrenia generates a somewhat Dionysian effluence to schizoanalysis, seeing madness as 'something wild and dark, a place of unfathomable mystery and uncontrollable passions existing beyond the confines of civilized life' (Sass 1994: 20). Sass quotes Sylvère Lotringer to describe how schizophrenia is defined in *Anti-Oedipus*, as 'the uncontrollable, polymorphous movement of desire emanating from within the social production' (Sass 1994: 20). Sass then argues that when Deleuze and Guattari 'see psychosis as something childlike or Dionysian, [...] they then make the romantic move of valorizing rather than pathologizing these supposedly primitive and uncontrolled conditions' (Sass 1994: 11).

Furthermore, fundamental *dis-ease* remains the heart of Deleuze and Guattari's argument. They engage with the schizophrenic as they do the anorexic, the 'junkie' and the 'perverse machines of the masochist' – as conceptual processes that form machines to rupture open and motivate the field of desire (Deleuze and Guattari 2004: 467; Guattari, Lotringer and Dosse 2008: 95). They wish to make a perverse use of psychoanalytic theory (which classifies these as pathological) in order to destroy its systematic malfunction. Deleuze and Guattari wish to subvert the system by perverting it, to liberate desire by breaking through what they see as its Oedipal wrenches, and use the sadist, the drug addict or 'our polymorphous perversion', mechanized to provide a motor for conceptual purposes (Deleuze and Guattari 2004: 474; Guattari, Lotringer and Dosse 2008: 102).

As such, critical thinking seems to replicate what it judges as the 'immense perversion', since Deleuze and Guattari use the act of suffering, or its perversion, to make an argument by which what they challenge (the law and logic of the clinical) will itself suffer (or be illegitimized) (Deleuze and Guattari 2004: 344). But, by utilizing the likes of perversion or sadism, to what extent can schizoanalysis provide an ethical, healing practice? When and how can we distinguish between Deleuze and Guattari invoking sadism conceptually in their argument (for *jouissance*) and the sadist like Schreber's father invoking it in his 'Pangymnastikon'?[13]

The question then becomes how and when can Deleuze and Guattari's use of Artaud and Schreber's writings provide a source of liberation and the counter-actualization of their sufferings, i.e. a restorative ethic, and when does it confirm their illness? Although Deleuze and Guattari are not interested either in palliative care or in schizophrenic individuals, they still rely on and then exclude these

individuals, as we have seen through Artaud and Schreber, and it is hard not to consider the moral implications of their ideas. Does Deleuze and Guattari's use of Schreber liberate him from his detainment as a schizophrenic? Can Schreber's *Memoirs* provide counter-actualization of his sufferings when either Freud or Deleuze and Guattari use them to define their new respective systems? How can the schizophrenic individual source their own recovery from what is defining their illness? How can destroying the system that names or diagnoses this illness provide anyone any relief? If the intention is not to provide relief but to *escape the system*, will this process provide some form of relief, and if it doesn't, what does it provide the individual?

Now I want to ask why particularly Deleuze relies on maladies in the way that he does throughout his œuvre. I want to think further about the individual case studies engaged with but not provided for in schizoanalysis and look at how Deleuze uses an act of suffering, or psychiatric illness, or perversion, to challenge clinical diagnoses and create a new system. How can we find a 'new earth' that is not just conceptual, but can provide the individual more than rupturous new thought? How can we find a process of counter-actualization that will engender the 'place of healing' promised but destroyed in *Anti-Oedipus*?

To take this further I turn to Deleuze's moral philosophy, as laid out in his *The Logic of Sense*. In this work Deleuze again uses the schizophrenic, and other disorders, but what is different is the way in which his moral philosophy draws upon aesthetics, when he calls upon art in the process of counter-actualization, using case studies of particular artists to define his moral principles. The process of making sense through art can be accessed and applied through a Deleuzian morality, which then (at last) offers the agency of the transformative therapeutics.

3. Deleuze's moral philosophy

In *The Logic of Sense* Deleuze presents his reasons for using amoral motifs throughout his œuvre, and he also brings forward practical principles of a moral philosophy. This is particularly interesting because it involves the counter-actualization of the wound and the sublimation of pain (implicating a different understanding of time and the event), which would seem to offer a restorative and ethical sense for the singularities of individualizing processes (rather than transcendental subjects) involved, which may then be applied to the case studies, such as Schreber or Artaud, which we saw in the first section (who found no counter-actualization in *Anti-Oedipus*).

In *The Logic of Sense* Deleuze presents a perspective that, as James Williams argues, offers us practical principles for a moral philosophy (Williams 2009: 135–174). Deleuze describes why he uses the amoral in his philosophy by showing how his repeated turn to the motifs of sadism, perversion and illnesses such as schizophrenia can be sourced from the Stoics' use of similar amoral motifs such as incest or cannibalism. Seeing how the Stoics used amoral motifs helps us understand why Deleuze's philosophy takes the direction that it does.

In the eighteenth series in *The Logic of Sense* Deleuze argues that entertaining maladies, or engaging with mania, depression or psychological problems, is a properly philosophical exercise. He says that we shouldn't equate philosophy with an illness, but 'there are properly philosophical diseases' (Deleuze 2004: 145). He then describes how mania 'guided' Plato, and says that the death of Socrates is something like a depressive suicide. Deleuze goes on to discuss how the Stoics used activities, such as masturbation, cannibalism or incest, and engaged with all sorts of decadence, alongside their thinking, in order to pose difficult and new philosophical questions:

> On one hand, the philosopher eats with great gluttony, he stuffs himself; he masturbates in public [...] he does not condemn incest with the mother, the sister or the daughter; he tolerates cannibalism and anthropophagy – but, in fact, he is also supremely sober and chaste. On the other hand, he keeps quiet when people ask him questions or gives them a blow with his staff. [...] Yet he also holds a new discourse, a new logos animated with paradox and philosophical values and significations which are new. (Deleuze 2004: 147–148)

These words seem to represent Deleuze's efforts to legitimize the controversy raised by his own philosophy's use of psychological problems. This is the way that Deleuze is defining what philosophy actually is – as he says at the end of the 18th series, 'What are we to call this new philosophical operation [...]? Perhaps we can call it "perversion"' (Deleuze 2004: 151). It seems a contentious proposition to equate philosophy with perversion, but the reason Deleuze is making this claim, and using the Stoic philosophy, is, he says, because it brings *the body* into play with thinking. Involving the body in this way then connects with the desiring-machine and BwO at play in schizoanalysis. Deleuze says that the Stoic philosophy, by engaging with amoral motifs, opens up 'the discovery of passions-bodies and of the infernal mixtures which they organize or submit to: burning poisons and paedophagous banquets' (Deleuze 2004: 149). The point of this is to re-orientate all thinking. Deleuze wants to define philosophy by perversion as part of his over-riding efforts to make a new kind of philosophy,

which uproots Platonic Idealism, dialectical contradiction, hierarchy, striation, causality, transcendence, signification and metaphysics:

> This is a reorientation of all thought and of what it means to think: *there is no longer depth of height.* The Cynical and Stoic sneers against Plato are many. It is always a matter of unseating the Ideas, of showing that the incorporeal is not high above (*en hauteur*), but is rather at the surface, that it is not the highest cause but the superficial effect par excellence, and that it is not Essence but event. (Deleuze 2004: 148, original emphasis)

In Deleuze the amoral motifs of incest or cannibalism engage with the 'passions-bodies', which then re-orientate thought away from Platonic Idealism or dialectical contradiction, by engaging with the flesh and forces of the body, which opens out a plane of immanence for the BwO (Deleuze 2004: 149). From the start, he says, the pre-Socratics make 'philosophical schizophrenia par excellence' because with it, Deleuze argues, they situate and activate thought in the body (Deleuze 2004: 147). The question is, to what extent can we think with the body without (potentially) damaging it?

Deleuze does anticipate such dubiousness from the reader. He questions the Stoics' use of amoral motifs, which raises the same questions for his own philosophy: 'How could the world of mixtures not be that of a black depth wherein everything is permitted?' (Deleuze 2004: 148). The Stoics paint a picture of 'a world of terror and cruelty, of incest and anthropophagy', Deleuze says, and the reason why this works is because it opens a new mode of thinking *at the surface of things* (Deleuze 2004: 150, original emphasis). There is another paradoxical part to these activities, beyond their perversity, which comes from a different and non-causal understanding of time. The surface lays out a theatre for a paradoxical intertwining of sense, which provides an interface for expressions and their representation – propositions, bodies and events in their immanent arousal. Here there is no hierarchy, depth or cause, just a flat surface for the body and its re-orientating of thought:

> [...] there is of course another story, namely, the story of that which, from the Heraclitean world, is able to climb to the surface and receive an entirely new status. This is the event in its difference in nature from causes-bodies, the Aion in its difference in nature from the devouring Chronos. [...] The Cynics and the Stoic establish themselves and wrap themselves up with the surface, the curtain, the carpet, and the mantle. The double sense of the surface, the continuity of the reverse and the right sides, replace height and depth. (Deleuze 2004: 149–150)

Deleuze gives us particular examples of moral problems: Nietzsche and Artaud's madness, Fitzgerald and Lowry's alcoholism or Bousquet's wound, because he

wants to provide a moral philosophy that is based from charting a series of singularities as events which, when considered as particular examples across a broad scan of society, demonstrate turning points that define the real (Deleuze 2004: 169–172, 176–183). He argues that we must consider and replay the events of suffering in order to source a process of counter-actualizing for what is amoral or damaging, whilst retaining the engagement with the process of the event and the emphasis on the body. In other words, to create his moral philosophy Deleuze presents case studies of singularities that mark a series of actual turning points. This develops a diagrammatic of intense relations and particular phenomena within society, which then charts how they set a pattern to constitute and divine new events.

James Williams argues that in Deleuze there will always be moral problems; moral philosophy is then about '*charting series of actual turning points*' when things are changing, the social, political, individual and singular turning points, and connecting diagrams of intense relations and particular phenomena within society (Williams 2008: 141, original emphasis). From this process it is possible to draw a chart that sees how moral problems constitute and divine *new* events, connected through the event that runs through all of them.

The point is to *actualize* the disruptive, corporeal *dynamic* that can be accessed through perverse or damaging behaviours, whilst simultaneously *counter-actualizing* their perverse or damaging *accident*:

> [...] the crack is nothing if it does not compromise the body, but it does not cease being and having a value when it intertwines its line with the other line, inside the body. We cannot foresee, we must take risks and endure the longest possible time, we must not lose sight of grand health. The eternal truth of the event is grasped only if the event is also inscribed in the flesh. (Deleuze 2004: 182)

Deleuze talks about how, in this way, the actor *actualizes* the event:

> The actor thus actualizes the event [...] Or rather, the actor redoubles this cosmic, or physical actualization, in his own way, which is singularly superficial – but because of it more distinct, trenchant and pure. Thus, the actor delimits the original, disengages from it an abstract line, and keeps from the event only its contour and its splendour, becoming thereby the actor of one's own events – a *counter-actualization*. (Deleuze 2004: 171, original emphasis)

The process of counter-actualization is the eternal return in a cyclical repetition of the future of the past. The event is actualized in its present happening, from a proliferation of virtual possibilities. It marks an eternal

wound on the present since it has an effect on us; then, in *willing* and *expressing* its presence in the present, as one of difference, one can access a sublimation that can counter-actualize its wounding. Deleuze builds his conception of *willing* the event from Stoic philosophy: 'Stoic ethics is concerned with the event; it consists of willing the event as such, that is, of willing that which occurs insofar as it does occur' (Deleuze 2004: 163). Deleuze then uses the example of French poet Joe Bousquet's injury, suffering, replaying, channelling and then counter-actualizing his wound to talk about how one can actually *will* the event:

> He [Joe Bousquet] apprehends the wound that he has deep within his body in its eternal truth as a pure event. To the extent that events are actualized in us, they wait for us and invite us in. they signal us: 'My wound existed before me, I was born to embody it'. It is a question of attaining this will that the event creates in us; of becoming the quasi-cause of what is produced within us, the Operator; of producing surfaces and linings in which the event is reflected [...]. (Deleuze 2004: 169)

The motor of this function is the repeating cycle of ontogenesis, in the becoming of the future of the past, which composes the sense of the present. In this context our wounds are the marks that make us real, and which demonstrate our contact with the world. As Jack Reynolds comments, in Deleuzian ethics we are all wounded: 'we are all traversed by some kind of fault-line (a virtual, impersonal intensity) that is supra-individual and not confined to the realms of bodies and states of affairs. [...I]t is the concept of counter-actualization that he uses to more fully describe what is involved in the appropriate manner of giving body to an incorporeal event-effect' (Reynolds 2007: 154).

In this context sense is the fourth dimension of a proposition, which is an expression of being-in-the-present. The other three dimensions are the denotation, manifestation and signification of a proposition. Sense and the event 'are the same thing' (Deleuze 2004: 191). The event has an intrinsic relation to sense through the process of counter-actualization. Buchanan says: 'The event is the sense *we make* of what happens. [...] To the extent we take charge of events we counter-actualize what occurs, we see beyond actions and live the purity of the event, the crystal of sense awaiting us in all phenomena' (Buchanan 2000: 79). As such, the event is something we have to *will*, rather than something to which we succumb, not as a figure of *ressentiment* to its eternal or damning trauma, but in expression comes counter-actualization and the opening for difference: 'The

event is not what occurs (an accident), it is rather inside what occurs, the purely expressed. It signals and awaits us' (Deleuze 2004: 170).

Deleuze uses Bousquet to describe how the moral actor acts by diminishing Chronos, or the wound, and using it to become something different (Deleuze 2004: 169–172). Bousquet uses his wound to inspire his Surrealist writing. There is a moment of elevation or sublimation, whereby the wound becomes something different. The tortured individual sublimates their wound and pain, releasing its counter-actualization, through replaying the event with creativity and expression: 'He apprehends the wound that he bears deep within his body in its eternal truth as a pure event' (Deleuze 2004: 169). Creation counter-actualizes the pain by re-enacting the wound and putting it in touch with values that run to counteract its suffering and injuries.

Deleuze argues that a stoic moral philosophy, which he upholds in *The Logic of Sense*, is about creative lives, and 'a concrete or poetic way of life' (Deleuze 2004: 169). The idea is that we can deal with moral problems by replaying the event of their occurrence with creativity, which can counter-actualize these problems' destructive or painful connotations. James Williams explains how the act of counter-actualization of the wound by replaying the event defines Deleuzian morality:

> The moral problem is [...] how to redouble the events occurring to us. These events are signs of the future and the past, but they have no necessary path. Deleuze's moral principles never recommend a particular course of action or align to necessary rules or models. On the contrary, they put forward guidelines and examples for picking our own way through the events that happen to us. His gift is of moral freedom in a complex structure and not compulsion or imperatives. (Williams 2009: 162)

Williams argues that Deleuze brings forward six moral principles in the twentieth series of *The Logic of Sense*, 'on the Moral Problem in Stoic Philosophy' (Williams 2009: 139–145). These principles present Deleuze's sense of how the individual can and should react to each singular situation that presents moral problems, and how one can *will* and respond creatively to them. Williams sources 32 further principles from Deleuze in the twenty-first series. He says that Deleuze's use of examples such as Bousquet or Fitzgerald presents case studies that illustrate his principles and provide a practical guide on how to act morally. On the one hand, Deleuze's engagement with art, and the necessity for creativity in dealing with pain and moral problems, is very important. But before we get to that point further moral questions are raised. Do we have to suffer, and

then replay suffering, to be free? How can the tortured individual know how to replay the events of their wound to find acceptance (or self-acceptance), nurture difference and source counter-actualization of suffering?

Deleuze asks questions similar to these in later chapters of *The Logic of Sense*. He talks about alcoholics, citing Fitzgerald's *The Crack Up*, which he uses to think about those who might suffer by reacting to the world in ways which Deleuze then wants to use to define his new philosophy. He is thinking about whether or how it is possible to use the 'Crack Up' as a figure of thought that engages with the body, but without actually cracking up:

> Is it possible to maintain the inherence of the incorporeal crack while taking care not to bring it into existence, and not to incarnate it in the depth of the body? More precisely, is it possible to limit ourselves to the counter-actualization of an event – to the actor's or dancer's simple, flat representation – while taking care to prevent the full actualization which characterizes the victim or the true patient? (Deleuze 2004: 178–179)

It is hard to know whether any of the questions that Deleuze asks himself here can be answered by following his moral philosophy. But they touch upon the same questions that direct Deleuze's work with Guattari and schizoanalysis. Schizoanalysis is concerned with founding a new way of thinking about desire, which engages with the body and can create a 'place of healing' for both the schizophrenic and all of us. Here Deleuze is asking how we can think with the body, replay the event and counter-actualize the process of cracking up. He goes on to discuss, with insight and sympathy, the alcoholic's pattern of behaviour and the reasons behind his dependence on drinking, as a 'process of demolition'. He ends the chapter with compassion, stating the hope that the effects of drugs or alcohol can be revived and recovered independently from the use or abuse of these substances:

> We cannot give up the hope that the effects of drugs and alcohol (their 'revelations') will be able to be relived and recovered for their own sake at the surface of the world, independently of the use of those substances, provided that the techniques of social alienation which determine this use are reversed into revolutionary means of exploration. (Deleuze 2004: 182–183)

This provides a stark contrast to Deleuze and Guattari's work with the '*schizo body*' and the '*drugged body*' in *A Thousand Plateaus*, where they advocate experimentation with clinical problems, in the name of dismantling the self: 'we haven't found our BwO yet, we haven't sufficiently dismantled our self' (Deleuze and Guattari 2004a: 166–167). We see this experimentation throughout *Anti-*

Oedipus, where they say 'one can never go far enough in the direction of deterritorialization' (Deleuze and Guattari 2004: 353). They do argue that caution and prudence are still necessary here, saying we should all be 'cautious' when we follow the schizoanalytic direction and adopt the mental processing of the drug addict, anorexic, masochist, etc.: 'Were you cautious enough? Not wisdom, caution. In doses. As a rule immanent to experimentation: injections of caution' (Deleuze and Guattari 2004a: 167). So it would be *better* if we could gain the thought process of the drug addict or alcoholic, *without* relying on drugs or drink.

In *The Logic of Sense* we see a different side to Deleuze, where his moral philosophy thinks about how we might be able to access and effect counter-actualization in response to these clinical problems. Through the examples of arts therapy and Art Brut we will see how counter-actualization might be made available. This will then open up the schizoanalytic practice operated by Guattari, in which art-making helps one of his patients evolve a way of making sense of life experiences that offers not just counter-actualization, but also 'new assemblages of enunciation and analysis' (Guattari and Rolnik 2008: 376). Here we will see how art practice is an application of schizoanalysis that provides transformative therapeutics and a making sense of the world.

We can then think about how Deleuze might try to respond to questions about how it is possible to experiment without cracking up by looking at the creativity and expression required to replay the event and counter-actualize suffering. Deleuze brings us examples from the arts, and his moral philosophy implicates an aesthetic; I propose taking this a step further and argue that his moral philosophy calls for the therapeutic application of an art practice, which I will here interpret through a case example of arts therapy and Art Brut.

I am also interested in how particularly the schizophrenic can benefit from an arts practice, because I want to see how we can apply Deleuzian morality to his thinking about subjectivity, to then bring forward a process of counter-actualization, which is an agency of transformative therapeutics. I want to think about how schizophrenics can find a method to counter-actualize the ways that they suffer from their illness, and how they can use art to respond to it with creativity and expression. We will then see how the actual schizos, who are exiled from the process of counter-actualization and liberation promised by schizoanalysis in *Anti-Oedipus,* can actually source these – as the ethical, accessible, transformative and therapeutic effects of art practice.

4. How to counter-actualize the event:
Art therapy, Art Brut and the schizophrenic

The process of counter-actualization is, as Ian Buchanan argues, central to Deleuze's constructivist philosophical enterprise (Buchanan 2000). It is a concept Deleuze uses, particularly in *The Logic of Sense* and with Guattari in *Anti-Oedipus*, to indicate a way of replaying the accident to connect it to the energy and potential of its impersonal event, which then provides differentiation. It means the possibility of living a situation in a way that might provide relief from its inherent misery. Counter-actualization is another way of describing a process that is healing; it will help us define the agency of transformative therapeutics that can be obtained by art practice, because it indicates the sense of replenishing, healing and production of the new that is opened when someone creates an artwork.

In this section I will think about how we can apply it through art, which then demonstrates that: 'Counter-actualization, Deleuze argues, is what the free can do, or more precisely what the free do; by free he means free of resentment and envy (the free do not try to profit from their wounds, they want only to own them)' (Buchanan 2000: 87). Deleuze draws on clinical problems, such as the alcoholic, the drug addict, the anorexic, the pervert and in particular the schizophrenic, to consider how one should live, and to define his understanding of being. We will now discuss how *art* can help us deal with these clinical problems and the moral problem of how one should live. We can see how *art therapy* can help us counter-actualize the wounding of the event. This will confirm and develop the use of arts therapies that was established in Chapter 2, specified in this chapter around the *singular* mode of 'art therapy' that concerns drawing and painting.[14] To do this I will describe how an example of art therapy can be seen to help the schizophrenic – with a case example – and then I will take this back to Deleuze to see how it can provide us with the 'place of healing' that *Anti-Oedipus* seeks to source – both for the schizophrenic and for all of us. (And, as Deleuze and Guattari argue throughout their work, there is a schizo in all of us.)

Beginning from the institutional edifice of arts therapy (in the plural) that was defined in Chapter 2, my contention here will be that art therapy, as I describe it in this chapter, offers a form of counter-actualization that will benefit schizophrenics in a way that schizoanalysis cannot. Recent research has demonstrated that different forms of arts therapies are effective for those who suffer from psychotic illness, such as schizophrenia (Brooker et al. 2007; Crawford and Patterson 2007). The National Institute of Clinical and Health

Excellence (NICE) issued recommendations on the application of arts therapy on the NHS for people with schizophrenia in 2008, which was publicized by the BBC.[15] Dr. Tim Kendall, co-director of the National Collaborating Centre for Mental Health, helped gain data from six different trials on several hundred people, finding from their results that dance, art and music therapy has 'a positive benefit' for schizophrenia.[16] Dr. Mike Crawford, also involved in this survey, said that arts therapy helps the psychotic because their illness leads to problems with communication: 'With psychoses, part of the problem is hallucinations and delusions and it becomes really hard to talk to people about them – and people become isolated because no one is listening to them' (Crawford and Patterson 2007: 69–70).

We can see an example of the diagnosed psychotic gaining restorative sense from art-making with the case study of Lena, which is brought forward by Joy Schaverien in her article 'Transference and transactional objects in the treatment of psychosis' (Schaverien and Killick 1997). We examined transference in Chapter 1, where it helped us understand how an artwork can express, hold and convey the artist's emotions and ideas, and evoke these for the viewer (or analyst) who encounters it. Schaverien describes the situation and case history of Lena, a woman suffering from a paranoid psychosis who is admitted to hospital after a serious suicide attempt, where she engages with art therapy (in the singular, this refers to visual art therapy, which involves painting and drawing). We are presented with images created by Lena, which demonstrate how she uses the practice of art-making to communicate with the therapist who is guiding her, and also as a method of making sense of her own condition and situation, which then offers her some degree of counter-actualization and liberation. One of Lena's creations, *Arrows*, is the shape of a basic human figure, outlined in black, which is intertwined with a yellow wire coiling around the body, as if it were trapped within its physical form. Its basic skeleton is made from a black stick figure and disjointed shapes of white, with an overlay of red lines that seem to indicate the nervous system (Figure 3.1). Black arrows pierce the outline of this figure and seem to be attacking it like daggers, pressing momentous pressures onto the body. The figure cries, and tears fall from its eyes and drip down its body. In the background are green vertical lines, with more arrows, which seem to suggest that this is a puppet. It is an intense and simple image, which brings forward an impression of how Lena was feeling when she made it. Schaverien describes how this work then provides therapy for Lena:

> There are no words in this picture which graphically and wordlessly embodies Lena's state. It reveals the pain of the potential fragmentation of psychosis in a

way which no words could convey. There are times when words can add nothing to an image: the picture says it all – it is its own vivid and powerful interpretation. [...] Lena was able to communicate her state to me through the vehicle of the picture. [...] Lena realized that it both confirmed her feeling and conveyed it to me because I took the picture very seriously. Lena then began to value her pictures as both an expression of her state and a way of communicating. To speak directly to anyone was to lose herself, but the picture made this possible; it mediated, holding the space in-between us. (Schaverien and Killick 2007: 28–29)

The image provides Lena with a method of communicating with the world. It also provides her with a method of getting in touch with how she is feeling, and

Figure 3.1 Joy Schaverien, case example of Lena, *Arrows*. Reproduced from Schaverien and Killick 2007. *Art, Psychotherapy and Psychosis*. London: Routledge. Figure 1.3, p. 28.

allows her to express this to the therapist. The sense of her illness is somewhat impossible to capture in words, but can be immediately expressed in this image. By looking at the image, and relating it to her patient, Schaverien is able to gain a sense of the momentous physical pressures that Lena is tied up with, in her tactile hallucinatory experiences, which are indicated by the arrow daggers and the yellow line that encircles the figure. The image is powerful because, as Schaverien says: 'The picture is "outside" and offers a reflection of some aspect of the self. There is a dawning of consciousness and the beginning of differentiation' (Schaverien and Killick 2007: 24–25). Lena creates an image that helps her make sense of her being, in terms of the psychotic pressures that she is feeling, and she makes an object which is separate from these pressures, and whose autonomy provides some sense of distance and relief from them. In this way Lena can embody the event of her feeling like a puppet attacked by dagger-arrows, and direct or will her autonomy from it. This results in a connection with her being, and beyond her being, with the therapist, which can counter-actualize the persecutory elements of Lena's inner world and take a step towards a place of healing from them. In this process Lena finds a way to objectify her symptoms, or make an artwork from them, which then reinterprets and so counter-actualizes what brings her discomfort and pain. It provides Lena with a method of maintaining a degree of subjectivity in a way that offers her restorative sense. As a consequence, art therapy seems to provide this individual with the kind of counter-actualization and process of liberation from which she is excluded in *Anti-Oedipus*.

In this way the case example given by Lena illustrates how 'the inherent communicative value of artistic endeavours seems particularly important for a specialized and idiosyncratic understanding of the schizophrenic person. Moreover, art works of schizophrenics may be not only prognostically significant but also lead to interventions which enhance the problem solving process for both therapist and patient' (Amos 1982: 142).

In this context, emphasis is given to the 'meaning' of the artwork that is made, as though what the client creates has a special and secret meaning beneath its exterior form. I would argue that in fact the meaning of their work is not separate from the physical construct of what it is made from. In this way my understanding of meaning is what Deleuze and Guattari call 'usage' (Deleuze and Guattari 2004: 92). Meaning is effect; it means what it does. There is meaning in the process of making because this process has restorative effects in itself. The process of interpreting, or making sense, of what is made also has restorative effects. Making sense is the process of interrogating the sensuous-intellectual data and ideas that constitute the style and contents, the elements of

the composition or the abstract machine, that pull the work together. It involves understanding the sense of the here and now – the material presence of the artist-client, their situation, emotions and needs, which charge their creation, and their rapport with the world, the therapist and the materials they are using. Meaning is immanent in the process of production, interaction and sense-making that constitute the artistic practice and the therapeutic communication which it creates. This provides an agency of transformative therapeutics that brings ontogenesis, as a replenishing, nourishing production of the new.

Such an agency is able to release an individual from their wounding and realize the possibility for difference. The artwork provides a means of making sense of oneself and the world, and a paradoxical release-cum-realization of one in the other, always becoming-other with the immanent sense and transformation involved during the creative process. As a consequence, we can see how art practice provides a method of counter-actualization, which embodies transformative therapeutics *per se*.

The role of or dependence on the art[s] therapist needs further thought: to what extent do these liberating ends rely on a trained professional's 'interpretation' of the artworks produced, or on the relations of transference and counter-transference between the therapist and the patient? Pamela Whitaker broaches the topic of arts therapy from a Deleuzian perspective, opening a schizoanalytic understanding of the relation between the therapist and the patient. This approach builds into what Whitaker calls a 'Deleuze and Guattari Art Therapy Assemblage', which opens a topography of differentiated forces (emotions, sensations, memories, narratives, interactions, expressions, improvisations) on the surface of the artworks made and in the relational contact between the arts therapist and the patient. The arts therapist does not project or impose 'meaning', but can be understood as 'a mediator, acting between art, words, body and the world. [...] The mediator is open to learning as it happens. The therapist and client are part of a co-operative investigation relating to the images in execution' (Whitaker 2012: 362). In this respect, the materiality of the art materials being used in the therapeutic and transformative exchange that occurs between therapist and patient (or between an artist, the world and the viewer) 'evokes a physical interaction, a subliminal expression to the viewer, a charge that stimulates a corresponding movement and energy within the art[s] therapist as witness' (Whitaker 2011: 362).

The artwork made in the context of arts therapy can also be considered as a form of Art Brut. Deleuze himself says that his philosophy is producing 'a kind of *art brut*' (Deleuze 1995: 89). Art Brut is a genre of art that was created

by Jean Dubuffet in 1948. Originally meant to denote art created by trauma survivors or people with mental illness (whose trauma or illness influences their work), Art Brut refers to artists who are self-taught and who do not participate in the 'mainstream art world' or who operate outside the institutions of Western culture. We can describe the artwork created in a therapeutic setup in accordance with this genre because it requires no training, it often involves making art in response to illness or injury and it is something that we can all engage with. Creating an artwork offers the individual a means by which they can will and replay the event, thus producing an ethical process of counter-actualization, through a Deleuzian morality. In this way art-making becomes a schizoanalytic procedure.

Dubuffet presented his manifesto for Art Brut in 1949:

> Art Brut. We understand by this works by those untouched by artistic culture; in which copying has little part, unlike the art of intellectuals. Similarly, the artists take everything (subjects, choice of materials, modes of transposition, rhythms, writing styles) from their own inner being, not from the canons of classical or fashionable art. We engage in an artistic enterprise that is completely pure, basic; totally guided in all its phases solely by the creators own impulses. It is therefore, an art which only manifests invention, not the characteristics of cultural art which are those of the chameleon and the monkey. (Dubuffet 1993: 596)

To think about the sense made in Art Brut, and then see how we can use it to rethink Deleuze's treatment of the schizophrenic, we can turn to the schizophrenic artist Adolf Wölfli (1864–1930). Wölfli lived the majority of his adult life in a Swiss psychiatric hospital, after repeated paedophilic episodes with young children and the diagnosis of schizophrenia. During his time at the Waldau Clinic in Berne Wölfli began to draw. He was outstandingly prolific, producing 45 volumes, which contained over 25,000 pages and 1,600 illustrations.

His pictures illustrate his psychotic fantasies and delusions. He built his very own world from them, by interpreting his existence in the form of an autobiographical epic, with fantastical stories of his sainthood and adventures illustrated with kaleidoscopic pages of music, words and colour. For Wölfli art becomes a way of being-in-the-world, since his whole sense of existence is created by his art-making. His creativity becomes the way that he makes sense of his existence and how he deals with life at the psychiatric hospital. This is *raw art*:

> It is Wölfli's greatest achievement that he could create his art both within the domain of his illness and in spite of it. With the pictorial and literary means of

this art he was able to express the existential condition that the psychosis forced him to experience, and in so doing, he allows us an insight into his particular *condition humaine*. (Spoerri 1997: 88)

We can see the world that Adolf Wölfli created for himself by examining his 1911 *General View of the Island Neveranger* (Figure 3.2). This is a labyrinthine composition created with colour pencil on a sheet of newsprint. It brings us an assemblage of colours, words, musical notes and images, which bring forward the cartography of a magical space. The piece is infinitely complex, with mandala-like circles bursting with queer creatures, symbols and crosses, and the whole composition is held together by a skeletal musical stave. We can practically hear a gypsy playing this strange, jolly tune on an accordion to a crowd of skulls with their creepy black eyes, death stares and glum faces. Words are squeezed in all the spaces so this image is infinitely complex and utterly engrossing. It is a privilege to be given the chance to see a vision of Wölfli's world. He spent his life locked up; art became his liberation and his sense of being: it provides the realization (or realizing, manifestation, enunciation) of his condition and the counter-actualization of his suffering. 'Wölfli experienced the "full collapse in a person" through his illness, and he saved himself by his art, which gave self-assurance to him and meaning to his life' (Spoerri 1997: 88).

Luke Skrebowski argues that Art Brut offers 'a practical approach' for fulfilling (Figure 3.2) Deleuze's schizoanalytic enterprise of 'dismantling the disciplined, unitary self' (Skrebowski 2005: 14–15). Skrebowski's horizon is the opposite of ours, since he would argue that the way Wölfli is saved through his art then contradicts Deleuze's project of schizoanalysis, but what my argument shows is how Wölfli's practice and Art Brut itself are in harmony with Deleuze's moral philosophy and Deleuze on counter-actualization, in a way that supplies the counter-actualization, transformative therapeutics and 'place of healing' implied but excluded from the schizophrenic in schizoanalysis. Skrebowski's article is still useful, however, because he states that by turning to Art Brut we can also fulfil the Stoic philosophy, as outlined in Deleuze's moral philosophy, by activating the kind of philosophy that operates as a 'practice of living', as 'explicitly a practical art, *technê* rather than *episteme*' (Skrebowski 2005: 5). Skrebowski quotes the Stoic Zeno's aphorism which defines art as 'a habit of roadbuilding' in order to bring forward a sense of the materiality of Deleuzian thinking and its immediate application as a way of living (Skrebowski 2005: 5). We can see from the example of Art Brut how the artist Wölfli used his creativity to provide a method of making sense – of his condition and the world of his delusions – and also a method of being in the present. The genre of Art Brut

Figure 3.2 Adolf Wölfli, General View of the Island Neveranger [General=Ansicht der Insel Niezohrn], 1911. From the Cradle to the Grave, Book 4, p. 257. Pencil and coloured pencil on newsprint. 99.8 × 71.2 cm. Adolf Wölfli Foundation, Museum of Fine Arts Berne, A9243–30(IV/p.257). Photo credit: © Adolf Wölfli Foundation, Museum of Fine Arts Berne.

is defined by untrained artists who use their creative process as a way of life, which is similar to how the Stoics defined their philosophy, and how Skrebowski interprets Deleuzism.

By now we can see how art-making is able to provide a machinic enterprise for counter-actualization of the wound, and transformative therapeutics, as well as a method of making sense of existence and being in the world. From this viewpoint, art-making fulfils some of the intentions of schizoanalysis that Deleuze and Guattari pose in *Anti-Oedipus*, by opening a 'place of healing' and a 'new earth' for its activists. It can thus be seen as a schizoanalytic procedure.

To conclude, I turn to Guattari's work, collaborating with Brazilian psychoanalyst Suely Rolnik, in *Molecular Revolution in Brazil*, where he outlines a schizoanalytic practice that applies 'a diversification of the means of semiotization' to build an understanding about subjectivity and subjectivation

from political, ethical and psycho-clinical settings (Guattari and Rolnik 2008: 376). This raises the same discussion of psychiatric disorders such as addiction or psychosis in relation to clinical detainment and the institution as we saw in *Anti-Oedipus*. But here Guattari is using schizoanalysis not to *destroy the clinic*, eradicate the institution, or to endorse psychiatric illnesses or problems such as addiction or schizophrenia ('that has *never* been among my intentions!') (Guattari and Rolnik 2008: 375). Indeed, 'There is not the slightest doubt that it is absolutely necessary that asylums and refuges should exist' (Guattari and Rolnik 2008: 376). However, Guattari wants to expand and open the largely monadic, narrow and punitive process of institutionalization, so it can operate as a 'polyphony' that can bring into play 'anthropological, social, and ethical dimensions that concern the whole of society' (Guattari and Rolnik 2008: 376).

We begin to see a different side of schizoanalysis to the caricature schizo discourse that defines Deleuze and Guattari's vociferous voice in *Anti-Oedipus*. Looking at Deleuze's and Guattari's later, individual works demonstrates an application of their ongoing intent (which we saw, in brief, in *Anti-Oedipus*) of making 'revolutionary' change happen, but as a meta-modelling rather than putrid destruction, from within the very system they are continuing to challenge.

5. Schizoanalysis, transformative therapeutics and art practice

Guattari gives us examples of his own interventions (as an analyst at La Borde) with schizoanalytic case studies, to illustrate his new schizoanalytic vision. He talks about a young schizophrenic named Jean-Baptiste, who had been living in and out of a psychiatric hospital for about ten years, with multiple admissions and intermittent violent psychotic episodes. His life when outside of the clinic consisted of a sheltered living with his elderly parents, on whom he was entirely dependent. He would see Guattari for 'analysis' (or 'therapy') once a week. Guattari describes how these sessions would be largely repetitive and consist of the same rituals: Jean-Baptiste would always begin by giving Guattari some chewing gum. It seemed that not much happened during 'analysis', and yet the threat of another psychotic episode and hospitalization was always present. Jean-Baptiste had a restricted life: 'he lived in a kind of total apraxia' (Guattari and Rolnik 2008: 357).

Guattari decided to conduct a radical, therapeutic experiment, by organizing for Jean-Baptiste to have more independent living, some financial income and

'the suspension of the threats for hospitalization' (Guattari and Rolnik 2008: 358). There were severe risks involved in this process – throwing Jean-Baptiste out on a limb, so to speak: he would be much more susceptible to provocation for another episode, by being alone with his distorted perceptions and problems with social relations. How could he cope with the real world, after such a sheltered, interned existence?

But this *schizoanalytic* experiment was a tremendous success. Although difficulties and a series of problems were raised, Jean-Baptiste shone with his new independence. This was demonstrated during the changes that took place at his weekly sessions with Guattari. What is most important for our purposes is the way that Jean-Baptiste's incorporation of *art* in his analysis and/or therapy sessions enabled him to continue his process of growth and making sense of his newfound existence. Guattari describes how Jean-Baptiste *began making drawings*. This simple activity involved describing and interpreting his new daily activities, achievements, failures and relations with his family. This was possible because Jean-Baptiste was able to build a new kind of assemblage through the creative process of art-making. This process provided a form of therapy that exceeded and replaced the restrictions posed by 'treatment' at the institution, in psychoanalysis and even in Guattari's individual sessions, because: '*In this new solitary assemblage, he began to create a mode of expression and develop it, creating a kind of cartography of his own universe*' (Guattari and Rolnik 2008: 360 original emphasis).

We can see here how art-making provides Jean-Baptiste with 'the invention of new assemblages of enunciation and analysis', which is 'something that he couldn't develop in the family territory, nor, of course, in the territory of a psychiatric hospital, nor even in his therapeutic relation' with Guattari (Guattari and Rolnik 2008: 360). By operating as a machine that functions to express, interpret and evaluate one's existential, interrelational, situated presence in the world, art-making offers a method of counter-actualizing the difficulties or sufferings that this presence, and the world itself, raise. Guattari's new, transformative process of schizoanalysis does not *psychoanalyse* Jean-Baptiste's psychosis, but rather opens 'the different modes of consistency of territories or different kinds of [...] "machinic processes" [...] that could be set into operation' to provide healing and a new way of living (Guattari and Rolnik 2008: 359). The motor of this process is fuelled by art-making.

We can also see another example of an applied schizoanalytic practice from Suely Rolnik's own work. She talks about how she underwent an informal practice of schizoanalysis, by the intervention of Deleuze (outside of

a clinic, and even though he was not an analyst). Rolnik says that Deleuze's intervention had profound affect on her life. The aesthetic and healing affect of this intervention concerned the individual subject, Rolnik, and also society at large, because it concerned the larger picture of Rolnik's native homeland, and the oppressive regime in Brazil. Rolnik describes how Deleuze encouraged her to listen to Alban Berg's opera *Lulu* and compare the death cries of Lulu, its lead character, with those of Maria, a character in *Wozzeck*, another opera by the same composer. Rolnik was in exile from Brazil, and based in Paris, at this time. Six years later, she was at a singing class in Paris. She suddenly began to sing a song written and performed in response to the dictatorship in Brazil. During this experience she recalled the direction that Deleuze had originally pointed her towards:

> [It] installed itself imperceptibly in my body and operated in silence, slowly oxygenating the fibers of desire, reactivating their drifts and the vital throughout that normally accompanies them. Six years later […] I could once more reconnect my body and speak through the singing of its sensible stages in voice, song, and speech. By launching a liberating movement through a sung cry. Deleuze had, in fact, been my schizoanalyst – even if such movement would only bear fruit years later. (Rolnik 2011)

This listening, absorbing and vibratory process of singing stimulated strong feelings about love, life and death, which concerned 'the intoxication of desire caused by the dictatorship's cruelty' in Rolnik's native Brazil. As a result, she recounts: 'I decide, there and then, to return to Brazil, even if I had never considered leaving Paris until then. I went back, and never for a moment doubted the wisdom of that decision' (Rolnik 2011). In this case it is 'the power of a song' that instigates schizoanalysis, and it provides Rolnik with insight into her own mentality and the world itself. Art practice – or, in this case, singing – instigates a process that provides transformative therapeutics, by transforming Rolnik's vision, arousing cathartic feelings and offering therapy in relation to the oppressive situation in Brazil. It also provides Rolnik with a means of making sense of the world, whereby she gains insight into the dictatorial regime in Brazil, counter-actualizes its oppression and chooses to return to live there.

Rolnik's schizoanalytic work with Deleuze shows us another example of the ways that art practice can realize schizoanalysis and provide the 'place of healing' that is elusive in *Anti-Oedipus*. The examples of the psychotic patient having art therapy and the schizophrenic artist have also enabled us to instigate a true

application of schizoanalysis (seen in the later Deleuze and Guattari) through an art practice that also applies a Deleuzian morality. As a consequence, we have seen a process of counter-actualization being accessed through the creative process of art-making, which then offers a degree of liberation for the artist, patient or participant. This then fulfils the intentions with which we began this chapter, by connecting to and releasing the moral problems that are raised by Deleuze's treatment of the schizophrenic, and other psychiatric disorders, in schizoanalysis.

We have seen how in *Anti-Oedipus* counter-actualization and any ethical healing are not available to the actual schizophrenic, addict or pervert (etc.), since these individuals are jettisoned from the schizoanalytic argument. By contrast, in my examples, and the examples from later Deleuze and Guattari, the individual gains counter-actualization and transformative therapeutics from the creative process of an art practice. By now we begin to see how this creative process can be relevant beyond the psychotic, and we can think about how it can be applied to us all.

In this chapter we have seen how creating an artwork provides an agency of transformative therapeutics, and a means of making sense of the world. The examples in this chapter thus explicitly develop the primary hypothesis of Making Sense. Counter-actualization is another way of describing the transformative therapeutics that defines this making sense. Opening up a schizoanalytic trajectory has challenged the psychoanalytic clinic to the point where, with Rolnik, we can see how its consequent affect and transformative therapeutics can be applied and made accessible *outside* of a clinic. Now we will examine this trajectory for Making Sense: sourcing the healing and transformative gains which we have seen from both psychoanalysis and schizoanalysis (although these have been questioned), but independently and outside of the psychiatric institution. How can we find sense, transformation, therapeutics and healing, if we don't have the fortune (or misfortune) of being 'treated' or analysed by a professional?

4

Making Sense *Outside the Clinic*

Figure 4.1 Kyle Reynolds *Monsters in my Head*, 2013, acrylic on canvas © Kyle Reynolds.

This chapter shows how art can take the place of the analyst for the ethical treatment of the symptom. It does this by working through Lacan's concept of the *sinthome*, which he uses to propose this very theme, set in relation to another schizophrenic artist, Kyle Reynolds. This artist uses painting as a method of healing that has enabled him to evade hospitalization and manage his psychosis for over a decade, without the formal intervention of an assigned analyst or arts therapist. By developing an understanding of Reynold's art and Lacan's *sinthome*, this chapter intends to show how art practice builds an agency of transformative therapeutics that makes sense,

specifically *outside the clinic.* Making Sense in this way will open and extend the creative and healing properties of art practice, based on independent, accessible and creative expression, which is not dependent on professional or clinical intervention.

The chapter proceeds in the following format: first of all, I present the artist Kyle Reynolds, and begin to expose how his paintings inspire and help him cope with his schizophrenic illness. Second, I introduce and discuss Lacan's *sinthome* to theorize the possibility of psychoanalytic theory, and the possibility of a cure, taking place and applying outside of the clinic. This relates back to Reynold's art, which I extend further using Deleuzian ideas about the (broken) sensory-motor, the body without organs, the time-image and Salvador Dalí's paranoia-criticism, all the time trying to build a greater understanding of how Reynolds is able to make sense of and from his existence, through and in spite of the symptoms that define his illness, by his art practice. Attending to these ideas raises the theoretical impasse of juxtaposing Lacan with Deleuze and Guattari, given their ideological differences with regard to desire and subjectivity. Although this chapter is not concerned with debating the controversial differences (and correspondences) in Deleuze and Guattari's thinking in relation to Lacan (which has been well versed in secondary literature),[1] I attend to these problems by utilizing the *sinthome* itself (which resolves this impasse) and returning to Reynolds, whose art fulfils our search for transformative therapeutics and confirms the sense it makes, outside the clinic.

1. The schizophrenic artist

Kyle Reynolds describes himself as '*a proud schizophrenic artist or a proud artist with schizophrenia*'.[2] The definitive synonymity between his being an artist and his being schizophrenic is what drives his creative passion. Art was born from the illness: Reynolds says that '[although] I have always loved art, I didn't start painting until my second breakdown in 2000. It was a way to refocus my mind'. We could argue that, then, the synonymity continues, since Reynolds's illness clearly feeds his art, although, and essentially, it is not caused by art.

Au contraire. For Reynolds the process of painting 'can help me make sense of the World, my World'. It then provides a method of being in the world, accepting and surviving the poignant and traumatic rollercoaster of the illness, and then furnishing a new sense of life with this illness. In simple terms painting is therapeutic: it helps Reynolds deal with the symptoms of schizophrenia: 'I

am my own worst enemy. When you live so much of your life in your head you have to let it spill out somehow. The canvas gives me a place to rest my broken head'.

Yet his art does not come from a scientifically psychotherapeutic approach. Despite having suffered with this illness for over a decade, and continuing to paint throughout this period, Reynolds has never 'done' 'art therapy', *per se*, nor has a therapist formally intervened into his practice (or his psyche). However, his art is clearly and definitely therapeutic, in the sense that it provides relief. But this relief takes place outside of the institution, nowhere near the clinic, and consists of pure, neat, solitary creativity. Reynolds has never been hospitalized, despite multiple breakdowns and years of intermittent suffering. It is very rare to have and cope with a breakdown at home. How has he managed? Reynolds says that prescribed antipsychotic medication has been instrumental to his dealing with the illness, and ongoing support from his family. Has his art-making also helped, and to what extent does art provide medical relief from traumatic symptoms? He said that art helps because:

> It has given me a way of communicate things that I other wise could not communicate. There have been times when I have been extremely depressed and just the pure process of painting helped ease the pain. Art can be like medicine although without my medication I would not be able to paint. Art is liberating it has given me a voice a chance to reach out and break down walls that need to be broken down.

Clearly the process of creating an artwork cannot, in Reynolds's case, replace antipsychotic drugs. Mental illness is to some extent a question of chemical imbalance, since most of the symptoms might possibly be reversed, resolved or reduced by taking appropriate pharmaceutical drugs, which suppress dopamine and serotonin receptor activity.[3] Without these drugs it is hardly possible to do *anything*, let alone concentrate or collect and arrange materials to paint with. Art, as everything, has limitations. The question of where and when art might be able to help is important, particularly in Reynolds's case, since his art seems to have replaced the role of the psychotherapist, or the analyst, in his rehabilitation.

2. The *sinthome*

Jacques Lacan takes up this position, that art can take the place of the analyst, in his work on the life and writings of James Joyce. Lacan applies Joyce's

existence and literary œuvre to develop his concept of the *sinthome*. This concept has a variety of interrelated meanings: the synthetic-artificial man, the synthesis between symptom and fantasy, Saint Thomas, the saint, enjoyment, enjoyment-in-sense (*jouis-sense*) or 'I hear sense' (*j'oûis sens*). *Sinthome* is an archaic spelling of the symptom.

Žižek says that Lacan's use of the *sinthome* brings an 'ontological status' to the symptom, which is 'the way we – the subjects – "avoid madness", the way we "choose something (the symptom-formation) instead of nothing (radical psychotic autism, the destruction of the symbolic universe)" through the binding of our enjoy-ment to a certain signifying, symbolic formation which assures a minimum of consistency to our being-in-the-world' (Žižek 1989: 75). Žižek understands the *sinthome* as a method of binding subjectivity, which enables the potentially psychotic individual to manage their symptoms and, we will argue through their art, find a way to exist in the world.

Lacan uses the *sinthome* to think about the ethical treatment of the symptom, and the interweaving amongst the Real, the Symbolic and the Imaginary that ties (or synthesizes) the 'Borromean knot' of the subject. The *sinthome* then establishes a new relation of the individual subject to culture and to the Other, so the concept locates and describes the symbiosis between an individual, their situational existence in the world and with other individuals beyond themselves.

In *Seminar XXIII, Joyce le symptom*, and related papers, Lacan proposes that in his writing, James Joyce becomes the *sinthome*, which then binds the Real-Symbolic-Imaginary topology of the subject together, so that his writing averts psychosis.[4] In this way, through the *sinthome*, we can think about how art replaces the analyst and provides healing. It does this because the *sinthome* provides a way to think about how the subject could confront political challenges in their life by promoting the Imaginary, which they do by creating an artwork and then using this artwork to provide a principal role in the subject's relation to the real. Thus the *sinthome* provides a path between two worlds – the Real and the Imaginary – through the subject who creates an artwork, and who then expresses the problems and difficulties faced during this (evidently political) path. In this way creating an artwork can alleviate the symptoms that arise during the subject's contact with the Real. For Lacan, the symptom 'reverses itself in effects of creation' during the *jouis-sance* (or enjoy-ment) that constitutes the art-making process, so it then alleviates suffering (Lacan 1966: 66). This process, and its transformative

affect, is the inherent meaning of the art object formed and it provides the liberation of the subject. As Lacan says, *jouissance*, or *j'ouis-sens*, 'is the same thing as to hear a meaning' (Lacan 1976).

We see this sense and meaning throughout Reynolds's artworks because they alleviate suffering and provide 'liberation'. They help Reynolds face and traverse the tumultuous and rocky path through the Real, the Imaginary, and the alienating Other (who pose stigma in relation to the illness).

Lacan uses the writing of James Joyce to suppose that the artwork replaces the analyst in activating the process of the *sinthome*. The artwork then produces the ethical treatment of the symptom. Lacan relates this to schizophrenia, since Joyce's daughter Lucia was diagnosed as schizophrenic. Joyce disputed this diagnosis, calling her 'telepathic', rather than psychotic (Lacan 1976a). But Lacan argues that Lucia's 'telepathic' (or psychotic) delusions are an 'extension' of Joyce's 'own symptom', and that this is what inspired his writing (Lacan 1976a). He asks 'Was Joyce mad?' (Lacan 1976b). By sourcing the answer to this question through (psycho)analysing the subject, content and process of Joyce's writing, we can see how his art is involved in the diagnosis and treatment of the symptom. The Irish author is thus appropriate for Lacan's psychoanalytic register with the *sinthome*.

Lacan also argues that Joyce was troubled (and inspired) by failures of fatherhood, as the father of a schizophrenic daughter and himself the son of an alcoholic father. In Lacanian terms, Joyce's art enabled a necessary 'supplement', compensating for this paternal lack (Lacan 1975). Faced in his childhood by the radical non-function or absence of the signifier of the Name-of-the-Father (a 'paternal metaphor' which Lacan applies to the cause of psychosis as well as Joyce's own problems with fatherhood), Joyce managed to avoid breakdown by deploying his art as *suppléance*, which means that art sewed the supplementary cord to tie the subjective knot. Lacan says that Joyce's artistic output and its creative economy provided him with a means of 'making a name for himself' (Lacan 1975). In simple terms, Joyce's writing enabled him to maintain his own sanity and continue living.

For Reynolds the art-making process entails a method of existing, and living with an illness in a way that accepts and arguably nurtures difference. In physical terms, art provides 'salvation' from the traumatic symptoms of the illness, by enabling a way to continue with or in spite of them, whilst it also enables a practice that can take value in and applaud the immense creativity, diversity and originality of these often deeply traumatic symptoms. So-called

thought 'distortions' or 'delusions' that form the contents of his visual and auditory hallucinations become acquired, realized and personified as fundamentals and as truth when they are painted onto canvas. They become on par with the normal world that most people see and experience, more valid, even, since Reynolds portrays them with such deft, depth and panache. His art then supports a *neurodiverse* mentality that opens doors on what is 'true' perception.

Upon being asked if he uses his art to visualize or represent his hallucinations, Reynolds says his breakdown involved 'religious delusions'. Although we don't witness figurative illustrations of visual hallucinations in his art, we can still see a way of existing, accepting reality, expressing torment and finding release and relief from this through the physical process of making an art work. In relation to the creative process as a method of transference, and seeing the artwork as a scapegoat transference (which we saw in Chapter 1), Reynolds is utilizing and redirecting the traumatic experiences of his illness to inspire and fuel his art-making. The negative or harmful energy that is raised during his hallucinatory experiences is not projected or represented, but redirected into a new, living kind of energy, which becomes the currency of his artworks.

Reynolds talks about the creative process, and says that: 'I think it's a way of making sense of life'. To a simple extent, it provides a past-time, or a way to pass time, *amidst the troubles*. But this time spent making art is not merely a distraction or leisure; it's a vital expression of identity that provides healing and acceptance. This is a practice of transformative therapeutics. It has become so much a part of Reynolds's everyday life that it becomes a proactive method of managing to live.

What is so interesting, and moving, about Reynolds's paintings is their literal presentation of the difference between the world we 'usually' see, through the norms of so-called reality, and the sometimes medicated repression of truth, and then the delusions or disturbances that define what provides suffering and torment. The different ways people perceive the world are raw and realized: Reynolds's paintings open doors for new perceptions and a method of accepting their disparity, living with their timely trauma and accepting the labels and judgements that meet their way. At their base is acceptance – as Reynolds paints in his self-portrait, in which he wears a badge saying: 'I'm Schizophrenic' (Figure 4.2). He is trying to break down stigma and ignorance into mental disorders; not so much replaying his torment as trying to express, understand and communicate it to a larger audience.

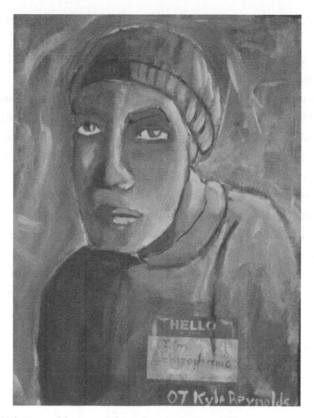

Figure 4.2 Kyle Reynolds, *I am Schizophrenic*, 2007, acrylic on canvas
© *Kyle Reynolds.*

In this way Reynolds's work sympathizes with Lacan's concept of the *sinthome*, because of the way that Reynolds uses his art to liberate himself from the desire of the alienating Other. Creating *ex nihilo* he gives birth to himself.

To develop our understanding of how Reynold's paintings operate in relation to the *sinthome* and to consider further how they offer a Making Sense that provides Reynolds with a transformative therapeutics with regard to his schizophrenia, I will now turn to Deleuze's ideas about the sensory motor and the time-image. By looking more closely at the heterogeneously multiple ways that Reynolds perceives the world, as seen in his psychotic hallucinations, we see that the neurological filter which sifts and orders perception is broken. Reynolds then directs these often-traumatic perceptions into his artwork, which relieves their symptomology, so the artwork thus acts as a *sinthome*. To understand this further, we will look through Reynold's series of 'Morphing' paintings and Deleuzian thinking about the sensory motor.

3. A broken sensory motor 'morphing monsters in my head'

Reynolds's 'Morphing' series of paintings include some particularly strong, powerful works, because of the way they express the multiple, transmuting elements involved in his perceptions of the real. We see how visions grow into each other, with interacting forms supplanting multiple organic bodies as *desire machines* that twist into, in Reynolds's words, 'misconfigured forms trapped in sometimes compromising positions'. As he says, 'A lot of what we do and see in life depends on our perspective'. These works question the singular, narrow and in effect teleological, or hierarchical common known as 'sense', and they show us there are more ways of understanding what is real.

This fact is instantly addressed in *Eyes Wide Shut*, a simple, austere image which presents a grey face with odd, open eyes projected out in a box (Figure 4.3). About this work, Reynolds says that 'Sometimes what appears to be true can somehow be distorted by our own sense of reality'. It might seem as though

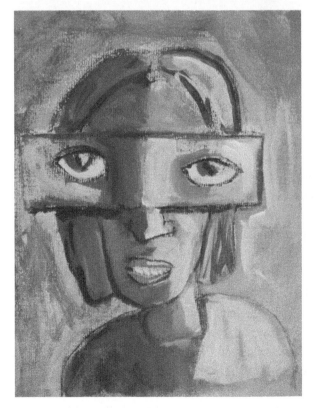

Figure 4.3 Kyle Reynolds, *Eyes Wide Shut*, 2010, acrylic on canvas © *Kyle Reynolds.*

when our eyes are wide open we can 'see' perfectly well, when in fact our eyes are repressing and re-presenting a very different state of affairs. The difference between perception and hallucination is posited and questioned here, and the breakdown of the sensory motor that filters and suppresses all our sensory impressions, before they are made conscious to us.

Here, perhaps, we meet Gilles Deleuze's concept of the time-image, which he posits in his two books devoted to cinema. We could compare Reynolds's schizo paintings to Deleuze's work on Italian neo-Realist films, which he argues portray time directly by breaking the sensory motor. The movement of the images in these films is disruptive, because there is no narrative or storyline. The scenes are unrecognizable and cannot be understood. They are hard to follow and seem nonsensical. In these images the world seems to have been suspended. Deleuze argues that their strange movement presents images that can't be identified, and which cause a direct apprehension of time (Deleuze 2005a: 260–269). When we look we 'see' time; we see how we exist in time. The images do not mean anything in particular, but are direct signs of pure colour and sound. We can't absorb these signs, and they cannot be edited by the brain's sensory motor apparatus. They exist autonomously and automatically, crystallizing as pure and shocking images that then show how our unconscious mechanisms of thought exist, before being edited by the brain and its systems of signification and representation. In these films we see images that show what happens before conscious sensation and subjective experience.

Deleuze argues that Italian neo-Realist films 'shock the system' by collapsing the sensory motor of the brain (Deleuze 2005a: 1–12 ff.). The images in these films then present what underlies the systematic process that turns sense-data into signified sense. They bring forward a direct image of time by demonstrating how thought happens in the brain. We are presented with images that show the process of thought itself. These films show the process of receiving optical or sound images that do not yet appear to make sense, and their durational change and becoming on the gangplank of sense-making, without being filtered by the systematic paradigm of representation that occurs in the conscious world of words or speech.

In a similar way we see a pure and immediate sense of what existence is, and a precedent logic of sense, in Reynolds's hallucinatory art. He expresses his particular vision of the world, and the way it is portrayed to him as a schizophrenic artist. By looking at his 'morphing' of 'the monsters in my head' we witness the ontological heterogeneity, or different senses of being, presented

by the psychotic hallucinations of schizophrenia. This art provides a method of maintaining existence in the face of these chaotic hallucinations, for Reynolds, and a chance to open up and traverse across the multiple strata and models of being that define the world.

As a consequence of this excursion into Deleuzian thinking, we gain a clearer sense of what is going on in Reynold's art, its agency, and we see how it acts as a *sinthome*.

Deleuze engages with schizophrenic discourse, and the schizophrenic take on the real, throughout his œuvre. We see this in particular in his *The Logic of Sense*, where Deleuze uses the schizophrenic's language because it brings forward a dual or paradoxical sense of sense and nonsense, at the edges or on the surface of sense-making. From the words of the schizophrenic like Artaud, such as 'Ratara ratara ratara Atara tatara rana Otara otara katara...' and the nonsensical words of Lewis Carroll like 'Pimpanicaille', Deleuze is trying to free up set meanings for words and open up their signification to a multitude of interpretations (Deleuze 2004: 96). In the schizophrenic's language, words become holdalls for travelling across a multitude of paradoxical meanings. Deleuze uses the multiple layers of reality that define the schizophrenic's psychosis to open similarly heterogeneous and spontaneous possibilities for making sense. This sense is embodied, and located, at the edge or on the surface of things and propositions.

We see this multiple, direct, unmediated and pure sense of the real by looking at Reynolds's paintings. The Morphing series, in particular, shows us part-object forms that are quasi-humanistic, with shapes like limbs, body parts or organs intertwining, copulating or growing into and out of each other (Figure 4.4). These forms operate as drives of an aesthetic machine that manufactures a method of maintaining a direct experience of reality at its raw edge. At this brink there is turmoil, in the evolving and revolving psychosis that defines Reynolds's schizophrenia. The paintings show us how he thinks during an episode, the turbulence and disturbance of the illness, and also how he copes with this, since the process of painting alleviates these symptoms and provides him with a voice to give birth to his true self. We return to Lacan's *sinthome*.

But we have not finished with Deleuze, and his breaking the sensory motor to make an argument for the time-image and source a pure form of time. Deleuze is trying to empty the self of all its perceptions, experiences and empirical content, so he can expose the transcendental form that precedes and conditions (or determines) all being. We might argue that for Deleuze

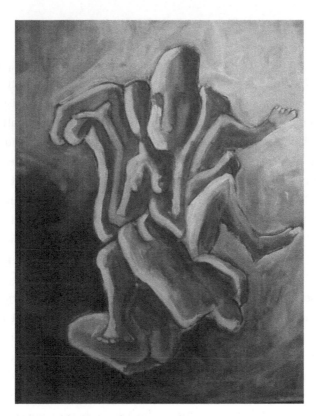

Figure 4.4 Kyle Reynolds, *Turmoil*, 2011, acrylic on canvas
© *Kyle Reynolds.*

the essential and conditional form of existence, in time and space, is quasi-psychotic and hallucinatory, which is why the schizophrenic mentality is so fundamental for his philosophical agenda. He wants to source time in such a way that it can determine thought and existence, without the contents and connotations of subjectivity.[5]

Deleuze is trying to collapse the sensory motor with his concept of the time-image, to break the system of signification that he also sees as operating in perception. He's trying to observe the automatic interplay occurring at the cutting edge, the interface of the real. We can see this interface in Reynolds's paintings because of the way they unfix conscious perception. Reality is a multiplicity of ingrowing, prenatal, phallic and paranoid forms that interact. These forms affect Reynolds, whilst he paints, because the process enables him to cope with his illness, whilst they also affect the viewer, who witnesses the immediate and ingenuous complexity that defines Reynolds's precedent, hallucinatory version of what is real.

4. Paranoid multiple-images

In this way we could compare Reynolds's Morphing series of paintings to Salvador Dalí's 'multiple-image' paintings. This comparison is useful because it will help us expand our grasp of the sensibility that Reynolds displays in his art. Dalí intended to produce a dynamism, motion and liberal duration in these paintings. They show a multitude of viewpoints, apparitions and situations, which bring movement and difference into a single picture plane, so that we can see reality from the multitude of viewpoints, or simulacra, that compose its essence. In Dalí's paintings different images appear in the bizarre anti-chronicle of their composition. They seem like Deleuze's work on Italian neo-Realist cinema: the more we look the more images we see, interacting and growing through our vision, without making sense as such, but becoming more real in the duration of our interaction with the artwork.

We can see this in Dalí's *The Transparent Simulacrum of the Feigned Image*. It pictures an unspecific, dimly lit, mountainous landscape set by the sea, which immediately appears somewhat plot-less, but then seems to commence a narrative whilst we look at the painting. The clouds are moving across the sky. The beach then seems like a table, with a drooping napkin that slides off it and looks like a penis. How disturbing. Those originally anonymous mountains then become a middle-aged woman, which is perhaps a reference to Dalí's mistress Gala. She gazes through the physical constraints of the painting and into the viewer's eyes, arousing strange aggression. Then we look further at the napkin, which is now floating into something nebulous, becoming something like a bird that looks as though it is trying to fly away from the viewer, who is now blinking at the lurid heat of this curious encounter. Suddenly indeterminate, the original landscape oil painting liquidizes, and is hardly coherent amidst the multiple images we can see from it. The shapes move between perspectives and only their colours are coherent, as they cling to the viewer's consciousness – which is confused and jolted by this painting (Figure 4.5).

The work emerges alongside Dalí's theory of 'paranoia-criticism'. Both the painting and this theory help us understand Reynolds's schizo art because they demonstrate how a 'normal' perception or interpretation of reality is made up of ideal forms superimposed and fixed as a result of the coercive and political systems of signification and representation. Dalí and Reynolds's works are liberating because they break out of these systems, by using paranoia (another word for schizophrenia) to emancipate perception.[6] Dalí uses paranoia as a method to access the multiple, constantly shifting simulacra (copies or substitutes of reality) that lie beneath these ideal forms. In his 'multiple-image'

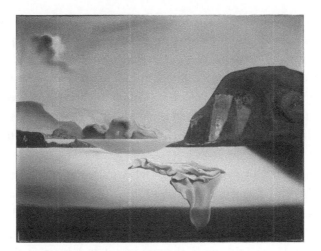

Figure 4.5 Salvador Dalí, *The Transparent Simulacrum of the Feigned Image*, 1938. Buffalo (NY), Albright-Knox Art Gallery. Oil on canvas, framed: 33 7/8 × 41 3/8 × 2 1/4"/support: 28 1/2 × 36 1/4" (72.39 × 92.07 cm). Bequest of A. Conger Goodyear, 1966. © 2013. Albright Knox Art Gallery/Art Resource, NY/Scala, Florence. © Salvador Dalí, Fundació Gala-Salvador Dalí, Artists Rights Society (ARS), New York 2014. © 2014 Artists Rights Society (ARS), New York / ADAGP, Paris

painting the different images have the same dynamism that Dalí uses to move the dialectical system of signification operating in perception, which imposes the object as fixed in our consciousness. As he says in *L'Âne Pourri*: 'The paranoiac mechanism giving birth to the image of multiple figuration endows our understanding with a key to the birth and origin of the essence of the simulacra, whose furore dominates the aspect under which are hidden the multiple appearances of the concrete' (Dali 1998: 224–225). In this way, I will argue, making art in response to paranoia then redirects the symptom, turning not towards psychotic breakdown, but towards an emancipation of perception in the artwork formed, which is applicable to Lacan's *sinthome*.

Dalí uses paranoia, where Deleuze uses cinema, to find a method of unfixing our consciousness and demonstrate the power of paranoiac-schizophrenic (rather than fixed and reduced) perception, and its multiplicity, so that the viewer can observe the interplay of truth occurring behind formal reality. As Dalí says '... the real is but eternal becoming' (Dali 1976: 144). It is as though here is the same power that Deleuze speaks of about cinema with his use of automatism in the concept of the time-image, which is theorized by Dalí's paranoia-criticism, and is immediately sensible in his multiple-image paintings.

Dalí uses automatism, not specifically of André Breton's Surrealist manifesto, but from the spontaneous and direct access to paranoia, or psychotic hallucinations, which he then wishes to mobilize in terms of the power of

thought, just as Deleuze does with cinema. Dalí's mobilization of paranoia allows for the same kind of automatism to seem contained and provoked by the painting itself. The interacting perspectives within the different planes of the picture's composition provide an automatism that generates its movement in the viewer's experience of the painting. This automatism is not technological like that of the moving image in cinema, which Deleuze writes about, but seems more like the spontaneous, genetic, Bergsonian *élan vital* of the aesthetic encounter.

By looking at Dalí's paintings and Deleuze's work on cinema with the concept of the time-image we learn about how the mind works and we gain a direct sense of the real before it is constrained by the rules and regulations that govern thought and consciousness. Dalí is interested in changing how we view the world. He sets this up in the movement and duration that evolve in his multiple-image paintings, and he theorizes it in his 'paranoia-criticism'. There are similarities between the works of Dalí and Deleuze because they both seek an automatism that precedes (and breaks) the governing systems that change and dictate how our sense experiences function. Reynolds's paintings are interesting on this account, since by creating them he is trying to find a way not just to understand, but most of all to manage the (often traumatic) ways that his sense experience functions. There is a movement and duration in Reynolds's works because of their continual growth, with their cystic and copulative expansion. He is not so much trying to break the sensory motor to discover what precedes it; but, rather, he wants to find a way to maintain himself, make sense of the world and cope with the disturbances that occur when the sensory motor is broken down, during his psychotic episodes. This is an ethical, rehabilitative practice, rather than a transcendental philosophy. As such, we can again see how Reynolds's artworks apply to the *sinthome*, because of their deflection of the symptom and their consequent agency of transformative therapeutics.

We can see this in Reynolds's *Conception*. Here is an image of a maternal figure with phallic, prosthetic, bulbous and prenatal forms growing inside her, lubricating and manipulating her internal organs and external shape. We see genital drives, their bodily expression, procreation and a raw, immediate display of the manifold and interactive urges and masses that define Reynolds's existence (Figure 4.6).

Reynolds describes this image as: 'the flow of life and in my case rebirth through mental illness'. His conception of reality is multiple, with interwoven forms growing in and out of each other. Different appearances tease the eye, as they move out of a formal, totalitarian or sealed sense of a body enclosed

by organs, and into an interactive movement of duration. Here we meet the Deleuzian *time-image* through Bergson's *Creative Evolution*.

Conception can be seen to demonstrate Reynolds's process of splitting 'good' and 'bad' objects, as Kleinian part-objects, to expel and introject different parts of his psyche and achieve a balanced flow of the fantastical, aggressive or erotic forces that charge his schizoid perceptions of the real. But what is different about Reynolds's process of psychic growth, through this painting, is that rather than progressing from paranoid-schizoid fantasy to a manic-depressive stage (which is not possible because of his schizophrenic illness), the part-objects and drives presented and utilized in *Conception* are alleviating the *symptoms* of schizophrenia, even though these symptoms are ongoing. Rather than achieving any teleologically rounded personality, or pseudo-cure, the *work* of the artwork is in its application of the *sinthome*. By continuing to provide treatment, as ways of coping with the symptoms that define Reynolds's illness, the artwork has an agency of transformative therapeutics that offers a method of Making Sense of Reynolds's (schizophrenic) world.

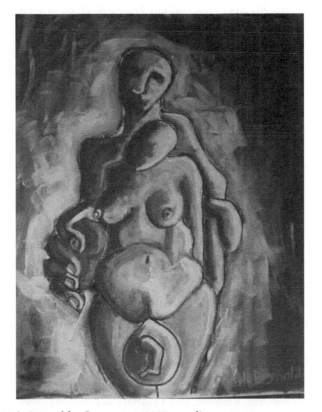

Figure 4.6 Kyle Reynolds, *Conception*, 2007, acrylic on canvas
© *Kyle Reynolds.*

5. The body without organs

Reynolds's works also seem to resonate with Deleuze and Guattari's notion of the 'body without organs' (BwO), which was introduced in Chapter 3. We will consider and develop this concept here because it will help us understand Reynolds's aesthetic and his schizophrenic subjectivity, in relation to his creative process. We will see how all this is relevant to utilizing the *sinthome* and so building a theory of Making Sense *outside the clinic*.

As we have seen, with the BwO Deleuze and Guattari want to open a motor from the raw matter of the mind, exposing and activating desire, which they define as a productive *method*. Desire is the incessant *act* of producing. To do this they engage with the hallucinatory, metamorphosing mentality of the schizophrenic, defining the BwO as: 'the unformed, unorganized, nonstratified, or destratified body and all its flows: subatomic and submolecular particles, pure intensities, prevital and prephysical free singularities' (Deleuze and Guattari 2004a: 49).

Deleuze initiates his use of the BwO in *The Logic of Sense*, where it circulates as a stream of simulacra or part-objects as 'blockages' and 'pressures' that simulate, stimulate and organize the drives of an individual's world (Deleuze 2004: 190). The BwO develops from Klein's understanding of object-relations, although Deleuze's use of the term disrupts all Oedipal fantasy and focuses on the decentring, disjunction and dissolution of the ego, rather than any psychic growth or resolution. In *Anti-Oedipus* Deleuze and Guattari critique Klein's part-objects, activating them – in contrast to her viewpoint – as 'world of explosions, rotations, vibrations' that make up the 'production of desire' of the BwO (Deleuze and Guattari 2004: 47–48).

Deleuze and Guattari then utilize the BwO to launch schizo discourse, which '*scrambles all codes*' in the lubrication of the real (Deleuze and Guattari 2004a: 16). They describe Adolf Wölfli's drawings, which advocate the BwO concept, and they say that by making these drawings: 'The schizo maintains a shaky balance [...]. Although the organ-machines attach themselves to the body without organs, the latter continues nonetheless to be without organs and does not become an organism in the ordinary sense of the world. It remains fluid and slippery. Agents of production likewise alight [...]' (Deleuze and Guattari 2004: 17). So the schizo's expressive, discursive artwork is a BwO, which provides them with a method of mobility and affectivity in their course of confronting the real. Deleuze and Guattari use Wölfli's drawings to show how they provide a proactive process of desiring production. This process

enables Wölfli to maintain 'a shaky balance' as he traverses across the psychotic interludes of his detained existence, whilst Deleuze and Guattari use the schizo discourse (from Wölfli's art) and its process of desiring production to drive their schizoanalytic system. In a similar way, Reynolds's paintings offer him a method of negotiating his symptoms and an agency of transformative therapeutics that help him make sense of the world.

In particular, we can use the BwO to think about Reynolds's art because he says that his psychotic delusions also concern 'the Judgment of God', and the 'stagnant and confining' seclusion of organized religion (in a similar way to Artaud's formulation of the BwO 'To Have Done with the Judgment of God', which we saw in Chapter 3). People with schizophrenia are particularly susceptible to the development of delusions (or misguided beliefs that have no basis in reality) due to the significant cognitive impairments that are symptomatic of the psychotic disorder. Their disorganized thinking and impaired ability to interpret new information often lead them to false perceptions. It is common for schizophrenics to have delusions centred around misguided ideas about one's relationship with God. Schizophrenic people with this type of delusion may believe they have a special relationship with God or that God has given them special powers. They may profess an ability to speak directly to God or a responsibility to carry out God's plans. In some cases, these individuals may actually believe that they are God.

In Reynolds's case, during a schizophrenic episode his fears and thought distortions mean that 'God' becomes a damaging enemy that forms an oppressive, autocratic presence that dictates his entire mentality. In relation to this, art helps dispel the darkness of organized religion that imprisons, encloses and constrains his mind (and his body). Reynolds says that the process of painting is a 'freeing' and flowing movement that enables him to cope with the trauma of a psychotic episode, break away from the constraints and pains of his illness and find a method of meeting and remaining in the real: 'it's about helping me get back to myself'.

In Deleuze and Guattari's understanding of the BwO, through Artaud's religious delusions, the concept presents a field of immanence of desire, in contrast to the restraints posed by the body enclosed by its organs, where the judgement of God dictates organ-ization, signification and subjectivation. By contrast, the BwO is a site of liberal flow. Deleuze and Guattari then use Artaud's BwO to release desire from Freudian fantasy, since they still have an ulterior philosophical and transcendental agenda (as we saw in Deleuze's work on the time-image).

The flow of the schizo's real, which is pure and immediate in the effects of artistic creation, will engage with the schizo's symptoms and alleviate their suffering, thus producing a 'new earth' that nurtures a new way of being. In this way, activating the BwO and engaging with schizo art involve the ethical treatment of the symptom, which (as we have seen) 'reverses itself in the effects of creation' (Lacan (Écrits) 1966: 66). We return to Lacan's *sinthome*.

6. Theoretical impasse

However, before any conclusions can be drawn from using the BwO as well as the *sinthome* to develop the transformative therapeutics from Reynolds's art, there are some serious theoretical problems with attempting to apply Lacanian theory alongside Deleuze and Guattari. Their respective opuses might seem (in some respects, although not all) oppositional antimonies, based around Lacan's defining desire as a *lack*, whilst Deleuze and Guattari define desire as inherent *production*. Their differing definitions of desire need to be discussed because any engagement with Lacan's *sinthome*, and its relation to the subject, involves his understanding of desire. Since, it has been argued, the *sinthome* is a theory of desire, to utilize the *sinthome* we must consider Lacanian desire.[7] We are also utilizing Deleuze and Guattari's conflicting views on desire when we discuss their concepts, since desire *per se* is a discussion of subjectivity. As a result, we must be careful not to reach a systematic blockage by juxtaposing Deleuze and Guattari with Lacan.

For Lacan, subjectivity is made up of an absence, or lack, whilst desire is directed towards regaining a completeness to make up for this lack, which is ultimately impossible to attain. He makes this argument in direct contradistinction to Descartes' Cogito, by saying that thought (and being, or subjectivity) is impossible outside the domain of language. Since all signs imply absence (the sign represents or stands for something else, which is not present, so there is no sign without the implication of absence), then each time I represent my thoughts in language, I am always-already implying my own absence. I imply the gap between the representation of myself, and what I am trying to represent. As such, for Lacan, the subject is alienated but defined by language. The subject is never present to itself when it speaks, since its structural configuration on language is based on the gap it has between the sign and what it represents. As a consequence, the immediacy sought by Descartes's Cogito Ergo Sum cannot be

achieved, since the subject is always already definitively absent and alienated in language (see Lacan 1979).

Although Deleuze and Guattari are also trying to disrupt the Cartesian subject, they have a fundamental disagreement with Lacan's deficient definition of subjectivity and desire. According to Deleuze and Guattari, seeing desire in terms of lack, as Lacan does, forces it into 'an idealistic (dialectical, nihilistic) conception' (Deleuze and Guattari 2004: 26). In psychoanalytic terms, desire depends upon the absence of an object, which produces fantasies of this object. This production detaches itself from the desired object, which is unobtainable (thus motivating the desire as lack). As a result, a Lacanian definition of desire as lack reduces desiring-production to producing fantasy, which initiates an 'idealist principle' that is (at least) one step removed from the world (Deleuze and Guattari 2004: 28).

Deleuze and Guattari take great pains to refute this argument in *Anti-Oedipus*. They denounce any notion of lack and want to utilize desire to fabricate a *machine of production* that generates the real, rather than being removed from it. They then use their constructive definition of desire to define the molar organization of the subject:

> Desire does not lack anything; it does not lack its object. [...] Desire and its object are one and the same thing: the machine, as a machine of a machine. Desire is a machine, and the object of desire is another machine connected to it. Hence the product is something removed or deducted from the process of producing: between the act of producing and the product, something becomes detached, thus giving the vagabond, nomad subject a residuum. The objective being of desire is the Real in and of itself. (Deleuze and Guattari 2004: 28)

However, despite their grievances, Deleuze and Guattari then engage with Lacan's idea of the 'object petit *a*' to resolve this situation, by turning desire into an instrument of production, a 'desiring-machine', rather than an inordinate (or any) supposition of fantasy or lack (Deleuze and Guattari 2004: 28). Whilst they vehemently oppose Lacan's relation of desire to lack, via the signifier, Deleuze and Guattari say that from the viewpoint of his objet petit *a*, Lacan conducts an 'admirable theory of desire' (Deleuze and Guattari 2004: 28).[8]

Lacan's object petit *a* has a key role in his topological representation of the knot of subjectivity; indeed Lacan even describes it as being 'wedged' between the Real, Symbolic and Imaginary as the very principle of their knotting. Since Lacan then uses the *sinthome* to re-knot the subject (with a fourth ring to the triad of the Real, Symbolic and Imaginary), the interrelation between the object

petit *a* and the *sintome* is clear. Thus if Deleuze and Guattari approve of the object petit *a* they would plausibly approve of the *sinthome*.

We can see Deleuze and Guattari as *using* rather than rejecting Lacan, as Stephen Caldwell does: 'Rather than rejecting the insights of Lacan, as Žižek claims, Deleuze and Guattari radicalize him in an effort to overturn the ideological apparatus of capitalism and liberate desire from reactivity' (Caldwell 2009). In a similar way we can draw Lacan's use of the *sinthome* to reach the end of analysis, or to replace the clinic, which would then adhere to Deleuze and Guattari's principles. Caldwell says that whether or not Deleuze and Guattari's project to 'radicalize' Lacan is successful 'remains dependent not upon abstract principles of ontology but rather in the ways that people can *use* it'. As Guattari says, 'We're strict functionalists: what we're interested in is how something works' (Caldwell 2009, my emphasis, quoting Guattari in Deleuze 1995: 21).[9]

So what happens if we *use* Lacan with Deleuze and Guattari? We achieve the end of analysis. Rather than having to destroy it, we simply don't need it anymore.

Since, as we have seen, Lacan 'evokes psychosis' in Joyce, so that when he reads Joyce's work and interprets his life, he diagnoses psychosis. Lacan then argues that Joyce's writing replaces the need for psychoanalytic intervention. We can see this reading of Lacan on Joyce in Jacques-Alain Miller's preface to *Joyce avec Lacan*:

> To evoke psychosis was not anymore applied psychoanalysis but on the contrary, *with* the Joyce-symptom taken for unanalyzable, it was the discourse of the analyst put into question, insofar as the subject identified with the symptom closes up in its artifice. And it could be that an analysis does not have a better ending… (Miller 1987)

As Deleuzian theorist jan jagodzinski writes (in *Psychoanalysing Cinema: A Productive Encounter with Lacan, Deleuze, and Žižek*), with Lacan's application of the *sinthome* we reach the stage of a 'productive psychosis', and here 'a reply to Deleuze/Guattari's schizophrenic is finally achieved. [...] When a subject identifies totally with his or her *sinthome*, then there is no analysis, no opening to insert a question' (jagodzinski 2012: 6). The psychotic (who we might or might not call an *Outsider artist*) produces artwork in response to their symptoms (without being clinically detained or Oedipalized by psychoanalysis). This process arguably then achieves what Deleuze and Guattari are trying to do with their engagement of the schizophrenic and their practice of schizoanalysis. As

a consequence, the *sinthome* realigns Lacan's definition of subjectivity as lack: 'With the *sinthome*, it seems desire is no longer defined by lack. It addresses the lack in the symbolic that is indicative of the unthought itself, the limit point of the Symbolic, the Outside' (jagodzinski 2012: 7). This would make the concept more applicable and acceptable to a Deleuzian/Guattarian (anti-)systematic.

However, although jagodzinski's work does effect a *productive encounter* with Deleuze and Lacan, via the Outsider artist, his use (and apparent deprecating) of the Outsider artist is misleading:

> The Outsider artist in effect closes him or herself off in her or his own art(ifice) as a One or ego, the ego no longer referring to that of the Freudian ego of signified representation, but to an investment in the One-body in relationship to the (big) Other's lack, an investment between the Real and the Imaginary, which itself is ambiguous. The ego here rather than being 'filled' with narcissism is emptied. The One becomes ignorant, just the opposite of arrogant, 'filled' with knowledge. It is perhaps no wonder that such Outside artists, such as Joyce 'makes a litter of the letter' [...] Outsider artists, in effect, gather up what is usually considered abject in the Kristevian sense, that which the symbolic order discards, sees as 'trash'. Joyce's litter of the letter, the trash and discards, the waste that society throws away, is picked up and reassembled to make a new Imaginary order. (jagodzinski 2012: 6)

Here, jagodzinski says that the Outsider or psychotic artist is incessantly attempting to accumulate and order *trash*, where 'the line between "madness" and artistry is always precarious' (jagodzinski 2012: 7). But we can see this process of reassembling as a creative process that provides a *making sense* of their symptoms, which arise from the ceaseless and overwhelming sensations that pervade their conscious minds. The Outsider artist is not necessarily *crazy*, nor producing artwork from *trash*; they are engaging with and directing their perceptions of the world, or their symptoms, in order to find a way of living with or inspite of them. The work they produce testifies to the sense they have made of themselves and the world, as we have seen by looking at the paintings of Kyle Reynolds.

And yet, it is inaccurate and sweeping to reduce all artists who use their symptoms to inspire and direct their art to the labels of 'psychotic' or 'Outsider' artists, or to say that *sinthome*-art is all about waste or trash. It is more useful to think about the ways that their creative process enables them to stay out of the clinic (which Deleuze and Guattari would surely agree with). Indeed, in another essay, jagodzinski discusses the ways that art-making is essential for Outsider artists, to help them cope and live with their symptoms:

In the realm of their symptoms, what Lacan was to call a *sinthome*, there are multiple voices at play, the fragmentation of the self which, like Humpty-Dumpty who fell off the wall, is somehow broken and cannot be put together again in some coherent fashion that could be called a stabilised ego, a consistent core self. The traumas that are lived out by Outsider artists require that they slay their monsters (fears and anxieties) through self-refleXive therapies of their own making. The nonsense signifiers that they create attached to bizarre images are ways to stave off madness, the fury of the body acting on its own, out of control. The cauldron of productive creativity is absolutely essential to keep the soul (life as *zoë*) in check as best as possible. (jagodinski 2012a: 179–180)

This is more like the approach we are taking from Reynolds's art. We can return to this now – how can we define his œuvre? Where is it apposite to situate it in relation to the aesthetic fields or the art world, which Lacan and Deleuze and Guattari refer us back to in their building of concepts like the *sinthome* (with Joyce), the body without organs (Artaud) or schizoanalysis itself (Schreber)?

7. Outside *Outsider Art*

So is Reynolds, as a schizophrenic artist, like Schreber, an Outsider Artist, or a practitioner of Art Brut? Or is his art Surrealist, like that of Dalí? Not specifically. With no formal art education or artistic background, Reynolds began to paint spontaneously, and specifically in response to his illness, so he may fit the criteria to situate himself into the pseudo-anti-school of *Art Brut*. But he is not consciously trying to position himself inside or outside any particular system or the art world in general. He is trying to situate himself in relation to different senses of the real, those of the norms considered by the public and how the majority live and rule, and the so-called delusions that define a so-called illness.

As he says, 'Art Transcends the unspeakable opening up new Worlds' – and here is the liberation. Reynolds says that there is a stigma to mental illness, and particularly schizophrenia, and he feels that it is his role, or job, to express himself and his illness to open and defy this stigma, making the world more aware of it. His courage and honesty define his practice:

Art is liberating. It has given me a voice a chance to reach out and break down walls that need to be broken down. Schizophrenia still tends to be that one mental illness that people do not want to touch. Art has given me a voice for an

illness misunderstood and much less talked about. By sharing my art I hope to influence others in same life situations to find their voice. I want people to see not only the beauty life can bring, but the difficult truth that comes with many of life's challenges.

Here is the true meaning and sense of art practice: to provide an affect of transformative therapeutics. When he creates an artwork, Reynolds initiates a method of expressing and transforming not just his own illness, but also the social constrictions, judgement and ignorance posed in the battleground of existing in the world. His artworks then *transform* this world, by changing the viewer's preconceptions and the restrictive hierarchy of 'common sense', and by providing Reynolds with a method of nurturing life with the multiple, cacophonic feelings and visions that define his personal sensibility.

During the painting process he diverts his (largely religious) fears and delusions: 'I just find religion to be so restricting like having blinders on and art is the complete opposite all about expression and being an individual'. Being, and becoming, an individual is made possible by making art because it provides a system of releasing and making sense of the raw, hallucinatory flows that define his illness. This release is the content and process involved in Reynolds's paintings, which are visual objects that inform and inspire the largely ignorant viewer, who tends to judge (or avoid) schizophrenia as some sort of crazy social or occupational dysfunction. We see an organic setting free of the symptom, and the birth of the self, outside of a clinic or an institution. Pure creation counters trauma and initiates a 'place of healing' for both the artist and their relation to society at large.

In this way Reynold's art fulfils the work Lacan projects with his writing on the *sinthome*, and also, arguably, in his psychoanalytic clinic, whilst remaining specifically *outside* this clinic.

8. Conclusion

To conclude, we can utilize this application and realization of Lacan's *sinthome* to crystallize the transformative therapeutics of art practice that has been established by attending to Reynolds's artworks. I have shown how Reynolds's creative process and his paintings provide him with a method of making sense of the world, and a procedure for living with or in spite of the symptoms that arise from his schizophrenic illness. His paintings then express his own heterogeneous viewpoint and offer him a means of grasping

some tangible sense of the real amidst its continual, overwhelming and often-traumatizing undulation. In this way Reynolds's art enables him to fold his subjectivity, not to dichotomize or restrict its incessant schizo flow, but to open and incorporate (or embody) the folding of nomad forces that define the *outside* of thought.[10]

In this way, Reynolds's artworks enable him to maintain a degree of stability that has helped him manage his symptoms, in a similar way to Lacan's use of James Joyce, and in both cases as an activation of the *sinthome*. As a consequence of examining this concept, I have shown how we can utilize psychoanalytic theory (in this chapter, about the *sinthome*) to get outside the psychoanalytic clinic, and show how art can be healing and transformative without a dependence on a clinical setting (which, as we saw in Chapter 3, is problematic – especially to Deleuze and Guattari) or professional input (which not everyone has the mis/fortune to have access to).

As a consequence, this chapter has opened out some of the creative and healing properties of art practice, by showing how it has helped Reynolds deal with his illness. By locating this healing, which is both a transformative therapeutics and a Making Sense of the world (for Reynolds, Joyce and Wölfli, at least – in this chapter), outside the clinic, my intent is to make it more accessible, practical and useful.

Now the task of this book is to think about transformative therapeutics and Making Sense for those of us who do not suffer from schizophrenia, psychosis or any kind of psychiatric illness (which the book has concentrated on, up to this point). Halfway through the book, we are *outside* the clinic and can build, transfer and expand this agency of transformative therapeutics beyond providing care and healing for the individual subject. Now we can establish the transformative therapeutics of art practice as a critical method of research on a larger scale, which can instigate social change and help us make sense of the world at large.

Part Two

Transformative Therapeutics as a Critical Method of Thinking

Making Sense of Territory:
Art Practice and Material Thinking

In this chapter, I present art practice as a transformative method of material thinking. I will demonstrate this by showing how manipulating and applying materials (to create an artwork) involves an expression and redistribution of their sensible, sensitive quanta (or physical attributes, also seen as dynamic forces). The consequent artwork formed consists of the interplay between these materials themselves, during and as a result of the artist's own process of working with them. Creating an artwork in this way involves the factors of care, 'handleability' and responsibility for these materials, building a tacit knowledge of their relational interaction. Drawing from Barbara Bolt and Paul Carter's work on art practice as research, I show how this process is a nuanced method of material thinking. It produces an agency of transformative therapeutics because of the way that there is a shift and realignment of – using Deleuze and Guattari's geophilosophical terms – a 'war machine', towards the provision of a 'creative line of flight', during the interaction of the different material factors involved. As a result, in this chapter, making an artwork is a territorial gesture, since mark-making inscribes territory, whilst it is also a method of thinking with and 'handling' materials that results in tacit knowledge.

After presenting an exegesis of my art practice, by describing what happens during an episode of painting, this chapter has two parts. The first part discusses how the creative process provides a critical and materialist method of thinking. Drawing from Paul Carter's *Material Thinking* and Barbara Bolt's notion of 'materializing practices', I examine how an episode of art practice can be utilized to provide a sensitive epistemology that concerns the care and handleability of the materials involved. The second part of the chapter examines how creating an artwork can provide a method of marking territory. By engaging with Deleuze and Guattari's ideas about geophilosophy, territorialization and the flux of forces and people who move or settle in space, and the correlative pattern we see in

my episode of art-making, we will see how territory is 'a result of art' (Deleuze and Guattari 2004a: 348). By examining the creative process and a series of artworks by Australian landscape painter Caroline Rannersberger, I will then conduct a process of making sense of the creative, expressive procedure that territorialization involves. This will show how art is involved in the ways that we inhabit the world. In both parts of the chapter, art practice builds a transformative therapeutics that is making sense of the world, by (sensitively) inscribing and inhabiting the surface of the world. The self-reflexive commentary on my own painting practice, and the equally reflexive commentary on Rannersberger's, then conducts a material thinking that harnesses and applies the emergent insights that arise during both of our creative processes, thus crystallizing how art provides an agency of transformative therapeutics. This helps us make sense of the world.

1. Preliminaries

Before I begin, it is important to lay down some definitions. 'Material thinking' is a term used by Paul Carter, which denotes the way the artist uses, manipulates and collaborates with the material forms of their medium as a method of creative research. For Carter this involves a recording (and sense-making) of the artist's work in the studio, through the written exegesis of the creative act. This collaborative, written recording produces knowledge, subsequent to and drawing from creative production (Carter 2004). Barbara Bolt applies Carter's material thinking through her own painting practice. She describes her interpretation of material thinking as 'a particular responsiveness to or conjunction with the intelligence of materials and processes in practice. Material thinking is the magic of handling' (Bolt 2006). For Bolt the collaboration and relationship involved in material thinking are between the artist and their materials, rather than between the image that this artist produces and the text that comments on this image. In this chapter, I will apply a material thinking in a double exegesis of my own painting practice and that of Australian landscape painter Caroline Rannersberger.

Deleuze and Guattari's terms, 'war machine' and 'creative line of flight', are useful for us to consider in relation to the content and application of material thinking, where art-making is seen as a territorial gesture. These terms are seen particularly in *A Thousand Plateaus*, where they are used to discuss the State's apparatus of capturing and governing territory, and the power and populace

of nomadic and sedimentary spaces. As a consequence, the war machine and line of flight can be seen as *geophilosophical* ideas, where 'geophilosophy' is an applied method of thinking, which Deleuze and Guattari coordinate and utilize to consider the space we inhabit, and how land becomes territorialized. With geophilosophy Deleuze and Guattari wish to lay down a topology for materialist thinking (see Deleuze and Guattari 1994: 85–116).

These ideas are relevant for us because, as Deleuze and Guattari argue, the creation and establishment of territory is an interplay of becoming between processes of deterritorialization and reterritorialization (or the moving processes that craft the refrain of territory), and this is a work of art. This is art's *work*. We can see the interaction and movement of space and its contents, with the potential for enabling a creative line of flight from the destructive war machine, from any process of art practice. This is one way of describing what I am calling transformative therapeutics.

The war machine has two poles. One pole forms a deterritorialized line of destruction. It is aggressive, and proceeds as a tool of destruction. But the other pole of the war machine is fundamentally creative; it does not have war as its object, but 'the drawing of a creative line of flight, the composition of a smooth space and the movement of people in that space' (Deleuze and Guattari 2004a: 466). We can think of a line of flight as the unfolding of forces or the generation of energy, which is inherently creative and potentially liberating. This is set as a contrast to the other pole of the war machine.

From these two poles we can understand the war machine as a way of thinking about the distribution of materials in space, and the interaction and friction that occur at their boundaries. It is thus easy to use the war machine and the line of flight to help us think about what happens during art practice, which is also concerned with the distribution and interaction of materials. The war machine is a nomadic invention, which indicates a certain way of occupying smooth space and the distribution of people or forces in this space. The differences in this distribution create positions and lines through movement, which then constitute their journeys in space.

What is particularly significant for this chapter is the way that a line of flight can provide transformation: it can make something change. It produces differentiation. We can use this capacity for transformation to define our agency of transformative therapeutics. It can also be seen as a process of counter-actualization, which was defined and considered in Chapter 3. In this chapter we want to engage with this potential and see how it is then possible to generate and apply the creative line of flight to realign the destructive energies of the

war machine. Establishing the transformative properties of art practice in this way will deliver a form of *material thinking* that is also a marking of territory or worldly becoming, through a process of expressing an embodied experience of being-in-the-world.

I will now describe an episode of my own painting practice, in order to develop the agency of transformative therapeutics (shifting a war machine to a creative line of flight) and instigate a method of material thinking that will deliver tacit knowledge, or embodied knowledge rooted in experience. Tacit knowledge (as defined by Michael Polanyi) brings about creative, implicit, practical learning about the materials I am using and their interaction, from the care, responsibility and 'handling' that I conjugate during my creative process (Polanyi 1958; 1967).

2. Exegesis one: An episode of the creative process

In this exegesis of an episode of my painting practice I articulate what emerges through the process and application of handling different materials. I consider what the emergent, *tacit* knowledge reveals about these materials and the situation of their interaction and state of becoming as I create a series of artworks. This will show how the creative process – as a method of material thinking – can provide an agency of transformative therapeutics. The subsequent self-reflexive text that follows from my painting episode intends to articulate and apply this agency in order to, following Barbara Bolt's work, *materialize practice*. As a consequence, I hope to develop art practice as a method of establishing territory and building a new sense of care, concern and responsibility that is therapeutic and transformative for the movement of materials and forces in space, which it involves.[1]

I experiment with paint, oil, flour and some wild indigo-coloured juniper berries, choosing each material because of its texture, consistency and colour. I want to play with these sensuous ingredients to try and think about how they interact and come to appear as a composition. The berries are chosen because they are bursting with blue juice, which I hope will express a dominant colour on the paper, when liquefied and made into a paint-able consistency by the water, thickened by mixing them with the flower, and moisturized by the oil.

I begin by mixing a liquid paste from the berries, flour and oil, which I intend to spread across a page in my sketchpad. As I do this, I am watching the different materials interact, which I see in terms of a territorialization of the

page. Immediately the oil is the most dominant ingredient. It seems to engender the same dynamic as a war machine, by engulfing the flour into a thick, heavy, overbearing mass, which makes the berries lose their blue colour and shrink into small, black molecular masses the size of pin heads.

When I try to shape this paste onto the paper the oil is immediately overbearing, sinking through and homogenizing several pages into bland, matt, non-usable, conformed space. The flour rests on top of the oil, with tiny stains of the now black berries, and when I gently press the mediums together it only produces an uncomfortable mess. The flour will not stick to the page, so I apply some PVA glue to help bring things together, since previous experiments have demonstrated that PVA glue is a reliable source for unifying fragmentary, disparate parts. This addition adds a thick shiny layer to the composition, which provides a gloss. It is no longer possible to see what is happening between the flour, oil and berries at all. I had hoped to heal things by applying PVA, and have only added a superficial layer that hides them.

And now, despite the supposed Band-Aid of the PVA, the flour is turning back into powder that blows away in the breeze through the window. So the page is left with the overbearing weight of the oil, with the strained black marks of its conquest over the juniper berries.

It seems I have made a war machine, which stretches several pages (the oil has weight and overcomes the surface of the paper), preventing me from using my sketchpad and all the other materials from having any life there (or anywhere) at all. The oil has soaked the sketchpad with a destructive line of flight, and brings forward a totalitarian dynamic which – since the paper is sodden and unusable – striates the space in the sketchpad and destroys the other materials' chance to assert and express their qualities on the page. This dynamic attunes to Deleuze and Guattari's discussion of the war machine in *A Thousand Plateaus*: '*turning to destruction, abolition pure and simple, the passion of abolition*' as the oil is making '*aggressiveness the basis of territory*' (Deleuze and Guattari 2004a: 253, 348, original emphasis).

I continue to think through these materials to see if it is possible to have any effect on this war machine. A few hours later, I turn over the page and look at the sodden, dull, damaged sheet below it. I consider how I could make it inhabitable for other materials, and how I could give it a means of expression, or regain some lifeline from it. I try earnestly to configure this territory in terms of a Deleuzian plane of immanence, and think how I might reorganize materials upon it, now that the oil has stained the page so damagingly. My intention is to try and open the possibility for expression which is the heart of art and becoming-territory,

as Deleuze and Guattari state it: 'this constitution, this freeing, of matters of expression in the movement of territoriality: the base or ground of art' (Deleuze and Guattari 2004a: 349). It is the dispersal of materials for expression, or the plane of composition for expression, which defines the territorial gesture explicit in the creative process.

Whilst thinking about how to use the qualities of the oil stain with those of the paper I feel drawn to apply some watercolours to the page. I paint upon the oil stain, and suddenly it comes to life before my eyes. The interaction from the opposition between the oil stain and these new watercolours erupts a voluptuous energy. Oil and water cannot logically inhabit the same space, they oppose each other. But I try and 'reterritorialize' the space so that it can welcome substances that oppose each other. I try to utilize the qualities of the oil barricade on the paper, which are its colourless thickness and density, in a way that can complement the delicate, light dripping liquidity of the watercolour. I find a way to twist their differing qualities and find a sense of intertwining whereby they can inhabit the same territory that I have made from this page. From destruction became invention, simple alliance-building between the elements, and a new beginning for the composition.

The micropolitics of this situation is an interplay between the molecules of oil, their resistance to water and the colours that I choose to apply in thick brushstrokes to the page. I then turn the page and see that this affect has seeped through to the other side of the paper; or, rather, the new side has kept its own dry and untouched parameters, but the dual imprint of oil stain and paint pattern both creates a backdrop that makes a much more comfortable, comforting territory from the paper. The line of flight – or the energy of these different materials – has turned from one of destruction to creation and expression in their interaction. This creativity is the essence of the war machine, which has two poles, one of which has war for its object, whilst the other 'has its object not war but the drawing of a creative line of flight, the composition of a smooth space and of the movement of people [or different materials] in that space' (Deleuze and Guattari 2004a: 466).

Wishing to engage with the creative energy that has revitalized the sketchpad I turn another page, and decide to readdress the problems that surmounted when I mixed oil with flour into a consistency that resulted in a destructive line of flight. I make another mixture, hoping that this one will not turn out to be another war machine (which further experimentation seems to have appeased, to the extent that the destructive effects of the first war machine have now become a creative line of flight).

I mix my materials more slowly, listening to their differing qualities. The oil was already here, on the page, so this time I use water, watercolour paints and some flour to add thickness and texture. There is immediately a fault here, since I cannot use the juniper berries because they have all dried or been destroyed by the previous experiment, so I have to utilize other resources. I am careful not to use too much oil this time. Both of these points may avoid, rather than face, the problem of the war machine. But I have found a balance and create a composition that reterritorializes a double page effortlessly. The materials, the page and I make a new territory, in which all our different qualities are compatible. What was originally posed as aggressive or oppositional now becomes complimentary difference, and provides source material for a pattern that my senses, the materials I used, and the image that compose the page, all feel comfortable with.

The next morning there seems to be a healthy rapport between the different pages, and their contents, in the series that makes up the territorial experimentation that I did the previous day. Each page bears witness to and acknowledges each other, whilst retaining their individuality and differing patterns, textures and composition. The war machine provided by the oil has itself been affected by the colours which I applied after its destruction. It has a slightly rosy tint now, which does not detract from the extroverted glaze and overbearing wash of thickness manufactured by the deal brokered between the oil and the PVA, which killed the flour and blue berries; but this rosy tint recalls the life of those berries, and allows one to glimpse the texture and font of the little flour that does remain, fixed to the page beneath its glaze. There is a different aura.

Meanwhile, the warlike oil, with its totalitarian weight, has indeed seeped through to the planes of composition on the other pages, but its initially overbearing, terroristic takeover of all space has changed now. Through diplomatic collaboration and interaction, through mutual expression of differing qualities between the different materials opposing each other on the page, they now find a way to inhabit the same space in my sketchpad. The oil's moisturizing quality (which was the reason for which it was originally taken on, since the pores of the flour needed something more oily than water to prevent it from cracking up the paper) enables the final page, composed of flour and water, to settle with its colours, contours and texture on the surface of the page. The edges of the page curl delicately, to allow for the change in weight, and beckon the transversal, unilateral dexterity of a mœbius

strip (a strip of paper that has two sides, which is folded round in a figure of eight shape, so that each side joins unilaterally, in three dimensions without division).

It is much more delicate and sensitive than I had expected. The colour is lighter so that you have to put your face right up close, near the page, to see the *sfumato* effect that has been created between the different materials, as they inhabit this space together. The flour's granular texture is impressed onto the page by the pigment from the juniper berries, and adds a soft powdered quality to the paper. The berries' colour has turned soft grey, which bursts its heart of violet softly, here and there, and the colour filters between grey and violet in the undulations of the page. You can see intricate details of this colouring, even though it is not very bright or extroverted at all. The colours are pale, but not subdued. Seeds from the berries nestle in surface ripples on the page, somewhat haphazardly. The oil's presence is visible, and it retains a sodden weight on the page, but this seems to flow rather than obstruct it.

The pecking order or hierarchy between the oil, water, berries, glue and flour has changed. Each material has their own place on the page, and they make an unexpected, sensitive and complex pattern of camaraderie between them. In this way, the destructive energy often posed by some of these materials when they meet has begun to become one that is creative.

Striated space, which in another arrangement would have been uncomfortably segmented, with ingredients subordinated and unable to show their individual qualities, now becomes soft, smooth and inhabitable (whilst retaining intricate strands of complexity).

This experiment has demonstrated the ways that one can think about territory and create territory through artistic practice. By listening to the materials and responding to their different qualities I have opened a creative line of flight that encounters and redistributes the destructive energy of a war machine. This is a valuable experiment because it demonstrates how negative or destructive forces could be redistributed benevolently, and the possibility for transformative therapeutics, which arises during the creative turning.

3. Material thinking

This exercise demonstrates how experimenting with materials and creating artwork provides a method of thinking about territory, which then enables one to consider how we can encounter and inhabit the world. The experiment

provides a means of expression for the artist-as-thinker and their materials, and opens a new space – which is creative and life-affirming – on the surface of the art object made. Being able to witness the transformation of a war machine into a creative line of flight – in a spiral of becoming as the different materials and rhythms co-evolve – is the summit of territorialization and demonstrates the necessity of art in this process.

It is also a clear method of material thinking. My method of listening to the materials I use and responding to their different qualities produces a tacit knowledge of how they can be applied and apprehended intuitively on the surface grounding of their interaction. This knowledge is formalized as a result of my written discourse that describes the episode. Paul Carter talks about the relation between text and image as a relational, back-and-forth 'hybrid discursivity' that enacts an epistemology, as it is situated in the social realm. (Carter 2004: 6–11). The consequent 'Material thinking – what happens when matter stands in-between the collaborators supplying the discursive situation of their work – is a different method of constructing the world in which we live' (Carter in Barrett and Bolt 2010: 19). Here we see how material thinking concerns *territory*, since making art involves manipulating materials and inscribing a refrain in space. Carter argues that when this artwork is examined and mapped as an enquiry in writing, then new relations of knowledge emerge from the artistic production. As a result, 'a double movement occurs, of decontextualization in which the found elements are rendered strange, and of recontextualization, in which new families of association and structures of meaning are established' (Carter in Barrett and Bolt 2010: 15–16).

This movement of de-contextualization and re-contextualization echoes Deleuze and Guattari's geophilosophical application of deterritorialization and reterritorialization. Both describe the spiral of becoming that contextualizes, distributes and inhabits territory, which is an art. We can see this in my painting episode because the materials are always in a state of becoming. As Carter argues, 'They are not to be imagined as crystalline, dry or elemental but as colloidal, humid and combinatory' (Carter in Barrett and Bolt 2010: 19). There is a micropolitical situation, or psychodrama, between their differing and sometimes opposing qualities, which I try to conjugate with aesthetic diplomacy. When I collaborate with these materials, we can see the shifting of a war machine towards a creative line of flight. There is 'an ethics of scattering and recombination' (Carter 2004: 183). A rhizomatic distribution of the sensible is the resultant logic of space, where each part plays a role in this sensitive situation. Carter shows how this artistic collaboration is territorial, and it affects

the way we inhabit the world. It can enable the application of a creative line of flight rather than a war machine in space:

> The right attitude towards materials is itself a concomitant of a right attitude towards collaboration. And this combination of right handing over at a material and interpersonal level expresses the idea of a different social relation, in which people may inhabit their environment recreatively rather than destructively. (Carter 2004: 183–184)

Material thinking through art-making, from this approach, is thus a potential source of transformative therapeutics. Carter's definition of collaboration involves an interactive, productive alliance between artists and writers. The artwork 'stands in-between the collaborators supplying the discursive situation of their work'. The art's *work* emerges in its exposition, which sets up the application and exchange of ideas in the public domain. Material thinking requires the physical, creative process of thinking through making, and the resultant image. It also involves a written commentary, or creative arts exegesis, which proceeds with the intention to make sense of this image. There is a dialectic relationship between studio practice and reflexive commentary. These two factors determine, articulate and then apply the possible outcomes that can be gained from art practice. The collaboration between image and text, in Carter, involves a diacritical process of 'dis-memberment', or resistance and pulling apart, where artistic collaborators collide and question the natural places of ideas, images and materials. This is followed by 're-membering', where dismembered elements are put back together in a way that is new, producing the invention of original, insightful points of view (Carter 2004: 11). This dual process of dis/re-membering, as we saw with de/re-contextualization, embodies the processes of de/reterritorialization that occur in the becoming of territory.

In the relation that Carter presents amongst the artist, image and collaborator, we can see similarities with the relation between the patient and an art therapist, which was considered in the first half of the book. In art therapy, the image is a transitional object or scapegoat transference that provides the locus of the interaction between the patient and the art therapist. In Carter's definition of collaboration and material thinking, the image is the *medium* through which the creative process of art-making and its exegesis seek to make sense of the world, by developing tacit knowledge about the social realm which situates the making of this image. Both cases require the interpretation of the image – on the one hand, by the therapist, on the other by the artist's

self-reflexive commentary on the artwork they create, or their collaborator's written or spoken critical discourse. However, in the case of art therapy, often the image is important because of what it *represents*, in relation to the patient's mental illness, and what it reveals about the individual psyche. By contrast, in the case of material thinking, the image is important because of what it is in itself, in terms of the materials that have been used to make it. The surface plane, upon which materials are applied, is a plane of immanence, which grounds and drives the consequent reflexive commentary. This commentary is not so much concerned with the artist's psyche (although, it could be), but 'articulating what has emerged or what has been realized through the process of handling materials and ideas, and what this emergent knowledge brings to bear on the discipline' that sets the social realm of their encounter (Barrett and Bolt 2010: 34).

At this point in the chapter, the commentary I present on my painting practice could be seen as an exegesis, which I am trying to crystallize and apply in relation to Deleuze and Guattari's ideas about the formation of territory, to see how it is possible to shift a potentially destructive war machine into a creative line of flight, and thus instigate the agency of transformative therapeutics. This involves material thinking, as we have seen, by paying attention to the materials I am using. The process of art-making is amplified over the consequent image made. Indeed, I do not so much create any specific or representative *images* (such as occur during the usual session of art therapy (in the singular, i.e. drawing and painting), or which Carter means to utilize in his notion of material thinking), but I focus on the process of making in itself. I let the materials speak for themselves – they are my collaborators.

In this way my application of material thinking is nuanced, and attunes to the work of Barbara Bolt, who instigates '*materializing practices*' to constitute the relationship between the artist's process and their speculative, discursive response to the emergent work (Barrett and Bolt 2010: 29–30). The interplay between the creative process, the materials' expression (and the artist's own expression) during this process, and the consequent cogitated enquiry is highly important, because it is central to the methodology of Making Sense that forms the purpose and contents of this book. The fuel of the enquiry into Making Sense is art practice, which generates an agency of transformative therapeutics – either for the materials being used, for the artist who uses these materials, or in relation to the situation that sets their usage. The consequent, explanatory commentary to show how and why this happens is a reflexive discourse that enacts the procedure of Making Sense, *per se*. This is important because it

consolidates and disperses the methodology of art practice, by demonstrating its production of transformative therapeutics, which defines how we make sense of the world, and which is applicable to us all.

Following Bolt, to instigate this procedure we must return to 'handling materials in practice'. This develops into a form of 'tacit knowledge' which, by providing 'a very specific way of understanding the world, one that is grounded in material practice', provides the material and engine for making sense (Barrett and Bolt 2010: 29). Here, writing is not just a question of 'mastering the rhetorical game of theorising what artists do', as Carter says, but concerns the articulation of what emerges through the process of handling materials (Carter 2004: xiii).

Bolt talks about the handling and 'handleability' of materials, drawing from Heidegger, to activate a new relation of care and concern that rethinks what is involved in art practice, so that 'the work of art is the particular understanding that is realized through our concernful dealings with the tools and materials of production' (Bolt 2004: 52). Influenced by Heidegger's philosophy of technology, which I will discuss and apply in Chapter 8, Bolt says that the artist needs to create a new relationship with the materials they use during their creative processes. Rather than being subsumed into the modernist (or post-postmodernist) age of an instrumentalist manipulation of technology (and Being), whereby materials are *ab*used according to a capitalist chain of hyper-consumption, in terms of their 'standing reserve' as supply, we need to instigate a new relation (with ourselves, our materials, our peers) in terms of a care-full responsibility:

> In the relation of care that characterizes production, the artist or craftsperson is no longer the sole creator or master of the work of art. Argued from this perspective, artistic practice shows us that the artist's relation with his/her tools is no longer of mastery, nor is it instrumentalist. Rather, the artist is co-responsible for bringing art forward into appearance. Artistic practice involves a particular responsiveness to, or conjunction with, other contributing elements that make up the particular art ensemble. (Bolt 2004: 53)

This new relation of *responsiveness* provides an agency of transformative therapeutics for each player in the 'complex relationship between humans, objects, tools and materials in artistic production', since this application of care and concern turns the creative process into an ecological prudence that can draw out the differentiation, interaction and collaboration between all these different factors (Bolt 2004: 53). This is not set according to a teleological or fixed ruling

of progress or normalcy, whereby each player in material thinking is 'improved' or 'made better' by their creative process. Rather, with sensitive application they are able to express and interact. This expression is what inscribes territory.

To consider how creating an artwork is a territorial gesture, and how the formation (and deformation) of territory is an art, I will now return to the geophilosophy of Deleuze and Guattari, whose war machine we encountered (and in some senses resolved or redistributed) during my creative process. By examining geophilosophy, and thinking further about expression, I hope to develop and deepen this discussion of material thinking, and thereby expose and expand how art practice involves a making sense of territory.

4. Geophilosophy: Territory and expression

With geophilosophy, Deleuze and Guattari lay out a surface plane to consider reality in terms of forces and space, not as it pre-exists, but as fields of relation and space-times of encounter. Using concepts such as de- and reterritorialization, rhizome, stratification, cartography, nomads, milieu, plateaus, smooth and striated space (amongst others), Deleuze and Guattari's geophilosophy inscribes a topology and genealogy of the interacting forces and coordinates that conjugate the refrain of our being-in-the-world. The point of geophilosophy is not a metaphorical use of language that illustrates the nature of reality, but a way of thinking that takes geography as a tool or model of rationality. This brings forward an analysis of our spacing in the world, which interprets the systems of power and micropolitics of the States that define and control it. From this method of thinking, Deleuze and Guattari want to open and reorientate philosophy:

> The concept is not paradigmatic but *syntagmatic*; not projective but *connective*; not hierarchical but *linking*; not referential but *consistent*. That being so, it is inevitable that philosophy, science and art are no longer organized as levels of a single projection and are not even differentiated according to a common matrix but are immediately posited or reconstituted in a respective independence, in a division of labor that gives rise to relationships of connection between them. (Deleuze and Guattari 1994: 91)

In this quotation we can see art and science oriented alongside philosophy. *What Is Philosophy?* sets itself the task of considering *how to think* across these different fields. Deleuze and Guattari say that to think is to experiment, which 'is always that which is in the process of coming about – the new, remarkable, and

interesting that replace the appearance of truth and are more demanding than it is' (Deleuze and Guattari 1994: 111). We can apply this experimental thought process through the material thinking carried out during and as a result of art-making. Carter's work on 'The Ethics of Invention', through the collaborative interchange involved in material thinking, can be seen to develop Deleuze and Guattari's propositions for (experimental) thought, since Carter situates thought in terms of the making process, which 'always issues from, and folds back into a social realm' (Carter in Barrett and Bolt 2010: 19). Here experimentation is 'the testing-ground of new ideas' (Carter in Barrett and Bolt 2010: 19).

In Deleuze and Guattari, thinking and experimentation concern wrestling with chaos and the creation of concepts. They illustrate this with the application of a new concept, the 'plane of immanence', in *What Is Philosophy?* (Deleuze and Guattari 1994: 35–60). Immanence is the raw, nude surface of the real, which is chaos. By creating a plane on the surface of where and how we exist, i.e. reality, then the plane of immanence shows a picture of (material) thinking: 'The plane of immanence is not a concept that is or can be thought but rather the image of thought, the image thought gives itself of what it means to think, to make use of thought, to find one's bearings in thought' (Deleuze and Guattari 1994: 37).

Deleuze and Guattari emphasize the way that the plane of immanence captures a sense of our immediate connection with the world (before it is de- or reterritorialized) by drawing a sieve over this chaos. This is a task for art: 'Art is not chaos but a composition of chaos that yields the vision or sensation [...]. Art struggles with chaos but it does so in order to render it sensory' (Deleuze and Guattari 1994: 204–205).

From immanent sensation Deleuze and Guattari define the artwork, as '*a bloc of sensations, [...] a compound of percepts and affects*' (Deleuze and Guattari 1994: 164, original emphasis). They say that the aim of art, with its material form, is to empower and transfer the percept from a perception of an object (the artwork) into a state in the perceiving subject. Deleuze and Guattari define the essence of painting as to 'paint forces' (Deleuze and Guattari 1994: 182). There is a correlation between the artwork as a physical object with material attributes, in terms of how it exists in the world, its structure, form, positioning and colour, and its existence as a pure being of sensation, relational encounter and interactive forces. The dialogue between sensation and the material is conjugated via *expression*. 'Sensation is no realized in the material without the material passing completely into the sensation, into the percept or affect. All the material becomes expressive. It is the affect that is metallic, crystalline, stony and

so on; and the sensation is not colored but, as Cézanne said, coloring' (Deleuze and Guattari 1994: 166–167).

Thus, the material form of the artwork exists in its capacity to carry affect, either from the artist, during their creative process, or for the viewer, who absorbs and reacts to it. The artwork's sensitive qualities conduct a process of material thinking, when these qualities are given the opportunity to express their differential attributes and kindle affect, during the creative process and each aesthetic encounter. The materials' fabric provides a basis for material thinking through expression, which consists of the stimulus provided by the artwork. The artwork then becomes a *monument* which celebrates and preserves this transformative interaction (Deleuze and Guattari 1994: 167, original emphasis). Here there are two stages of material thinking: the first is the agency of the matter by itself, where there is a process of expression as interaction, i.e. thinking, which takes place during the interplay between different materials that are used to create an artwork. Deleuze and Guattari's philosophy then provides a commentary that installs this agency of materials' thinking, which crystallizes their affect and instigates a proactive approach of furthering it.

From this point of view, the artwork is defined by the forces it provokes, and the materials it is composed of, because of its capacity to *express*. As the modus operandi of the artwork, this faculty of expression is then territorial. Art crafts territory, through expression, or, as Deleuze and Guattari put it, 'what defines the territory is the emergence of matters of expression (qualities)' (Deleuze and Guattari 2004a: 347). This is because art is the doing or activity through which a world comes into place. Each time we make a mark and express a quality, territory is formed. Such territory can be seen as a refrain that terminates and then begins a process. This is a rhythmic vacillation of deterritorialization and reterritorialization in a spiral of becoming.

The formation in becoming of territory is made by the artwork. This is an expressive event. Deleuze and Guattari describe this event in *A Thousand Plateaus*:

> Territorialization is an act of rhythm that has become expressive, or of milieu components that have become qualitative. The marking of a territory is dimensional, but it is not a meter, it is a rhythm. [...] the territorializing factor, must be sought [...] in the becoming-expressive of rhythm or melody, in other words, in the emergence or proper qualities (color, odor, sound, silhouette...).
>
> Can this becoming, this emergence, be called Art? That would make the territory a result of art. The artist: the first person to set out a boundary stone, or to make a mark. (Deleuze and Guattari 2004a: 348)

The painting event is expressive whilst being territorial because it involves making a mark, and its ex-position, which then changes and reterritorializes the distribution of the sensible. Considering art as expression involves territory because the qualities of an artwork constitute the mark that demonstrates an inhabitable domain or abode:

> The expressive is primary in relation to the possessive; expressive qualities, or matters of expression, are necessarily appropriative and constitute a having more profound than being. Not in the sense that these qualities belong to a subject, but in the sense that they delineated a territory that will belong to the subject that carries or produces them. These qualities are signatures, but the signature, the proper name, is not the constituted mark of a subject, but the constituting mark of a domain, an abode. (Deleuze and Guattari 2004a: 349)

Deleuze and Guattari emphasize the materiality of the artwork and the immanence of its sensations as intrinsically territorial because, they argue, 'Perhaps art begins with the animal, at least with the animal that carves out a territory and constructs a house [...] the territory implies the emergence of pure sensory qualities, of sensibilia that cease to be merely functional and become expressive features, making possible a transformation of functions' (Deleuze and Guattari 1994: 183).

In this quote we see the emphasis of the non-human sharing of experience. Territory involves emergent expressive qualities, which is an artistic process, but this does not always (or necessarily) rely on the individual subject who is *expressing* their subjective *feelings*. When Deleuze and Guattari say that expression is territorial, or that territorialization is expressive, and thus an art, they do not necessarily mean to present the hypothesis that an artwork expresses emotions or has some kind of separated or deeper meaning; there is no division between the surface appearance and a depth of meaning in the artwork. It has no transcendent content of expressive meaning but exists as an independent monument, or block of sensations. These sensations are vibrations, which cannot be separated from the material form of the artwork, or the resultant affect that occurs during the aesthetic encounter.

It would be interesting to compare and contrast Deleuze and Guattari's presentation of the artwork as a monument of sensation, which stands between the artist and spectator (and exists as vibrating quanta), and the art therapist's usage of the artwork as a transitional object or scapegoat transference, once again standing in between the therapist and the patient. In both cases, the creative process and the material form of the artwork are important. With all

the arts therapies, the creative process can provide healing, and be cathartic, in itself. This involves material thinking, by engrossing oneself into the materials one is using, whilst the following interpretation with the therapist (although this could be seen to be controversial or inaccurate) then provides an exegesis that consolidates and applies further healing. On the other hand, with Deleuze and Guattari's understanding of the artwork (artist and spectator), there is a focus on a somewhat dehumanized and materialist account of the affective, physical qualities that this artwork consists of. It can still be seen as a transitional object, mediating between the dialogical dichotomies between creator and spectator, and each with this object. However, this object (or the vibrations it endows/ consists of) does not stand in for or *transfer* something. It is what it is, in itself. But it still has the capacity to express, which is a fundamental ground of territory.

As a result, we can see the process of creating an artwork as a geophilosophical agency. We can extend Deleuzian scholar and performance artist Simon O'Sullivan's ideas about *Art Encounters Deleuze and Guattari: Thought Beyond Representation*, where 'art is a form of thought in and of itself' (O'Sullivan 2006: 98). In this book, O'Sullivan experiments with reading Deleuze and Guattari's geophilosophy through an art practice. O'Sullivan describes how the artist Robert Smithson's artworks or 'earthworks' create a new image of thought, which has a function of deterritorialization (O'Sullivan 2006: 111). He writes about Deleuze and Guattari's notion of the plane of immanence as 'the non-philosophical moment of philosophy' and calls to artistic creativity to provide new images of thought for their philosophical enterprise (O'Sullivan 2006: 112). O'Sullivan focuses on Smithson's *Spiral Jettty* (1979) as a work of 'geoaesthetics' to describe these new images of thought (O'Sullivan 2006: 120).

Spiral Jetty is an enormous coil of rocks and mud in the Great Salt Lake, Utah, measuring 1500 metres long and 15 metres wide. Its ecological manoeuvring and sensitive acuity to the physical strata it consists of demonstrate how *Spiral Jetty* commences as a method of thinking with and through the materials it comprises. Smithson has also written an essay about creating this work and the sense made by its construction (Smithson 1996). O'Sullivan interprets the combination of the earthwork itself, and Smithson's reflections on it, as 'a body-brain-earth assemblage' or 'a machine that produces a different experience of the world – a new myth – and thus a different, we might say altered, consciousness' (O'Sullivan 2006: 118–119). From the way that it redistributes geography *Spiral Jetty* is intrinsically territorial, and also a work

of geophilosophy. It also resonates with Carter's understanding of invention, and Deleuze and Guattari on the experimentation of thought (which is also an art). O'Sullivan then neologizes *geoaesthetics* to demonstrate the operative artistic endeavour in this field (O'Sullivan 2006: 120). Smithson's earthwork and writing dialogue is also, clearly, a case of material thinking, whereby he creates an artwork (which is an explicit territorial gesture) and writes a self-reflexive commentary to *materialize* this aesthetic practice.

So with Smithson, via O'Sullivan, we reach an interface between geophilosophy and material thinking, via *geoaesthetics*. This term has been defined by Toni Eerola, to describe 'aesthetics produced by natural geological processes, such as rocks, or by man, when he uses geological elements or concepts to produce art' (Eerola 2008). But the kind of artwork that pertains to geoaesthetics, or conducts material thinking (with or without a consequent written commentary), is not restricted to earthworks like *Spiral Jetty*. I will now describe the artistic practice of the Australian landscape painter Caroline Rannersberger, whose complex paintings bring forward a sense of earth becoming territory and thus fulfil a geophilosophical or geoaesthetic perspective. Attending to Rannersberger's aesthetic will advance our application of material thinking because of the ways that her artworks help us think about territory.

5. Exegesis two: Caroline Rannersberger

This section will attend to the ways that Rannersberger's works are geophilosophical, which demonstrates how art informs us about territory. I will describe two paintings by Rannersberger and her process of creation in a way that is immediately geophilosophical, whilst demonstrating the creative transformation involved in the artwork, which can realign a war machine into a creative line of flight. My commentary in this section is the second exegesis of art practice presented in this chapter (the first was my self-reflexive narrative about my own painting process). As a result, the chapter demonstrates an application and harnessing of material thinking, in itself. It does this by approaching and making sense of the elements of – in this case, Caroline Rannersberger's – artistic practice, to crystallize how this informs us about territory and the ways that we inhabit the world.

First it is important to emphasize how much Rannersberger's works immediately attune to Deleuze and Guattari's writings about the art of land

becoming territory. This is apparent from the way that they express an intimate sense of the territorial process, and because they are made specifically in response to the sensations that her local territory and its climate provoke. Rannersberger describes her artistic process in terms of its setting in her native homeland – the 'tropical savannahs' of the Northern Territory in Australia.[2] Her process is geophilosophical because it has the intention of inhabiting and making sense of this territory, and so the action of painting becomes a process of de- and reterritorialization, whilst she uses her painting materials to withdraw and conjure a sense of its landscape.

The territorialization involved in Rannersberger's practice, and its geophilosophical agency, echoes Bolt's notion of materializing practice, since Rannersberger's collaboration with her materials and her immersion into the atmospheric, tectonic fabric of the climate clearly approximate Bolt's emphasis on the agency of materials and the process, event and performance which produce tacit knowledge that is situated in a particular context in the world. For Rannersberger the creative process is a performance in the landscape and on the canvas, which supplies a method of thinking that supersedes any fixed telos of the final image. Here we see her work attuning to a method of material thinking (and her materials' thinking) that corresponds with Bolt rather than Carter's elaboration of this process. Bolt's work as an artist also resonates with Rannersberger since she describes an instance of her own painting practice offering a making sense of landscape (Barratt and Bolt 2010). Both Bolt and Rannersberger are Australian artists painting the territorialization of Australian landscape. Bolt describes her process of 'rendering this complex landscape in paint', arguing that it delivers what she calls a 'praxical knowledge' from 'a performative understanding of art' (Barratt and Bolt 2010: 31–34). Following a similar methodology, this chapter means to demonstrate how the process of creation provides an epistemological agent that offers direction in response to Deleuzian ideas.

Rannersberger's work is composed of series of panels that build a sense of the landscape from painting the texture, rhythms and intensities of forces that emerge from the climate and land around her. Her works bring forward a graphic sense of the landscape's definitive energies and assemblages: cyclonic winds, crashing waves and the palpable swamps of drifting land fragments and mangroves, as living mass that shifts and changes form, or assemblages which are never stuck or static but always-becoming masses that reach between land and water.

One of her works, *The Fold*, is a landscape made from six panels presenting the different layers of a horizon. This piece represents the way

that Rannersberger is affected by the landscape of Australia. She describes an impression that she had whilst making this piece: 'I had a strong sense of near imperceptible difference repeating itself over and over again, and of country shifting slightly with each new becoming, which I have suggested through the use of repeated panels'. The same circular rhythm is repeated throughout the six panels, marked by white gestural lines that penetrate into the earth and its organic land matter, drift into clouds and brush across distant mountain tops and the different layers that compose a landscape lineated and subdivided nearly into six rectangular panel pieces. The boundaries in this piece are firmly set and the piece is tightly contained in its subdivision of six panel pieces. But inside these sections ferments a tidal rhythm and whirlwind of energy that is always becoming, interwoven through the set parameters that ground and contain this painting. The earth and its tormenting natural rhythms expose a dynamic territory in the process of shifting with the transient forces of the weather. Ripples in the clouds, waves and the soil compliment a pivoting pattern which is repeated and turns around in its repetition throughout the sections of the piece. The same circular rhythm is folded through the air, land and water to crystallize a fragmentary sense of the hot and dramatic energy that defines the climactic sense that Rannersberger is responding to here (Figure 5.1).

Her palette is somewhat muted or soft, with pastel colours that are remindful of old photographs or discoloured, faded prints. This is a contrast to the energy that is the life of this piece, which then imbues a sense of mystery to the composition, with the different layers that make up the life of this landscape. The title is a direct reference to Deleuze's *The Fold*. This is appropriate since 'the fold' can be taken to present a geophilosophical agency. It is a concept which involves the action of folding the thought of difference with itself.

Deleuze's writing on the fold presents diagrams of our subjectivity, where to 'have' is to fold that which is outside inside and to 'be' is to be continually becoming-different or developing, changing and folding different layers of subjectivity. Deleuze describes this as an exteriorization of the outside, a folding or redoubling of the Other, which generates a repetition of the Different. The dynamic of the fold is like an eternal return of difference. As Deleuze writes about Nietzsche, it is not the same that returns, it is the returning – or becoming – that is the same: 'It is not some one thing which returns but rather returning itself is the one thing which is affirmed of diversity or multiplicity' (Deleuze 1983: 48).

Figure 5.1 Caroline Rannersberger, *The fold 6 panel* 2009; oil and encaustic on solid African mahogany; 116cm × 38cm.

The motion of returning or becoming is like a fold. This folding of difference as repetition is an oscillation of becoming that recalls the rhythmic movement of de- and reterritorialization in geophilosophy, and also Paul Carter's understanding of material thinking as the dismembering and remembering involved in collaboration and the creative process. All three cases, the fold, territorialization and material thinking, present geophilosophical thought that has dimensions and motion. It is appropriate to use these ideas to describe Rannersberger's art because the repeating rhythm and surging energy in her paintings enact this substantial, mobile enterprise for thought.

Each rectangular panel of the painting provides a ground for the transversal extensions that it opens upon their horizon. The repeated panel becomes a stylistic motif seen throughout Rannersberger's œuvre and compliments the idiosyncrasies of her facture. It opens what Deleuze would call a refrain to ground and open the territoriality and intensity of these works. We can think of the refrain as the repeating pattern of nature becoming art, or art becoming nature, until it is installed and becomes second nature. This happens when we sing a song together and repeat the chorus or refrain after each verse – repeating it until we know the chorus and it creeps under the skin and inhabits the territory of the mind as a memory. The panels in Rannersberger's *The Fold* open the possibility for this kind of territory-in-becoming.

Deleuze and Guattari write about the refrain in terms of its expression and territorialization: 'The refrain is rhythm and melody that have become territorialized because they have become expressive – and have become expressive because they are territorializing' (Deleuze and Guattari 2004a: 349). Deleuze and Guattari talk about birdsong and say that the bird's song has a territorial function, as 'an act of rhythm that has become expressive' (Deleuze and Guattari 2004a: 348). The bird sings in order to mark its territory. What defines or marks territory is the emergence of matters for expression (Deleuze and Guattari 2004a: 347). It is *expression* which territorializes.

This link between the refrain and territoriality, through expression, is utilized by philosopher/artist Erin Manning, in her proposed art/theory practice of 'Research-Creation' (which, to some extent, is an application of material thinking or materializing practice). Manning describes how and why creating an artwork involves territory: 'The refrain is rhythm and melody actively recomposing into a territoriality that becomes a work, a gesticulation, an iteration. It is territorial because it is expressive' (Manning 2008).

Rannersberger also writes about the refrain, and how it fits within her artistic praxis of making sense of the landscape and climate of Australia. She says of the refrain:

> [...] this perhaps becomes tangible in my thought and as an image when I wake up in the morning to waves of birdsong which come from the direction of the rising sun. The higher the sun, the louder the birdsong. I often imagine the sounds spreading and unfolding across country across the Timor Sea into Indonesia and beyond. It is like a visible wave of sound as the earth spins and song and time travel with the rhythmic dawning of first light.

Here Rannersberger brings forth a sense of the raw climate, the heat and forces of her country, which ooze plump data for her senses. The artist laps up these sensations and revolves them into the dynamic gestures that are held by her paintings. She describes the painting event as it takes place *en plein air*:

> During the painting event I felt engulfed by the humidity. There was no longer any tripartite division between me as the painter, the painting and the painted, the country. Worlds and existence itself seemed to merge like the warped continuum of a mobius strip circle, heaving under the force of humidity and atmospheric pressure. [...] I sought to [...] render the sense of country palpable. (Rannersberger 2011: 6)

In the context of Rannersberger's paintings, it is important to realize that in Australia 'country' has a particular meaning, which refers to the influence of Aboriginal inhabitants in relation to Colonial settlers. Country and territory are potentially different or even oppositional notions, since country does not evoke a single space but speaks instead of the Aboriginal practice of 'dreaming' in a topological landscape that is always in transition, and constantly being reformed (like a work of art). We see this processual quality felt in Rannersberger's description of her practice. Her description of it then provides a self-reflexive commentary, which inscribes and applies her practice as a method of material thinking. As a result, we can then begin to consider the discursive, cultural and socio-political situation of Rannersberger's work. The setting in the Australian outback is significant. Bolt and Carter, with their respective nuances of material thinking, also work in this backdrop, in relation to the 'mythopoetic inventions' of 'colonizing white settler societies' (Carter 2004: xii).

For Rannersberger, her art practice is first and foremost a process of working with the materials in the climate and landscape that surround her. It is in this way territorial, but before that an ecstatic immersion into the atmosphere

and heat (where ecstatic is most definitely a bodily experience, felt inside Rannersberger, rather than the out-of-body experience that Stephen Newton described in Chapter 1). 'The only way I can paint clouds', she says

> is to feel them flow through me: To lean into the direction of the wind and to sense a lifting, or a dampening pressure from the humidity and the atmosphere itself. [...] Such degrees of different qualities invariably shift between subject and object, where affect is caught up with effect and the painting can be both subjective and objective at the same time.

What is particularly interesting for the paintings of Caroline Rannersberger is the way that the division between the viewer and the artwork is dissolved in the immanence of sensation. This is a bodily experience. Deleuze's *Logic of Sensation* presents this argument, using the contorted, agonized figures of Francis Bacon (Deleuze 2003). Deleuze says that Bacon's figures break through their figurative boundaries when they cause and become sensations in the viewer's mind. This provides a logic that similarly breaks up the binary dichotomy posed between the subject looking and the object looked at – the self and artwork. Rannersberger describes a similar process occurring during the painting event, where the division amongst herself, what she is painting and the materials she is using dissolves into the continuum of sensation that inspires the work. To some extent this dissolution echoes the sense of communion we saw in Chapter 1.

This sensory melting of division and territorialization is seen in another of Rannersberger's paintings – *Parallel Worlds* (2008). Rannersberger draws upon Deleuze's notion of 'aparallel evolution' here, to describe the landscape of *Parallel Worlds*: 'Between these parallel worlds, I also sense a kind of fusion of parallel incarnations: physical and incorporeal/metaphysical and transcendental [...]. This fusion involves a process of dissolution, where rhizomatic shoots form new becomings'. Here Rannersberger is talking about the eternal return of difference that defines the way the world is never static but always becoming and growing, which is particularly apparent in the tumultuous harsh climate in Australia. Rannersberger says that this work was made specifically in response to the cycles of weather and the oscillating movement of country becoming territory (and back again) in the Northern Territory of Australia. This is a rhythm of de- and reterritorialization, which again echoes the vacillation of de- and re-constitution and dis- and re-membering that is involved in Carter's understanding of material thinking (Figure 5.2).

Figure 5.2 Caroline Rannersberger, *Parallel worlds*, 2008; oil on BFK Rives paper; 240cm × 240cm, 6 panels, each 120cm × 80cm.

There is a quasi-romantic cool serenity to the wetness and also an arid parchment to the simultaneous dryness of the six panels that compose this painting. Different layers of beeswax, pigment, print and paint conjugate the composition. Curly archaic handwriting printed from the nineteenth-century German scientist and explorer Ludwig Leichhardt is screen-printed upon it, and it sprawls across the 30 landscape and skyscape that express the deep heat of the bush – or the Australian outback – that is presented by this work.

Leichhardt's curvilinear handwriting ornaments *Parallel Worlds*, which then provides an ode to the beauty and the discovery of landscape, whilst also bringing forward a dirge to its inherent beating pressure and the punitive trespass of colonial invasion. The panels are fragmentary assemblages. The writing is barely illegible but beautiful. The shadows seem forlorn and to echo Rannersberger's series of works on *Despair*, and there is an aura of melancholia that dominates the harsh heat and its elegant beauty shown throughout her œuvre.

The fragments from Leichhardt's journals are prominent in this work, and they feature in paintings throughout Rannersberger's œuvre. These journals refer to Leichhardt's colonial exploration of indigenous territory, and the explorer's wanderings across the landscape of the Northern Territory.[3] This portrayal of the colonial landscape is a theme that reoccurs in Rannersberger's paintings.

It provides another link with Bolt and Carter, who also utilize their differing accounts of material thinking to think about colonialism in Australia.

In *Parallel Worlds*, the colonial discovery (or invasion) of indigenous territory is presented from the contemporary perspective of Rannersberger's own European heritage and her habitation of the Northern Territory. Such an assemblage of territory and identity elements is presented with a melancholic aura, because of the subdued palette, which is grounded in the emphatic and unrelenting pressure of the landscape. Rannersberger wishes to demonstrate the 'futility of invasion and the transience of settlement' for the colonial in this extreme landscape (Rothwell 2008).

Leichhardt's journals describe the trials and tribulations that arise in his discovering of strange lands and unknown indigenous people in Australia. Their place in Rannersberger's work demonstrates a replaying of these colonial discoveries, set in relation to the continuous pressure and forces of the territory they invade. As such, Rannersberger's painting subverts or counter-actualizes this colonial invasion, by emphasizing the unrelenting forces of the landscape, and the ongoing process of territory-in-becoming. This painting thus demonstrates the two poles that a war machine has in relation to territorialization, the line of destruction and the line of flight, and the agency of transformative therapeutics, which is possible through art. By folding colonial elements into this painting Rannersberger shifts the war machine of colonial invasion into a creative line of flight.

Rannersberger uses autobiographical material to influence her work and invoke a position that brings into play this colonial history, which can then be shifted and counter-actualized. Her family is German and Polish, rather than Australian, and the influence of Central Europe is apparent in the way that she draws from Leichhardt, and also Albrecht Dürer and Hans Jakob Christoffel Grimmelshausen in her paintings. On one level Rannersberger is relating to Leichhardt as a first-generation Australian living around or alongside indigenous culture, on another level she is confronting and counter-actualizing the colonial invasion by drawing out the unremitting climate and unconquerable, vast landscape of the Northern Territory. As Nicolas Rothwell says, Rannersberger's landscapes can 'be read as a subversion of the colonial invasion' (Rothwell 2008).

This is another way of showing how art can provide transformative therapeutics. In Rannersberger's art, such agency is applied in relation to transforming the situation of her own life and the political, cultural and historical setting of her work. At the same time, Rannersberger is clearly

taking great care for her materials, which are so sensitively and intuitively applied on the surface of her delicate, but intense and powerful paintings. We can see a responsive handleability in Rannersberger's process that draws out the materials' agency so that her works then have the capacity to affect and provoke. She is interacting with these materials in relation to the conflictive socio-political landscape that sets the scene of her perceptions and reflections in the outback of Australia. There is clearly a process of material thinking that goes on here, which can be read from my interpretation of Rannersberger's paintings, and from their geophilosophical application. The paintings in themselves also activate a *materializing practice* in their instigation of transformative therapeutics and the shifting motor from a war machine to a creative line of flight.

6. Conclusion

This exegesis of Rannersberger thus conducts a material thinking that intends to determine the insight that I have gained from my investigation into Rannersberger's creative process and her beautiful paintings. Both her process and her paintings are territorial advances that bring form to Deleuze and Guattari's ideas about territory and geophilosophy. We also see the shift from a war machine to a creative line of flight, which is the transformative therapeutics that defines the nuance of material thinking posed by this book.

My collaboration and series of interviews with Rannersberger drew out her own self-reflexive commentary on her work, which is based on her collaboration with the different materials she uses and, in particular, the tempestuous qualities that are so uncontainable in the landscape and climate that feed into her art. This collaboration with materials also played a central part in my own painting practice. I also responded to the turbulent climate, as it was raised by the interacting mediums I was using. These mediums (berries, glue, water, oil, paint) co-operated and clashed on the landscape of the surface in my sketchpad. In both cases, with Rannersberger's practice and my own, there is a shifting from a war machine to a creative line of flight. This provides the agency of transformative therapeutics, in relation to opposing qualities finding a way to co-inhabit space (in the case of my paintings), and in relation to subverting or counter-actualizing elements of colonialism (with Rannersberger's paintings). This agency is forthcoming through the handleability of the fabrics utilized. There is agency in the matter, which brings a sense of tacit knowledge about

interaction, expression and (thus) the becoming-of-territory, during and as a result of *materializing art practice.*

This tacit knowledge is a territorial gesture of mark-making that revolves around a process of material thinking. We have seen two different stages to material thinking in this chapter. The first is during the interaction and manipulation of materials – whether ethical and constructive, or destructive (dis/re-membering, de/re-constitution, de/re-territorialization). This is a process, practice or performance that brings into play the agency of matter and has an objective dynamism, obtained through the handleability of matter. As we have seen, Carter focuses on utilizing the image made as a result of this process, whilst Bolt stays with the proactive procedure of making in itself. Although both interpretations of material thinking are useful, my own painting practice and Caroline Rannersberger's reap from the process before the image. We have seen this because we have applied this process to the second stage of material thinking (as it has been activated in this chapter). This is the commentary and exegesis of the first stage, as a development and harnessing of the rewards and gains provided by the creative process or the consequent image (or non-image, expression of qualities) that has been made.

The question of whether we can obtain an emergent sense about territory or the world we inhabit, without the second stage of material thinking, is hard to define without written commentary. Any effort to define the gains that can be made by art practice by itself (without words), but by using words, is perhaps self-contradictory. However, as Bolt says, 'The Magic is in Handling' (Barrett and Bolt 2010: 27–34). Knowledge, insight and the formation of territory arise during the handling and interaction of different materials when we create an artwork. Words might possibly be used to describe or narrate what happens during the creative process, when the materials have voices of their own. These material voices express and reveal much about their differentiation, qualities and the situation of their encounter (without words), through the artist's guiding hands. The result is, as we have seen, the potential for accessing transformative therapeutics and a making sense of the world.

Making Political Sense:
Vera Frenkel's *String Games*

In this chapter *making political sense* means to form a conception or comprehension about the conditions of our collective life, judged from a sensory engagement with it. The purpose of this investigation is to consider, grasp and then apply the emancipatory, and thus transformative, therapeutic agency that is opened by the political sense of art practice. To make his argument I engage with Canadian artist Vera Frenkel, and her 1974 performance-installation *String Games: Improvisations for Inter-City Video*. Frenkel's creative process and the performance of this artwork will help us think about how an artwork, and thinking with this artwork, is a political venture. Politics is immediately important to the central thesis of Making Sense outlined in this book because it concerns the conditions, constitution, administration and distribution of how and where we inhabit the world, whilst it then concerns whether or how we can transform and make sense of this world.

To develop this argument, I will use insight gained from engaging with Frenkel's performative artwork to open and develop Jacques Rancière's thesis about how aesthetics is political, and in particular his notion of the 'partage du sensible'. I use this notion, commonly translated as the 'distribution of the sensible', to think about what is fundamentally at stake in Frenkel's art performance, seeing its political sense as a sharing of the sensible and in terms of its technics – the technology of the game and of the inter-city video facility. Through Frenkel's work, technics adds a new dimension to Rancière's political aesthetics. The point of this theoretical exegesis is to find a method and way of thinking that helps us understand and extend the emancipatory potential and power that can be gained from the political sense of Frenkel's work. This chapter is an exercise of philosophy, or critical theory, rather than analytical art psychotherapy, since I am examining the political effect that an artwork has *in the world*, rather than its diagnostic or healing relation to the individual psyche.

From its theoretical emphasis, the chapter develops into a further exposition of the agency of transformative therapeutics made available by art practice by returning to a different sense of 'partage' from Rancière's use of this term, using Jean-Luc Nancy. Nancy helps build a sense of the intimate sharing, spacing and distance, and the *poiêtic technê* distributed by *String Games*. By developing an understanding of 'partage' through the distribution, *technê*, and then the sharing of the sensible, I show how an artwork can deliver its political sense, as a transformative therapeutics that poses itself as a method of actualizing freedom. Synonyms of freedom, emancipation and liberty are utilized throughout this chapter. I define freedom as the sharing and expression of the sensible coordinates of the world and of voices that respond to this world; the technology and autonomy of play; and the possibility for a holistic community of sense. All these factors are obtained through art practice – in this chapter, playing *String Games: Improvisations for Inter-City Video.* By demonstrating how this is possible, my interpretation of freedom (emancipation, or liberty) develops the ongoing notion of transformative therapeutics and adds to the ways art helps us make sense of the world.

In the following chapter I will first define political sense, consider how it relates to and can possibly supply the agency of transformative therapeutics, and second introduce Frenkel and describe this work in some detail. I shall then lay out Rancière's thesis of the distribution of the sensible, and think through Rancière's defining of aesthetics as politics, by drawing it through the technology, game-play and language provided by *String Games*. As a consequence, I hope to open and develop Rancière's notion by attuning to the political sense made through the *technê* of Frenkel's work. This theoretical focus on technology returns to Jean-Luc Nancy, through a phenomenological dimension, and via the political sense of Erin Manning. This then enables me to compare Nancy and Rancière's thinking of sense as 'partage', evaluating which of these senses can help us think about what is fundamental to Frenkel's performance-installation. Drawing from 'partage' and then defining any consequent politics as a *sharing*, rather than a somewhat militant cut-and-paste distribution, of the sensible, will bring out a sense of how and why playing *String Games*, and the performance of this artwork, provides its agency of transformative therapeutics.

1. Defining political sense

Before we begin it is important to define how an artwork might make political sense. As we will see, in *The Distribution of the Sensible* Rancière argues that an

artwork can evoke political sense by the way it frames and ex-poses a specific space-time sensorium that is autonomous from, but can react to and provoke, the conditions of our communal living space (Rancière 2004: 12–14). We can consider how Rancière's notion fits into our central project of Making Sense when he says that: 'A distribution of the sensible is a matrix that defines a set of relations between sense and sense: that is, between a form of sensory experience and an interpretation which makes sense of it' (Rancière 2009b: 275). In this way the distribution of the sensible is a political process that has two stages. The first stage is the formation and material content of a sensory experience and the second is the consequent interpretation of this experience. Examining both of these stages, by thinking about how an artwork reorganizes the ground plan of sensory experience, and reflecting on the resulting effect that this experience produces, will develop a political sense that helps us build the agency of transformative therapeutics thence provided by the artwork.

In this chapter I define 'political sense' as a way of thinking about, and effecting: how we live in a community (our communal, and personal or private, living space), the conditions of our collective life (who determines the constitution of this space), the relationship between individuals and society (our basic rights and citizenship), and the relationship between society and the world (the territorialization of natural resources). Politics concerns the segmentation and divisions of communal living space, and how we inhabit the world within (or on the periphery of) these communal living spaces. Our habitation and constitution in the world involves the factors of terrain, boundary, identity and communication. These matters are equally aesthetic as they are political.

When we think about how we can make sense of the world by engaging with art, or by creating an artwork, this sensible, sensitive and sensuous undertaking also refers to the way that art offers a method of *being* in this communal living space, in terms of sharing it with others and forming a sense of community therein. This facility has political implications and connotations. Art opens a political space since each work is constituted by the expression, or *parole*, of its maker, which is offered as an interface for opinion – dissensus or agreement – to those who encounter and react to it. Making art, and making sense through this collaborative experience, opens a space to express our place in the world and our reaction to it. By offering this expressive space and activity, the artwork then produces its agency of transformative therapeutics, since it enables and empowers a possibility for individuals to discover and become their differing identities, whilst building a rapport with others and the world in which we live together. This involves the factors of politics, communication and language.

From making sense of an artwork, and those sensations obtained whilst making it, the artwork *offers a way of thinking about the world – and engaging with it – that can open this world in a creative manner.* We can make a new sense of space, and then go and live differently in this space. Here we can see both parts of Carter's material thinking (which was outlined in Chapter 5): first the initial and immediate sensory affect that is received from an artwork, during and as a result of art practice, has the potential to create a long-standing and political or ethical effect. This effect is crystallized and installed during the consequent, contemplative, sense-making process, which deepens and materializes the practice so it can have long-standing influence on the world at large. In this chapter I will show how this influence is a *political* sense. As we shall see, here lies the power of art.

2. Vera Frenkel

Vera Frenkel is a Canadian artist known for the ways that her interdisciplinary works present a raw and critically political sense of the consumerist, capitalist and technological zeitgeist that defines contemporary life. Frenkel is, as art historian Griselda Pollock states it, a 'sardonic storyteller, major social commentator and ethnographical analyst, who presents a metacritical perspective on technological practice and domestic consumption'.[1]

Working in many different mediums, disciplines and formats – video, installation, performance, the internet, photography and continued fragments of critical and fictional writing – Frenkel creates an art that situates, diagnoses and confronts the truth (or the layers of fictive simulacra that pertain as truth) of our time.[2] Whilst the finished works expose for the viewer timely socio-political issues of migration and deracination, the construction of meaning, truth, cultural memory and history, and the oppressive power of state bureaucracy, Frenkel's process of making them revolves around the basic need to find out how to have a home, identity and profession – *how to live* – in this world that is, she says, 'getting darker and darker'.[3]

Complex and multifaceted, since these works seem to express the transience and uncertainty that defines the present, there is always the danger that they too will also pass with time (or *as* time), their insight being too dangerously revealing and *true* to be recorded by history. Also, their constitutive 'open structure', based on the web or in mediums that 'migrate' and change form (with the ongoing ethos of her practice), as Frenkel says, 'it all might disappear [...] the greatest uncertainty is whether the work survives or in what form' (Langill 2006).[4]

What can survive (or what we can retain) is the ethical and political *sense* that Frenkel makes with these works. This sense is multiple, elastic, in transmission, continually evolving and can be gained from fragments of sensory insight that emerge from Frenkel's interacting video channels, websites, images or texts. These fragments form a collage that provides a sensuous scaffolding for the viewer, who becomes a participant upon sensing, entering, reflecting upon and making sense from Frenkel's work. Upon this scaffolding, when engaging with Frenkel's work, we encounter both a world diagnosed in terms of its conflict, migration and oppression, and a platform upon which we can consider the ways that we can live here.

Frenkel's creative process of making art raises questions about the world in such a way that it provides her with the *technê* – or skill – to live in spite of the difficulties, which she exposes, and which affect her in daily life. Her art is at once 'diagnostic' and an 'axiom of citizenship', explicitly political, confrontational and activist (Frenkel 2001: 36). These factors develop the agency of transformative therapeutics in the ways that Frenkel's art provides her with a voice with which she can react to, express and retaliate the problems encountered, and the lies that are told, from those who create history and control what we can experience within and make of the world.

3. String games: Improvisations for inter-city video[5]

This work was a performance-installation that took place in 1974. It involved playing a game of cat's cradle between ten people across two cities using inter-city video. To a certain extent the event of this work and its consequent exhibition have been insufficiently recorded in art historical or critical scholarship.[6] I first heard of it on a visit to the artist's studio, where I was struck by a large wall hanging in the bathroom. This was composed of three sections of black paper, with Frenkel's writing chalked across it, and some photographs of trees. I stared at it intermittently for hours, first because it took me a while to work out what it said, since each sentence began in one section and then jumped over to the next section, and then because I was so impressed by the power and sense of these words (for clarity's sake, here transcribed into one section):

> With every act of perception being a selection, the responsibility of wishing this on others without also revealing to the extent one can show how the act was arrived at seems arrogant, and perhaps, if all human interaction can indeed be described as in some sense political – an aggressive act. Those works of art in

which a feedback system or eco-logical cycle is evident seem to me the most giving, evocative, renewing, and the ongoing harbourers of human dignity.

The artist as perceiver is as bound as other humans – not perhaps in the aspects of perceptions and revelation themselves, for that is the artist's work – but in the sharing of a common jeopardy, a common yearning and blindness. It is essential to acknowledge this. To be the blind leading the blind may be foolish but honest. To claim to see – and for others – is misleading.

So-called Philistine rage is Frightening, but rage at art is no surprise. Rage must occur when one is either deceived or revealed as helpless. The heroics are over. Must be over. The pain of acknowledging this is not the only pain there is to face, but it is one which plagues art, artists and viewers more immediately than other confrontations required of them.

Where will the hero artists/artists as heroes go? Where will the denying diversion-seeking 'appreciators' go? Well; they'll sur-vive. They always do, just as beauty survives has of soul and still remains seductive.

The rest of us, trying to deal with our Broken faiths and stubborn illusions just continue trying to share This process, becoming witnesses, instruments, trying to expect nothing.

This wall hanging was a fragment produced by Frenkel during the final exhibition of the work, at Galerie Espace 5 in Montreal. Enamoured by the complexity, expanse and playfulness of this performance-installation, as I investigated how in fact it worked, its *political sense* became increasingly striking. Its politics was apparent in terms of the sharing of the sensible, the invention (and articulation) of meaning involved during the improvisations of the work's performance and also from its technics – the technology of the game and of the inter-city video facility.

It was created in 1974, a time when the latest innovative technological gadget was a 'teleconferencing' facility that made it possible to video and transmit discussions between people in different locations. This facility was being developed by the corporation Bell Canada, from their new 'Teleconferencing Studios' in Montreal and Toronto. Frenkel heard about this technological innovation and, upon investigating the facility located in her home city of Toronto, was immediately inspired by the layout of the studio, which consisted of five seats, facing cameras, fixed around a semi-circular console table. The studio seemed to Frenkel to be shaped like a hand, with five fingers and a wrist.

From this 'manual' intuition, the artist had the idea that she could use the technology of the teleconferencing facility as though it were a hand, to play a game of 'cat's cradle'.[7] She thought that 'I can put a hand in each city and we can play *Le berceau* (or "cat's cradle"), as a matrix for performance, and in that way I

can connect [...] two cities, and then we can replay both sides of this exchange in the gallery' (Langill 2006 n. 2).

Frenkel said that she wanted to utilize the 'shared tactile experience' and cross-cultural transmission offered by the string game, and play a *non*-string version of it, using the technological transmission provided by inter-city video. Video would enable the intimate and tactile contact offered by hands and string to be extended and mutated. The intertwining between cutting-edge technology and ancient, primal game kept the eight figures of cat's cradle as a constant point of reference and ground, as Frenkel says: 'The live simultaneous transmission used as armature or choreographic structuring principle the eight figures of the classic cat's cradle string game' (Frenkel 1998: 2–14). From this framework, Frenkel could create a performance-installation which was, she said, 'located at a nexus between cultural formats; a very old, nearly universal one, the string game, was re-enacted and transformed via a newly developed one, video transmission'.

The piece was created with the collaboration of nine participants, and took the form of three sessions of transmission and playback at Bell Canada's two teleconferencing studios in Montreal and Toronto. After three separate events of 'playing the game', and its transmission, the consequent footage of this, which amounted to nine hours of videotape, was exhibited, unedited, in an exhibition at Montreal. There was a second, edited version of the work exhibited in 2005, in Toronto, and a third, edited version of the work exhibited in Ontario in 2011. These later showings of *String Games* demonstrate its critical importance: 'Widely acknowledged as an anchor work in Frenkel's oeuvre, it marks a bold turning point in the history of art in Canada'.[8]

Video enabled Frenkel to transcribe a game usually played between two immediately proximate people to cross between ten people and two cities Figure 6.1. Each person played the part of a different finger, together making up two hands, one in either city, whilst the technology of inter-city video provided an analogue for the loop of string that connected the two hands, and two cities, together. From ten people, the non-string version of the game evoked ten fingers, thus two hands or one person, whilst the game with string requires two people. Asked about this, Frenkel replied:

> Cat's cradle is indeed played by two people with four hands. Had we had access to four teleconferencing studios, I might have designed the work differently, and created two sets of improvisations. However, at that stage of the technology, co-ordinating the 'dance' of the formation of the string figures would have required developing a set of cues between the two pairs of studios.

What I created instead was a set of improvisations based on a distilled choreographic matrix using both achieved string figures and their positions, and on the plotted movements between one figure and the next as sources for the interaction between the two cities.

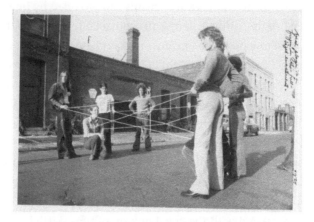

Figure 6.1 Vera Frenkel, *String Games*, street rehearsals for video transmission, Toronto 1974.

To prepare for playing the game by video, participants played cat's cradle with their hands, to learn how to form the sequence of eight different figures with string. Next, they took this to a larger scale and played *Street Games*, with 50 yards of rope, and made the same sequence of figures on the large-scale version. Now, each player's body took the position of a finger, and they completed the different figures by moving their bodies in the same direction, and to create the same pattern, as their respective finger would do on a hand playing the same string games. After these *digital* and *figural* variants of string games, participants were ready to play the *technological* version that provided the medium for Frenkel's artwork.

In the final version, participants replaced these physical movements with their own particular variants of nine different categories set by Frenkel. These categories were: a number, a word, a name, a sentence, a fragment of a poem, a visual image, a gesture and a sound. Each participant chose their own particular number, letter, name, sentence, etc., and in doing so they formed their own language, which they then used to evoke and re-enact the familiar eight figures of cat's cradle. The universal, timeless game of cat's cradle was in this way personalized, and participants formed their improvised reinterpretation of the moves and figures of the string game by performing their number, gesture, sound (etc.) in front of the camera.

The eight patterns in cat's cradle were 'mapped' to give the positions that each finger held to form each figure, and the order that the fingers had to move to make them. This mapping made a 'plan version', or notation of the pattern of the string figures, as seen from above. The movement of making these patterns, and transforming the figures, was also mapped, according to what movements the two hands (and each finger) had to do to create the next figure in the sequence of eight. This mapping provided the notation of the movement *between* figures.

Thus the eight string figures were notated into diagrammatic format to indicate *which fingers were active*, and the order in which they moved the string, to form the subsequent figure. From these maps/diagrams of the string version of the game, the participants could see where and when their own finger, which they were playing as, had to move to form a certain figure. These moments of digital activity were re-enacted by the players' improvisations of components from the eight different categories that were set by Frenkel.

During transmission, Frenkel would name the particular string figure that should be formed (number one to eight), the category (or combination of categories) from which those participants whose fingers were used to create this figure should perform their own variant, to convey the pattern of this figure, and the movement sequence that was required to form it with string. A diagram of the respective string figure was produced along with the spoken instructions, and then the players commenced their improvisation.

So the ten participants, including Frenkel (she was the ring finger on the Montreal hand), would be sitting down in five seats, behind five cameras, in either city. These cameras and seats were fixed, and placed around a semi-circular main table-console, which showed the image that was being transmitted to the other city. Frenkel would state, for instance, 'one, gesture' and those fingers who had to move to form the first string figure – 'The Cradle' – would stand up, and perform their respective versions of this component, gesture, according to the order and positions that would make up the figure when playing the game with hands and string. The order in which each finger had to move, and its positioning within this movement, was choreographed in the diagrams that were displayed whilst the instructions of which figure and component should be formed were given.

Playing the game in this way produced an infinitely complex dance, which was continually developing and changing form, from the expression and interaction of each participant's different language, and the different components and versions of the game.

There were three modes of play: in the 'plan version', players conveyed the pattern of the string figure; in the 'movement version', players re-enacted the sequence required to form this figure from the previous one; in the 'space version' either the plan or movement versions were carried out, but this time in 'real space'. Players turned away from the fixed cameras in front of them, and towards the actual direction of the other hand in the other city. So now, in 'real space', they were in fact facing each other, 350 miles apart, but they could no longer see each other since this escaped the cameras' span.

The exhibition of this work was reviewed in *The Montreal Daily Star* by Henry Lehman. His account of encountering this work, and making sense of it, helps us imagine what actually happened:

> [...] The moves were then translated into a personal language – each of the nine participants chose a number, word, name, gesture, sound which he would pronounce when the artist called out the string figure and the component to be used.
>
> The images emanating from the monitors at Espace 5 show the participants in the Bell Canada studios responding, waving, grunting, snoring, shouting. Though these images have nothing of the painterly, they do share an important element with recent electronic abstractions by Chartier and Jean-Pierre Boyer – they express, as does music, felt time. The participants who watched electronic images of themselves were part of a temporal experience.
>
> Like video pieces by Frank Gillete or Keith Sonnier, Ms Frenkel's consist of a closed circuit, a system of echoes, communications, reflections and dialogue linking the self with what is outside the self and then looping back again.
>
> The intensity of the relationships between the participants was expressed at the end of each transmission when their electronic images blinked out and 'died'.
>
> [...] It was like a kind of] inter-city group therapy [...V]ideo has allowed the viewer to come alive and react aggressively to transmissions, thus liberating our major medium of communication from its commercialized ivory tower. [...] It is clinical video with love. (Lehman 1974)

A sense of the game-play may also be gained from the recollections of one of the players, Stephen Schofield. He was the 'Little Finger' on the Toronto Hand. The components that he chose for the eight categories were: Number: two, Letter: I, Word: taciturnity, Name: Shah Jahan, Sentence: I think I shall not hang myself today, Poem: Fragment murmuring of innumerable bees, Image:

unicorn, Gesture: turning around in seat, Sound: rattling keys. He described the work as a 'magical experience':

> There was an oddly mechanical aspect to the piece which harkened back to the kind of Bauhaus projects like Oscar Schlemmer's theatre project. [...] We gave a slow and awkward performance, but it was delivered with lots of attention and energy so I associate it with Oscar Schlemmer's theatre pieces. Again I see the connections here where idealism and failure meet.[9]

Playing string games between two cities via inter-city video in this way presented a *Glass Bead Game* of modernist theatre. The audience in this performance were its participants. As Schofield says, 'We had become the subject'.

There were three different performances of transmission. During each, two monitors in the teleconferencing studios recorded a documentary of proceedings. This created nine hours of footage, which formed the main part of the finished artwork, *String Games: Improvisations for Inter-City Video*, which was exhibited in Montreal. This exhibition took place in three events of cumulative transmission, showing 'live' the video experiment that was occurring during the game between Montreal and Toronto. The gallery had four monitors showing documentary video footage of game-play between the two cities. The rest of the space in the exhibition became a relocation of Frenkel's studio, containing the background documentation and photos of the project, and sketches such as the wall hanging that first drew me to the work (Figure 6.2).

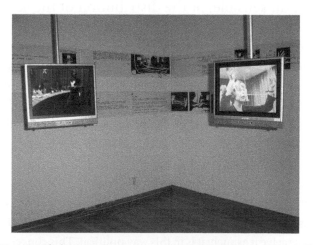

Figure 6.2 Vera Frenkel, *String Games*, two-channel installation with wall panels, detail and partial view, inaugural exhibition, InterAccess Electronic Media Arts Centre, Toronto 2005.

Despite direct communication with the participants in this work, it has proved to be difficult to hunt and work out what happened in its performance, installation and exhibition. The work has not been sufficiently recorded by the world, it has 'been disappeared' by the world, because of the way it refigures, and challenges the distribution of the sensible therein. It is because of this that I turn to Rancière's notion of the 'partage du sensible', or the distribution of the sensible, in trying to think about what is fundamentally at stake in this art performance. The active forgetting of the work, or its disappearance from public view, demonstrates the determinant political sense that it makes, in accordance with Rancière's notion, because it provides evidence of the laws and bureaucratic systems of power that lie behind an artwork being received, exposed and retained. Rancière's aesthetic theory is particularly applicable in terms of the sharing of the sensible seen from the way that this work plays *String Games* through *Improvisations for Inter-City Video*. We can ask Rancière's theory to help us consider how the artwork creates and exposes a sense that is intrinsically political. This will show us how the procedure of playing and performing *String Games* provides an agency of transformative therapeutics for its participants, which is seen (at this stage in the chapter) as a way of fundamentally reorganizing and reinventing the sensible coordinates of the world in which the performance takes place.

4. Making political sense: Rancière's notion of the 'partage du sensible', or the distribution of the sensible[10]

Rancière's notion of the 'partage du sensible', or the 'distribution of the sensible', contains his idiosyncratic understanding of aesthetics *as* politics. He brings forward this notion in his monograph on *The Politics of Aesthetics: The Distribution of the Sensible* and he also discusses the politics of aesthetics in *Aesthetics and Its Discontents*. The following exposition of the distribution of the sensible will draw from both of these works, and also from a selection of articles that Rancière has published, which deliberate the distribution of the sensible and how aesthetics is political.

When Rancière talks about the distribution of the sensible, he is referring to how 'the sensible', or what is possible for us to sense-perceive, is distributed, so that we may perceive it as such; it is in this way political. This concerns more than bare *aisthesis*, commonly understood as the sense-data that is imprinted onto our senses and bears testimony to our immediate contact with the world; with

his notion of the distribution of the sensible Rancière is denoting the structures behind this contact, which control our access to it, and also our consequent reaction to any contact that we may or may not have: 'it is the configuration of a specific space, the framing [*découpage*] of a particular sphere of experience, of objects posited as common and as pertaining to a common decision, of subjects recognized as capable of designating these objects and putting forward arguments about them' (Rancière 2009: 24). Rancière is interested in what is sense-*ible*, i.e. what it is possible to sense, by whom, where and how; and then, also what we can do here, with what we sense, and how we can articulate a response to it.

This notion then involves knowledge attribution and participating in the world, in apprehension and reaction to our sensory connection with it:

> A distribution of the sensible therefore establishes at one and the same time something in common that is shared and exclusive parts. This apportionment of parts and positions is based on a distribution of spaces, times, and forms of activity that determines the very manner in which something in common lends itself to participation and in what way various individuals have a part in this distribution. (Rancière 2004: 12)

Rancière talks about an aesthetics of knowledge, defining aesthetics as 'a division of knowledge, an interface in the order of sensible experience which brings social positions, tastes, attitudes, knowledges and illusions into correspondence' (Rancière 2006: 6). From this perspective, the distribution of the sensible denotes the boundaries of our *active participation and place within the world*, rather than merely pointing to our passively receptive contact with it. Here making sense of the world, or our sensory experience in the world, is fundamentally transformative. This is an agency that is aesthetic and transformative because it is political (and vice versa).

> It is a delimitation [*découpage*] of spaces and times, of the visible and the invisible, or speech and noise, that simultaneously determines the place and stakes of politics as a form of experience. Politics revolves around what is seen and what can be said about it, around who has the ability to see and the talent to speak, around the properties of space and the possibilities of time. (Rancière 2004: 13)

This view implies a sociological awareness of the world, rather than a merely phenomenological one, since Rancière is talking about the *laws* and *systems* that govern, determine and deterritorialize communal space, in terms of the power structures that control who can participate in this space, where and how they do

so. The distribution of the sensible is the determination and administration, or law and order, governing what is visible or audible or not, and who is allowed to see, hear or say it, in a communal space. It determines who can have a share in what is common to the community, and it is in this way political. Art and politics then both exist according to a particular partition of the sensible: 'This distribution and redistribution of places and identities, this apportioning and reapportioning of spaces and times, of the visible and the invisible, and of noise and speech constitutes what I call the distribution of the sensible. Politics consists in reconfiguring the distribution of the sensible which defines the common of a community' (Rancière 2009: 24–25). Rancière argues that the same laws that determine what exists in communal space, and our participation in this space, also then determine our transcendental modes of perception.

Rancière says that the transcendental conditions of possibility for thought are 'immanent in a particular system of thought, a particular system of expression' which then 'depends on a historically constituted regime of perception and intelligibility' (Rancière 2004a: 50). In this way Rancière is offering a radical (or at least Foucauldian) definition of the transcendental field. He says that the distribution of the sensible is at once an activated imposition, being the *découpage* or deterritorialization of communal space, whilst it is also something that provides the passive conditions of base perception. In this sense, he says, to think about the distribution of the sensible: 'aesthetics can be understood in a Kantian sense [...] as the system of *a priori* forms determining what presents itself to sense experience' (Rancière 2004: 13). As such, Rancière's notion of the distribution of the sensible holds that the conditions of our sensory experience are not made from transcendentally universal structures, and that *a priori* forms depend upon a historical, contingent partitioning of the sensible. Here the influence from Foucault's archaeology of knowledge is clear. But it surely raises a question, since any *partage*, or distribution of the sensible, which has been territorialized (i.e. planned, determined, rearranged, distributed and (selectively) governed), cannot simultaneously be a place of *a priori* conditions, since it has taken a large degree of *a posteriori* manufacture to construe in this manner. Rancière's *a priori* is provocatively social and historical: 'One could talk about *a priori* forms of sensible experience, although transposing and expanding the Kantian concept. But these *a priori* forms are always historically determined' (Rancière 2009: 157).

Within his analysis of the decoupage of sensible forms, Rancière includes the arrangement of these forms, and access to them, in terms of those places and forms in which we partake in communitarian life: It is this 'sensible

delimitation [*découpage*] of what is common to the community, the forms of its visibility and of its organization. It is from this perspective that it is possible to reflect on artists' political interventions' (Rancière 2004: 18). Thus the sensible becomes a matter of the material constructs of our citizenship. It is where, and how, we can participate in composite space and form a political community. Rancière stretches 'the sensible', or *aisthesis*, as bare, receptive sensory form, to include its cognitive apprehension, and the formulation of an articulated reaction that then can then redefine the original decoupage of the sensible. From this perspective the politics of the sensible involves: 'the very conflict over […] the designation of objects as pertaining to the common and of subjects as having the capacity of a common speech' (Rancière 2009: 24).

The articulation of our reaction to how the sensible is cut up and portioned out then redefines its *découpage*, and our own modes of perception. This moment of verbal dissensus, and the consequent realignment of the sensible, defines Rancière's understanding of politics. The politics of the sensible then involves the separation of those who can speak words of reason, and those whose words are just noise: 'Politics consists in reconfiguring the distribution of the sensible which defines the common of a community, to introduce into it new subjects and objects, to render visible what had not been, and to make heard as speakers those who had been perceived as noisy animals. This work involved in creating dissensus informs an aesthetics of politics' (Rancière 2009: 25).

Rancière's *The Distribution of the Sensible* is the subtitle of *The Politics of Aesthetics* because the sensible remains a matter of *aisthesis*, which concerns aesthetics, whilst its denotations of the layout in common space, and the potential for dissensus therein, are political. In his *Aesthetics and Its Discontents*, he defines the relation between aesthetics and politics: 'the way in which the practices and forms of visibility of art themselves intervene in the distribution of the sensible and its reconfiguration, in which they distribute spaces and times, subjects and objects, the common and the singular' (Rancière 2009: 25).

With this hypothesis, Rancière is interested in the way that an artwork is ex-posed in space for a certain amount of time and then redefines the sensible coordinates and situation of its placement. Quite simply, making and exhibiting an artwork realigns the partitioning of the sensible, in a way that is autonomous from the system and laws governing the arrangement of and access to common space. The artwork offers some degree of emancipation because it can provide the site for dissensus or reaction to this arrangement of common space, whilst repartitioning it in a material sense. This opportunity for emancipation feeds the artwork's potential to provide the agency of transformative therapeutics, in

its capacity to share and express the sensible coordinates of the world, and also opens the possibility for responding or reacting to this world.

From this capacity Rancière says that the task of art is to construct and reconfigure (materially and symbolically) the spaces and relations that make up the territory of the common. The artwork is political not because it takes an explicit stance in response to a certain regime, or because it expresses overt political values, or presents an image of iconography or propaganda, but because it forms an autonomous space that is opened for the community, which then changes the sensible set-up of their collective space.

5. Making political sense: Distributing the sensible through String Games

Rancière's notion of the distribution of the sensible can help us try to think about the *political sense* in Frenkel's *String Games: Improvisations for Inter-city Video*. In the following section I will discuss and think about how this artwork can be described using Rancière's terms. The power of this artwork is provided by its use of video as a medium that connects the articulations between ten participants across two different cities. The structure, format and content of this work and its underlying political ethos exemplify Rancière's notion of the distribution of the sensible, from its constitutive realignment and sharing out of space and time, and consequent making of a new sense (which is the *work* of art) during the improvised game-play of its performance and transmission. As we will see, the way that space, time and the sensible are distributed in *String Games* shows how it operates a distribution of the sensible, which then generates a political sense by revealing how we might structure the community. We will use Rancière to help us understand how this political sense is made from playing the game of cat's cradle. But we will also see that we need to supplement Rancière and add the dimensions of technology and touch, looking through Nancy (via Erin Manning), to fully understand how *String Games* is making political sense. An expanded understanding of the distribution of the sensible, and the political sense of *String Games*, will demonstrate how this artwork is transformative, therapeutic and offers new ways of making sense of the world.

The links between Frenkel's artwork and Rancière's notion are based on the way that the work creates a new sense and mode of interaction between a communal space that spreads across two cities. This new sense is

spatio-temporal, in terms of the connection and spacing of the topological location in Montreal and Toronto, and the nine hours of performance and transmission; it is also about communication and language, where each player invents and improvises their own interpretation of the categories set by Frenkel, to form a language that is continually evolving. The language conjured by the piece, and the ongoing 'attempt at language' that drives the whole game-play of performance (which Frenkel calls the axiom behind it), becomes a theatrical dance in which the audience are also the participants. In this way *String Games* resonates with Rancière's work on the communitarian ethos of Modernist theatre, and consequent emancipation of the spectator, seen in his *The Emancipated Spectator*:

> Theatre appeared as a form of aesthetic constitution – meaning the sensory constitution – of the community. By that I mean the community as a way of occupying a place and a time, a set of perceptions, gestures and attitudes that precede and pre-form laws and political institutions. More than any other art, theatre has been associated with the Romantic idea of an aesthetic revolution, changing not the mechanics of the state and laws, but the sensible forms of human experience. (Rancière 2009a: 6)

The way that this artwork fabricates a new communitarian sensibility for its participants would seem to draw from Rancière's discussion of the distribution of the sensible in his article 'Aesthetic Separation, Aesthetic Community: Scenes from the Aesthetic Regime of Art'. Rancière here discusses how artists weave 'a new sensory fabric' by creating their work; this new fabric then involves

> creating a form of common expression, or a form of expression of the community, namely 'the song of the earth or the cry of men'. [...] The human beings are tied together by a certain sensory fabric, I would say a certain distribution of the sensible, which defines their way of being together and politics is about the transformation of the sensory fabric of the 'being together'. (Rancière 2008: 3–4)

This weaving of sensory fabric then builds from the artwork a 'community of sense, or a *sensus communis*' (Rancière 2008: 4).

We can liken Rancière's sensory fabric to the piece of string, looped around the fingers, connecting two different players, which forms the game that inspired Frenkel's artwork. Its transposition into the virtual, cyber medium of inter-city video, with ten players rather than two, expands the consequent community of sense that is created by the distance of their 'being together'. This affect and the community of sense is one of the ways that the artwork is emancipatory for its participants. They collaborate and play together in a therapeutic alliance,

building teams that contest each other, in an autonomous sense that is separated from (although still voicing and reacting to) the political systems in the world at large, which sets the situation of the performance. As a consequence they devise and improvise new ways of being together, responding to each other's differing moves and expressing themselves in their own individually stylized languages. All of these factors are liberating, transformative and therapeutic.

Rancière talks about this community of sense, in terms of the way it is 'woven by artistic practice' as 'a new set of vibrations of the human community', in which people are both apart and together in relation as 'a new community between human beings, a new political people' (Rancière 2008: 5). We can see this notion of distance and proximity in the way that Frenkel's artwork distributes space and generates a new sense of community between people in two different cities, via the intermission and technology of video. *String Games* then offers a community of sense, which provides

> a multiplication of connections and disconnections that reframe the relation between bodies, the world where they live and the way in which they are 'equipped' for fitting it. It is a multiplicity of folds and gaps in the fabric of common experience that change the cartography of the perceptible, the thinkable and the feasible. As such, it allows for new modes of political construction of common objects and new possibilities of collective enunciation. (Rancière 2008: 11)

We see an example of this community of sense in *String Games* because it presents a picture of an organic, holistic society. Stephen Schofield describes it:

> The political connotation of the piece can be seen in an abstract manner as a metaphor for the inter-connectedness of the different parts of a society. In that sense it is a rather holistic image of an organic society, some parts more important than others, but all playing together for the game.

This opening of the possibility for a holistic community of sense is one of the ways that the artwork generates an experience of freedom.

Rancière's perspective of the artwork shows how it generates a political effect, and thus helps us understand how Frenkel's artwork is making political sense. We can see how the *work* of Frenkel's artwork involves the construction of a community of people assembled in their distance (which we can think of in terms of the event and process of creating this work, the inter-city transmission of sense via video). This distance then builds the political. In Rancière, it forms 'The Work of the Image' (or 'Le Travail de l'image'), which:

> [...] builds effective forms of community: communities between objects and images, between images and voices, between voices and words, which weave

relationships between pasts and the present, between distant spaces and the exhibition space. These communities only assemble together at the cost of creating distance. But to separate, to create distance, this is also to make the words, the images, and the things in a community larger than these acts of thinking, creation, speaking and listening, which can then name themselves and respond. (Rancière 2007: 209, my translation)

There is an ancient rivalry between the two cities that Frenkel chose – Montreal and Toronto. To play a game of cat's cradle between these two cities seems an effort to build an intimate, *disinterested* connection and interface between them. The point is for the sake of playing the game, rather than to play with politics, although the work then has political connotations, since it opens the possibility of communicating between people in two locations (which are potentially in conflict) in a new format. This opens a space for difference of opinion, and differing forms of expression. Frenkel uses jazz to describe the kind of politics, and 'sensus communis', that this work then forms for the participants:

> As with jazz, one of the intentions is to delight the players; another is that sharing the session may move others in similar ways. However, unlike formal performance, there is nothing finished about this three-part event. On the contrary; it represents a sharing of the development of skills, as well as the exercise of those skills and a self-imposed critique of what has been achieved. (Frenkel 1974)

The *political* value in *String Games* lies in the collaborative activity of *playing* cat's cradle. In Frenkel's artwork the activity of playing the game provides a sense of freedom for the players. There is no teleological finality or purpose to this activity, beyond enjoying the game for itself, and so it provides an autonomous, disinterested connection between the players. This connection is an intimate bond that is at once released from the constraints of everyday life, hence the sense of freedom, whilst it also provides a communitarian rapport, from which these constraints can be addressed. In this way, playing *String Games* provides an experience of freedom. This builds our notion of the agency of transformative therapeutics made possible by art practice. As journalist Henry Lehman (a viewer at its original exhibition) said, this piece is like 'inter-city group therapy [...] clinical video with love' (Lehman 1974). Clearly transformative as well as therapeutic, this artwork could even be seen to provide an ethical morale-building exercise for its participants, whilst they were playing the game together.

Such a communitarian rapport is formed from the technology of the game, which creates (in addition to the patterns of string) a moment of communication – in a universal, neutral language – between the players. This language, and the connection between the players, demonstrates the 'civilising function' of play. As Huizinga writes, in his *Homo Ludens*, 'Pure play is one of the main bases of civilisation' (Huizinga 1970).

This link between politics and play is an important ingredient in Rancière's aesthetic theory; play is a strand of the distribution of the sensible seen in *Aesthetics and its Discontents*. Rancière, through Schiller, uses play to define humanity: 'Play is, Schiller tells us, the very humanity of man: "Man is only fully a human being when he plays"' (Rancière 2009: 28). From this perspective play can then be mobilized to provide political agency. Rancière uses Schiller to say that 'the "play drive" – *Spieltrieb* – will reconstruct both the edifice of art and the edifice of life' (Rancière 2002: 137).

Rancière defines play as 'any activity that has no end other than itself, that does not intend to gain any effective power over things and persons' (Rancière 2009: 30). Since play generates an activity that is *free*, it can be thought of as essential in the task to found both: 'the autonomy of a specific domain of art and the construction of forms for a new collective life' (Rancière 2009: 28). Rancière is particularly interested in how play relates to the distribution and conditions of the sensible. He thinks about the 'free play' of the faculties that condition our sensory experience, in terms of a Kantian aesthetics, where Kant talks about the 'free play' of the sensible and intellectual faculties in terms of how we experience the world.[11] This free play and the distribution of the sensible then build into a 'suspension' that can build a new art of living, a new form of life in the common (Rancière 2009: 30–31).

Frenkel's artwork can be discussed in Rancière's terms because *String Games* involves what Rancière calls 'the formation of a new sensorium – one which signifies, in actuality, a new ethos' (Rancière 2002: 137). This new ethos that is provided by *String Games* 'promises a non-polemical consensual framing of the common world' (Rancère 2002: 137). It is committed to creating a new partition of the perceptible. This is what *String Games does*. We arrive at what Rancière calls the 'motto of the politics of the aesthetic regime', which is 'let us save the 'heterogeneous sensible' (Rancère 2002: 143). By fulfilling these ethical, ecological and aesthetic ends the artwork provides some degree of emancipation, whilst developing its increasingly apparent agency of transformative therapeutics.

The medium and technology of the video seem to play a key part in the political sense of *String Games*. The medium of video concerns the distribution

of the sensible because of the way it brings a different sense of space and the factor of time into the game of cat's cradle. It therefore offers a differing construction of sense (i.e. the distribution of the sensible) through performance, language and transmission. The movement from string to video is a breaking up, a spacing, of the originary, material technicity and intimacy of the string games, and presents a different kind of spacing through the technology of video. The agency and the materiality of the medium, in terms of the spacing from the video, of this artwork then generate its political sense. It then illustrates Rancière's understanding of the ways that 'Film, Video art, photography, installation, etc. rework the frame of our perceptions and the dynamisms of our affects. As such they may open new passages toward new forms of political subjectivization' (Rancière 2006: 14). *String Games* is transformative. It reworks perceptions and is in this way political, through the medium and technology of video.

Video forms a warped connection. Playing string games provides an intimate language formed by hands being tied together. This connection, and its enclosed space, is broken through video. Hence, as Stephen Schofield said, the 'failure to communicate' was 'far more poignant' than what was in fact communicated. The players face fixed *cameras*, rather than the *people* with whom they are communicating. When they turn to face the *actual* location of their counterparts – in 'real' space – they are invisible to the camera and transmissions in the teleconferencing studios. The cameras open up the possibilities for communication and performance, and yet they are *fixed* and create an *illusory* picture and direction of 'real' space. What looks real is in fact illusory.

And yet the work simultaneously capitalizes upon the *value* of technology. By confronting and re-contextualizing this fact (and its situation), the *work* of this art then becomes something intrinsically political: it confronts a situation, which is the 'construction' or 'artifice' of what is said to be 'true' – as captured by the illusion, control and power (and capitalist economy) of the teleconferencing facility. The radically cutting-edge communication aperture provided by this video took the form of a fixed *iron glove* (a metaphor used to imply the features of power, control and illusion behind the technology). As Frenkel says, the medium and technology of teleconferencing video is an 'enemy', and the work diagnoses its constitution and 'codification of lies' (Frenkel 1974). By engaging with this as a creative medium, the work diagnoses and disorientates: the oppressive power of states and institutions; the logic of capitalism and consumerism; the system of government.

The political sense made by *String Games* seems to be generated from the technology of game-play and the technology of the medium of video in a way that cannot be fully expressed by Rancière's understanding of the distribution of the sensible. Rancière's notion has enabled us to understand the political sense made by *String Games* in terms of the distribution of the sensible, the community of sense and the importance of play involved in this work. However in order to fully understand its political sense we need to consider further the political importance of *technology* in this artwork, and we also need to think further about how to define the element of 'partage' in the political sense it makes.

6. Making political sense: Sharing the sensible through the technology of String Games

String Games makes its political sense, beyond its play with the sensible and its distribution of space and time, through the technology and the sense of touch involved in the artwork. The technology of this political sense stretches Rancière's notion of the distribution of the sensible and it becomes useful to think of a different interpretation of 'partage'. For this we supplement Rancière by turning (through Erin Manning) to Jean-Luc Nancy, which develops our understanding of how *String Games* makes political sense.

The Frenkel piece involves the technology of the video, the bodily technique of the game – a non-instrumental, *poiêtic* (Heidegerrean) sense of *technê*, a *technê* of the artistic event. As such this work is the bearer of a fundamental articulation of the sensible as the technical. Thus politics involves *technê*. This brings Rancière's distribution of the sensible into contact with a phenomenological account of technology.

The political value of playing string games assembles through the *technê* of touch. Frenkel says that she was first attracted to the intimate connection of the 'shared tactile experience' offered by playing games with string. This emphasis on touch and the connection with string remained throughout its reinterpretation with playing the same game with video. Frenkel wanted to engage with the way that string games is a cross-cultural language and activity, which is seen to be played in almost every culture of the world. She was enamoured by the basic method of communicating and *being-with* people that string games provides its players.

During this activity of playing a game with string there is a sense of closure, as the string is wrapped around both your hands and those of the friend

with whom you are playing, forming an intimate tactile connection. The string encloses the spacing between your hands; the other player releases this containment, by forming another figure as they take it off your hands. Thus your release moves the sequence onto the next figure, and an interplay is created between the opening and enclosing of the string, forming different patterns and growing a bond through the collaborative creation by the two players. It is possible to 'make sense' and communicate, by using this bodily technique and tactile language, across many different cultures. There is an originary and therapeutic sense of *technê* to this activity: learning the sequence of figures is a skill that can be learned by anyone, whilst sharing this skill can offer a communitarian bond, and provide distinct pleasure. This activity would seem to offer a political sense of 'partage' more accurately described in terms of a sharing rather than distribution.

By keeping the focus on the string and hands, we can see how string games are political in a *material* sense. Erin Manning brings forward a 'Making Sense of politics' through a *Politics of Touch*, which we can use to develop our understanding of the political sense made by *String Games* (Manning 2007: 127–144). Manning draws a tactile circle through a Nancean sense of 'partage' to locate the political sense of touch, which, she argues, then generates liberty. Manning uses Nancy to read liberty as a non-signifying, bodily event of sense-making, which we can then draw through the material sense and politics we have just made from playing *String Games*. Manning defines liberty as:

> [...] a sharing of movement that is a reaching toward. Sharing as a participation in a spacing through which timed-spaces and spaced-times are created and passed through. Sharing as the experience of two bodies touching, creating spacings through which they surprise themselves, again and again. Spacing, for Nancy, is at the heart of the concept of liberty. (Manning 2007: 125)

Here liberty is defined in terms of sharing singularities in the spatial-temporal unfolding of the intelligible world, which offers a Nancean sense of sharing and spacing. We have arrived at a sense of 'partage' which seems different from Rancière's interpretation of this term, by drawing this tactful, tactile circle to Nancy's thinking about *The Experience of Freedom*. Nancy's sense of spacing could be seen to describe the distribution, or *sharing* of the sensible, and the *technê* of *String Games*. This spacing is shared, which then generates its freedom. This helps us understand how the political sense made by *String Games* is emancipatory. This is because the political sense of *String Games* (through its technology) provides a *sharing*, rather than a cut-and-paste, of the sensible,

which is, then, more of a Nancean sense of 'partage' than Rancièrean, and builds a communitarian interface – provided by the improvisation of different languages of each participant, and the distribution of their meaning across the two cities, which constituted the game-play.

The political sense made by this artwork, and its *work*, is the space that it opened for each participant to create their own language and meaning, set within an ecology of improvisation and the game-play of cat's cradle. Participants expressed their own interpretation of the different components that comprise the set, universal string figures. The artistry was in the invention, the improvisation and the game-play of the different voices. These voices were formed through the individuals' various gestures, sounds and the different elements within their permanence and interaction.

The artwork opens and shares a space or platform for the enunciation and expression of individuals' personal language. This platform delivers its emancipatory, political potential, via a Nancean understanding of *The Experience of Freedom*:

> [...] this determination of the political [...] does not primarily consist in the composition and dynamics of powers [...], but in the opening of a space. This space is opened by freedom – initial, inaugural, arising – and freedom there presents itself in action. Freedom does not come to produce anything, but only comes to produce itself there (it is not *poièsis*, but *praxis*), in the sense that an actor, in order to be the actor that he is, produces himself on stage. Freedom (equality, fraternity, justice) thus produces itself as existence in accordance with relation. The opening of this scene (and the dis-tension of this relation) supposes a breaking open, a strike, a decision: it is also the political that freedom *is* the leap. It supposes the strike, the cut, the decision, and the leap onto the scene (but the leap itself is what opens the scene) of that which cannot be received from elsewhere or reproduced from any model, since it is always beginning, 'each time'. (Nancy 1994: 78, in the chapter 'Sharing Freedom' pp. 66–80)

This links us with Rancière's interpretation of politics and his definition of the distribution, or 'partage', of the sensible. Indeed, in this quote Nancy seems to be thinking in a way that seems more like the Rancière we are using him to move away from, by talking about how politics operates with a cut or a decision, which could feasibly be thought in terms of a militant or violent distribution of space. We clearly need to make room for this way of speaking about space. But what *String Games* allows us to think of is a way of configuring space so that division and decision are held within a bigger matrix of sharing and spacing. The work formed, provided and became an interface for communicating and interacting

with a playful gesture, which made room for each individual language, and made sense occur – or transmit – between participants. This is the nourishing communitarian interface offered by creativity, whereby the art practice is a social act and provides a real degree of emancipation. This is the power, and *work*, that is so touching about *String Games*.

We come to a very Nancean sense of 'partage', as seen from his *Partage des voix*, translated as 'Sharing Voices'. In this work Nancy uses 'partage' to describe the *technê*, articulation and communion that constitute the interaction of different beings. 'Partage', or sharing, forms the opening of the community, which is composed from the singular episodes of an expressive 'fraternity':

> The sharing (the dialogue) is understood here as a provisional necessity, whether this is fortunate or unfortunate, whether it is an enrichment of an impediment to the community of interlocutors. On the horizon resides a communion, lost or still to come, in meaning. But, in truth, that which is the communion is only to be involved in communication. It is neither a horizon, nor an end, nor an essence. It is made of and by the sharing; it understands the sharing to be infinitely finished (completed) in the other by the other, in you by me, in us by us. And it is comprehended by the sharing. The community remains to think according to the sharing of the *logos*. This surely cannot be a new *groundwork* for the community. But perhaps it indicates a new task with regards to the community [...]. (Nancy 1990: 247)

It is important to note that Nancy's sense of 'partage', or the sharing of voices, which forms the ground of a community, has an inherent *technê*:

> The *technê*, undiscoverable by the hermeneut, then, is concerned with the propriety of the discourses, not their competence. It concerns the propriety of the delivery, and this propriety is, by essence, multiple, shared according to the roles. The undiscoverable *technê* will have been found in what is not any one *technê*, but in the sharing of voices [*le partage des voix*], in their deliveries, and in their addresses. The 'proper self-sameness' of *hermêmeia*; that is the difference between the singular characteristics [*propriétés*] of the voices. (Nancy 1990: 243, translation modified)

At this point it is necessary to (briefly) consider why Nancy and Rancière would interpret 'partage' differently. Rancière comes from a different school of thought to Nancy. Educated through Althusser and studying Marx via Lacan and Hegel, the background to Rancière's thinking is formalistic and involves both a sense of abstract, symbolic order and a socialist politics. These influences produce a sense of militancy seen in Rancière's use of the word 'partage', which then

signifies a violent cut and pasting of the sensible, with a backdrop of power and imposition. This contrasts with Nancy's hermeneutic of 'partage' in terms of a more elastic 'spacing' and 'sharing'. Indeed, Rancière's notion of the 'partage du sensible' interprets 'partage' in a way very different from Nancy. A Rancièrian 'partage', commonly translated as distribution, seems like a violent cut and pasting, involving power, imposition and aggression. It involves fundamental antagonisms and militancy. With Nancy, by contrast, 'partage' brings an intimate generosity: it is a sharing, where space and sense are folded together and there is a spacing or distance that is at the same time about contact, communication and community. It brings a spatializing of sense, a giving out, a sharing of it; rather than cutting it up with formalistic violence and militancy. This interpretation draws out our understanding of the artwork as an agent of transformative therapeutics.

In applying this to Rancière's notion of the 'partage du sensible' we can see how important the technical is in relation to the sensible. Thinking through a Nancean sense of 'partage' we arrive at *The Experience of Freedom*, which attunes to the holistic spacing and political sense of this artwork, thus delivering its agency of transformative therapeutics. Eventually we have discovered the sharing and emancipation that arise from the political sense made by this artwork. This develops our primary hypothesis, that engaging with art helps us make sense of the world, because of the ways that *String Games* has opened and shared the distribution of the sensible. The procedure of sharing, during the installation and performance of this work, demonstrates how it provides the agency of transformative therapeutics for (at least, and arguably beyond) the players who collaborated and created it: sharing, expressing and transforming the sensible; responding to the world – inventing and improvising meaning; the free play of the game itself; and the consequent activation of a community of sense.

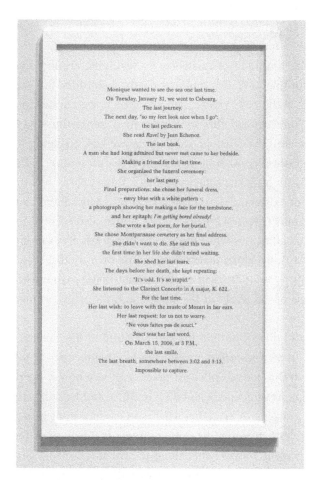

Figure 7.1 Sophie Calle, Detail of text from Autobiographies (The Obituary), 2012. Digital print with text panel. Courtesy of Sophie Calle and Paula Cooper Gallery, New York. Photo: Steven Probert. © 2013 Artists Rights Society (ARS), New York/ADAGP, Paris.

This chapter raises two issues: first, we will think about how an artwork can offer a sense of the ineffable threshold of existence, or a limit experience of

the real, during an aesthetic encounter. Second, we will see how the process of making an artwork can provide a form of therapeutic palliation, as the capacity to enable a method or *technique* of 'being in the present' in relation to this limit. In this way, by examining an encounter with Sophie Calle's installation *Couldn't Capture Death*, Calle's artistic process, and then turning to American video-installation artist Bill Viola (who also works on the threshold), through the aesthetic theory of Jean-Luc Nancy, we will see how engaging with art can provide the transformative therapeutics that defines our Making Sense of the world.

I start this investigation by first bringing forward Sophie Calle's *Couldn't Capture Death*, which is an artwork that seems to present and share purely our limit at the threshold of existence, by revolving around a documentary-like video recording of Calle's mother's death. I consider the situation of this artwork's place in the 2007 Venice Biennale, which was curated by Robert Storr. I argue that Storr curated this show around a 'sense-thinking' (or thinking through the senses) that was pitched to generate how engaging with art might provide sensuously affective transformation. After presenting Calle's installation I intertwine it with Jean-Luc Nancy's aesthetic theory about how art can express the threshold of existence. Here I bring in another installation work shown in Venice, Bill Viola's *Ocean Without a Shore*, which also seemed to be trying to express a sense of the threshold between life and death. By examining this work, and another work by Viola, which features his own mother's death, I develop and confirm my hypothesis regarding how an aesthetic encounter might provide a making sense of the world *at the limit, our* limit, which is ungraspable and passing.

I then expand this sense onto the second point of the chapter, which shows how creating an artwork offers transformative therapeutics at this limit. Here I examine the technique of Calle's art practice, to see how it provides the artist with a way of expressing and responding to our finitude: rather than providing any means of grasping or retaining what is in essence pure passing, the artist's technique enables a 'being in the present' towards this limit. This technique of 'being in the present' means being alongside the ungraspable passing in a way that produces care for the self. In this way we will see how the process of creating an artwork is palliative and provides a degree of transformative therapeutics for both Calle and her mother. I examine how Calle's work involves the process of mourning for her mother (the 'lost object'), through the Freudian psychoanalysis of Darian Leader. This leads me to consider the role of the artwork in relation to framing absence or lack. The Kleinian concept of 'reparation' helps me develop

the technique of 'being in the present', as transformative therapeutics, which art provides for Calle and Viola in this chapter. By examining the technique through Nancy and Heidegger, moving with Calle and also involving the œuvre and artistic purpose of Viola, this chapter aims to show how an artwork might then provide a practical living ethos at the limit of existence. Here I conclude with Foucault's understanding of art practice as a technique and a care of the self, to further define how art makes transformative and therapeutic sense of the world.

Part One: The artwork and the threshold of existence

1. The setting for this enquiry, in Venice

Sophie Calle's *Couldn't Capture Death*[1] is an installation artwork that was shown in the large exhibition hall of the Venice Biennale, in 2007.[2] It was part of the main international exhibition at this event, which was curated by Robert Storr. Storr selected work by a broad range of contemporary artists in this show, according to a logic of the sensory experience, directing works around the idea that during the aesthetic encounter we can *Think with the Senses, Feel with the Mind* and thereby open a sense of our world in the present. The theme of this show is particularly important and relevant for us since through it the exhibition seemed to demonstrate how one might try to make some sense of the complex situation of the world by engaging with art.

It did this from the ways that Storr's mise en scène provided an intricate and international picture of the consequences of war, terrorism, globalization, political unrest, deportation, migration and identity politics that beset the world. The exhibition set up artworks reacting to these issues and offered a somewhat *microtopian* space for sense-thinking, or thinking through the senses, that dissolved the contradictions surmounting their coercing of the present.

'Microtopian space' is an inferred link to Bourriaud's *Relational Aesthetics*, where he defines contemporary artwork in terms of its 'living' and 'relational form', which involves and implicates the viewer, who becomes a participant (and thus part creator) when they encounter and then produce a work (Bourriaud 2002: 13–15, 31). In this way an aesthetic encounter is not simply the receptive consumption of an artwork, but involves art practice, as a productive, creative act. Bourriaud argues that the aesthetic experience gives the viewer a chance to learn how 'to inhabit the world in a better way' so contemporary art is 'definitively developing a political project' (Bourriaud 2002: 13–15, 31). This is

to some extent a narrow view of the reception of an artwork, if the transformative therapeutics that I argue is the result of Storr's show was only a possible affect for the elite few who entered and engaged with it. We might then argue that the 2007 Venice Biennale (or perhaps any exhibition) provides merely a microscopic utopian space, as a small enclosed area for an exclusive few who could perceive, indulge and reflect in the sweltering sensations of *Think with the Senses, Feel with the Mind, Art in the Present Tense*. However, affect is made manifest beyond individual encounters, and artworks continue to prompt differentiation and change as a consequence of their expression and representation in an exhibition. Indeed, Bourriaud's *Relational Aesthetics* refers to an artwork as a set of artistic practices 'which take as their theoretical and practical point of departure the whole of human relations and their social context, rather than an independent and private space' (Bourriaud 2002: 113).

Although Bourriaud's account of the emancipatory potential of an aesthetic encounter could seem problematically teleological, homogenous and reductive (as opposed to Nancy's understanding of any 'inoperative' community of viewing subjects[3]), we can still use it to think about how Storr's show stimulated transformative therapeutics during the setting of an encounter. Here was not a disparate blur of monumental issues that bypassed any lucrative or possible sensibility, but a pure and new space for their reflexive expression, differentiation and equal measure.

This exhibition juxtaposed artworks with specific sociological and political emphases, such as Charles Gaines and León Ferrari's crashing airplanes, Indian artist Yto Barrada's 'politics of flowers' and the installation of assault rifles by Nedko Solakov. There was a meditation on the Pinochet coup by Melik Ohanian, and Paolo Canevari's video of a child playing soccer with a rubber model of a human skull in the bombed-out ruins of Belgrade, besides Rainer Ganahl's portraits of 'radicals' such as Edward Said and Eric Hobsbawm. Such a macabre tone was set and then revived by the haunting, cavernous beauty of Sigmar Polke's seven darkly majestic paintings. These were named, and indeed posed together, *The Axis of Time*. Polke's works were hung around a room in the middle of the pavilion, coating the walls with what seemed so sensuous, almost velvety and carnal: mammoth, textural black paintings that glowed and tugged the eyes to bathe in their alluring, allusive beauty. Polke's canvases gave a multilayered, intricate affect: looking around *The Axis of Time* it seemed as if these works were made from a burnt lava reflected in the shadow of an X-ray; as though by looking we could reach to the core of the earth, which had become subsumed into some kind of entropic black hole. But this murky tone was in

effect reviving: when gazing at their complex, mysterious medium (concocted from a transparent ground soaked in lacquer), paint seemed to provide a transformative therapeutics in its alchemy, as life lilted from the sensations that erupted and vibrated as the viewer looked.

The Biennale provided a nodal point for this sombre, reflexive theme and mapped the world around it, offering some sensuous degree of emancipation from these issues from their presencing and particular juxtaposition around the show. Storr directed this to present the contradictions, dichotomies and the logic of opposition that determine, segregate and dictate the way that we exist. This concerns the loss of identity (and censure of non-identity) in a globalized, institutionalized world. Storr was trying to show how art might state and react to such a crisis and offer some degree of affective transformation which might then prompt acceptance, difference or change:

> Sadly this is a period when ideological, cultural and religious antagonisms – rather than 'nature' – drive man to kill his fellow man, to imprison and torture him. These horrors are visible in the glass art holds up to the world, though reality's ugliness may be transformed into a terrible beauty or crystallized into a prism through which we can examine the human flaws that produce it.[4]

As Storr said: 'the more you sense, the more you realise the enormity of what this destruction is. By itself art cannot remake the world – but it can articulate things in a way that allows us to address the contradictions we live out with greater clarity and understanding'.[5] *Think with the Senses, Feel with the Mind, Art in the Present Tense* mapped the multiplicity and complexity of the present. This provided the 'grotesque', since one could (literally, through Calle or Viola) inhale death, and the aching misery of the population, but also in the sense of the grotto as a cave or treasure trove, returning to one's most basic, chthonic sense of nature.

2. The threshold in Sophie Calle

Sophie Calle's work provided an existential epicentre for Storr's show. I was particularly drawn into this two-roomed installation, which was on the right side of the pavilion, by a distant orchestral sound that I half recognized. The first room had a very simple, elegant décor, with an oil painting and a photograph of Calle's mother hung on plain white walls. This room also featured some text which explained the context of this work, which was created in response to

the tragic coincidence of Calle learning of her commission to represent France at the Biennale (with another work, *Take Care of Yourself*, which was in the French pavilion) and also of the terminal illness of her mother, Monique, who only had a few months left to live. Calle tells us that she learned of this tragic coincidence from two telephone calls that she received on 15 February 2006. One of Monique's last wishes was that she could have gone to Venice to see her daughter showing her work here. As Calle wrote on the wall in the first room of this installation: 'She is there'.

There was a calm and ambient sound in the background of this work – a clarinet concerto by Mozart. As I walked into the second room I saw more words on the walls, which counted down the last experiences of Monique's life. There was a small screen, below eye-level, which pictured an old lady lying on a bed. As I sat down to watch this film the music ended. It brought to mind one of the lines of a poem by Calle, which was printed on the wall of the installation: '*Her last wish: to leave with the music of Mozart in her ears*'.

The film exposed the deathbed of Monique, and by entering this installation it felt like I was being invited to be beside her bedside and witness the very last moments of her life. There was a single frame to the film and hardly anything happened. This was set within the slightly muted pastel colours and fuzzy repetition of the music in the décor of the installation. In the film Monique seemed to be lying on the bed peacefully, her head was propped up by a pillow and there were some yellow spring flowers in bloom on her bedside table. Her eyes were closed and her expiring skin looked like gently polished dulcet porcelain. The film was so still, it was hard to know whether she was alive or dead. After a while a nurse entered the frame to check her pulse. She touched Monique's neck for a sign of life, and, unsure, the other side. Then, whispering, another woman – Calle herself – came in. They could not tell whether or not Monique's last breath had come and gone … This is, as Calle says in her poem, the moment of: '*The last breath, somewhere between 3:02 and 3:13*'. This moment is '*impossible to capture*'.

The film in the installation continued to play, on continuous loop, around this indeterminate time of Monique's death. It seemed to show me, purely, the threshold of existence, by circulating this fleeting moment that is *impossible to capture* in eternal repetition (that the event of its encounter, my encounter, by then had become). Time seemed suspended around the moment where passage of life turned to the 'pas au-delà' of death.

I was held here. This was not *my* death, but for the time that I dwelled in this installation, and sat by the bedside of this old lady, as it seemed in this artwork,

I felt in a strangely intimate proximity with life's passing away. There was an instinctive need to try and grasp what I was witnessing. Perhaps the work was – and is – so moving and therapeutic because it presents what cannot be grasped, and what has no sign, and yet it is in some senses held within that very effort to grasp it, via the artistic form of its expression. We watch someone die here, but we cannot 'see' death. There is an instinctive need to grasp it, to try and withdraw any life that might remain, to seize hold of life; but that moment and possibility elude all conscious sensibility, they pass out of time.

Calle's artwork seemed to provide a certain showing and sharing *at* the moment of Monique's finitude. We do not share her death; we witness something we cannot and must not share, and in such exposure is built a vestige of life and love. From such exposure we share an intimate relation (which is our non-relation, since we can't capture it) to the threshold of existence. The work provides a way for the viewer to approach and consider what is inappropriable, when we apprehend something fundamental about our being. In this space, and in creating this affect, the work shares a vestige of Monique's life and the love she shared with her daughter. The creation of this work exposes the ritual of the mourning process, and its exhibition in Venice opens up the social dimension of bereavement for the public who may identify with this experience of love and loss. Such identification is therapeutic and transformative for the viewer, who leaves with a poignant sense of who we are at our limit.

Calle's work in Venice presents similar issues to those raised by Jean-Luc Nancy's aesthetic theory, when he claims that the aesthetic encounter can present 'the threshold of existence'. Juxtaposing this theoretical element with Calle's work can develop our understanding of how the artwork can present to us an intimate sense of our finitude. An encounter with *Couldn't Capture Death* and the threshold of mortality concern the extreme and absolute limit. Yet Nancy argues that, to some extent, every artwork presents a limit-experience of the real. We will now turn to Nancy's theory to help us consider further what goes on in the aesthetic encounter, in relation to our finitude. We will then open our reading of 'making sense at the limit' to another artist at the Venice Biennale, Bill Viola. We will see how Nancy's aesthetic theory can help us extend the argument from Calle or Viola's work into a larger picture about how an artwork can help us make sense of the world by providing a transformative and therapeutic limit experience of the real. We will then see how the artwork can offer a degree of transformative therapeutics which is here interpreted as palliation, reparation or a technique of 'being in the present', in relation and response to this threshold and the imminence of death.

3. The threshold through Jean-Luc Nancy

To begin to consider how an artwork can provide a limit experience of the real, and a real experience of our limit, and how this provides transformative therapeutics that defines our making sense of the world, in this section I will draw from the aesthetic theory of Nancy. In 'On the Threshold' Nancy argues that the aesthetic encounter exposes an ungraspable sense of limit, or the threshold of existence, in terms of providing a direct contact with the raw real that cannot be represented. Nancean aesthetics circulate around considering the aesthetic encounter in terms of how it can present 'the threshold of existence' as an experience of our limit, which evades signification (Nancy 1996: 61). During an aesthetic encounter, Nancy argues, there is no gap between the individual and their experience of the artwork in question, and no mediated process of making sense of this artwork. What we sense is at the limit of our being in contact with the world, as it is provided by this artwork. This limit is the threshold, or brink, that delineates our existence. To posit this argument Nancy considers what we access in our engagement with a work of art, how this is presented to us, the limit of this presentation and the consequent withdrawal involved during the aesthetic encounter. This seemingly dialectical idea of presentation and its withdrawal, or our withdrawal from it, situates the way we sense a limit – *our* limit – in art. Nancy uses a singular encounter with Caravaggio's *The Death of the Virgin* to write about the way that the artwork exposes this limit, and our finitude, as something that we can't grasp, define or understand.[6]

Nancy gains his sense of the painting by Caravaggio as an event: from the particular lecture he gave, standing in front of the work. For Nancy the overall 'sense of the world' is what conditions the possibility of the singular spatial-temporal events that compose the sense (i.e. the sensuous-intelligibility) of the here and now. Sense is given in these events as what is always-already withdrawn from them. Indeed, Nancy's methodology of utilizing the singular plural event amplifies and justifies the constellation and concentration of singular encounters and specific artists that are used to build the argument for Making Sense throughout this book.

In his account of the Caravaggio, Nancy begins with the self-contradictory statement that 'So, we have entered there where we will never enter', and proceeds to account for the way that this painting presents us with a fundamental existential experience, of sensing death, around a continuing dialectic of access and non-access, proximity and withdrawal, presence and absence (Nancy

1996: 57). Nancy argues that the relation between these contradictory ideas forms both the substance of the aesthetic encounter and the threshold of our existence, since each encounter traces the limit between what we can access and what we cannot access, what is immediately near and what remains at a distance. In thinking of 'limit' as a line that demarcates our existence, traced between life and death, Nancy implies that we touch this line, or we touch the fact that this line exists (being on the threshold or exposed to it, rather than crossing it) in the aesthetic encounter.

He brings forward the idea that this tracing of limit is presented to us here, by thinking about the outline traced by the painting. Nancy focuses on the limit of the painting, and what we *cannot* access in our sense-experience of it, to hypothesize that it presents (rather than represents) the threshold of existence. He leads his analysis of presentation from the exterior position, or exhibition, of the painting, exhibited out in front of us. This necessarily begins with the question of distance, since when we look at the painting it is placed away from us, or detached from our vision, hung on the wall and exhibited in the gallery (in this instance). Nancy uses this idea of distance to conjugate a logic of presentation based on the eventual essence of sense (i.e. in terms of a singular event, which brings us to the absolute limit of what can or cannot be accessed), which can be seen throughout his aesthetics (Nancy 2005: 12). The absolute limit presented to us here, in the exposition of this painting, is both the distance of the painting (in its placing, away from us, on the wall) and its image of death, to which we have absolutely no access.[7]

Nancy argues that a powerful affect can be drawn from admiring the masterful way that this image presents a dead woman, and from the sense of limit or distance to this experience. He argues that there is an analogy between our necessary distance from the moment of death, and the experience of the painting: whilst we can only be ever on one side of death or the other – either before it or beyond it, and never actually have an experience of or within death itself, just so we can never get any closer to the image than its physical contours, we cannot 'get inside' the painting. There is a degree of non-access, or withdrawal of access, involved in the encounter with this painting just as in our imminence towards death. We cannot know the in between, this – as 'pure death' – is invisible, *impossible to capture*, just as we cannot know 'behind' the weaving or threads of the canvas. There is no fundamental absolute category of 'Death', the closest we can come to death is by watching others die, or by sensing the material threshold of its 'inappropriability'; just as all that there is to see in

the painting is in the flesh of sensing it. Therefore, as Nancy puts it, the threshold of sensing this painting demonstrates the threshold of existence:

> Here. (the) painting is our access to the fact that we do not acede – either to the inside of the outside of ourselves. Thus we exist. This painting paints the threshold of existence. In these conditions, to paint does not mean to represent, but simply to pose the ground, the texture, and the pigment of the threshold. (Nancy 1996: 61)

By defining the threshold and presentation in art with the notion of distance, whereby we are always at a distance from a painting and cannot get 'inside' it, so there is nothing behind the oil paint and canvas, Nancy wishes to emphasize that death is inappropriable and the closest we can get is to the fact that it is impossible to get any closer (Nancy 1996: 61). This hypothesis might seem disoriented with the medium of installation, where we 'enter' the space of the artwork, with its three-dimensional forms and multiple sensory stimuli. The 'being singular plural' composite of Sophie Calle's installation brings forward two rooms containing a painting, photography, film, text and sound. Each of the multiple parts of the installation has a barrier, to some extent, but the work is formed from the way that these parts are brought together in a space we are invited to enter into. The work does not have the same barrier line between spectator and artwork or access and non-access that Nancy reads from a painting.

Although we still cannot access death, Calle's work poses a space of access and threshold of apprehension rather different from that described by Nancy, when he categorizes Caravaggio's painting of death (and its correspondence with 'the threshold of existence') as a scene where 'No one looks at us or invites us in. Indiscreet, we have, in sum, entered by force' (Nancy 1996: 57). By contrast, the structure of Calle's work seems to elaborate something like an invitation, in the way that there is a low bench, where we can sit down in comfort and we feel as though we share this installation. In this way Calle's installation has the aura and capacity for the viewer to access some degree of transformative therapeutics in their encounter, where we share an intimate relation to our inappropriable finitude, becoming touched by the event of someone's passing out of time. We receive and share this sense, whilst in Nancy's account of the threshold we invade the work, where we are unsolicited and confronted by our limit.

In *The Evidence of Film* Nancy uses the cinematic 'look [...] on the real' to think about what cannot be accessed, or represented, and what conditions the real (Nancy 2001: 16). Nancy talks about the way that death is an impossible

subject because it cannot be represented. The withdrawal of the image, and its absolute non-presence, constitutes a blind spot for the viewer: 'Death is *neither* the opposite of life *nor* the passage into another life: it is itself the blind spot that opens up the looking, and it is such a way of looking that films life' (Nancy 2001: 18). We can apply this idea of the blind spot to Calle's installation, where we find the equivalent in time, at the exposure of the ungraspable 'passage' between life and death, the moment where life passes away, which we cannot recognize or hold in our consciousness. It becomes, in this artwork, a monument or vestige.

In Nancy's account of the threshold he says that our reaction to the artwork demonstrates how the work can conjugate, from within its necessary distance to us, a moment of *excess* that cannot be signified, and which evades its limit. This idea of excess helps us think about how we respond to an artwork, how it moves us and how it might then provide a method of sense-thinking that dissolves the dichotomy between ourselves and any art object. Considering distance, Nancy moves from limit, through touch, to the affectuous excess that demarcates our encounter. It is this affect that exposes the infinite opening of sense. This excess is exposed by (or composed of) the *forces* which are held by the painting, or, rather, by the way that the image, form and facture of the artwork capture our attention and prompt our reaction, so that its immanent affect in the viewer spills over any material limit in its actual structure. Thus the artwork arouses us, and, as Nancy says of the painting by Caravaggio, 'We are seized there' (Nancy 1996: 57). This can be directly applied to other mediums, not just painting: we are similarly aroused and 'held' in the ungraspable rites of passage that define our finitude, which we see from Calle's work at Venice.

Thus the artwork exposes or presents its material reality to us in a way that such a presentation exposes the ek-sistence of its immanence, or the patent sense of its material, affectuous reality. As a consequence the work exists in its capacity to exist outside of itself, i.e. ek-sist. This recalls the ek-stasis we found, via Stephen Newton, Heidegger and Nancy, in Chapter 1. In this way the patent immanence of the artwork's presentation extends outwards, beyond the material limits of the artwork and each singular presentation, by its ongoing capacity to affect. From this Nancy builds his concept of 'transimmanence' to describe the patent sense of the artwork.

> [A]rt is the transcendence of immanence as such, the transcendence of an immanence that does not go outside itself in transcending, which is not ex-static but ek-sistant. A 'transimmanence'. Art exposes this. Once again, it does not

'represent' this. Art is its ex-position. The transimmanence, or patency, of the world takes place as art, as works of art. (Nancy 1996: 34–35)

With 'transimmanence' Nancy undercuts the dichotomy between transcendence and immanence, and describes how in the aesthetic experience we sense or touch a limit: what is untouchable or non-signifiable, and also the fact of its untouchability, demonstrates our being alive and our being-in-common. In this sensation there is a *jouissance* of excess in the threshold of forces evoked by the artwork. This transimmanent, excessive affect is what Deleuze might call a 'monument of sensation' (Deleuze and Guattari 1994: 158). We can use transimmanence to build our definition of sense-thinking, which applies to the dissolution of the dichotomy or binary opposition between the sensible and the intelligible (or the sensation of the artwork and the artwork itself), which occurs during art practice and during an aesthetic encounter, and which can then prompt the transformative therapeutics that defines our Making Sense of the world.

Transimmanence then opens a different kind of withdrawal, in terms of our sensuous contact with the artwork. There is a drawing-with to this withdrawal, in the intimate moment of the aesthetic encounter. As we gaze out in front of us, at the picture on the wall (in Nancy's case), it is held away at a distance, and yet it still has the capacity to affect or touch us, since our sense organs react to its visual stimuli, passively affected and touched by the work, withdrawing sense data from it. This withdrawal is the singular event of sense, taken from the limit of the presentation of the image. Withdrawal is like a 'transmission' between what is presented to us, but remains at a distance (Nancy 2005: 127).

What we withdraw or draw-with from a work like Calle's installation, which we physically enter and become a part of, rather than being held away on a wall at a distance, is arguably a more intimate and relational aesthetic encounter. We are held by and share an empathic relation to our ineluctable finitude, which we recognize and become part of when we enter the work. But we still cannot grasp and remain distant from what it presents to us, so Nancy's emphasis on distance and limit remains and helps us understand what is so powerful and moving about the threshold exposed in Calle's work.

Having broadened our understanding of how the aesthetic encounter presents a sense of the limit of our worldly experience, through Nancy, and seen how Calle's installation opens Nancy's aesthetic theory on finitude, we will now turn to Bill Viola, another artist who was working *on the threshold* at the 2007

Venice Biennale. Viola's installation at Venice and his ongoing works continually mould and manipulate limit, by presenting sumptuous environments that envelop the senses with surround sound and dazzling moving images on large screens. Examining Viola's œuvre will help us learn how an artwork provides a making sense *at the limit*, and then how it offers transformative therapeutics in relation to this threshold of existence.

4. The threshold in Bill Viola

Bill Viola's *Ocean Without a Shore* is a high-definition video and sound installation, which was shown in the intimate and exquisite location of the tiny fifteenth-century Venetian church of San Gallo at the 2007 Biennale.[8] This edition of the work used three stone alters as video screens, and erupted a cyclical progression of images that described 'a series of encounters at the intersection between life and death'.[9] These videos presented a theatrical melodrama of the human form passing through an invisible threshold between and beyond the physical and supernatural worlds, seeing this 'crossing of the threshold' as 'an intense moment of infinite feeling and acute physical awareness'.[10] In an interview for Tate Modern's archives, Viola described how in this work he was trying to capture a tangible but sensitive, pliable sense of this threshold and express something fundamental about the human condition:

> [...] this is a piece about humanity and it's about the fragility of life, like the borderline between life and death is actually not a hard wall, it's not to be opened with a lock and key, its actually very fragile, very tenuous. You can cross it like that in an instant and I think religions, you know institutions aside, I think just the nature of our awareness of death is one of the things that in any culture makes human beings have that profound feeling of what we call the human condition and that's really something I am really interested in. I think this piece really has a lot to do with our own mortality and all that that means.[11]

Ocean Without a Shore seemed to play with and on the rites of passage that condition human existence, using actors and state-of-the-art technology. It involved the same theme of the threshold that is 'impossible to capture', made manifest in Calle's *Couldn't Capture Death*. Although Viola's work had a different, more flamboyant tone to Calle's, and it was not documenting a particular loved one's death, it still seemed to be expressing something broadly fundamental about death itself. Despite being theatrical, rather than biopic, the installation had an enveloping affect in the small chapel in Venice: I entered the

space and found myself surrendering to the intensity of the ghostly atmosphere in the work as it was set, all around me. The videos showed a glowing drama of human forms emerging and disappearing somewhere between an imagined life and death, splashing through water and a permeable osmotic medium that was conjured through sound and vision. The result was a sonic and visual rapture, until the fifteenth-century architecture of this Venetian church began to vibrate, and I felt tipsy in my senses, on the threshold between this sensuous experience and its object, the artwork.

Viola is world-renown as an artistic innovator who explores new cerebral, emotional and sensual possibilities from video. The visual impact of the shifting resolution and interacting patterns in his work in Venice, with its reflected light, moody shadows, submerged bodies and rippling waves, was elegant, soft and sumptuous. It seemed to articulate and elaborate the indeterminacy of the threshold and an intimate sense of mortal existence.

Entering Viola's work (as we entered Calle's) we encounter an expression of the threshold. Sensations from this work seem to dissolve the binary line between life and death into a beautiful, amorphous ambiguity; the senses seem to float in intimate indeterminacy, as the figures on the screens emerge and disappear through the surface of water or air, and become and then withdraw from view. Still following Robert Storr's curatorial dynamic (in the International pavilion, which was another part of the Biennale, but secreted all around Venice), we could think through the senses and dwell here, where the line between ourselves and our relation to this artwork, and to finitude itself, syncopated. We still cannot see, know or share death, but the fact of its inappropriability and finality was teased and lubricated by the intense and microtopic space of this encounter.

Bill Viola has made another work, *The Passing*, which, like *Couldn't Capture Death*, also features the face of her mother as she lay dying in a coma, after a brain haemorrhage.[12] It examines and exposes specifically a pure and ungraspable sense of life passing to death, and plays with the indiscernibility of this moment that ends and conditions our existence. The film also shows frames of Viola's mother alive and moving and, on another screen, the birth of a child. Set to a soundtrack of the rhythmic pattern of the dying lady's last breaths, the three screens of this installation offer 'a circular, moving, sensory imprint of living and dying' (Wilson 2012: 8).

The moving images in this work consist of an interplay of light and dark, with close-up frames of the black cavities and wrinkles on the dying lady's pure white skin. Interwoven with twisting, nebulous and textural images of water and landscape, Viola's mother's uninhabited apartment, alongside a documentary of

the very beginning of a child's life, time is laboured, distilled and constantly moving in the cadence of the labouring breath. On the one hand, this film is fraught, poignant and an elemental and experimental portrayal of the human condition *at the limit*; on the other hand, it shows a very personal, individual expression of Viola's love and grief for his mother. As Wilson argues in her *Love, Mortality and the Moving Image*, by 'Showing the passing of his mother from his life', in Viola's work 'The sweep of the camera, the apparently embodied perspective it offers, intimates a personal vision of the loved one missing' (Wilson 2012: 9).

The practical importance of filming, and creating an artwork in response to the imminence of death and in the face of our finitude, is important because we find it in Calle's *Couldn't Capture Death*, which was also made as a method of coping with Calle's mother's terminal illness. This is a question about artistic technique, the second issue that we are considering in this chapter. We will now examine how the production of an artwork can provide a form of palliation, as a technique of 'being in the present', *at the limit*. We can return to Nancy's aesthetic theory to begin to develop the ideas of technique and the present. Technique allows us to consider art as a method or process, in terms of the artist as a 'technician' making their work, rather than just in terms of its final end product (via a teleological logic) that we are viewing. By examining technique through Nancy we can begin to establish how the process of making art provides transformative therapeutics, as a mode of 'being in the present'. This will also involve thinking through the psychology of mourning (through psychoanalysts Freud, Leader, Klein and Segal), in relation to the artwork's involvement in the mourning process, and considering how art-making provides 'reparation' (another synonym of transformative therapeutics) in response to suffering, pain and distress.

Part Two: Technique of 'being in the present'

1. Technique in Nancy

Nancy's ideas about technique, presentation and limit are also raised in his essay on the painter, On Kawara.[13] This work was again originally pronounced as a lecture directly in front of the paintings that he refers to throughout this essay. Nancy here asserts that art is a *Technique of the present*, describing art as '*Tekné poétiké*: productive technique [...] It is technique productive

of presence' (Nancy 2006: 191). This idea of art as technique of the present enables us to think about the situation of the aesthetic encounter (and its limit-threshold), and the technical production or the 'how' of the artwork that has made possible this encounter.

Nancy opens out how art provides a 'productive technique', which produces the present by opening up a space that can persist in time. The artwork is therefore ek-static – it exists outside of itself. This means that the work of art moves out of its stasis as an object into the dimension of time, by continuing to remain and enduring its presence. Therefore the immanent surface of the work (which we look at, from our distance, and react to) is transcendent, since the object exists through time and opens spacing into time.[14] By Nancy's hypothesis, the space of the work is thence the origin of (its) time, whereby art actually disposes the present: 'Art is a setting in position. It sets the position of the thing according to the dictates of presence' (Nancy 2006: 191).

Behind these remarks, the relation between space and time is important for Nancy because his overall sense-philosophy means to collapse their distinction and articulate a quasi-transcendental singular form that can account for the materiality of sense, which is his main objective. Nancy intends to intertwine time and space into a Derridean moment of *différance*, incorporating a fundamental ontological concept of 'spacing' that erases the limit or dividing line between time and space, from which spacing marks the ek-static being of sense. It is from this (groundless) grounding that Nancy's aesthetic thinking emphasizes the materiality of art and its spatial coordinates, since Nancy locates the facticity of reality in its immediate objectivity, which is patently presented in the art object, whilst art has the substantial ability to release the world from signification via the senses. For Nancy the overall 'sense of the world' is made up of the singular spatial-temporal events that compose the sense (i.e. the sensuous-intelligibility) of the here and now. Nancy argues that this sense is denoted by each aesthetic encounter, whilst the artwork itself (in its ek-stasis) is the opening and the origin of time: 'Space is the origin of time', and 'On Kawara's art is a technique that produces this spacing' (Nancy 2006: 192).

The most important part of this essay, for our purposes, is where he says that the '*work*' of art is to ask this vital question: 'How can we grasp the ungraspable character of passing? How can we grasp the pure conjunction of passing and presence, of fleeing and stasis?' (Nancy 2006: 192). This question is useful because it brings us directly to Calle's artwork, *Couldn't Capture Death*, which is constituted around the ungraspable moment of her mother's death. Viola's

The Passing also revolves around specifically this theme and question. Both œuvres seems to hold on continuous loop the question that Nancy raises as the work or purpose of art. This 'ungraspable of passing', as shown on the film that keeps on playing the indeterminate time of Monique's death, appears to present specifically the threshold of existence. We see this in both of the works by Viola that we have examined here.

That this ungraspable moment is essentially impossible to capture perhaps demonstrates that the threshold of existence cannot be thought of in terms of a decisive *line*; and so this work seems to syncopate or shake up the analogy between the outline of Caravaggio's painting and a line demarcating the threshold of our existence, which Nancy raises in 'On the Threshold', whilst drawing together his aesthetic theories on technique and the threshold.

By examining Viola's technique or process of making this work, and his reasons for being an artist, we can see further similarities to Calle, which will help us build the sense of transformative therapeutics that defines our method for Making Sense of the world. We now need to return to Calle and think about technique. How does art not just make a 'technique of the present', which Nancy hypothesizes, but a technique of 'being in the present', in the face of our finitude?

2. The artist's technique

When we examine Calle's process of making *Couldn't Capture Death* and Viola's process of making *The Passing*, we can see how art practice, or the process of filming the dying mother, and then creating this installation provides a way of responding to the imminence of death and finding a way of 'being in the present' towards this limit. The consequent exhibition of the work then involves and plays out the process of mourning. And yet, neither *Couldn't Capture Death* nor *The Passing* was made specifically to become an artwork, but rather as a way of reacting to and coping with this tragic situation. Indeed, Calle says that making this film was not so much a consciously planned activity, but more like an automatic response to what was happening. The basic process of making this work, and filming her mother, became a method of being present at such a difficult time. Making this artwork then provides 'a form of palliation' for Calle and her mother, since it offers them some degree of relief, release or reparation in response to this terminal illness (Wilson 2012: 77). In a similar way to Calle, Viola filmed his mother dying to help him cope with the tragedy of this situation. Filming provided him with

an instinctive technique of dealing with his mother's death. In this way we can see how art practice is transformative and therapeutic.

First we turn to Calle's practice. Emma Wilson argues that Calle's work is palliative, in the sense that palliative care means therapeutic care for the terminally ill and their families, because of the way that making this work generated for Calle and her mother a way of facing and managing death.[15] The artwork is palliative for Calle because the technology and practical tasks involved in the film-apparatus – in terms of handling the camera, changing the film or setting the zoom – provided a cathartic distraction to the point that such technology quite simply became her way of being. Making the film provided a technique of 'being in the present', whilst the 'objectivity of the filming eye' – a concept which we usually think of with regard to the viewer – provided a technique of continuous presence that enabled both Calle and her mother to endure the fateful passing of time. Calle describes this very clearly. Here she is talking about why and how she started filming her mother:

> It was because since I was afraid to be absent at the moment, I became the camera in a way, as long as the camera was working I felt I was in the room with her, I felt with her. I felt better. Also it made a displacement with my obsession. I was absolutely obsessed with how many more minutes she would have of life, I was obsessed with some technical problem like how many more minutes there were left in the tape. So it moved my obsession. It helped me to be there with her and in my idea she knew that the camera was there, like I was there.[16]

In an interview with Louise Neri, Calle describes how the techniques involved in making the work, filming her mother, and then turning this into an installation at Venice, provided a way of continuing and being in the present during such a difficult time:

> Bob [Robert Storr] knew I had filmed my mother's death and he suggested – and then insisted – that I deal with the subject. I didn't feel ready to watch the 80 hours of film that I had taken of her dying, but then I remembered the 11 minutes between her life and her death during which I was really wondering where she was. Once I accepted to do it, I had to put the footage on my screen to find the passage and edit it. So it became a kind of background while I lived and worked … And then it became a work – I was able to take distance with it. Then when I finally came to show the film in Venice I was busy with all the usual technical issues: sound, lighting, painting, and the size of the image. It was only when it was installed and I went to look at it that I realized that this was my mother, and I started to cry. (Calle in Blazwick et al. 2009: 154–155)

Here we can see how making this work provided a basic palliative technique: a way of dealing with such a difficult experience, whilst the objective filming eye provided a constant *presence* for both Calle and her mother. This presence affirms their continued desire to try to record and so grasp hold of every last moment of Monique's life, and to provide a constant companion during the passage of this moment. What the work shows, however, is that despite this continued desire, this moment is ungraspable. That the moment cannot quite be captured or recorded allows for an opening and sharing of sense, which is present in the artwork. This sense is our collective inability to grasp that moment, and the sharing of our exposure to its ungraspability.

For Calle (and her mother), this film, and the whole installation itself (particularly in the poem Calle wrote), seemed to provide a way of answering unanswerable questions, such as how do we prepare for death? How can we make the most of the time that remains, and not leave anything undone? How can we make something that provides a presence that will outlast what is about to become absent? How can we continue in the face of finitude?

Making art helped Calle think about these questions and make some tangible form of answering them, as it did for myself when I encountered what she had created. The artistic creation and its encounter can make sense, in making meaning from those fundamental matters of existence, which cannot be signified. This is the technique and real *work* of art.

Making this work seems so fundamentally basic, natural and necessary. The process – or technique – provided both a way of dealing with such a difficult experience and a constant *presence* for both Calle and her mother, in the objectivity of the filming eye which could record every last moment. Calle says how she was 'afraid to miss the last moment of the last word', and that the film became something that could capture the real itself that was so hard to face, in its imminent passing away.

In this way the work creates a *vestige* for Calle's mother's life, which provides a monument of Calle's love and care for her. This vestige is shared with those who encounter this work. Although the installation clearly involves a process of mourning, rather than trying to create meaning from mourning, or offering redemption for being-towards-death, the aura of this work is much more about living love and care. Despite showing on auto-repeat that ungraspable moment at which death occurs, the work does not labour here. The point is not to dwell on what we cannot access or an ending, but to share the vestige of a life and its constituting love.

Nancy writes about the vestige in *The Muses*, saying that the trace of the artwork is its contact with being. This is a testament to Monique's *being*, both as a vestige of her life and love, and – for all of us – as a sense of passage or the passage of sense. This vestige is Nancean in the way that the work is composed of the passage and *absence* of presence. What we see and share is the fact that she is gone. Nancy says that the essence of art is the way that it provides this kind of vestige:

> The passer by passes, *is* in the passage: what is also called *existing*. Existing: the passing being of being itself. Coming, departure, succession, passing the limits, moving away, rhythm, and syncopated blackout of being. Thus not the demand for sense, but the passage as a whole *taking place* of sense, as its whole presence. (Nancy 1996: 99)

The vestige relates to what Nancy writes about *The Evidence of Film*. Nancy describes Kiarostami's films from the perspective of the objective truth of the cinematographic gaze, and how watching these films provides the viewer with an exposure to the passage of the real (Nancy 2001: 15–19). In its certainty of capturing the reality it opens upon, the filming eye can record evidence of the presence of this reality (Nancy 2001: 57). Life is not recorded or retained, it passes. In this way, as one of Kiarostami's films is titled, *Et la vie continue*.[17]

Nancy's analysis of Kiarostami and film is directed towards 'the look' in terms of its direct contact and retaining of the present, the real. We could move this analysis to what it means to *make*, rather than just to look. What is important in Calle's artistry is how necessary it is to make in the context of her own life. This is clear in all her works – the reason she creates is not to make something that will be valuable or have meaning for others to view, as a radical artwork, but rather as an instinctive method for her own personal needs, and to provide herself with a technique of 'being in the present'.

Having become a 'professional' artist more by chance than pedagogy, Calle's art seems like a multimedia journal of her life experiences. Her artistic practice is based around the fact that its process and product, which might then (later) be exposed as an artwork, have a practical, cathartic effect on her life. Calle often describes how making art provides her with a kind of 'exorcism', which relieves what is troubling her and eases or placates her desires and obsessions. She says that she makes things because by doing so she can 'filling an absence', 'healing wounds' and 'improving life'.[18] Each work she creates is based around the transformative and therapeutic value that she gains from the process of making it. This is the patent sense of Calle's art.

The usual tone of Calle's work has been described as at once an intimate 'reality show' about the self and a frivolous game that brings the self into play (Savelli in Sauvageot 2007: 71). An example of this is seen in *Take Care of Yourself* (also shown at Venice, in the French pavilion), which was composed of over a hundred women's professional responses to a 'break-up' letter Calle had received from her (then) boyfriend, Bruno Racine. She asked 107 women to interpret this letter 'in their professional capacity', to help her get over this 'moment of rupture', and transformed the episode into an artwork (that was curated by a member of the public, whom Calle selected from respondents to an advertisement she had placed in *Le Monde*). Although some viewers may find the 'jeu' of the 'je' (or the 'game' of the 'I') apparent in much of Calle's work offensive, it remains clear that, as Sauvageot emphasizes (at the base of her somewhat facetious categorizing of Calle in terms of 'Chameleon art'): 'Behind the frivolities hide tribulations of work on the self, on the "we", on the human condition, on her frailty' (Sauvageot 2007: 15). This is the kind of fundamental tone, and need, that we sense in *Couldn't Capture Death*.

From the viewpoint of Calle's ongoing 'autoportrait' style, it becomes clear that nothing would seem more natural to Calle than to film such a monumentally personal occasion as the last moments of her mother's life. As a consequence, Calle's artistic techniques, which she uses to create her artworks, such as filming her mother, and turning this episode into an installation, provide her with a technique that has a transformative therapeutic and existential function, as a technique of 'being in the present'.

We also see this basic need to create as a method of being in the present throughout the work of Bill Viola. In an interview with John Tusa, Viola talks about how filming his mother whilst she was dying enabled him to continue and be present at such a difficult time:

> It was a necessity sort of for me in a way, I mean you just feel so helpless, here's your own mother in this state. [...] And video for me has by that time, 1990 had become my own life line to the world and I just felt that, I mean I had to do something I was going nuts [...] for me there was an image in front of me for the first time in my life that I could not understand, I could not accept, I could not grasp. It was like the forbidden image, the worst image that you could possibly imagine and I just had to not run away from that image or close my eyes to that image, but go right through that image. So I took out the camera [...].[19]

Here we can see another example of the transformative therapeutic affect that is provided by the practical process of filming. Viola used his artistic technique as

a method of being present at such a difficult time, in the face of the death of his mother. Talking about the making of *The Passing*, and filming his mother as she lay dying, he says:

> This is, I'm drowning and if I don't hold onto some line I'm going to go under. So that [filming his dying mother] was absolute necessity and I just went back home after that horrific event after the funeral and just took those tapes, it was like the little box of ashes, I just like put them in a little place on my shelf.[20]

Calle and Viola's use of art practice as an existential technique for dealing with a tragic situation helps us build the transformative therapeutics that defines how we make sense of the world. To crystallize this existential technique we need to think about how the artwork specifically relates to the process of mourning. To develop further our understanding of how art-making helps us deal with the loss of a loved one (or come to terms with loss, grief, suffering and pain more generally speaking), as is the case with Calle and Viola, I will now look into some psychoanalytically oriented research into the process of mourning.

3. Technique as a process of mourning

In the case of Calle and Viola, we can see that their creative process is a work of mourning, where mourning is defined (through Freud) as 'the reaction to the loss of a loved one' (Freud 1974 (Vol. XIV): 250). In this case, the artwork involves mourning, not as a dirge or elegy that laments loss, but as a process of celebrating life, and finding a method (or technique) to continue in the face of death. Filming and creating an artwork out of the mother's death provide a process of coming to terms with this lost loved one. Darian Leader discusses Freudian psychoanalysis, and Segal's psychoanalytic approach to aesthetics, in relation to several artworks by Sophie Calle, in *The New Black: Mourning, Melancholia, and Depression*. This book is important because of the way Leader demonstrates how the creative process involves mourning – for both the artist and the viewer/spectator: 'arts exist to allow us access to grief, and they do this by showing publicly how creation can emerge from the turbulence of a human life' (Leader 2008: 87). The artwork is made as a response to, and a way of dealing with grief, which can relate to any experience of pain, loss or suffering. Artworks then assemble in culture '*as a set of instruments to help us mourn*' (Leader 2008: 87, original emphasis).

To develop his hypothesis about art and mourning, Leader examines Calle's *Exquisite Pain* (Calle 2004). This work is an installation and book in which Calle compiles a 'dialogue of mournings', made in response to a dramatic ending of a love affair. Calle asked 99 people – friends and strangers – to respond to the question 'When did you suffer most?' Collecting other people's stories of pain and mourning helps Calle to process the degree of distress that the end of this relationship caused her.

In this case, and in *Couldn't Capture Death*, Calle creates an artwork out of the prospect of the *absence* and separation of the image of the loved one. The final artwork then symbolizes this lost object and it signifies absence. As Freud says, 'the loved object no longer exists' (Freud 1974 (Vol. XIV): 244). The process of filming was not necessarily about grief, since Calle's mother had not yet died, and it was not made with the intention of becoming a work of art (but as a technique of 'being in the present' at this difficult time). But the consequent editing and exhibition of the film as an artwork then involve the process of mourning. The artwork is then framed in response to mourning, so lack becomes an object (i.e. the artwork), whilst mourning involves the constitution of this object, in the artwork.

The artwork is powerful because it allows Calle to articulate her loss of her mother, and her mother's loss of life itself. This loss is an empty space, an absence (of the mother, of life). The process of mourning needs to frame such absence, which is made possible through the creation and exhibition of this installation artwork. We can see resonances here with Lacan's *object a*, defined as an object that has come into being in being lost. In the case of Calle (and also Viola), the artwork comes into being (and is exhibited) as a result of the loss or lack of the mother. The artist creates from a lack – not necessarily to replace what is missing, but to constitute something real and substantial in itself, to fulfil the psychical work of mourning.

Following Klein, Segal argues that through their work on mourning the artist achieves the difficult task of giving up the lost object and replaces it by a symbolic construction that takes the form of a work of art. This involves the sublimation of the depressive position understood as the elaboration of the mourning process, set in relation to the baby's relation and feelings towards the mother. Shifting emotions from aggression to remorse and love stimulate the artist's urge to create. The creative process is then *reparative*, since it resolves the struggle of anxieties and aggression prefigured by the loss of the loved object (i.e. the mother, or the breast). In the depressive position 'The predominant fear is that of the loss of the loved object in the external world and in (one's) own inside'

(Segal 1952: 191). From this position, artistic activity is grounded in the struggle to counter aggression: 'The wish to restore and re-create (the damaged object) is thus the basis of later sublimation and creativity' (Segal 1952: 191). Thence, the creative process can be seen as an attempt 'to restore and re-create the loved object outside and inside the ego' (Segal 1952: 197).

From this viewpoint we could argue that for Calle and Viola art-making is a reparative act, out of concern and pining for the mother. Reparation is a term introduced by Klein, indicating the loss of an object, which involves a reliving of the giving up of the mother/breast. Similar to Freud's notion of sublimation, reparation implies a work of mourning. Both terms lead to symbol formation. Klein and Segal both argue that through the production and incorporation of symbols the ego is enriched and strengthened. Although Calle and Viola's artworks are made in response to the forthcoming absence of the mother, the artwork is not necessarily a *symbol* that represents the lost mother (thus removed from her presence), but rather an ongoing and living vestige of her life and love. As we saw through Nancy, *Et la vie continue*. But we can still use Klein's notion of reparation, in the way it involves the restoration or renewal of a thing, a part or the self. In Klein and Segal, reparation is the driving force in the integration of the ego, in terms of its growth and adaption to reality. We can see this growth in the technique of 'being in the present' that is enabled by Calle and Viola's creative processes, whilst it allows them to exist and adapt to the tragic reality of the mother's terminal illness. From this perspective, reparation helps us build our ongoing notion of transformative therapeutics.

In object-relations theory, reparation is involved in the movement from the paranoid-schizoid position to the depressive position. Reparation concerns the recognition of one's separateness from one's parents, which makes possible the reparative attempt to restore their inner representations. This is emphasized in the case of Calle's creation of *Couldn't Capture Death*, since the work is about the ultimate separation between Calle and her mother (via her mother's death), whilst creating the work provided a method of restoring a living sense of her mother's life.

In this way, the artwork's reparative capacity provides a technique of 'being in the present' in the prospect and onset of loss, pain and suffering. Reparation involves the restoring and balancing of the emotions and struggles faced by the self, in the process of individuation and during the mourning procedure that this involves. This procedure is emphatic in Calle and Viola's works, which deal with mourning so explicitly. What is so interesting and powerful here is the technique of existence that art-making provides. To understand how this happens,

and develop the technique of 'being in the present' that art provides for (and beyond) Calle and Viola, we will now look through Heidegger's understanding of technology. We will then turn to Foucault's elaboration of the artwork as a living technique and care of the self to conclude *Making Sense at the limit*.

4. Technique as transformative therapeutics

Heidegger uses his 'The Question Concerning Technology' to sound a warning cry against the ecological dangers of modern, instrumental technology, whilst appealing for a more authentic and responsible understanding of the logic of the *technê*, which can provide a different way of thinking towards our existence. For Heidegger the essence of technology is not a mechanical instrument, but an artistic bringing-forth (or presencing, *'poiêsis'*), which enables us to touch and preserve our contact with the world.[21] The idea of *technê* concerns our interrelation with the unfolding process of reality (which, in a sense, is what he means by 'Being'), and bringing-forth something that testifies to this connection. He interprets technology as a way that 'Being' can reveal itself and be sustained. From this viewpoint, he is thinking about technology beyond the terms of technological instruments that dictate a common understanding of this term (which can have a corrosive ecological effect on the world), and instead as a dynamic way of being in the world (Heidegger 1977: 10–13, 30–34). We will return to Heidegger's understanding about the essence of technology in Chapter 8.

This way of thinking about technology seems to resonate in both Calle and Viola's work, because filming the mother's death provided such a fundamental technique of presence, and 'being in the present', to the point where the artist's sense of being seems to become synonymous with the technology they are making with, and it becomes their method of being there. In this way, utilizing technological instruments (such as the camera) re-appropriates their instrumentality into bringing-forth something *poietic*. This enables Calle and Viola to preserve their own contact with the world, and to some extent, their mothers'. It is as though the *technê* of filming (its technology and her technique) thus offers the artist a 'saving power', provided by an artistic appropriation of technology (Heidegger 1977: 34). This idea of 'saving power', which we can see through (and beyond) Calle and Viola, is the ameliorative value that is, as Heidegger puts it, the 'restorative surmounting of the essence of technology' (Heidegger 1977: 39).

In this phrase Heidegger means to say that the *poietic* process of 'bringing forth' – in a way such as Calle's or Viola's making a film – provides a 'turning' which is then an 'event of appropriation' (Heidegger 1977: 39). Heidegger's ideas may raise the problematic question of an 'Onto-theological constitution of metaphysics', but we can use his dynamic of thinking, and the ontological, *poietic* and restorative connection that it can show us about technology, quite simply: to impress how essential and fundamental the technique of making or bringing forth the work is for the artist, in terms of how it enables them to be there in the present as the moment passes. This technique then provides a transformative therapeutics.

The technique provided Calle with a mode of being, in the sheer face of finitude, as she watched her mother die. We see this again in Viola. Such a technique, in this way of thinking, seems to move beyond Nancy's 'technique of the present'; it is a technique of 'being in the present'. This hypothesis, and our extension of Nancy, is confirmed and extended even further by Benoît Goetz. In his interpretation of 'technique of the present', Goetz says that Nancy's theory about technique can be seen to present 'a technique of existence' (Goetz and Nancy 1999). Goetz elaborates this in his interview with Nancy, and puts it to him that his thinking about technique could even impart 'the order of a first ethics [...] *the art of existence,* or *the art of existing*' (Goetz and Nancy 1999). Nancy responds affirmatively to this idea, in terms of its place within his thinking, and describes its appropriate proximity to Foucault's thinking about a 'care of the self' and 'life as a work of art' (Goetz and Nancy 1999).[22]

Indeed, Foucault's work on 'techniques of the self' and the 'arts of existence' can develop the transformative therapeutics that defines how we make sense of the world and will enable us to tentatively intertwine the two threads of this chapter, which thinks about threshold and limit-experience sensed in the aesthetic encounter, and the consideration of art as technique. Foucault is particularly important because for him the constitution of the self is a technique, or an *art,* which is a question of *taking care.* Foucault calls *life* a work of art, requiring and involving a practical technique, by which he means 'those reflective and voluntary practices by which men not only set themselves rules of conduct, but seek to transform themselves, to change themselves in their singular being, and to make of their life into an œuvre' (Foucault 1990b: 10–11).

Foucault's account of the process of taking care and the practical technique of life *as* art brings us back to Calle, since her method of making art seems at once, in some ways, to provide a method and ethos of existing whilst 'her life, her œuvre' definitively sums up her artistry, process and existence

(Pacquement in Calle et al. 2003: 15). Calle's entire work seems based around blurring boundaries, whilst providing an ethos towards limit (as we sensed from *Couldn't Capture Death*). Art continues to provide Calle with a transformative therapeutics, or technique of 'being in the present'. Her life seems indistinguishable from her art – life feeds art, art is technique for life – in a way that persistently refigures limit. Whilst they continue to provide a fundamental technique for 'being in the present', Calle's artworks thrive on rethinking boundary lines – between identity and practice, artist and spectator, artist and curator, public and private spaces, fiction and reality, pleasure and pain, absence and presence, and so on. This is evident in the conflation seen amongst her life experiences, professional identity, artistic medium, source material and the final exposition of what she is producing. We find this exemplified by the way she advertised in *Le Monde* to find someone (potentially anyone) to curate her commission to represent France at Venice, and built this work, *Take Care of Yourself*, around *other* people's reactions to her ex-boyfriend's break-up call of 'take care of yourself'. Calle's aim for the artwork was to find out how she might be able to do just that. Here we find another specific instance of the transformative therapeutics sought for and provided by art practice.

We also see this merging between life and art, and the consequent technique that provides transformative therapeutics, throughout the work of Bill Viola. For Viola art-making becomes a practical method of making sense of the world. This is because he was born with a learning disability called 'Dysgraphia', where the brain interprets the world through pictures rather than words, so that the orthographic and motor skills of writing become impaired. From this condition he uses visual and sonic art, in particular the moving image and video, as a method of making sense, to see the world through images rather than linguistics or rhetoric:

> I remember struggling with trying to logically put together concepts and trying to form ideas in time in a way that was sequential and even to the extent that when I would go to the movies, even as an adult with my wife […] and I would have to lean over and go, what's going on? You know, because I just figured later and I'd always watched movies like that, I was being completely carried away by the imagery, you know, and I wasn't focused on what the characters where saying, and I wasn't really able to follow the plot too well.[23]

Here we can see how Viola makes sense of the world through images rather than words. His preferred medium of video audio-visuals then provides his method

of expressing how he interprets reality. In this way art practice continues to provide his method of being in and interpreting the present.

There is, then, clearly an interlinkage (or Nancean, deconstructed sense) amongst identity, profession and living habit, which is possibly the case for every artist. Certainly it is plausible to extend the idea that art provides a technique of 'being in the present' to all the cases considered in this enquiry, with Calle and Viola, and also Nancy's readings of Caravaggio and On Kawara. If we look at the situation in which these artists are making their works, it is immediately clear that their artistic practice provides a technique for fundamentally *being* in the present, which is then an agency for transformative therapeutics.

Taking this idea further through Foucault, it seems that art practice can provide both a *technology* and a *care* of the self, whilst the artwork consequently made and encountered is able to touch, articulate and maintain a limit experience of what is real. In Nancy we touch this limit during *any* aesthetic encounter, not just those that deal explicitly with death (as we have seen in the examples of Calle and Viola), so that every sensuous engagement with art presents the threshold of existence. What Calle and Viola add to this hypothesis is the way that their practices and artworks also offer an ethos towards limit and a question of care, or transformative therapeutics, in relation to the tragic, ineluctable fact of imminent finitude.

In this way the works we have considered in this chapter develop our primary hypothesis about art helping us make sense of the world, because of the way art practice provides for (and beyond) Calle and Viola a technique of transformative therapeutics.

Making Sense with the Pharma

This chapter responds to the 'disenchantment' of the contemporary world, as it is presented and critiqued by Bernard Stiegler. I use the term 'pharma' to account for pharmaceutics and the drug industry, and also the 'pharmakon', which is a dual-sided concept – used by Stiegler – that can indicate both a poison and a cure. Sourcing the curative pole of the pharmakon is the object of this chapter. Stiegler partakes in this search in *What makes life worth living: On Pharmacology*. The title of this book captures the extent of our situation: Stiegler says that the misery of the present (the 'disenchantment of the world') has led us to lose the sentiment to exist, and now we just don't know why life is worth living. This situation introduces our need for the curative pole of the pharmakon, whilst it also sets up the ambiguous and ambivalent notion of 'treatment' that is supposedly provided by the pharmaceutical industry, but actually (as we will see) feeds into the toxic malaise of the present.

To define the world's disenchantment I first examine Stiegler's description of the technological nature of the human, which is set in relation to the massive synchronization of our conscious minds towards incessant consumption, as it is exploited by marketing and hyper-industry. This situation is a 'symbolic misery' and defines the world's disenchantment. It involves the pharmaceutical industry because of the various pathologies (such as attention deficit disorder) that are forthcoming as a result of the commodification of our experience of time, through the capture and control of our attention. These pathologies are then arguably sustained by the manipulative policy behind contemporary medicine, which is more interested in dulling symptoms and conforming to the producer/consumer capitalist stereotype, rather than treating the underlying causes of illness.

I will then consider how Stiegler proposes to change this situation and 're-enchant the world', by introducing his notion of the pharmakon. I will present the roots of this concept in Plato, who uses it to describe writing, which Derrida

shows is subject to the logic of the supplement. Then I will look at Stiegler's understanding of the pharmakon – he uses it to respond to the symbolic misery and disenchantment of the present, and considers its signification in terms of technics. Stiegler uses the image of the pharmakon to talk about technics, since it allows him to take into account both positive and negative poles, in the way that technics can provide both a poison, or something destructive, and a relief or a cure. Sourcing a cure from the ills of technology, and the curative pole of the pharmakon, is the object of this chapter. After returning to Heidegger's understanding of the *poiêtic* roots of technics we will locate this cure from the artwork.

The search for cure leads me through D. W. Winnicott on the transitional object, which is a key concept that Stiegler uses in his consideration of just how the pharmakon can provide meaning and value for life, in relation to symbolic misery and the disenchantment of the present. Winnicott shows us how we can use an artwork to supply a resource for re-enchantment and the curative situation of the pharmakon. We see how art uses creativity and play to define meaning, sense and healing. Winnicott's psychoanalysis raises the clinical setting and leads us to consider the role that pharmaceutics has to play in the search for a cure. Here I consider whether, as Stiegler argues, the use of psychiatric drugs is amplified to make people functional members of the workforce, so that 'normality' is controlled or manipulated by capitalism and consumption.

The purpose of the chapter is to find further evidence to demonstrate how art practice can provide an agency of transformative therapeutics. This agency does not necessarily replace drugs, but it can provide a dosage of *care* and re-enchantment, which leads to (some degree of) healing for the subject. At the end of the chapter I will demonstrate this hypothesis by opening up the 'diachronic milieu' presented by the participative art of Hierophantes (the artistic collaboration of Yves-Marie L'Hour and Benoit Meudic). Here we will find a liberalized sense of time, free time, for spontaneous and interactive invention, imagination and play, which delivers a remedial situation for the senses.

1. Technics and the disenchantment of the world

To set the scene for this discussion of the pharma I turn to Stiegler's method of considering the human as a definitively technical being. This is an important way of thinking about the human because it enables us to consider the vast spread, speed and all-encompassing hegemony of industry (i.e. 'hyper-industry'), which

then defines the currently 'disenchanted' situation in the world, and shapes the development and evolution of this human.

Stiegler's critical project revolves around technology and the exteriorization of the human. Stiegler discusses the evolution of our sense organs and of technical prostheses, in terms of the advancements of those instruments and appliances (such as TV, DVD, MP3, CD, smartphone, laptop) that supplement and direct our lives, so they then replace and ultimately destroy our memory and nervous system. Stiegler wants to bring forward a genealogy of our conscious experience. He is interested in the forces in marketing, directed according to the synchronicity of consumer capitalism and hyper-industry, and the effects that they have on our conscious experience. He is trying to plot and map this experience in terms of coordinates that are temporal and prosthetic.

As we will see throughout this chapter, from his evolutionary hypotheses about epiphylogenesis, organology and tertiary retentions, Stiegler goes some way towards illustrating the effects that the technical age of capitalist consumer industry, and in particular the broad span and influence of the media, have had on what makes us human. Stiegler proceeds to analyse what he sees as the industrialization of memory and consciousness, in terms of the hyper-industrial direction or manipulation of the prosthetic instruments or appliances that supplement and replace our mental functions. Stiegler analyses the way we use objects to exteriorize memory and the nervous system, and how technological innovations and '*the machinic turning of sensibility*' affects, directs and controls our attention span (Stiegler 2005: 26, original emphasis).[1] He is interested in the effects of hyper-industry, through marketing and publicity campaigns, in relation to the conditions for our sensible and temporal experiences.

In *Technics and Time, 1: The Fault of Epimetheus* Stiegler brings forward the hypothesis that man has no origin and is essentially a technical being. The human is originally outside of itself, i.e. prosthetic: 'The being of humankind is to be outside itself. In order to make up for the fault of Epimetheus, Prometheus gives humans the present of putting outside themselves' (Stiegler 1998: 193). Here Stiegler refers to the myth of Prometheus and Epimetheus, which comes from Plato's *Protagoras*. This is a myth about the origins of living things. Epimetheus (whose name means 'afterthought') was assigned the task of passing out the assets for survival amongst all the animals, but he forgot to give human beings anything. As a result of this forgetting, his twin brother Prometheus (whose name means 'forethought') stole fire from Hephaestus and practical wisdom from Athena, and gave them to human beings. Stiegler uses this myth to demonstrate that there is an original relation between the human

and the technical, which is temporality. Man is the fruit of a double fault: an act of forgetting and then of theft. At origin there is fault. This fault is the default of origin or origin as de-fault: 'Humans only occur through their being forgotten; they only appear in disappearing. Fruit of a double fault – an act of forgetting, then of theft – they are naked' (Stiegler 1998: 188). This is a key point for Stiegler. He then says that politics, invention, religion and speech are all the effects of this de-fault of origin. The essential is the accident, the absence of quality.

Stiegler uses the term 'epiphylogenesis' to describe technology as a structural feature of the human. Epiphylogenesis indicates a sense of evolution that is not genetic, but constituted by those technological machines or appliances that support and define our memory, and constitute the exteriorization and replacement of the nervous system. The 'who', or the human, is defined by the 'what', or prostheses, the technical:

> *Epiphylogenesis*, a recapitulating, dynamic, and morphogenetic (*phylogenetic*) accumulation of individual experiences (*epi*), designates the appearance of a new relation between the organism and its environment, which is also a new state of matter. If the individual is organic organized matter, then its relation to its environment (to matter in general, organic of inorganic), when it is a question of a *who*, is mediated by the organized but inorganic matter of the *organon*, the tool with its instructive role (its role *qua* instrument), the *what*. It is in this sense that the *what* invents the *who* just as much as it is invented by it. (Stiegler 1998: 177)

The human is originally outside of itself, and is always already defined by prostheses and technology. Since Stiegler argues that technical prosthesis defines the human, the question concerns how to use these tools for good rather than harm, which is why, as we will see, he needs the two-sided concept of the pharmakon. Stiegler is trying to present the aesthetic history of the human, in terms of man's physiological organization (i.e. his body), his artificial organs (i.e. technological instruments, tools, objects and artworks) and his social organizations. Stiegler's 'general organology' involves a study of the history of these three dimensions. Organology is the science of musical instruments and their classification. It involves the study of instruments' history, their use in different cultures, technical aspects of how instruments produce sound and musical instrument's classification. Stiegler reinterprets organology as a way of thinking about the co-individuation of human organs, technical organs and social organizations. In *De la misère symbolique* ('Of Symbolic Misery') Stiegler uses his 'organological genealogy' to define the physiological changes, what he

calls 'tertiary retentions', or the exterior appliances or technological prostheses like telephones that carry our memory, have on our nervous system, and to define prostheses that supplement, and then replace, our organs (Stiegler 2005: 99 ff.).

Stiegler uses the term *transindividuation* to describe the formation of the human. The 'transindividual' refers neither to a singular individual nor to a collective, but it is the co-individuation of the 'I' and 'we' in a pre-individual milieu. Stiegler uses Simondon's understanding of individualization to consider the individual as a permanent state of becoming that is the process of individuation, in relation to other singularities in their own processes of becoming, and the gathering or formation of milieu of co-individuation.[2] Stiegler introduces transindividuation as the conclusion of *Technics and Time 2*: 'All "consciousness" is itself temporal and consequently awhirl; [...] caught up in a whirling flux that is *already-there*, prosthetically supported and synthesized and more broadly, that should not be called "intersubjectivity" but, as we learned from Simondon, *transindividuation*' (Stiegler 2009: 243).

Stiegler argues that the situation of the transindividual is immediately technical, and must be considered in terms of the prostheses that influence and define our consciousness. He is thinking about how we become individuals. This involves examining our primary and secondary retentions, which Stiegler takes from Husserl to mean what we perceive and remember in the temporal flux of consciousness, and what Stiegler calls *tertiary* retentions. It also involves considering how our retentions are in fact selections, and how they then constitute our individuation. Stiegler is interested in temporal objects, such as music, because of the way they constitute our consciousness, by appearing to collapse and disappear in the measure that they come to presence. When we watch a film or the television, during the time that we spend watching this edition our consciousness collapses into and adopts the time the temporal object narrates. We can suspend our conscious sense of time and enter the time of the film. Because of this structure of temporal objects contemporary culture industries force us to adopt the time of consumption: we are synchronized into the time of advertisements by marketing.

Stiegler analyses the way industry influences our consciousness, replaces our memory, directs our knowledge and actually constitutes time. Stiegler says that the present is shaped by hyper-industry, marketing and consumerism, under what Deleuze calls 'societies of control' (Deleuze 1995: 240–247). This is a key notion seen throughout Stiegler's critical project, and in particular in *De la misère symbolique, 1*, where he uses Deleuze to show just how the

'symbolic misery' of being human is 'what engenders "societies of control"' (Stiegler 2004: 14). Here Stiegler refers to a late piece that Deleuze wrote near the end of his life, in 1990. Stiegler uses this notion to refer to the contemporary situation of the social, arguing that this is manufactured by marketing, which is the instrument of social control, where the individual is subsumed into the mass marketplace of consumerism, and their fundamental sensory and temporal existence is controlled and manipulated by societies of control. Stiegler retrieves these ideas from Deleuze, who brings forward the idea of societies of control to define the present, as a contrast to what Foucault called 'disciplinary societies' of the eighteenth and nineteenth centuries. Deleuze says that societies of control replace disciplinary societies, where control refers to what Foucault would call our 'immediate future', i.e. the present situation for Stiegler's analysis. In societies of control, Deleuze and then Stiegler argue, individuals become hyper-synchronized 'dividuals' and are subsumed into the masses. Deleuze says that societies of control operate by computers, where technological evolution involves a mutation of capitalism, and where marketing becomes the centre of corporations of power (and their corruption). The operation of the markets then becomes 'an instrument of social control' (Deleuze 1995: 245).

This results in a proletarianization, which means a loss of knowledge, or a different kind of distribution of existential energies (the existence of producers and consumers). Stiegler says that Simondon argues that proletarianization consists of a loss of knowledge in relation to techniques of production, or a loss of *savoir-faire* (know-how or job skills) (Stiegler 2005: 53–54). Stiegler then argues that in the twentieth century proletarianization changes from being about production to consumption, so it becomes a loss of knowledge of the techniques of living, which Stiegler refers to as the loss of *savoir-vivre* (social or life skills) (Stiegler 2005: 148). Consumption involves capturing and sublimating the libidinal fruits of desire. As the consciousness of the masses becomes *hyper-synchronized* onto consumption, primordial narcissism is destroyed, which prompts a loss of individuation (Stiegler 2005: 126).

Stiegler's genealogy of our conscious sensory experience is set in relation to the technological infrastructure of societies of control, which results in the destruction of primordial narcissism, from the channelling of consumers' libido through the objects of consumption. Stiegler describes our consequent symbolic misery by thinking about the loss of individuation in the age of hyper-industry. It is not consumption that is the problem here, but hyper-synchronization, since this involves the colonization of the temporality of consciousness by

marketing. We can see this when Stiegler looks at how individuation is changed in hypermodernity, or the hyper-industry, because of the ways that marketing controls the time we are conscious, and what we do in our conscious lives, by the machinization of everyday life (Stiegler 2004: 19–20).

All this so-called misery provides further evidence of the disenchantment of the world. To look further into the effects of the synchronization of consciousness, I will now consider the role that pharmaceutics has to play in resolving and/or causing this miserable situation.

2. Disenchantment and pharmaceutics

When people watch the same event on the television, at the same moment, millions of consciousnesses around the world are interiorizing, adopting and living the same temporal objects at the same moment. As a consequence of our audio-visual consumption our libido is destroyed. Stiegler says that TV has the vocation to synchronize individual times of consciousness to constitute the world markets (Stiegler 2004: 176). TV tends to liquidize the diversity of individual secondary retentions, and turn them into a sort of synchronized singularity of looking onto the images. Audio-visual technology permits the channelling and control of individual protentions; it then exploits them. Here tertiary retentions are objective memorizations or technologies of memorialization. According to Stiegler the exploitation of tertiary retentions, by marketing and hyper-industry, affects our libidinal economy and hurts our conscious lives (Stiegler 2004: 125). Stiegler then discusses the way that TV synchronizes individual times of consciousness in terms of the world markets (Stiegler 2004: 150). As a consequence, audio-visual technologies have the capacity to control, exploit and channel individual protentions.

This economic manipulation of the psychic processes leads to pathology. As we are adopted to and adapted by the time of the program industry, whilst our existential energies are strapped to mimetic, consumptive behaviour, we lose the ability to think for ourselves. We have no more 'free time', or otium, since our entire conscious awareness is seized and manipulated by the hegemonic systems of control that direct how we pay attention. This *deprivation of individuation* becomes pathological when we lose our ability to form 'deep attention'. Stiegler cites Katherine Hayles' work on the difference between deep and hyper attention here, to argue that the massive growth and grasp of psycho-technologies and media stimulation have adverse effects on the brain. This results in attention

destruction that creates 'a collective pathology with many diverse, harmful consequences' (Stiegler 2010: 94).

Cognitive illnesses such as attention deficit hyperactive disorder (ADHD) in children, or cognitive overflow syndrome in adults, are arguably caused by the media and audio-visual technological industry. As a consequence, Stiegler then argues, the capture and destruction of attention is all-pervading, inescapable and destructive, extending so that our contemporary world is characterized by 'a *global attention deficit disorder*' (Stiegler 2010: 57, original emphasis).

The pharmaceutical industry responds to this situation by prescribing and marketing attention-deficit drugs such as Ritalin. This is a cortical psychostimulant, prescribed to treat disruptive behaviour, inattention and hyperactivity, by influencing a part of the brain that changes mental and behavioural reactions. Attention-deficit drugs may increase concentration in the short term, but their use (and misuse) by the pharmaceutical industry has been enormously controversial. ADHD is a particularly divisive problem in medical debate and the public sphere since its diagnosis and (so-called) 'treatment' have escalated dramatically: in 2012, prescriptions for ADHD drugs in the United Kingdom had risen 50 percent in six years.[3] When given to children over long periods of time, these drugs have been seen to have serious side effects (such as stunting growth, or later substance abuse), whilst it is not always evident that they improve school achievement or reduce behaviour problems.[4]

The relation between mental illness, pharmaceutics and capitalism has been debated profusely in the media. It is clear that increasing numbers of people are misdiagnosed and/or overmedicated. This fact is to some extent the fault of the pharmaceutical industry, which is seeking to market the latest brand of 'happy pills' to resolve any psychiatric illness, *qua* (mere) chemical imbalance. It has been argued that the pharmaceutical industry distorts and conceals data from trials of their products in order to maintain their hold of profit margins.[5] As a consequence, many supposedly miraculous medications turn out to be no better than, or even more dangerous than, their less-profitable predecessors. Widely prescribed, these medications are immensely profitable, but their efficacy is highly questionable.

Mark Fisher's polemic *Capitalist Realism: Is There No Alternative?* argues that the 'chemico-biologization' of mental illness, or the pharmaceutical industry's diagnosis and supposed treatment of mental illness according to a reductive (mis)logic of chemical imbalance, is a schema that maintains and feeds into the capitalist economy (Fisher 2009: 37). Oliver James presents the same argument in his own polemical account of capitalism's caustic

consequences on the mind and our being in the (disenchanted) world. As a result of our hyper-industrial zeitgeist, or the capitalist societal synchronicity we are consumed by in the twenty-first century, we place an increasingly high value on money, possessions and appearances, fed by a mentality of keeping up with the Joneses, or maladjusted social comparisons. James argues that this puts us at a statistically greater risk of suffering a common mental illness such as depression, anxiety, substance abuse or personality disorders. In order to maintain the libido for consumption, the economy then has to feed and sustain mental illness, which it does by marketing psychiatric drugs (which become yet another attractive thing to desire and consume). This is, James says, *Selfish Capitalism*, whereby 'the economic model of the last thirty years has created an epidemic of depression'.[6]

In this way, our consciousness and libido become directed and subsumed by consumption, at the limit of capitalism, until it becomes the sole function and operation of our lives. Returning to Stiegler, we can see the link between the cannelization of attention, mental illness and pharmaceutics (via capitalism):

> This channelling of the libido, operates through attention capture, leads directly to the liquidation of consumers' skills [*savoir-vivre*] [...] This destruction of desire (and of attention and care) is a new limit encountered by capitalism, not only as a mode of production but as a mode of consumption (as a *mode de vie*, a way of life). (Stiegler 2010: 47–48)

We can see how the overwhelming and manipulative sweep of technics by marketing, through hyper-industry, has led us to the misery of the present. Stiegler says we have arrived at a 'malaise' of civilization. He uses the view of Paul Valéry, who was writing around the time of the World War I, and defined the world according to what he called the 'crisis of mind or spirit' (Valéry 1931). We have military, economic and spiritual crises: our bodily organs are shaped and fed data from the manipulation of marketing, whilst a system of artificial organs replaces and demises their function in the new hyper-industrial age. Meanwhile we develop mental illnesses that respond to and are nourished by the pharmaceutical industry's role in the hegemonic, capitalist economy. Here is the disenchantment of the world.

In response to this situation, in 2005 Stiegler assembled a group of intellectuals under the slogan of 'The Re-Enchantment of the World', which became the slogan for a project which aimed to present a different kind of understanding of the mind as well as a re-evaluated organization of the economy, in response to the consumer capitalism, hyper-industry and societies of control that define

the present (Stiegler 2006: 12).[7] Stiegler, with Georges Collins, Marc Crépon, Catherine Perret and Caroline Stiegler, then founded Ars Industrialis as an association which could provide the agency to *passer à l'acte* and which proceeded from this quest to re-enchant the world, and the idea that today philosophy must lead a new combat: 'It is to lead this struggle that the association *Ars Industrialis* was created: to find the new philosophical arms needed for this political combat' (Stiegler 2006: 21).

The aim of Ars Industrialis, to re-enchant the world, proceeds from and responds directly to the symbolic misery and disenchantment that is perceived in the present. Stiegler's own understanding of the present begins from this misery, which is, he says, a *'crisis'* (Stiegler 2013: 28). Stiegler's critical project is set to analyse this crisis, provide a telling critique of the situation that gives rise to it and of the problems and changes that it raises and also, with Ars Industrialis, to generate agency and actually change it.

This effort does not mean to solve the problems raised by the pharmaceutical industry, specifically, and it is not explicitly concerning itself with any problems that might be raised in medicinal practice. Rather, it is looking at the underlying logic and economy that directs and remunerates this field. Stiegler is trying to instigate a new method of thinking and an agency that can promote change. To do this, he utilizes the notion of the pharmakon, as a dual-sided concept that can indicate both remedy and re-enchantment in response to the symbolic misery and disenchantment of the present. The concept of the pharmakon is particularly relevant and applicable in relation to pharmaceutics since it refers to medicine, remedy or cure; whilst it can also be seen to be the reverse of these remedial synonyms and provide an effect that is dangerous or even poisonous. We can see that pharmaceutics are an example of the pharmakon, since the drug industry is supposed to provide medications to *cure* illness, whilst these medications often have detrimental, toxic consequences. What I am terming 'pharma' refers to the intertwining and libidinal energy that exists between these two opposing poles. This needs more thought.

3. The pharmakon

In this section I move away from the pharmaceutical industry to look further at the pharmakon, *per se*. I will present the origins of this term in Plato (via Derrida). After defining the term, and considering its origins and possible agency, I then interpret it (as Stiegler recommends) as technics, looking

through Heidegger. This interpretation allows me to draw out an artistic appropriation of the pharmakon, so that it becomes possible to source and activate its creative essence by turning to encounter and participate in a performative artwork by Hierophantes. Here we will (eventually) source a dose of remedy and *care*; this does not *replace* the ongoing need for (successful) medication, but it offers a dose of *care* and transformative therapeutics that does indeed provide a remedial venture.

Stiegler describes the pharmakon in *What Makes Life Worth Living: On Pharmacology*. He uses the pharmakon to consider just how we can restore sense and (as Deleuze put it) 'believe in the world' again, in consideration of its inherent disenchantment.[8] He says that we have hit 'rock bottom', and then asks: how can we go on? What on earth makes life worth living? (Stiegler 2013: 77).

Stiegler takes the pharmakon from Plato through Derrida, and uses this concept as a way of understanding modern technology. This view is extended in his book on the pharmakon, where he asserts that human destiny is definitively technical and, as such, pharmacological.

The pharmakon is a way of describing something that is both positive and negative. The term originates from Plato's *Phaedrus*. In this work Plato uses the concept of the pharmakon to describe writing, in order to imply that writing is both poison and cure. He does this by designing writing as an artifice and memory aid. In Plato's interpretation, this means that writing makes us actually *lose* our memory by replacing this function of our minds.

Derrida analyses Plato's use of the pharmakon as writing in *Dissemination*. Here Derrida shows how ambivalence is at work in the pharmakon, when it indicates a substance or drug that provides simultaneous medicine and poison (Derrida 2004: 98–118). In Derridean terms the pharmakon provides the medium and site for the production of difference. Derrida sources the term in Plato's *Phaedrus*, where it is used to describe a remedial 'prescription', where the pharmakon means writing, in terms of something like a text of publicity, or an advertisement, which can entice someone to come into the city; or a critique, which recommends that they should stay away from it. Derrida is here examining the double structure of the concept of writing in Plato, showing how its negative coding, in terms of the way that it replaces and so destroys the function of memory, is tangled up with its positive, useful and remedial coding, of providing an access to knowledge. These two opposing implications of the pharmakon demonstrate its purpose as the locus for difference, which is why Derrida is using it. Derrida quotes the section in *Phaedrus* where Socrates is talking to Phaedrus about the surrounding area:

> Forgive me, my good man. You see I'm a lover of learning, and the country places and the trees won't teach me anything, as the people in the city will. But you seem to have found the *prescription* (pharmakon) to get me out. [...] you seem to be capable of leading me round all Attica and wherever else you please by proffering me speeches (logoi) in books all the way. (230d–e, my emphasis)[9]

Here the pharmakon as writing replaces memory; Derrida says that its paradoxical operation is foreign to dialectics, which is why, he says, Plato is seeking to control it: 'Insofar as writing *lends a hand* to hypomnesia and not to live memory, it, too, is foreign to true science, to amnesia in its properly psychic motion, to truth in the process of (its) presentation, to dialectics' (Derrida 2004: 110). In this way Derrida shows how Plato's associating the pharmakon with writing is subject to the logic of the supplement. As both poison and cure, the pharmakon is structured as a supplement. This is because the supplement has two meanings – it is both originary and additional. By this logic writing is structured as secondary, external and compensatory, and it substitutes (thus replacing and destroying) writing or memory. As Derrida writes in *Dissemination*: 'The *pharmakon* is that dangerous supplement that breaks into the very thing that would have liked to do without it yet lets itself *at once* be breached, roughed up, fulfilled, and replaced, completed by the very trace through which the present increases itself in the act of disappearing' (Derrida 2004: 113).

Derrida uses the pharmakon as a concept that juxtaposes contradictory elements, where both oppositional elements hover as constitutive *différance* amidst their differing and deferring significations, in continual, contrasting juxtaposition outside the dialectic system. From this perspective:

> The *pharmakon* is the movement, the locus, and the play: (the production of) difference. It is the differance of difference. It holds in reserve, in its undecided shadow and vigil, the opposites and the differends that the process of discriminations will come to carve out. Contradictions and pairs of opposites are lifted from the bottom of this diacritical, differing, deferring, reserve. (Derrida 2004: 130)

Here we can see how writing can provide an instance of the pharmakon. In Plato's understanding of the pharmakon, it is used as an image to refer to writing. Writing is Plato's example of a technology as a dangerous aid. This technical dimension is important for Stiegler. It is useful to pause here and think about what a pharmacological understanding of technics means. Certainly we can see how the pharmakon in Stiegler is a technology. Stiegler says that the *destiny* of human life is ineluctably technological. To gain a clearer

sense of this and to think further about accessing agency from the pharmakon we can look through Heidegger's 'Question Concerning Technology'.[10] Can we source the two poles of the pharmakon from Heidegger's understanding of technology? Will thinking of the pharmakon through technology provide re-enchantment?

4. Technology and remedy

In *The Question Concerning Technology* Heidegger talks about the way humans view, manipulate and exploit everything in the world in terms of its utilization or production. The picture he presents of the world, in terms of a modern and instrumental violation of technology, seems to provide more evidence of the disenchantment we have mapped through Stiegler. Heidegger uses the word 'enframing' to talk about the essence of technology (Heidegger 1977: 10). We can think of enframing as further proof of the world's disenchantment. From an enframed viewpoint, everything is considered in terms of its instrumental 'orderability' or 'standing-reserve' to be produced and consumed – in the whirlwind of what Stiegler calls hyper-industry (Heidegger 1977: 17). Heidegger then argues that such *marketing* destroys both the intrinsic value of ontic objects, as beings, and our own fundamental relationship with Being, or the unfolding process of reality, by the way we misuse and abuse them. From an enframed attitude we use technology to set everything in place as 'ready-to-hand' supply, or as equipment for utility. From this, he argues, our awareness and connection with the real is blocked and our existence impoverished. The ultimate threat of this disconnects *Dasein* from Being, or the unfolding process of reality, since man himself becomes an instrument, sucked into the vicious cycle of orderability.

Heidegger explains it further, saying that it is '*destining*' that sets enframing in motion and fuels the consideration and utilization of everything as 'orderable' or 'standing-reserve' and, in that, enframes Being (Heidegger 1977: 37). With this term 'destining' Heidegger means to incorporate skill and destiny, meaning to define the way that destining enframes *Dasein's* dangerous attitude to technology, which then enframes Being. Here is the danger: '[...] when destining reigns in the mode of Enframing, it is the supreme danger. [...] As soon as what is concealed [... does so] exclusively as standing-reserve, then he comes to the very brink of a precipitous fall; that is, he comes to the point where he himself will have to be taken as standing-reserve' (Heidegger 1977: 26–27).

But, alongside this danger, Heidegger argues that enframing can also bring our awareness towards this threat. Enframing can stimulate a process of consideration which instigates a more healthy relationship of *Dasein* as being-in-the-world by considering the subject and its effects on Being. Heidegger says that this *thought* is the only positive way forward in a society that is irreversibly enframed, or disenchanted. He says that when we recognize this danger, enframing has provided us with the meditative process that can raise our thought beyond it. Therefore enframing is simultaneously the danger and, by prompting this reflection, the 'saving power' – a dialectic that forms a major part of Heidegger's methodology and reflects the pharmakon that we are trying to source. Heidegger quotes Hölderlin: 'But where the danger is, grows/The saving power also' (Heidegger 1977: 42). Here in Heidegger we have moved from 'The Question Concerning Technology' to 'The Turning'. What is useful for our discussion is the way that, for Heidegger, it is *art* that can provide agency here.

Heidegger returns to the artistic origins of the word *technê* to assign where the true, authentic essence of technology is and where the 'essential reflection' and 'questioning' upon it that he recommends should be directed: 'Such a realm is art' (Heidegger 1977: 35). He says we should regain the *poiêsis* of *technê* and recover its creative roots and the original responsibility towards materials and towards Being, bringing forth a less-destructive sense of *alethêia* or truth.[11] Stiegler argues that Heidegger sets up an opposition here, between the 'authentic' and the 'instrumental' understanding of technology (Stiegler 1998: 141). He challenges Heidegger by saying that not only is technology essentially instrumental, but it also constitutes how we exist in time. But, as we will see in the next part of this chapter, Stiegler's challenge to Heidegger's understanding of technology might be expanded and developed, if we use the technical instrument to provide the *poiêsis* of an artistic medium.

5. Transitional object and creativity

Thinking about the pharmakon in terms of technics, and looking through Heidegger, we may have found a potential agency for re-enchantment in the artwork. This can also be found in Stiegler's appeal to D.W. Winnicott in *What Makes Life Worth Living: On Pharmacology*. In this work Stiegler introduces the pharmakon as a basic *existential* problem, arguing that not only do we have the disenchantment of the world, which is a problem of the economy and politics

of capitalist hyper-industry, but we have also lost the feeling that life is worth living. This is where Stiegler begins his efforts to make reality otherwise. He says that the heart of his search for the pharmakon lies in psychoanalyst Winnicott's notion of the transitional object.

Winnicott develops the transitional object in his model of object-relations, to account for the psychological development of the child. It is an object (such as a soft toy) adopted by the young child, which demonstrates their first 'not-me' possession or attachment. Stiegler calls it the first pharmakon because of the way that it can be both harmful and comforting to the child. As the child's first possession it represents their transition from a state of being merged with the mother, to a state of being exterior to the mother, who then becomes recognized as something separate and outside. The transitional object becomes a substitute, which makes up for the mother's less-than-perfect adaption to the infant's needs. It provides an intermediate area of experience, which allows the child to begin to form a relationship with external reality beyond the mother. This intermediary area of experience, unchallenged in respect of its belonging to inner or exterior reality, constitutes the greater part of the infant's experience. Winnicott says that the transitional object involves the task of reality-acceptance that is never completed, since no human being is ever free from the strain of relating inner and outer realities. Relief from this strain is provided by the intermediate area of playful experience, motivations, drives and attachments that are provided by engagement with the transitional object.

Every human being is concerned with this existential problem of experiencing and judging the relationship between the inner and outer worlds. We all strive to resolve the opposition and difference between the object or thing that is phenomenologically perceived and the subjective or inner conception of this experience. The transitional object, as a pharmakon, locates the initiation of this problem. It represents the relationship between the child and the world. Winnicott says that in this way the transitional object retains its importance throughout life, and then provides the source of intense creative experiences of the arts, religion and scientific discovery (Winnicott 2005: 7, 18).

Winnicott is interesting for Stiegler because of the way he gets outside the inner life of the human. Winnicott uses and integrates what is exterior, where the transitional object is exterior to and defines the human. Stiegler can then use this to provide source material for his ideas about exteriorization, tertiary retentions and prostheses. From the transitional object comes the 'intermediary area' or transitional space, which is neither inside nor outside, but – as their interconnection – constitutes the *relation* of the object to the subject.

Stiegler says that the pharmakon as the transitional object is the starting point for the formation of a healthy psyche, transindividuation and growing up to adult life. Stiegler draws from Winnicott's claim that the transitional object then provides the source of all cultural experience (Winnicott 2005: 135) and says that it is, as the pharmakon, the origin of artworks, and of *all* objects:

> [...] the transitional object does not only concern the child and mother: it is also, as first *pharmakon*, the origin of works of art and, more generally, of the life of the mind or spirit in all its forms, because an object is always that which, once upon a time, appeared to a mind that *projected* it. (Stiegler 2013: 3, original emphasis)

After showing how the transitional object, and so the pharmakon, locates an 'art de vivre', which Winnicott calls 'creativity', Stiegler then moves his analysis to see how we can use this notion to deliberate and *move* the current crises and disenchantment perceived in the world (Stiegler 2013: 41; Winnicott 2005: 71 ff.). The pharmakon becomes a matter of transformational technologies, grammatization and the production of tertiary retentions and hyper-industry. For Stiegler this is both a matter of defining and effecting the zeitgeist of our contemporary era and an effort to present a new understanding of the human, in terms of *technê*, exteriorization and prosthesis.

But what remains important about the transitional object is the role it has to play in our ongoing search for cure and remedy. In terms of pharma, the transitional object can also be understood as a pharmakon in terms of the mutual usage of psychotherapy and psychopharmacology in the treatment of the patient. Psychotropic medication has symbolic, economic, cultural and commodity functions in the intermediary (or transitional) space between the doctor and the patient, which means that the 'happy pill' is the nodule point of the dyad's interaction and negotiation, in the name of treatment (Metzl and Riba 2003: 45–48). The usage of medicine as a transitional object also plays an important role in the theatre of transference and counter-transference between the doctor/therapist and the patient.[12]

In Stiegler's argument, the question of the pharmakon calls for a question of *care*. We must take care – in the prescription and consumption of pharmaceutical drugs, and as we tread the rocky path and try to pay attention through our disenchanted world. Thinking about *care* will help us build our notion of transformative therapeutics, especially when it is sourced by the creative process of art-making.

In his work on the pharmakon Stiegler thinks about how we can indeed take care in terms of the political economy. He says that it is not only a question of

ethics. Stiegler goes on to present his 'economy of contribution', which, he says, provides the new economic system that we need for re-enchantment (Stiegler 2013: 54–56). Stiegler says that taking care involves the pharmakon, which is a question of thinking about attention in terms of '*therapeuma, epimeleia, cura* [...] the generating of systems of care' (Stiegler 2010: 173). Here we can see that there is a transformative therapeutics in the pharmacology of attention. Taking care means to cultivate, transform and improve; it concerns the therapeutic and curative pole of the pharmakon:

> [...] taking care, *stricto senso*, means to *cultivate what it means to take care*, to make it productive, and in that sense to transform it in order to improve it through the effort of taking action intermittently, which Aristotle calls *noêsis*. To take care, to cultivate, is to dedicate oneself to a cult, to believe there is something better: the *non-inhuman* par excellence, both in its projection to the level of ideas (consistencies) and in that this 'better' *must* come. This is exactly the *ethos* for which techniques of the self are required [...]. (Stiegler 2010: 178–179, original emphasis)

But the question remains as to how we might be able to source any system of care or these curative qualities. All we see in the present is our symbolic misery. We are still trying to answer the question that Stiegler raises in his book on the pharmakon, namely how can we make life worth living? How can we re-enchant the world? Looking through Heidegger we have seen further criticism of the world's disenchantment and a potential appeal to a more artistic interpretation of the logic of *technê*, from which we locate the pharmakon. So how can we interpret the pharmakon to provide remedy, rather than poison, and what might that mean in terms of Stiegler's ongoing aim to *re-enchant the world*? How can we *Take Care* with the pharmakon, and where can we source the agency of transformative therapeutics?

Like Stiegler we can follow Winnicott's understanding about how vital art and creativity are to defining life's meaning and our being (Winnicott 2005: 87, 91). We can see how art provides a care-full agency for making a difference in lieu of the ills caused by hyper-industry, marketing and consumer capitalism.

The installation-performance of Hierophantes at the second Making Sense colloquium, which was held at the Centre Pompidou in 2010, provides its participants with a remedy, through its artistic and Heideggerian, i.e. *poietic*, use of computer technology. The technology of this artwork conditions its manufacture. We can look at how this work uses its technology and interactive medium to provide participants with the kind of sensuous and transformative therapy, care and otium that we all need in our symbolic misery at this

disenchanted world. Otium denotes a periodic sense of time that is truly *free* for leisurely activity (or non-activity). In the disenchanted world we have no free time, since our consciousness is pathologically subsumed into consumption 24/7. By attending to this artwork, we will find a liberal, diachronic (rather than synchronic) sense of time, which will enable the transformative potential of the aesthetic experience as a method of making sense of the world.

6. Taking care *In-Existence*

In-Existence § 1: Becoming Myst is a performance-installation artwork by Hierophantes (the artistic collaboration of Yves-Marie L'Hour and Benoit Meudic), which was enacted at the second Making Sense colloquium at the Centre Pompidou in 2010.[13] It is a new and immersive medium which uses technology to create what we can, using Stiegler's terms, call a 'diachronic milieu' for its participants, which provides a sensuous therapeutic experience that exposes the curative and enchanting elements of the pharmakon.[14]

I use the term 'diachronic milieu' to describe the time of consciousness that is opened for those who take part in this performance-installation-environmental artwork, one that is not hyper-synchronized on consumption, but participative, interactive and diachronic. This experience differs and develops for each participant, whose involvement then constitutes and creates the work.

This artwork creates a liberal, *transitional* environment for play, invention and making sense that fulfils the pharma we have seen in Winnicott's model of object-relations. This is because the diachronic milieu of participating in *In-Existence* provides a transitional space that exists between and as a product of the interaction of all of its participants. This space is for imaginative expression, experimentation, play and interaction, where each member of the audience is a performer: we exist as separate entities and come (and belong) together during the site of creativity that is opened by the artwork.

I argue this point because of the way that this artwork involves audience participation. It is made up of the times that it has been performed and the way that the audience enter the work, react to Hierophantes' own performance and themselves perform, so that the work changes according to who is participating and the location it is presented in. It provides an interactive and creative use of technology in the time of consciousness of its experience, which is repeated in various locations. The repetition is the way that Hierophantes repeat the

presentation of this diachronic milieu at different locations and for different audiences.[15] It changes with each. With repetition there is difference (which is the being of repetition).

The work is created as the installation of a multimedia environment of projected moving and three-dimensional, high-definition images and surround sounds. It consists of synthetic videos projected onto a semicircle of three stereoscopic transmission screens (one at the front of the room, two on the walls on either side). These screens show abstract images that are constantly changing (at a speed of 25 frames a second) organic visions of colour growing like psychotic hallucinations, set against the ambience music of electronic percussion sounds, whose beat and timbre shift and develop with the lights' constant evolution.

The sound and images envelop the space and present an immersive and visionary environment in which the viewer performs, in harmony with Hierophantes. For this performance is a dance – Yves-Marie L'Hour and Benoit Meudic move with the music and, facing the audience, lead them into what becomes a communal dance and the dispersal and sharing of sense, as we move in time and play together. The artists – and here, as Joseph Beuys would say, we are all artists – are controlling these sounds and the lights by the movements of their dancing. This works via the technology of the interaction system and wifi of an infrared motion-tracking programme that responds to the movements of participants in relation to the specificities of the space, so it changes and develops according to how participants respond to Hierophantes' dancing and their vision of the world.

By entering the environment of this work we plunge into another world, where organic images move and develop by responding to our movements, in a constant cycle of the blooming, fading and rebirth of microcosmic patterns. These patterns envelop the space and move in time to the queer electronic sounds, which sometimes sound like an oriental meditation ceremony, other times like a mathematic percussion beat; the clicking cadence providing a soundtrack to the rattling movement of these images.

Experiencing this artwork is like bursting free into the infinite, intricate dimensions of a black hole in outer space. I sink into the lights which pierce the dark aura of the room where this performance-installation is occurring. There is a soothing saturation of the sounds and images, we dance in time to them. I move to the music because it seems the most natural and needed thing to do, following the two artists, who lead us and become our guides in this ritual. It is as though Hierophantes are like Hermes, the messenger god, who goes down to the underworld and comes back from the darkness with visions for the mortals.

These visions have a beat, which is absorbing and immersive – they become part of us as we all respond, and move together. This is at once something very old, like the Eleusinian mysteries of ancient Greece, with their sacrifices and purification rituals.[16] It is also something oriental, and even older, since the shapes and patterns of the images echo Taoist and Mahayana abstract imagery. It is also something fundamentally contemporary, produced and made possible by the technology of our digital age.

The piece lasts about an hour and is composed of three movements. The first movement is like an introduction, immersing participants into this strange new world of abstract images and sounds. Hierophantes dance and show us how we can move our bodies in response to this eruption and inundate of sense-data. It becomes like a ceremony for the senses. Soon the images and sounds gather momentum, and in the second movement they have a rhythmic and aggressive rapidity. Hierophantes move their bodies with orgasmic zest – jumping and dancing, leaping around in the space. We all begin dancing faster, the sound is uncomfortably loud and has a punitive tone; the images pierce the darkness and then they bleed in floods of colours. This is a cathartic dance, a revelry, an eruption. We release the energy, through the movements of our dancing. There is a narcissistic ecstasy to these stroboscopic rhythms and the spinning, resonating light. It feels intense and violent.

Soon the sounds and images grow into an emulsion that is the birth of sense. Invigorated by the cathartic dancing and its rapid, robust energy, now there is a peacefulness, a care and healing for the senses. The images slow down and grow into bulbous, rhyzomatic shoots that twist, bloat and circulate like the bloodstream of existence. The beat of the music slows down as it emanates remedy – after releasing all that violence there is now time and space for amity. I sink onto my knees and pray in this ethereal eruption of spirituality. Fellow-participants lie down, there is a calming and caring after the storm; we feel in harmony and synthesis, a togetherness is forming here.

The technology that composes this environment provides an immensely therapeutic experience. I feel a sensuous connection with the primary retentions my senses submerge themselves in, and with the other people I am dancing with. These participants in the milieu of our performance are diachronic singularities: separated, each in their own little world, experiencing their own sense and movement. Everyone responds to this influx of sense-data differently, independently, developing over time, but we are joined – we become, we transindividuate – in a common opening and sharing of the technology – the *technê* – of this ritual. There is a violence to our interaction, but there is also a

resolution and an opening of sense. We collaborate and move with sense together here. The co-becoming of individuation in our performance is therapeutic and it attunes to what Stiegler says about the artwork in *De la misère symbolique*: 'Conjunctions of *I* and *we* which break up, artworks are the supports of psychic *and* collective individuation, as noetic or as an act of sublime' (Stiegler 2005: 268).

This piece provides us with the therapeutic and technological facets of the pharmakon that we have drawn together throughout this chapter. It also offers a remedy for the senses, by bathing them in such rich and interactive new data, so I leave this experience understanding what Winnicott means when he says that 'creativity belongs to being alive' (Winnicott 2005: 91). By the way that my fellow participants and I pay attention, become absorbed and participate, by playing and dancing here together, this piece has an economy of contribution.

The artwork is therapeutic because of the way it provides a stimulus and activity that is cathartic, so that we sense, respond and move together, which is a comforting commotion. In this way the artwork then provides us with a system of care, which produces an interlude of otium. Stiegler's philosophy is all about *taking care* in response to the world's disenchantment. The pharmakon is a 'philosophy of care' (Stiegler 2013: 24). We can see this explicitly deliberated throughout *Taking Care* (Stiegler 2010: 177–179). The artwork is, as pharmacological, a remedial activity, which provides 'a therapeutic capable [...] of treating its inherent poisons' (Stiegler 2010: 85). This therapeutic quality of the artwork confirms what Stiegler says in *De la misère symbolique*: 'Art and artworks sustain me when I lose myself or decline' (Stiegler 2004: 268).

Technê is the motor of the artwork, in terms of the multimedia stereoscopic images, surround sound and wifi, i.e. the technology. This provides a technical space which is poîetic, creative and immersive, which dissolves the opposition between the instrumental and the artistic that Stiegler sees in Heidegger. By withdrawing an aesthetic dimension from this technological space we find the relation between the technical and the aesthetic that Simondon talks about in *On the Mode of Existence of Technical Objects*. Simondon discusses how a tool might be beautiful and recover its aesthetic dimension (Simondon 1958: 186). In Hierophantes' work the *technê* lies in the spiritual exercise, which is like a *game*, in the experience of moving with the other participants and making sense together.[17] The artwork then opens a system of *care*, which is a technique of the self.[18]

Utilizing the creative process as a performative method of taking care of the self, and as an art of life, provides another perspective of the transformative therapeutics that can be offered by art practice. In this chapter we can see how

participating in the artwork provides us with a liberal sense of time, which is healing and *poietic*. It allows us to free our conscious minds, connect with our bodies and move forwards as a collaborative community of participants as we improvise creatively together. Our performance becomes a ritual.

We can think about how this kind of therapy applies to Stiegler's general organology; after the way that hyper-industry and consumer capitalism have poisoned our sense of and in the world, in terms of the world itself and our sensing it, we need to access this remedy. Stiegler's account of the pharmakon says that it is something technological, which requires a drastic new critique and a new political economy. Inspired by Winnicott's *Playing and Reality* Stiegler uses the pharmakon to find out what makes life worth living. He critiques the world's disenchantment and lays out the consequent misery for our sense organs, without providing them with much comfort or condolence. To source the re-enchantment, therapy and care that his technocentric philosophy calls for, and to discover what makes life worth living, we need art practice.

But using my experience of this artwork to source the curative qualities of the pharmakon raises some critical questions. It seems to provide the few people who participate with a pleasurable aesthetic experience, but what is it in relation to Stiegler's ideas about our symbolic misery and the disenchantment of the world?[19] Is this artwork merely a distraction, recreation or a moment of rest from the larger, bleaker picture? No. The experience of this artwork, and the diachronic milieu that it creates for those who take part in it, is creative, therapeutic and meaningful. The interactive participation involved means that the piece changes according to the movements of its participants, using a 'wifi' technology, so the whole artwork becomes collaborative, like a 'wiki' in dance. This is not mere distraction, but a new genre or medium of participatory art. This is what Stiegler is calling for when he says that 'The question is therefore about participation, and it is here that we must explore a new concept of art: the concept of *an expanded art*' (Stiegler 2005: 123, original emphasis).

In *De la misère symbolique* Stiegler talks about the 'loss of participation' that defines our current misery. Then he provides examples of the constructive, positive use of new technologies, such as tele-reality, karaoke, *sampling, house music* and DJ, *blogs* (Stiegler 2005: 57, original emphasis). Stiegler says that these audio-visual technologies and the internet create a different kind of public access and involvement. Stiegler argues that this is both demonstrative of the misery of the present and potentially a future saving grace from it, by providing the agency for challenging and changing this misery. Technological innovation, through art, can provide liberation: 'Art in general is what seeks to temporalize otherwise,

and to make the time of consciousness of the *I*, which sustains the ground of the unconscious and its embodied memory, always diachronic and liberated' (Stiegler 2004: 182). The question of opening a different kind of time of consciousness, one that is not hyper-synchronized on consumption, but participative, interactive and diachronic, is what we find in Hierophantes' artwork. As such, it is not mere distraction but, rather, a truly innovative kind of art.

Hierophantes describe this work as a 'participatory ritual' and they emphasize the ritualistic elements of it.[20] Their name comes from Hierophant, meaning he who shows sacred things, the hierophant of mysteries. Do all the mysterious, ritualistic qualities of this piece make it a pseudo-cultic experience? If so, does that make it regressive? No. It is easy to criticize the mystic side of this artwork, and say that it offers no more than a limited time or speculative leisure activity, for a select few, which is politically meaningless and uninteresting. But, if we accept that it opens a pseudo-cultic experience, we can see that it actually sublimates and realizes Stiegler's ideas about what he calls 'mystagogy' and art (Stiegler 2005: 186; Stiegler 2010: 36–53). This artwork offers us what Stiegler calls an 'accès au sauvage' – or an access to the wild (Stiegler 1994: back cover). Providing a therapeutic, remedial experience does not make this artwork regressive; on the contrary, it shows us how we can participate in *Taking Care* and open the curative qualities of the pharmakon (TC 85). The 'cultic' components offer the kind of experience from which we can cult-ivate ourselves, and, as such, it provides the base elements of a cult-ure. We can use the way Stiegler defines a cult-ure in terms of *Taking Care*, responsibility and the socio-technical process of transindividuation (Stiegler 2004: 150).

7. Conclusion

Thus we have eventually been able to source some form of remedy, and the curative pole of the pharmakon, by participating in the creative process of making a collaborative artwork. This has developed our understanding of the consequent agency of art practice, transformative therapeutics, as a method of *taking care*. Creating an artwork opens a technique for caring for the self, or an art of being in the world, since it produces a liberal way of existing and creating, collaborating *in time*. This provides relief from the disenchanted world, and our (not just symbolic) misery. The result is an autonomous space of re-enchantment, which is not a separation or removal from the real, but a material

immersion into a different and creative method of *being alive*. The artwork opens a transitional space where transformation occurs, during the play and consumption of performance.

This artwork can provide a technique for transformation and therapy; it opens the curative pole of the pharmakon. In this respect, am I arguing that the artwork itself is a pharmakon, or that it can replace medication (rather like – as we saw through Plato – writing replaces memory) and cure mental illness? Does the artwork have a poisonous pole as well as curative? No. I have yet to find a poisonous pole in the artwork, and I am not suggesting that art-making can *replace* pharmaceutics or clinical intervention. Although I have argued that creating an artwork is remedial, this does not mean that art can be used to cure (all) medical or psychiatric illnesses. I have argued that the pharmaceutical industry is itself poisonous, due to the hegemonic systems of power and the consumer capitalist synchrony that direct its grasp over our conscious minds. But this is not to say that drugs never work, and it is not to say that art-making is the only solution to *all* problems. In many cases, as we saw in Chapter 4, with schizophrenic artist Kyle Reynolds, psychotropic drugs are essential. Even when drugs are utilized to 'patch up' problems so we can get back to work, although this may be a problematic attitude, this is not necessarily a bad thing. Drugs can help us find a way to get by. It is the (sometimes manipulative) systems behind their prescription, dispensing and marketing that pose the threat.

In response to these hegemonic systems we need a liberating sense of time that can hold and nourish our attention. We find such support and sustenance by creating an artwork and engaging sensuously with the creative process that is involved in either making or viewing, all the time participating in, the art. This argument has been considered and tested in different formats, mediums and situations in every chapter of the book. It has reached a crescendo in this final chapter, where art is shown to express and manufacture a transformative, therapeutic experience which, although it cannot replace (all) medical intervention, provides an emancipatory method of making sense of the world that can open caring and new ways of being.

Our effort to understand how art practice can help us make sense of the world has brought us more evidence for the agency of transformative therapeutics that makes this process possible. Rather than delivering any specific, singular interpretation of what the world means, and thereby making sense of it, this process has generated a plural and multidimensional method of engaging with, expressing, reacting to and being in this world. Now we are ready to conclude by launching a utopian sense of the real. From here we can build a new world.

Conclusion: Making Sense of the World

The final chapter on the pharma opened a liberal sense of time, which initiated a process of caring and new ways of being in the world, through the transformative therapeutic agency of the artwork. At the conclusion we are ready to launch a fresh, utopian sensibility that will enable us to build a new world. This 'new world' can be launched by opening a chance to affect, transform, comprehend, feel or heal one's existence and situation in the world, which, as we have seen, is produced by the process of creating an artwork.

In more detail, throughout this book we have developed an understanding of how and why an artwork can have an affect on us. This affect provides an agency of transformative therapeutics and opens a technique of *Making Sense* of the world. It does this by instigating a method of healing and psychological self-awareness during the process of making an artwork. We have seen how the transformative, therapeutic products of art practice can apply specifically to the individual who makes the artwork, and they can be utilized in terms of different kinds of arts therapy and psychoanalysis. In this case they refer to illuminating psychopathology, symptomology or developing a diagnosis, and providing (to some degree) cure, in relation to the psychiatric clinic. We have then located therapy *outside* of the clinic, and our agency of transformative therapeutics has extended beyond the individual case examples to provide a critical method of thinking about society that can affect the world at large. At the end we have questioned the remaining disenchantment of the world, and the influence and dependence on the drug industry, which pose limitations to *Making Sense*. But we have still located and begun to understand how art practice can provide both a method of being in the world, understanding it, and an agency of transformative therapeutics that is applicable to all.

My definition of transformative therapeutics has developed in each chapter. In the first half of the book this definition has been positioned in relation to psychiatric illness, in the context of the psychiatric clinic. In the second half of the book transformative therapeutics has been utilized as a critical method of *material thinking* on a broader scale, in relation to making sense of the world at large. In more detail, the first chapter showed how the artwork can

nourish the senses. Considering the artwork in terms of the psychoanalytical concepts of transference and the transitional object produces transformation and nourishment for the artist and the viewer. Chapter 2 presented an exegesis of episodes of the creative arts therapies. This was set in relation to psychopathology, and showed how art-making provides a psychic epistemology that transforms the symptom, provides a 'coping mechanism' to deal with distress, and opens new ways of being, specifically in relation to suffering from psychiatric illness. Chapter 3 defined transformative therapeutics as an ethical model of counter-actualization. In this chapter arts therapy is a critical, theoretical tool from a Deleuzian viewpoint. Psychoanalysis is questioned and critiqued by Deleuze and Guattari's practice of schizoanalysis, which opens art practice as a method of making sense of existence and being in the world. This method is as transformative as it is therapeutic because it opens a 'place of healing', in relation to and beyond the case study of the schizophrenic. Chapter 4 then moved the ethical treatment of the symptom *outside* the clinic, in relation to another schizophrenic artist, Kyle Reynolds. Working with Lacan's *symptom*, we see how art-making becomes a method of managing to live. Self-expression through art practice is transformative because it helps the individual cope with their illness, whilst it also transforms preconceptions and the stigma attached to this illness.

The second half of the book expanded the notion of transformative therapeutics beyond the clinic. In Chapter 5 art practice was developed as a transformative method of material thinking, which produces tacit knowledge. Creating an artwork involves marking territory, and this process enables the redistribution of negative or destructive forces (the war machine) into a creative line of flight. It is in this way transformative. Chapter 6 opened the political sense of art-making, whereby the creative process provides an emancipatory agency that engenders a making sense of and in the world. This chapter discusses the sharing and distribution of the sensible, which occurs during the making of an artwork and which provides a method of actualizing freedom. Here freedom is a subset of transformative therapeutics, defined as the sharing or expression of the sensible coordinates of the world and of the voices that respond to this world; the technology and autonomy of play; and the possibility for a holistic community of sense. Chapter 7 showed how making an artwork provides therapeutic palliation at the limit of existence, and a technique of being in the present in relation to this limit. Art-making is a reparative act, in the prospect or onset of loss, pain and suffering. In this sense it provides a method of taking care and an ethos towards limit. In the final chapter, art practice presented transformative therapeutics as

a liberalized sense of time, free time, for spontaneous and interactive invention, imagination and play. This was set in relation to the disenchantment of the world, hyper-industry, pathology and the mass synchronization of consciousness (or the poisonous, toxic pole of the pharmakon). The artwork initiates a system of care and opens a transitional space where transformation occurs, during the play and consumption of performance.

Thus, we have established how art practice opens transformative therapeutics in relation to the individual and the world at large. The bridge between the individual and the world is the opening of *Making Sense* that is provided by the agency of transformative therapeutics. The process of creating an artwork (whether in therapy, inside or outside of the clinic, or in the artist's studio – which can be anywhere) provides the means to make something change or to initiate difference. It is thus transformative. This transformation can potentially provide a remedial action or therapeutics. Both of these factors connect the individual who creates this artwork with themselves and the world they live in. This is because the agency of transformative therapeutics provides for the artist a method of being and becoming, expression and containment within the situation that sets their position and livelihood in the world. This is another way of describing the process of Making Sense, which is a process based on *Making*, or *poiêsis*, the artisanal craftsmanship or performance of creating an artwork (in any medium); and *Sense*, or the resultant feeling, meaning, expression and understanding, which is the result of this material process. Sense is always and already situated in the world, responds to this world, changes it and helps the creative individual to find their place therein. These factors require and result from the transformative and therapeutic products of art practice.

From this viewpoint, where the transformative therapeutics of art practice opens a method of *Making Sense* of the world, we can now build an aesthetico-therapeutic paradigm. This paradigm entails a new way of thinking about the world and being in the world, thus a new world in itself (in our experience of it). Here we reach the conclusion of this book, since I am arguing that we are all artists, since everyone can create an artwork, and we can all receive these transformative therapeutic effects.

To open a new paradigm means to define a distinct concept or thought pattern, which affects the way an individual perceives reality and responds to that perception. In social science, the term paradigm is used to describe the set of experiences, beliefs and values that affect change in the basic assumptions. A 'paradigm shift' is defined by scientist Thomas Kuhn to denote a change in how a given society goes about organizing and understanding reality (Kuhn 1962).

Thus, in order to open a new paradigm, the task of *Making Sense: Art Practice and Transformative Therapeutics* is to stimulate, launch and make accessible the possibility for the transformative, therapeutic affects of art practice, so that they can help people make sense of the world (and themselves) in a fundamentally new way.

This conclusive and utopian agenda bears relevance to Félix Guattari's development of a new *ethico-aesthetic* paradigm in *Chaosmosis*. To draw the strands in this book to an end, I turn to Guattari's work, because it helps me draw out the ways that the creative process is able to initiate its transformative and therapeutic dimensions. Guattari helps me understand the agency that is provided by art practice.

This is because Guattari says that the creative process opens up the possible and multiple interconnections between the different ways of becoming different, which happens when we interact with material forms and respond to the shifting sense of being – or our own identity – that creates with the work. The surface of the artwork created then provides a ground plan that maps possibilities for change, and offers a diagram on which we can plot our experience of the world, from which we can then Make Sense of it. In this way the artwork, and the creative process of making it, initiates an *ontogenesis*, which means the development of an individual organism or anatomical or behavioural feature from the earliest stage to maturity. Making Sense through art practice activates a process of individuation and develops an understanding of our growth in and with time.

It does not necessarily require an arts therapist or psychoanalyst to get in touch with the ontogenesis that occurs here, it is something that we can all access. By responding to our being with materials and making an artwork that then composes our presence within the present, we enter into the intrinsic symbiosis between ethics and aesthetics, in accordance with the 'ethico-aesthetic paradigm' that Guattari calls for in *Chaosmosis* (Guattari 1995: 8). This bears relevance to the aesthetico-therapeutic paradigm that I am proposing in this book because Guattari develops the implications that the creative process has for subjectivity, which is important to consider in any proposition of the production of affect or agency from art practice. Guattari says that art opens up a 'constellation of Universes' for our different ways of being in the world (Guattari 1995: 17). The 'artistic cartographies' (or surfaces, which plot our experience of the world) mapped by the creative process provide what Guattari calls 'a mutant production of enunciation, where expression is not a signifier but a transversal machine for the production of difference' (Guattari 1995: 130–131). Here *expression* formulates a mechanized methodology for Making Sense, through

the agency of transformative therapeutics that it initiates in the creation of the artwork. The artwork formed by this machine is 'the enunciative assemblage'; it is 'a certain mode of aesthetic enunciation' because it opens up a machinery of subjectivation, or the motor that forms and reforms the individuation of identity, for the artist, who can express and counter-actualize their subjection (and potential suffering) through its creation (Guattari 1995: 14, 29).

For Guattari, this process of creation involves a different kind of subjectivity and a different semiology, or study of signs (the difference between a thing-in-itself, or an object, and the sign or word that represents this thing). The artwork actualizes a sense of autonomy, or *autopoiêsis*, which is a self-producing and self-maintaining system for the person who makes it. This system, which operates in the artwork, opens osmotic (or *Chaosmotic*) possibilities for transformative therapeutics, which circulate and nourish the ontogenesis of the artwork formed, feeding these effects to the artist by their expression and enunciation during the creative process (Guattari 1995: 7).

In theoretical terms, this indicates a semiotics that moves from semiologist Hjelmslev's structuralist coupling of Expression/Content and becomes an abstract machine that is not defined by a binary opposition, but as a discursive force with 'energetico-spatio-temporal coordinates' (Guattari 1995: 25). This is important because the 'assemblage of enunciation' expressed as the artwork has an existential function – where the symptoms function as an 'existential refrain' in their counter-actualization and a new mode of subjectivity is continually reinvented and always becoming different (Guattari 1995: 26).

Guattari says that the creative process engenders the invention of new qualities of being. It affirms itself as 'existential nuclei' and 'autopoietic machines', which then provide a new means of communication alongside these new qualities of being (Guattari 1995: 106). The de-territorialized and autonomous segment of the real presented by the artwork has no sign or meaning transcendent to its immanent function of Making Sense, through the agency of transformative therapeutics. The sense it makes offers a new way of being in the world:

> The work of art, for those who use it, is an activity of unframing, of rupturing sense, of baroque proliferation or extreme impoverishment, which leads to a recreation and a reinvention of the subject itself. A new existential support will oscillate on the work of art, based on a double register of reterritorialisation (refrain function) and resingularisation. (Guattari 1995: 131)

This creative process defines an art which does not just apply to the activities of established artists, nor just to therapy for the patient in the clinic (although we

can learn from these examples), but rather offers a subjective creativity 'which traverses the generations and oppressed peoples, ghettoes, minorities....', so it applies to us all (Guattari 1995: 91).

Thus it can be argued that this sense that is made by the artwork is universally accessible, whilst it holds the potential to provide transformative therapeutics for everyone who chooses to activate it. Deleuze and Guattari describe how the artwork, as a monument of sensation, can provide a way of expressing and responding to suffering, which might open a universe of new worlds for all of us, in *What Is Philosophy?*:

> A monument does not commemorate or celebrate something that happened but confides in the ear of the future the persistent sensations that embody the event: the constantly renewed suffering of men and women, their re-created protestations, their constantly resumed struggle. [...] The victory of a revolution is immanent and consists in the new bonds it installs between people, even if these bonds last no longer than the revolution's fused material and quickly give way to division and betrayal. (Deleuze and Guattari 1994: 176–177)

This revolution is a summit for Deleuze and Guattari's writings, and we can use it to build the aesthetico-therapeutic paradigm that is the summit of this book. The activation of the creative process and its transformative, therapeutic effects is an application of schizoanalytic practice. Schizoanalysis, which was defined in Chapter 3, helps us tie together the different strands of arts therapy, psychoanalysis and post-structuralist thought that have knitted the fabric of *Making Sense*. To do this, I turn to arts therapist Pamela Whitaker, who initiates a Deleuze and Guattarian interpretation of arts therapy. She builds her therapeutic practice into what she calls a 'Deleuze and Guattari Art Therapy Assemblage (DGATA)' (Whitaker 2012).

Whitaker's DGATA constructs a machinic enterprise that combines post-structuralist thought with its therapeutic application, to create a pluralized and accumulating 'landscape of identity', where the patient/client is always becoming different, exploring and growing according to the varying and tumultuous rhythms of their experiences, perceptions, thoughts and emotions. Whitaker's work on art therapy helps us conclude this book, since she crosses the bridge between post-structuralist and psychoanalytic thought, through the active practice of arts therapy, which initiates a transformative, kinaesthetic and healing method of individuation. Whitaker uses Deleuze and Guattari to define the subject's evolution during the therapeutic process, as a heterogeneous, continually growing map of perceptions and reactions to their being in the world.

The artworks created during sessions that involve Whitaker's DGATA approach provide 'an imagescape' of discovery (Whitaker 2012: 347). This does not reduce or close an issue, but elaborates a game plan of potential ways to react and behave in response to this issue. Art therapy, from this viewpoint, creates a collection of images that 'extends life potential into an ongoing encounter with change' (Whitaker 2012: 348). Meaning is not interpreted or fixed; it is a process of interaction, chance, inspiration, stimulation, transference and continual transformation. Art practice brings 'the potential to view one's life as a cartography of assembling relationships that usher forth an imagescape of desire and expression' (Whitaker 2012: 365).

Whitaker's application of arts therapy is a schizoanalytic procedure which liberates the participant (patient, artist, individual) and provides the opportunity for new ways of being in the world:

> The DGATA approach circulates material connections and the co-mingling of ideas as a propositional understanding. This is not an interpretative approach but a navigational one, documenting how a person lives in the here and now in relation to current affairs that carry the past and the future within their expression. A globalised world perspective is not reductive; its defining capacity lies in its ability to travel across information borders, so that knowledge is abstracted from more than one origin. There is a positive, non-diagnostic flavour to schizoanalysis, a spirit of adventure that is forward-looking and full of vigour. It is not caught up in shame or dysfunction; rather it opens the door to the complicated nature of subjectivity that surpasses interpretative statements. (Whitaker 2012: 358)

Whitaker's model of arts therapy opens opportunities for those who engage with the arts (whether in episodes of arts therapy, in the artist's studio or in every situation of art-making) to grow, develop their subjectivity, situate themselves and source a means of *Making Sense* of the world. This is a process transformative therapeutics. We move away from the analyst's couch, or the clinic, and the interpretation of secret 'deep' meanings from the patient's unconscious, towards the provision of an active and immediately accessible power for living.

Art practice is about unlocking this ontogenetic and *autopoiêtic* capacity to generate life: 'Unlocking new areas of sensation – new colours, noises, rhythms, odours, textures, longings, desires, practices, feelings, beliefs, gestures and knowledges – gives rise to new facts, new events, new rhythmic relations, new logics of sensation, in short: new ways to appreciate life and new ways to live' (Slack 2005: 140).

Much has been said about the ways that the artwork can initiate some kind of transformation, whether psychic, existential, political, sociological or mondial, but it is still difficult to understand exactly *how* this happens. How does the structure of the artwork, and of art practice itself, initiate agency? Ehrenzweig, whom we engaged with in Chapter 1, talks about *The Hidden Order of Art*, and discusses how the different stages to the creative process lead to growth and individuation, through 'an enriching experience of envelopment and unconscious integration' (Ehrenzweig 1967: 172).

From Ehrenzweig's viewpoint (and our conclusive viewpoint), the artwork does not necessarily symbolize or represent a feeling, as a substitute of it (although, in some cases (such as during arts therapies), this substitutive role can be used to effectively communicate something that is unspeakable in words). But, rather, the artworks are transformative because they are 'affirmative', which means that 'they are not in place of anything; they do not *stand for* but stand, that is to say, they function through their material and its organization' (Lyotard 1989: 158). This quote is from Lyotard, who wrote the preface to the French translation of Ehrenzweig's *The Hidden Order of Art*. Lyotard's critique of Ehrenzweig is important for this conclusion because he sources the agency of art in its capacity to exist and go 'Beyond Representation' (the title of his essay on Ehrenzweig). The artwork is pure surface, as a plane of immanence for reaction, action, change and difference. This affective topology instigates transformative therapeutics because it vibrates with forces that capture, hold and emit a symbiotic vessel that has an osmotic motor fuelled by pure sensation.

Ehrenzweig lays down different structural stages in the creative process. He says that the artist has to go through the chaotic and overwhelming process of an 'oceanic' eruption of schizoid fragments from their unconscious mind, and then the process of creating an artwork can potentially entail the working through and resolving of this manic and engulfing experience. Ehrenzweig says that 'the work of art acts as a containing "womb" which receives the fragmented projections of the artist's self. A mighty pulse issues from it which ripples through the painting and sucks the spectator into its embrace' (Ehrenzweig 1967: 172).

Thinking of the artwork as a pulse vibrating in the artwork, so that it affects the viewer, returns us to Deleuze and Guattari's work on the monument of sensation, which we saw in Chapter 1. I will now think further about how an artwork exists in as much as it has the capacity to express and affect sensation, and how mere sense data can prompt transformation. Sensations may initiate development, change and *Making Sense* because the process of creating an

artwork involves contact with and the expression of something fundamentally true about the artist who creates it, in terms of their own identity and the situation of this creative event of art-making (be it in therapy, inside or outside of the clinic, in a studio, or *anywhere*). The artwork (in limitless dimensions, performance, installation or any medium) shows the mark of its creator, inscribing their placement in the world, as a vibrating force of the sensations that this placement provokes and means for the artist, which they are expressing within it. As a consequence, the artwork exists as a pulsing force, as Ehrenzweig and Deleuze and Guattari have developed for us, expressing the artist's vision and opening this vision as an opportunity for the viewer to become a participant and share it, in as much as they are *feeling* it. This feeling initiates transformation because it causes new perceptions of the world, which arise from the immanent and provocative sense data that immediately erupt from the artwork. Raw and nude sensations, which occur as we make art or view art, lead us to more developed, comprehensive perceptions, and the process of *Making Sense* begins, which eventuates the agency of transformative therapeutics. Here we make our new world.

Thus art practice has the capacity to generate this agency because mark-making (using any medium) expresses the artist's true picture of themselves and of their worldview, which begins from a reactive, affective sensory experience and develops into deeper levels of awareness and communication that initiate new perceptions, thoughts and feelings. Here is the opportunity for change. The artwork that the artist creates generates agency for the person who encounters or participates in its exposition because the artist's expressive marks (movements, gestures or other methods of reaching out through their medium) *hold* those sensations which provoked the creation of this artwork. In this way the artwork exists as a monument of the artist's sensations, which are provocatively visible in the work through the artist's facture, in as much as the work then affects the viewer. This affectation again begins from raw sensations, developing into perceptions and the process of *Making Sense* that effects transformative therapeutics.

This book began with the task of trying to understand how and why engaging with the artwork can help us make sense of the world. This quest has delivered agency which provides creative transformation and opens a new paradigm. In this way we could say that rather than informing us about the world, and in that way *Making Sense* of it, engaging with art helps actually create the world. To conclude we can remember that the affect, sense and agency generated by engaging with an artwork are accessible to all of us.

There might seem to be limitations to this argument: the idea that art's potential of affective transformation is 'universally accessible' could be difficult to prove *in fact*. Some might consider that art is neither universally accessible (on the level of language or education for example) nor culturally universal (the concept 'art' being both historically and culturally specific), making its purported therapeutic value similarly situated and specific, rather than universal. I have used individual examples, of particular artists, artworks and my own (singular) experiences. Thus it might be difficult to hypothesize my argument of *Making Sense: Art Practice and Transformative Therapeutics* beyond these specific case studies. Indeed, not everyone has the same opportunity or desire to encounter or create an artwork, and there remain suffering and disenchantment in the world, particularly if we look at contemporary bio-political developments. How could art help in a time beset by war, terrorism, capitalist burnout, global warming, etc.?

The question of what can be done in view of this caustic picture of the world concerns politics, education, communication and culture, which extend beyond the realm of art practice, the aesthetic experience and this book. However, the direct experience of making an artwork can still open the world to us all, through its ensuing agency of transformative therapeutics. This can be applied to the individual (whether a patient, artist or any living being who has the chance to express themselves through art practice) or a specific (larger) context or situation in the world. I have used individual examples to illustrate this point because it is impossible to suppose any affect or hypothesize any argument without utilizing specific examples where it has been seen to occur. I have then used relevant psychoanalytic, philosophical and theoretical literature, and further case studies, to extend my argument beyond these examples. Rather than criticizing any restraints that might be conceptually perceived (or projected) from my book, I ask the reader to experiment and try it out for themselves. Go and make an artwork. Express your being in the world. There, change is possible; it is up to you to make it actual. Inspiring the reader to be creative, dare to actualize the agency of transformative therapeutics, and see how this operates a *Making Sense* of the world, is the ending of this book, which remains unfinished until it stimulates further opportunities for art-making.

Notes

Chapter 1

1 This quote comes from Newton's (2001) *Painting, Psychoanalysis and Spirituality*, and also the author's email correspondence with Newton.

2 We will return to Nancy's work on On Kawara, and the technique of the present, in Chapter 7.

3 Deleuze sums this up in *Difference and Repetition*: 'The work of art leaves the domain of representation in order to become "experience", transcendental empiricism of science of the sensible' (Deleuze 2004a: 56).

4 We will return to the transitional object in Chapter 6. For now it is important to use it as a formative plane that draws together and activates the different parts and stages of the aesthetic experience. It is, Winnicott argues, the source of intense creative experiences of the arts, religion and scientific discovery (Winnicott 2005: 7, 18). The transitional object provides the source of all cultural experience (Winnicott 2005: 135).

5 This quote is taken from Chardel's website, http://www.jbchardel-art.com [last accessed 01 January 2011].

6 cf. Aristotle *De Anima* 11.9, 11.11 (Aristotle 1986: 180–186). This emphasis on touch concurs with Mark Paterson, who says: '[…] through touch, the world is with us. It is through haptic experience that we feel engaged in the world, and through affect that the world and its objects touch us' (Paterson 2007: 101).

7 Derrida critiques Merleau-Ponty's notion of flesh throughout *On Touching*. Derrida says that despite Merleau-Ponty's efforts to move phenomenological discourse from its oculocentric emphasis, and privilege *touch*, rather than *sight*, Merleau-Ponty's ontology of the sensible in *The Visible and the Invisible* actually still privileges *sight* over touch, whilst he misreads Husserl in his efforts to use touch to build an ontology of being (Derrida 2005: 185–190). This phenomenological dispute between the optic and the haptic in Merleau-Ponty, Derrida and also Nancy becomes a battle for the 'democracy of the senses' (Derrida 2000: 230–231). This dispute is discussed at length in *Downcast Eyes: The Denigration of Vision in Twentieth-Century French Thought*. cf. Jay 1993: 319–320. For more critical literature on Merleau-Ponty's notion of flesh, which is still useful and insightful for my study of the aesthetic encounter, see Evans and Lawlor's monograph on this subject (Evans and Lawlor 2000).

8 I consider how Merleau-Ponty's notion of flesh can be applied to the aesthetic encounter in my article on the sculptor Louise Bourgeois (Collins 2010).

9 When we consider how the artwork draws from both Deleuze's logic of sensation and Merleau-Ponty's flesh, we must be cautious, because Deleuze takes great pains to emphasize that he is *not* a phenomenologist. Leonard Lawlor discusses Deleuze's challenge to phenomenology in his article on 'The end of phenomenology: Expressionism in Deleuze and Merleau-Ponty'. Lawlor argues that Deleuze's challenge to phenomenology rests on his radically *empirical* understanding of immanence, whilst phenomenology turns immanence into an immanence of *consciousness,* which invokes a transcendental subjectivity and falls into onto-theology (Deleuze and Guattari 1994: 49, 141–142; Lawlor 1998: 15–34).

10 This has been questioned by Derrida, who argues that Merleau-Ponty's attempt to build a haptocentric, absolute system for flesh from the metonymic hand is contradictory and onto-theological (Derrida 2005: 183–215).

11 *Nosce teipsum* means 'know thyself'. There is a long history to this aphorism. It is a central theme that has been used (and sought) throughout the history of philosophy, particularly in Platonic dialogue. To know yourself is seen to be the highest form of knowledge. It is also seen in later philosophy – for example, Thomas Hobbes' 1651 *Leviathan* interprets nosce teipsum as '*read* thyself' (Hobbes 1996). This interpretation is interesting for our purposes because it adds a visual dimension that we can apply to the aesthetic encounter. When we interact with an artwork it reveals something about ourselves; by making sense of this experience we learn about our own desires, drives and feelings. The artwork is in this way transformative and therapeutic.

Chapter 2

1 Cf. The BAAT website: http://www.baat.org/ArtsTherapies2010Flyer.pdf [accessed 09 November 2013]. Case and Dalley's *The Handbook of Art Therapy* (2006) brings forward a detailed, comprehensive introduction to the field of arts therapy in various settings, with useful references to the considerable literature that exists on arts therapy in and outside of clinical practice. This book is a useful reference, which remains relevant in the background of the transformative therapeutics I am developing in this chapter.

2 Cf. The NCCATA website: http://www.nccata.org [accessed 09 November 2013].

3 This is a reference to *Remedial Art: A Bibliography*, which compiles the considerable literature available on the healing affects of art therapy.

4 As Shaun McNiff describes in *Art Heals: How Creativity Cures the Soul*, the space assigned for arts therapy is 'a *temenos,* a sacred place that acts as a vessel of

transformation. [...] the space becomes a temple of creation, holding people in a protected yet challenging enclosure' (McNiff 2004: 30).

5 Whilst anorexia has already been defined, by Schaverien, schizoaffective disorder is a psychotic illness defined by hallucinations, delusions and depressive mood symptoms.

6 This approach, where the making of imagery supersedes a verbal or interpretive exchange between the patient and therapist, is discussed by Roger Wilks and Angela Byers in Waller and Gilroy (eds.) (1992): xii, 96–103.

7 My art was itself a form of medication (alongside the pharmaceuticals). The healing affect of art, as it is manifested in arts therapy, generates what McNiff calls 'art medicines' that formulate an active clinical practice (McNiff 2004: 122). We can see this clinical application of art therapy materialized in Landgarten's *Clinical Art Therapy: A Comprehensive Guide* (2013). This is why arts therapy has such an important role for *Making Sense inside the clinic*. Its medicinal, healing affect is part of its agency as transformative therapeutics.

8 See Patricia Caddy, 'A pilot body image intervention programme for in-patients with eating disorders in an NHS setting' (Caddy 2012: 190–199).

9 The Association of Dance and Movement Therapy's definition of this form of therapy, and further information, is given on their website: http://www.admt. org.uk/ [accessed 17 January 2013]. The United States of America is generally accepted as the founder and world leader in dance and movement therapy. We can see a history of the key pioneers in American dance and movement therapy in Fran Levy's *Dance Movement Therapy, a Healing Art* (1992). This therapy developed in the United Kingdom in the 1970s. Bonnie Meekums writes a chronicle of the specifically *British* 'DMT Pioneers', naming Leah Bartal (Bartal and Ne'eman 1975, 1993), Lynn Crane, Sarah Holden, Fran Lavendel, Jeannette Mac Donald, Bonnie Meekums, Helen Payne, Kedzie Penfield and Marie Ware as the key figures in the birth and development of this form of therapy in the United Kingdom (Meekums 2007).

10 There is much literature on the interlinkage between music and memory formation and recollection. Music therapy has been seen to relieve symptoms in patients suffering from Alzheimer's or dementia, and also for those recovering from neurological damage. See Pavlicevi (1997: 56–64); Tomaino (2009: 211–220); Aldridge (2000).

11 Music has been used as a therapeutic tool for centuries. The British Association for Music Therapy describes how making and listening to music can be therapeutic, since it plays such

> an important role in our everyday lives. It can be exciting or calming, joyful or poignant, can stir memories and powerfully resonate with our feelings, helping us to express them and to communicate with others. Music therapy uses these

qualities and the musical components of rhythm, melody and tonality to provide
a means of relating within a therapeutic relationship. In music therapy, people
work with a wide range of accessible instruments and their voices to create a
musical language which reflects their emotional and physical condition; this
enables them to build connections with their inner selves and with others around
them.

See http://www.bamt.org/ [accessed 08 November 2013]. For a history of music
therapy, as it has developed in the United Kingdom, see Barrington (2005); Blunt
(2004: 13–26).

Chapter 3

1 This chapter does not intend to give a full account of the complexities of
 schizoanalysis. My aim is to introduce it in relation to psychoanalysis, and Deleuze
 and Guattari's attempts to critique Freud. The purpose of this section of the
 chapter is to set up the background for a critique of schizoanalysis as it is seen in
 Anti-Oedipus. We will later see that schizoanalysis can be interpreted in a more
 therapeutic rather than punitive manner, by engaging with art. For a more detailed
 introduction to schizoanalysis, see Holland (1999); Buchanan and MacCormack
 (2008); Stivale (1980).
2 cf. WHO (1992: 325–332).
3 In this chapter I am focusing on schizophrenia, whilst in the previous chapter
 I discussed schizoaffective disorder. The main difference between these two
 psychotic illnesses is that people with schizoaffective disorder experience
 overlapping periods of psychotic and mood symptoms (major depressive,
 manic or mixed episodes), whereas with schizophrenia these mood aspects are
 not present. Compared to schizophrenia, people with schizoaffective disorder
 have fewer psychotic symptoms and fewer problems thinking. Cf. 'WebMD'
 http://www.webmd.com/schizophrenia/guide/mental-health-schizoaffective-
 disorder [accessed 14 November 2013].
4 In brief, with the Oedipus complex, Freud explains repressed, unconscious
 emotions and ideas on a child's desire to sexually possess the parent of the opposite
 sex (e.g. males attracted to their mothers, whereas females are attracted to their
 fathers). Freud bases his entire system of psychoanalysis and diagnostic around this
 complex, and its development into a castration complex. See Freud (1991: 242 ff).
5 I will not go into Deleuze and Guattari's argument against Freud, via Kant, here.
 For a more detailed account of it, see Buchanan (2000: 48–80).
6 Note Schreber is the only 'real' schizophrenic, whilst Lenz is a fictional
 reconstruction by Büchner, and Malone is a character in a novel by Beckett.

Schreber's case is examined in Freud's infamous 'Psycho-Analytic Notes on an Autobiographical Account of a Case of Paranoia (Dementia Paranoides) (1911)', subsequently known as 'The Schreber Case'. Freud bases his diagnoses of Schreber's schizophrenia on Schreber's narration of his hallucinatory experiences in his *Memoirs of My Nervous Illness*, which was published in 1903. In this work Schreber describes his beliefs about the causes of his illness, which becomes manifest in persecutory hallucinations, delusions of sexual abuse and ongoing suicidal attempts. Schreber believes that he has been emasculated, that he has an intimate relation and copulation with God and he holds the strong conviction of being the founding saviour of humanity. In his memoirs he wants to explain all these things in terms of what he understands to be 'The Order of the World' ('*die Weltordnung*', Schreber 1988: 43). Such delusional beliefs inhabit his body, becoming sensory or 'nervous' charges that produce multi-sensual hallucinations and overcome his consciousness as a psychosis that he describes as '*mental torture*', said to be conditioned by the divine 'Order', which *causes* the suicidal disorder of his illness, and enforces his involuntary hospitalization and classified 'mental derangement' (Schreber 1988: 12s3, 276). This motivates both Freud, and Deleuze and Guattari, because the psychotic Schreber presents what Freud would later term as an autistic, dissociated 'loss of reality', in his 1924 essay 'The Loss of Reality in Neurosis and Psychosis' (Freud 2001 [1961] (vol. 19): 183–187). He evades both the psychoanalytic Oedipal-reduction and Freud's so-called 'talking cure'. Thus Freud tries to use Schreber to provide further proof for his theory about the homosexual causation of paranoia – as a clinical psychiatrist looking for diagnosis and cure, and a critical theoretician seeking to totalize his system. Deleuze and Guattari then use Schreber's case to break up Freud's system, unhook desire and demonstrate how the psychotic has not 'lost' reality but rather *is* at the forefront of how things truly are, by exemplifying and reacting to 'the whole social field' in the effects of capitalist power (i.e. the locus for what Deleuze and Guattari are trying to critique and affect).

7 Guattari sums this up when he says that: 'Psychosis starkly reveals an essential source of being-in-the-world' (Guattari 1995: 77).

8 We can see some of Freud's work on the unconscious in *Introductory Lectures on Psychoanalysis* (Freud 1991: 249, 265, 335).

9 As Richard Wolheim (a biographer of Freud) argues, for Freud a 'phantasy' is the 'portrayal or representation of a desire come true' (Wihelm 1981: 93). See Freud's introduction to 'phantasies' (or 'day-dreams') in Freud (1991: 127–128, 420–424). In Freud, desire is defined in the negative term of lack; you always desire what you don't have or what you are not – we can see this emphasized by Lacan, in *Le Transfert* (1960–1961), where Lacan states that lack is what *causes* desire (Lacan 1991: 202–203).

10 On the 'anti-oedipal viewpoint' and critical motor versus Freud in Deleuze and
 Guattari, see Stivale (1980: 47–48); Alliez (2006: 159–169).
11 Deleuze elucidates the fascistic when he says that; 'Organism is the enemy [...]
 which imposes the organs a regime of totalization' (Deleuze 2003: 20).
12 'Could what the drug user or masochist obtains also be obtained in a different
 fashion in the conditions of the plane, so it would even be possible to use
 drugs without using drugs, to get soused on pure water, as in Henry Miller's
 experimentations' (Deleuze and Guattari 2004a: 183/204).
13 Deleuze and Guattari describe how in his 'Pangymnastikon', Schreber's father
 used torturous 'little machines, sadistico-paranoiac machines', which literally
 en-shackled children with iron rods to force their 'correct' deportment (Deleuze
 and Guattari 2004: 327/353).
14 In this chapter I refer to art therapy in the singular, rather than the plural (as I
 discussed in Chapter 2), since the therapy I discuss here involves the singular mode
 of specifically visual art therapy, which concerns drawing and painting. I do not
 discuss any of the other forms of arts therapies that were explored in the previous
 chapter.
15 BBC News, 'NHS Art Therapy for Schizophrenia' [accessed 14 March 2008].
16 Tim Kendall is quoted in BBC News [accessed 14 March 2008].

Chapter 4

1 See Žižek (2004); jagodzinski (2012); Smith (2004); Caldwell (2009), for example.
2 All quotes from Kyle Reynolds are taken from the author's email correspondence
 with this artist, and from his website: http://www.Reynoldsreynolds.ca [accessed
 02 September 2013].
3 This position is taken further and debated in Chapter 8, Making Sense with the
 Pharma.
4 My references to Lacan's series of lessons on the sinthome are taken from
 C. Gallagher's translations of *Seminar XXIII, Joyce and the Sinthome, 1975–6*.
 Each subdivision of references to 1975, 1976, 1976a or 1976b refers to the
 different dates of these different lessons. For more exact references, see the
 bibliography. Gallagher's translations are reproduced from: http://www.
 lacaninireland.com/web/wp-content/uploads/2010/06/Book-23-Joyce-and-the-
 Sinthome-Part-1.pdf [accessed 01 December 2013].
5 Deleuze's use of cinema is thus motivated by his need to undercut Kantian
 transcendental analytics. Deleuze needs to confront key philosophical problems
 posed by Kant and Descartes using cinema because in his view the root of these
 problems, the Cogito (or 'I think, therefore I am'), is the source of the division

of the self and fractured by time, which seems to him intrinsic only to cinema. Responding to Kant, Deleuze is seeking the transcendental conditions that transpose the undetermined Cartesian Sum, in terms of its naked becoming and difference, into the determining subjectivity of the Cogito. Deleuze takes from Kant the idea of time as the determinable of the Cogito, arguing that it is the line of time that separates the I think from the I am, which thus fractures the self and provides the source of dualism. Deleuze accordingly uses cinema as a way to source, understand and picture both a subject-less gaze outside this line of time and time itself.

6　'Paranoid schizophrenia' is a subtype of schizophrenia, characterized predominantly by delusions of persecution and megalomania.

7　For an argument about utilizing the *sinthome* as a theory of desire, see Azari (2009).

8　It has been argued that Deleuze and Guattari are not necessarily waging a war against Lacan, and there are many points of comparison between their two systems. Guattari was in fact trained by Lacan, so his influence is always apparent, whilst, as Daniel Smith argues, 'Deleuze can be seen as one of Lacan's most profound, but also most independent disciples, inventing a whole new set of concepts to describe the inverse side of the symbolic structure' (Smith 2004: 635–650).

9　This argument is also seen in Smith (2004: 635).

10　See Foucault's notion of the outside of thought, in *Maurice Blanchot: The Thought from Outside* (Foucault 1990).

Chapter 5

1　The reader might wonder what is the relation between the art that I describe making in this chapter and the art I made during the episodes of arts therapy, which I described in Chapter 2. Both cases feature and produce the agency of transformative therapeutics. In the case of arts therapy this was applied to myself, whilst in the case of the material thinking I propound in this chapter, transformative therapeutics is apparent in relation to the materials I am using and the artworks I create as objects. In fact, this process also had transformative and therapeutic affects on myself, in relation to my own being-in-the-world, but these affects are not the focus of this chapter.

2　All quotations from Rannersberger are taken from the author's email correspondence.

3　Leichhardt traversed the Northern Territory in 1845 – from Moreton Bay, Brisbane (Queensland) to Port Essington, Coburg Penninsula (Northern Territory) (Leichhardt 2004).

Chapter 6

1 Lecture by Griselda Pollock, 'Fictions of fact: memory in transit in Vera Frenkel's installations', Faculty of Art History, University of Cambridge, 28 February 2008. This lecture was part of the 2008 Slade Lecture Series, published in *After-Images/ After-Affects: Trauma and Aesthetic Inscription in the Virtual Feminist Museum* (Pollock 2013).

2 For instance, *Body Missing* is an ongoing project by Frenkel, which consists of a site-specific, multichannel photo-video-text installation and website, and gives a sense of the complexity, controversy and depth of her artistic vision. Lifting off from the 'Kunstraub' (art theft) policies of the Third Reich, the proposed 'Führermuseum' in Linz (which was never formed), and investigating the fate of artworks that went missing during World War II, this work takes the form of a six-channel video installation with a fully functioning piano bar, with daily newspapers, palms, a pianist and a bartender. The visitor can sit down, have a drink, read a newspaper and socialize with the bartender and other visitors. In this space documentary and fictional realities, present and past, art and life meet, and occasionally change places. The monitors in the bar show 14 individuals' personal experiences of displacement and exile, with stories about the experience of finding oneself between cultures, about love, about the bar; amongst the backdrop of conversations about the neurosis and fetish of Hitler's art-collecting fever, war, cultural memory and totalitarian power. First installed at the Offenes Kulturhaus Linz (in a gallery that was once a Weirmacht torture prison) in 1994, this work has now toured 15 cities and ten countries, whilst the website continues to attract hundreds of respondents who seek documentary information about stolen artworks. The relations between fact and fiction, virtual and physical reality, testimony and construction of truth, artwork and documentary are continually confused and mutated (rather than made mute). Cf. http://www.yorku.ca/ BodyMissing [accessed 15 August 2013]). For more on Frenkel's art see Frenkel 2005; http://www.verafrenkel.com [accessed 15 August 2013].

3 All unreferenced quotations from Vera Frenkel come from the author's private email exchange and discussions in the artist's studio or via Skype. Interviews began in 2008, and this conversation is ongoing.

4 This reference comes from an interview with Frenkel by Caroline Langill in 2006, as part of Langill's study on *Exemplary Works of Canadian Electronic Media Art Produced Between 1970 and 1991*. Langill's study is a rare example of critical attention paid to this area (Langill 2006 n. 7).

5 Vera Frenkel (1974) *String Games: Improvisations for Inter-City Video*. Three live transmissions from Bell Canada Teleconferencing Studios in Montreal and Toronto. Exhibited as cumulative playback (made possible by Sony Canada Ltd.) at Galerie

Espace 5, 115 Sherbrooke West, Montreal. The work was then shown again, in Toronto, at InterAccess Electronic Media Arts Centre, in 2005, and in Ontario, in the Samuel J. Zacks Gallery, Agnes Etherington Art Centre, Queen's University, Kingston, 30 July–11 December 2011.

Participants/collaborators in Toronto 'Hand': Little Finger: Stephen Schofield, Ring Finger: Ellen Maidman, Middle Finger: Thomas Stiffler, Index Finger: Julia Grant, Thumb: Bill Dwyer. Montreal 'Hand': Little Finger: Lawrence Adams, Ring Finger: Vera Frenkel, Middle Finger: Miriam Adams, Index Finger: Linda Kelly, Thumb: Tom Graham.

6 Granted, there have been studies on Frenkel's work by Caroline Langill and Dot Tuer, and the first major survey of Frenkel's work has (finally) just been published in book form (edited by Sigrid Schade) (Langill 2006, 2009; Schade 2013; Tuer 1998). But this is set within a general climate of ignorance towards *String Games*. It is as though the work has actively been 'disappeared' by the world, perhaps because of the power and connotations of its political insight. Tuer's chapter in Schade, 'Beyond the New Media Frame: The Poetics of Absence in Vera Frenkel's *String Games*', develops this notion of disappearance, or absence, as the key to understanding the timely power and provocation of this work (Tuer 2013: 38–63).

7 Cat's cradle is a game played between two people with a loop of string. One player wraps the loop of string through their fingers and around their wrists, forming a particular pattern or figure. The other person then takes hold of the string in a certain way, so that when they pull it onto their own hands it forms a different figure. Each time a player takes the string off their collaborator's hands, and puts it around their own, they form a different figure with the string; this continues, producing a sequence of eight different figures.

8 This quote is taken from curator Jan Allen's description of the work on the website of the Agnes Everington Art Centre, Ontario, where it was shown in 2011. cf. http://www.aeac.ca/exhibitions/upcoming/frenkel.html [accessed 16 July 2011].

9 All quotations from Stephen Schofield are taken from the author's email exchange with him (in January 2009) and his own private notes (recounted in this exchange), which were written directly in response to his participation in *String Games*, whilst it was being performed.

10 The original French, 'partage du sensible', is important to maintain throughout its translation as the 'distribution of the sensible', since we will draw a different interpretation of 'partage', with Jean-Luc Nancy, at the end of the chapter. Whenever Rancière's interpretation of 'partage', as distribution, is used, it is important to remember that – as we will see – there are other ways of interpreting and then applying this term.

11 See *Critique of Judgment* Ak. 241–244, Kant (1987: 91–95).

Chapter 7

1 Sophie Calle, *Pas pu saisir la mort*, 2007. Installation, International Pavilion,
 Venice Biennale 10 June–21 November 2007. This work was also shown in Calle's
 retrospective at the Whitechapel Gallery in London, *Sophie Calle: Talking to
 Strangers* (16 October 2009–03 January 2010), whilst Calle used the same material
 to develop another installation at the Palais de Tokyo, *Rachel, Monique* (19 October
 2010–28 November 2010). The setting of the work's initial exhibition at Venice is
 the spotlight here because of its place in Robert Storr's sensuous mise en scène,
 which I argue develops a sense-thinking that stimulates the transformative
 therapeutics of engaging with art.

2 This artwork has stimulated some critical commentary. Marcelline Block
 juxtaposes Calle's artwork with Simone Beauvoir's *A Very Easy Death* to bring
 forward a survey of motherhood and death (Block 2009: 71–88). Jean-Michel
 Rabaté approaches *Couldn't Capture Death* from a different viewpoint, initially
 with his self-described 'negative reaction' to the work in Venice, reading from Calle
 bathotic sentimentalism and 'a dangerous descent into triteness' (Rabaté 2010:
 165, 166). Rabaté then unfolds the different layers of complexity and beauty, the
 'Anti-Bathos', which make this work so profoundly moving. Other critics on Calle
 relevant to our discussion of this work include McMahon (2010); Gratton (2006);
 Fève (2004).

3 Bourriaud argues that relational artworks are 'harmonious' because they draw
 together a community of viewers by something they have in common. This is
 opposed to Nancy's *Inoperative Community*, where he argues (against Marx)
 that any community is defined by difference rather than communion. See
 Claire Bishop's 'Antagonism and Relational Aesthetics' (in Kocur and Leung
 2013: 166–193).

4 Robert Storr, Thoughts on the 52nd Venice Biennale, pp. 33–37, Vogue Italia
 Biennale Arte. Venezia, issued 07 June.

5 Author's interview with Robert Storr at the Arsenale in Venice, 08 June 2007.

6 To set the scene for Nancy's argument in 'On the Threshold': This is often regarded
 as one of Caravaggio's most realistic, sanctimonious paintings. The basic image
 shows a group of men dressed in swathing fabrics looking at a woman who has
 recently died and is laid out in front of them. The men stare at the body in disbelief,
 as though looking for something that is no longer there, overcome with grief and
 shock that such a precious thing as life has gone. In the foreground a younger
 woman sits on a chair and leans over her knees, falling into her tears. It is a very
 touching work, particularly so because the texture of Caravaggio's *sfumato* shading
 adds such weight to the corpus of the image. It was painted at a very violent
 moment in Caravaggio's life: around the time of painting this image he killed a man

and soon afterwards fled from his hometown in Rome. Matters of life and death thus infuse the painting – from both the figurative image and the situation that took place during its production. Perhaps the process of painting such violently grave realism, with its shimmers of light, provided Caravaggio with a technique for 'being in the present'.

7 This is to some extent derived from Blanchot's writings about the impossibility of death (Blanchot 1955: 202–203). Since we can never be conscious of death, we can never know it as such. It has no state for existence; it is a state of non-existence. We are 'condemned' to its impossibility, and therefore alive (Blanchot 1949: 255).

8 *Ocean Without a Shore*, 2007 Video/sound installation, Church of San Gallo, Venice. Colour High-Definition video triptych, two 65" plasma screens, one 103" screen mounted vertically, six loudspeakers (three pairs with stereo sound). Room dimensions variable. Performer: Blake Viola.

9 Press release, see: http://prod-images.exhibit-e.com/www_jamescohan_com/7b282473.pdf [last accessed 05 May 2013].

10 Press release, see: http://prod-images.exhibit-e.com/www_jamescohan_com/7b282473.pdf [last accessed 05 May 2013].

11 TateShots. Venice Biennale: Bill Viola. 30 June 2007. See http://www.tate.org.uk/context-comment/video/venice-biennale-new-work-bill-viola [last accessed 05 May 2013].

12 *The Passing*, 1991(in memory of Wynne Lee Viola; video, black-and-white, mono sound; 54 min.). This work is one of the three screens in Viola's 1992 *Nantes Triptych* (video, three projections, colour and stereo sound; 29 min., 46 sec. Collection: Tate).

13 The essay refers On Kawara's 1997 exhibition of his 'Date paintings'. These paintings simply imprint (in capital letters and numbers) the date on which the painting was made. Kawara's art is known for its banal, compulsive repetition, which continues to the point that recording these details seems to become the utter substance of this artist's existence. As Adrien Searle writes: 'On Kawara's work is a matter of life and death, a question of survival […] he seems to exist as pure consciousness, recording his persistence' (Searle 2002). Thus, whilst he produces a Nancean 'technique of the present', this process seems to provide for Kawara a technique of 'being in the present'.

14 Nancy uses the concepts 'transimmanent' and 'inoperative' to describe this idea, and consider how the artwork exists beyond its immediately present, singular objective form so that one can have multiple experiences of encountering it (Nancy 1996: 103–105).

15 As Emma Wilson argues in *Love, Mortality and the Moving Image*. Considering art as 'a form of palliation' will continue to be an important idea in this chapter

(Wilson 2012: 77). Wilson's assertion, that 'the process of making art is palliative', is upheld throughout this book, since palliation is another example of the ways that this book shows how engaging with art has the capacity to provide a means of transformative therapeutics (Wilson 2012: 88).

16 The author's interview with Calle, 26 March 2008.

17 The English title of this film is *Life and Nothing More*. I would like to reserve the French title, which means 'And life continues'.

18 The ideas of 'exorcism', 'filling an absence', 'healing wounds' and 'improving life' are quotes from Calle, and represent ongoing motifs that provide a sense throughout her work.

19 John Tusa, 'Interview with video artist Bill Viola' (Tusa 2003).

20 John Tusa, 'Interview with video artist Bill Viola' (Tusa 2003).

21 To extend this reading of Heidegger, I quote Sabatino: For Heidegger, technology 'represents a way of dealing with things and one another that has a fateful impact not just on the kind of world it helps to shape, but on the very meaning and being of our humanness as well' (Sabatino 2007: 65).

22 Goetz's ideas tie in with what Nancy says in *Being Singular Plural*: 'art understood absolutely in its modern sense, *technê* as a mode of the execution of Being' (Nancy 2001a: 122). This also relates to Nancy's thinking about technics in *Finite Thinking*, in terms of technics' existential capacity to bring-forth a 'sending of Being', or seeing 'The "nexus" of technologies' of Being as 'the opening of its finitude' (Nancy 2003: 24–25). In Nancy existence is fundamentally 'technological' in the face of absolute finitude.

23 John Tusa, 'Interview with video artist Bill Viola' (Tusa 2003).

Chapter 8

1 At the time of writing this book, the series of *De la misère symbolique* has not been published in translation. All references refer to my own translation of the original French edition.

2 In Simondon transindividual collective and psychic individuation are two phases of the individualization process, which mutually balance each other to bring a manner of being and of individuating. The individual is considered only in relation to other individuals, and the worldly situation or milieu in which it ex-sists (Simondon 2006: 250, 277–278. See also Simondon 1989: 220).

3 See http://www.bbc.co.uk/news/health-23674235. NHS prescriptions for methylphenidate drugs, including Ritalin, rose from 420,000 in 2007 to 657,000 last year, the Care Quality Commission said.

4 These controversies are raised in Alan Sroufe's article 'Ritalin Gone Wrong' in *New York Times*, 28 January 2012. This article caused a backlash of strong opinions

in varying agreement and disagreement with Sroufe's viewpoint. There is a large degree of literature about the polemics of Ritalin. See, for instance, Breggin (2002).

5 See Robert Whitaker (2010) *Anatomy of an Epidemic: Magic Bullets, Psychiatric Drugs, and the Astonishing Rise of Mental Illness in America*, for example.

6 See James (2010) and Fisher (2009). This point is also argued vociferously in Ben Goldacre's *Bad Pharma* – see Goldacre (2012).

7 At the time of writing, Stiegler's opus on *Reenchanter Le Monde: La Valeur Esprit Contre Le Populisme Industriel* has not been published in translation. The translation is due to appear in print in February 2014, as *The Re-Enchantment of the World: The Value of Spirit Against Industrial Populism* (tr. Trevor Arthur, Bloomsbury). All quotations are the author's own translation of the original French edition.

8 See Deleuze (2005a): 171–172.

9 The translation I am using is C. J. Rowe (1986).

10 Using Heidegger in this way then recalls the technological dimension of Vera Frenkel's *String Games* we saw in Chapter 6, and also the artistic sense of *technê* we saw from Sophie Calle's artistic process in Chapter 7.

11 Barbara Bolt's work on *Art Beyond Representation*, which we saw in Chapter 5, is useful here, because Bolt uses Heidegger's understanding of technology (and 'handleability') to bring forward a hypothesis on the relationship of care, concern, co-responsibility and responsiveness (or what I am calling transformative therapeutics) that brings about the emergence of art. In Bolt, the artist's responsiveness to their materials reappropriates any instrumental apprehension of tools towards a *poietic* process of transformation. This process is performative, and brings forth a work of art that reveals tacit knowledge, or truth (Bolt 2004: 52–86).

12 Cf. Adelman (1985); Hausner (1985).

13 *In-Existence § 1: Becoming Myst*, by Hierophantes: a multimedia stereoscopic, participative installation for synthetic videos and electronic sounds, held at the Making Sense colloquium, Centre Pompidou, Paris, 19 October 2010.

14 'Diachronic milieu' is a term developed by the author in conversation with Stiegler at his class on the pharmakon, at Maison-Ecole du Grand Meaulness, Epineuil le Fleuriel, on 18 December 2010.

15 *In-Existence* was created at two different locations in 2010: 20 September 2010, the festival Antilope (La Chaux-de-fond, Switzerland), and at Centre George Pompidou, (Paris, France). A version of this work was also performed in 2008 and 2009 at the Cube (Issy-les-Moulineaux, France), L'Autre Canal (Nancy, France) and at the Bellevilloise (Paris, France). See http://www.hierophantes.net/category/calendar/calendar-in-existence/ [accessed 05 October 2013].

16 The ritualistic elements of performing *In-Existence* recall the work on art and ritual which we saw through Stephen Newton, in Chapter 1.

17 This recalls the kind of *technê* we found in Chapter 6.

18 Hierophantes' artwork is similar to the pharmacological, spiritual activity that took place in the series of workshops and the 'workshop of techniques of the self' in Ars Industrialis, in 2008. 'Techniques of the self' comes from Foucault. It concerns ideas and practices about 'The care of the self (*epimeleia heautou* or *cura sui*)' (Foucault 2005: 491). The workshops at Ars Industrialis were defined to be therapeutic, and thus pharmacological. The relation between 'technique of the self' and the pharmakon, as a means of taking care, can be seen from elements of the Ars Industrialis website, and Stiegler's *On Pharmacology* (Stiegler 2013: 76–77, 95–96).

19 Reserving the potentially liberating effect of engaging with this artwork for only a select or elite few participants then raises the problem of how it might be able to speak to or for a larger audience and thus effect or resolve the disenchantment of the world at large. If the transformative therapeutics that I felt from this artwork can only be applied to those who encountered it, then how can I make an argument that expands this application and makes it more equally accessible? We saw these problems raised when I discussed Bourriaud's *Relational Aesthetics* in Chapter 7.

20 http://www.hierophantes.net/category/texts/texts-in-existence/ [accessed 31 December 2013]. Again we recall Stephen Newton's understanding of the processive connection between *Art and Ritual*, as it was introduced in Chapter 1.

Bibliography

Adelman, S. A. (1985) 'Pills as Transitional Objects: A Dynamic Understanding of the Use of Medication in Psychotherapy' in *Psychiatry*, 48, 3: 246–253.

Aldridge, D. (2000) *Music Therapy in Dementia Care: More New Voices*, London: Jessica Kingsley Publishers.

Alliez, E. (2006) '*Anti-Oedipus* Thirty Years On (Between Art and Politics)' in M. Fuglsang and B. Meier Sorensen (eds.) *Deleuze and the Social (Deleuze Connections)*, Edinburgh: University Press, 151–168.

Amos, S. P. (1982) 'The Diagnostic, Prognostic, and Therapeutic Implications of Schizophrenic Art' in *The Arts in Psychotherapy*, 9: 131–143.

Aristotle. (1986) *De Anima (On the Soul)*, trans. H. Lawson-Tancred, London: Penguin Books.

Artaud, A. (1988 [1947]) 'To Be Done with the Judgment of God' in S. Sontag (ed.) *Selected Writings*, California: University of California Press, 570–571.

Azari, E. (2009) *Lacan and the Destiny of Literature: Desire, Jouissance and the Sinthome in Shakespeare, Donne, Joyce and Ashbery*, London: Continuum Literary Studies.

BAAT (2003) 'Defining art therapy' in Edwards, D. (ed.) (2004) *Art Therapy (Creative Therapies in Practice series)*, London: Sage Publications Ltd, 2–3.

BBC NEWS (14 September 2008) *NHS Art Therapy for Schizophrenia*, Reproduced from: http://news.bbc.co.uk/go/pr/fr/-/1/hi/health/7612901.stm [accessed 01 January 2010].

Barrett, B. and B. Bolt (eds.) (2010) *Practice as Research: Approaches to Creative Arts Enquiry*, London: I. B. Tauris.

Barrington, Katherine A. (2005) *Music Therapy: A Study in Professionalisation*, Durham theses, Durham University. Reproduced from: http://etheses.dur.ac.uk/2791/ [accessed 08 November 2013].

Bartal, L. and N. Ne'eman (1975) *Movement Awareness & Creativity*, London: Harper Row.

———. (1993) *Metaphoric Body, Guide to Expressive Therapy Through Images and Archetypes*, London: Jessica Kingsley Publishers.

Bergson, H. (1911) *Creative Evolution*, trans. A. Mitchell, New York: Henry Hold and Company.

Blanchot, M. (1949) *La Part du feu*, Paris: Gallimard.

———. (1955) *L'Espace litteraire*, Paris: Galilée.

Blazwick, I., et al. (2009) *Sophie Calle: The Reader*, London: Whitechapel Gallery Ventures Limited.

Block, M. (2009) 'Unburied Mothers: The Death of the Maternal in Simone de Beauvoir's Une mort très douce and Sophie Calle's Pas pu saisir la mort' in M. Souza and C. Staudt (eds.) *The Many Ways We Talk about Death in Contemporary Society: Interdisciplinary Studies in Portrayal and Classification*, Lewiston, New York: Edwin Mellen Press.

Bolt, B. (2004) *Art Beyond Representation: The Performative Power of the Image*, London: I. B. Tauris.

———. (2006) 'Materializing Pedagogies' in *Working Papers in Art and Design*, 4. Reproduced from: http://www.herts.ac.uk/__data/assets/pdf_file/0015/12381/WPIAAD_vol4_bolt.pdf [accessed 04 December 2013].

Bourriaud, N. (2002) *Relational Aesthetics*, trans. S. Pleasance and F. Woods with the participation of M. Copeland, Paris: Les Presses du Réel.

Breggin, P. (2002) *The Ritalin Fact Book: What Your Doctor Won't Tell You About Adhd and Stimulant Drugs*, Cambridge, MA: Perseus Books Group.

Brooker, J., et al. (2007) *The Use of Art Work in Art Psychotherapy with People Who Are Prone to Psychotic States: An Evidence-Based Clinical Practice Guideline*, London: Goldsmiths, University of London.

Buchanan, I. (2000) *Deleuzism: A Metacommentary*, Durham: Duke University Press.

———. and P. MacCormack (eds.) (2008) *Deleuze and the Schizoanalysis of Cinema*, London: Continuum.

Bunt, L. (2004) *Music Therapy: An Art Beyond Words*, London: Routledge.

Caddy, P. (2012) 'A Pilot Body Image Intervention Programme for In-patients with Eating Disorders in an NHS Setting' in *International Journal of Therapy and Rehabilitation*, 19, 4: 190–199.

Caldwell, L. (2009) 'Schizophrenizing Lacan: Deleuze, [Guattari], and *Anti-Oedipus*' in *Intersections*, 10, 3: 18–27.

Calle, S., et al. (2003) *Sophie Calle: M'as tu vue? – Did you see me?*, New York: Prestel Publishing.

———. (2004) *Exquisite Pain*, London: Thames and Hudson.

Carter, P. (2004) *Material Thinking*, Melbourne: Melbourne University Press.

Case, C. and T. Dalley (2006) *The Handbook of Art Therapy: Second Edition*, Routledge: East Sussex.

Chardel, J.-B. (2008) 'L'Art, beauté, spiritualité', unpublished essay.

———. (2011) Reproduced from: http://www.jbchardel-art.com [last accessed 01 January 2011].

Collins, L. (2010) 'The Wild Being of Louise Bourgeois: Merleau-Ponty in the Flesh' in *Romance Studies*, 28, 1: 47–56.

Crawford, M. J. and S. Patterson (2007) 'Arts Therapies for People with Schizophrenia: An Emerging Evidence Base', in *Evidence Based Mental Health*, 10: 69–70.

Dalí, S. (1976) *The Unspeakable Confessions of Salvador Dalí: As Told to Andre Parinaud*, trans. H. J. Salemson, London: W.H. Allen.

———. (1998) *The Collected Writings of Salvador Dalí*, trans. H. Finkelstein, Cambridge: Cambridge University Press, 224–225.

Dalley, T. (1984) *Art as Therapy: An Introduction to the Use of Art as a Therapeutic Technique*, New York: Tavistock Publications.

Deleuze, G. 1972. *L'Arc '49; Gilles* Deleuze, 1415, 34, 837.

———. (1983) *Nietzsche and Philosophy*, trans. Hugh Tomlinson, London: The Athlone Press.

———. (1995) *Negotiations 1972–1990*, trans. M. Joughin, New York: Columbia University Press.

———. (2003) *Two Regimes of Madness: Texts and Interviews 1975–1995*, ed. D. Lapoujade, trans. A. Hodges and M. Taormina, Semiotext(e): MIT Press.

———. (2004 [1990]) *The Logic of Sense*, trans. M. Lester, with C. Stivale; ed. C. V. Boundas, London: Continuum.

———. (2004a [1994]) *Difference and Repetition*, trans. P. Batton, London: Continuum.

———. (2005) *Francis Bacon: The Logic of Sensation*, trans. D. W. Smith, London: Continuum.

———. (2005a) *Cinema 2: The Time-Image*, trans. H. Tomlinson and R. Galeta, London: Continuum.

Deleuze, G. and F. Guattari (1994) *What Is Philosophy?*, trans. G. Burchell and H. Tomlinson, London: Verso.

———. (2004 [1983]) *Anti-Oedipus: Capitalism and Schizophrenia*, trans. R. Hurley, M. Seem and H. R. Lane, London: Continuum.

———. (2004a [1987]) *A Thousand Plateaus: Capitalism and Schizophrenia*, trans. B. Massumi, London: Continuum.

Deleuze, G. and C. Parnet (1987) *Dialogues*, trans. B. Habberjam and H. Tomlinson, London: Continuum International Publishing Group Ltd.

Derrida, J. (2004) *Dissemination*, trans. B. Johnson, London: Continuum.

———. (2005) *On Touching – Jean-Luc Nancy*, trans. C. Irizary, Stanford, California: Stanford University Press.

Dubuffet, J. (1993 [1948]), 'Crude Art' in C. Harrison and P. J. Wood (eds.) *Art in Theory 1900–1990: An Anthology of Changing Ideas*, London: Wiley-Blackwell, pp. 605–607.

Edwards, D. (2004) *Art Therapy (Creative Therapies in Practice series)*, London: Sage Publications Ltd.

Eerola, T. (2008) 'Geoaesthetics and its applications', GeoLanguage Oy (Finland). Retrieved from: http://www.cprm.gov.br/33IGC/1342989.html [accessed 30/05/14].

Ehrenzweig, A. (1967) *The Hidden Order of Art*, Berkeley and Los Angeles, California: University of California Press.

———. (1975) *The Psychoanalysis of Artistic Vision and Hearing; An Introduction to a Theory of Unconscious Perception*, London: Sheldon Press.

Evans, F. and L. Lawlor (eds.) (2000) *Chiasms: Merleau-Ponty's Notion of Flesh*, New York: State University of New York Press.

Fève, N. (2004) 'Rhétorique de la photographie dans l'autobiographie contemporaine: Des histoires vraies de Sophie Calle' in A. R. Silvester and D. Scott (eds.) *Reading Images and Seeing Words*, Amsterdam, Netherlands: Rodopi, 157–170.

Fisher, M. (2009) *Capitalist Realism: Is There No Alternative?*, London: Zero Books.

Foucault, M. (1990) *Maurice Blanchot: The Thought from Outside*, trans. J. Mehlman and B. Massumi, New York: Zone Books.

———. (1990b) *The History of Sexuality, Vol. 2: The Use of Pleasure*, trans. R. Hurley, Vintage Books: Water Damage edition.

———. (2005) *The Hermeneutics of the Subject: Lectures at the College de France 1981-1982*, eds. F. Gross and F. Ewald, New York: Picador.

Frenkel, V. (2013) Reproduced from: http://www.verafrenkel.com [accessed 15 December 2013].

———. (1974) *String Games: Improvisations for Inter-City Video*, VAG exhibition catalogue.

———. (1994) *Body Missing*. Reproduced from : http://www.yorku.ca/BodyMissing [accessed 15 August 2008].

———. (1998) 'Vera Frenkel with Dot Tuer and Clive Robertson; The Story Is Always Partial: A Conversation with Vera Frenkel' in *Art Journal*, 57, 4: 2–15.

———. (2001) 'A Kind of Listening; Notes from an Interdisciplinary Practice' in L. Hughes and M.-J. Lafortune (eds.) *Penser l'indiscipline: Recherches Interdisciplinaires en art Contemporain*, Montreal: OPTICA, pp. 31–47.

———. (2005) *Of Memory and Displacement/Vera Frenkel: Collected Works*, [on DVD-ROM].

Freud, S. (1955 [1923]) *The Standard Edition of Complete Psychological Works of Sigmund Freud, Vol. 18*, ed. and trans. J. Strachey, London: Penguin.

———. (1974) *The Standard Edition of the Complete Psychological Works of Sigmund Freud, Vol. 14*, ed. and trans. J. Strachey, London: The Hogarth Press.

———. (1978 [1958]) *The Standard Edition of the Complete Psychological Works of Sigmund Freud, Vol. 12*, ed. and trans. J. Strachey, London: The Hogarth Press.

———. (1991) *Introductory Lectures on Psychoanalysis*, London: Penguin Books Ltd.

———. (1991a) *The Penguin Freud Library Volume 4: The Interpretation of Dreams*, London: Penguin Books Ltd.

———. (2001 [1961]) *The Standard Edition of the Complete Psychological Works of Sigmund Freud, Volume XIX (1923–1925)*, Vintage Classics: Random House.

———. (2002 [1911]) *The Schreber Case*, trans. A. Webber, Penguin Classics.

———. (2002a) *The 'Wolfman' and Other Cases*, ed. A. Phillips, London: Penguin Books.

———. (2004) *Studies on Hysteria*, trans. N. Luckhurst, London: Penguin.

———. (2012) *A General Introduction to Psychoanalysis*, London: Wordsworth Editions Ltd, Classic World Literature Edition.

Goetz, B. and J.-L. Nancy (1999) 'Jean-Luc Nancy "Techniques du présent" Entretien avec Benoît Goetz' in *Le Portique* 3. Reproduced from: http://leportique.revues.org/309 [accessed 06 December 2013].

Goldacre, B. (2012) *Bad Pharma*, London: Faber & Faber.

Gratton, J. (2006) 'Du documentaire au documontage: Vingt ans après de Sophie Calle' in *Intermédialités: Histoire et Théorie des Arts, des Lettres et des Techniques*, 7: 167–202.

Guattari (1995) *Chaosmosis: An Ethico-Aesthetic Paradigm*, trans. P. Bains and J. Pefanis, Indiana: Indiana University Press.

———. (1996) *The Guattari Reader*, ed. G. Genosko, London: Blackwell.

Guattari, F. and S. Rolnik (2008) *Molecular Revolution in Brazil*, trans. K. Clapshow and B. Holmes, Semiotext(e): MIT Press.

———, S. Lotringer and F. Dosse (2008) *Chaosophy: Texts and Interviews 1972–1977*, Semiotext(e)/Foreign Agents: MIT Press.

Hallward, P. (2006) *Out of This World: Deleuze and the Philosophy of Creation*, London: Verso.

Harrison, C. and P. J. Wood (2002) *Art in Theory 1900–2000: An Anthology of Changing Ideas*, London: Wiley-Blackwell.

Hausner, R. S. (1985) 'Medication and Transitional Phenomena' in *International Journal of Psychoanalytic Psychotherapy*, 11: 375–398.

Heidegger, M. (1962) *Being and Time*, trans. J. Macquarrie and E. Robinson, Oxford: Blackwell Publishing.

———. (1971) 'The Origin of the Work of Art' in M. Heidegger (ed.) *Poetry, Language, Thought*, trans. A. Hofstadter, London: Harper & Row, 15–87.

———. (1977) 'The Question Concerning Technology' (3–35) and 'The Turning' (36–49)' in *The Question Concerning Technology and Other Essays*, trans. W. Lovitt, New York: Harper & Row Publishers, Inc.

———. (1987) *Nietzsche, Volume III: The Will to Power as Knowledge and as Metaphysics*, ed. D. Farrell Krell, trans. J. Stambaugh, D. Farrell Krell and F. Capuzzi, San Francisco: Harper and Row.

Hillman, J. (1997) *The Soul's Code: In Search of Character and Calling*, New York: Warner Books Edition.

Hobbes, T. (1996) *Leviathan*, ed. J. Gaskin, Oxford: Oxford University Press.

Holland, E. W. (1999) *Deleuze and Guattari's Anti-Oedipus: Introduction to Schizoanalysis*, London: Routledge.

Holmes, L. (2012) 'Perversion and Pathology: A Critique of Psychoanalytic Criticism in Art' in *Journal of Aesthetics and Culture*, 4: 1–10.

Huizinga, J. (1970) *Homo Ludens: A Study of the Play Element in Culture*, London: Maurice Temple Smith Ltd.

Jagodzinski, J. (ed.) (2012) *Psychoanalysing Cinema: A Productive Encounter with Lacan, Deleuze, and Žižek*, New York: Palgrave Macmillan.

———. (2012a) 'Outside the Outside: In the Realms of the Real (Hogancamp, Johnston, and Darger)' in A. Wexler (ed.) *Art Education Beyond the Classroom: Pondering the Outsider and Other Sites of Learning*, London: Palgrave Macmillan, 159–196.

James, O. (2010) *Britain on the Couch: How Keeping up with the Joneses has Depressed us since 1950*, London: Vermilion.

Jay, M. (1993) *Downcast Eyes: The Denigration of Vision in Twentieth-Century French Thought*, California: California University Press.

Jung, C. G. (1946) 'The Psychology of the Transference' in *Collected Works*, 16, London: Routledge and Kegan Paul 163–327.

Kandinsky, W. (1994) *Complete Writings on Art*, ed. K. C. Lindsay and P. Vergo, Cambridge, MA: Da Capo Press.

Kant, I. (1987) *Critique of Judgement*, trans. W. S. Pluhar, Indianapolis : Hacking Publishing Company, Inc.

——. (1998) *Critique of Pure Reason*, trans. P. Guyer and A. W. Wood, Cambridge: Cambridge University Press.

Kocur, Z. and S. Leung (eds.) (2012) *Theory in Contemporary Art since 1985*, West Sussex: John Wiley & Sons Inc.

Kuhn (1962) *The Structure of Scientific Revolutions*, Chicago: University of Chicago Press.

Kuhns, R. F. (1983) *Psychoanalytic Theory of Art: A Philosophy of Art on Developmental Principles*, Columbia: Columbia University Press.

Lacan, J. (1966) *Écrits*, Paris: Seuil.

——. (1975) *Seminar XXIII: Joyce and the Sinthome*, lesson of 18 November, 3, trans. C. Galagher. Reproduced from: http://www.lacaninireland.com/web/wp-content/uploads/2010/06/THE-SEMINAR-OF-JACQUES-LACAN-XXIII.pdf [accessed 01 December 2013].

——. (1976) *Seminar XXIII: Joyce and the Sinthome*, lesson of 13 January, 4, trans. C. Gallagher. Reproduced from: http://www.lacaninireland.com/web/wp-content/uploads/2010/06/THE-SEMINAR-OF-JACQUES-LACAN-XXIII.pdf [accessed 01 December 2013].

——. (1976a) *Seminar XXIII: Joyce and the Sinthome*, lesson of 17 February, 7, trans. C. Gallagher. Reproduced from: http://www.lacaninireland.com/web/wp-content/uploads/2010/06/THE-SEMINAR-OF-JACQUES-LACAN-XXIII.pdf [accessed 01 December 2013].

——. (1976b) *Seminar XXIII: Joyce and the Sinthome*, lesson of 10 February, 6, trans. C. Gallagher. Reproduced from: http://www.lacaninireland.com/web/wp-content/uploads/2010/06/THE-SEMINAR-OF-JACQUES-LACAN-XXIII.pdf [accessed 01 December 2013].

——. (1977) *Ecrits: A Selection*, trans. A. Sheridan, London: Tavistock.

——. (1979) *The Four Fundamental Concepts of Psycho-Analysis*, trans. A. Sheridan, New York: Penguin Books Ltd.

——. (1991) *Le Seminaire VIII: Le transfert (1960–61)*, Paris: Seuil.

Landgarten, H. B. (2013) *Clinical Art Therapy: A Comprehensive Guide*, London: Routledge.

Langill, C. (2006) Interview with Vera Frenkel. Reproduced from: http://www.
fondation-langlois.org/html/e/page.php?NumPage=1932 [accessed 29 November
2010].

———. (2009) 'Vera Frenkel' in *Shifting Polarities Exemplary Works of Canadian
Electronic Media Art Produced Between 1970 and 1991*, Daniel Langlois
Foundation. Reproduced from: http://www.fondation-langlois.org/html/e/page.
php?NumPage=1949 [accessed 01 January. 2009].

Lawlor, L. (1998) 'The End of Phenomenology: Expressionism in Deleuze and Merleau-
Ponty' in *Continental Philosophy Review*, 31: 15–34.

Leader, D. (2008) *The New Black: Mourning, Melancholia and Depression*, London:
Penguin Books.

Lehman, H. (1974) '...and connecting with strangers' in *The Montreal Daily Star*,
9 November 1974.

Leichhardt, L. (2004) *Journal of an Overland Expedition in Australia: from Moreton
Bay to Port*. Project Gutenberg. Reproduced from: http://www.gutenberg.org/
ebooks/5005 [accessed 01 December 2012].

Levy, F. (1992) *Dance Movement Therapy, a Healing Art*, Amer Alliance for Health
Physical.

Lyotard, J.-F. (1989) 'Beyond Representation' in A. Benjamin (ed.) *The Lyotard Reader*,
London: Blackwell Readers, 155–169.

Manning, E. (2007) *Politics of Touch: Sense, Movement, Sovereignty*, Minnesota:
University of Minnesota Press.

———. (2008) 'Creative Thoughts for Thought in Motion' in *Inflexions*, 1, 1, Reproduced
from: http://www.senselab.ca/inflexions/htm/node/Manning.html [accessed 15 May
2011].

McMahon, M. (2010) 'Touching Intact: Sophie Calle's Threat to Privacy' in G. Evans
and A. Kay (eds.) *Threat: Essays in French Literature, Thought and Visual Culture*,
Oxford, England: Peter Lang, 69–83.

McNiff, S. (1993) *Art as Medicine: Creating a Therapy of the Imagination*,
Massachussettes: Shambhala Publications Inc.

———. (2004) *Art Heals: How Creativity Cures the Soul*, Massachussettes: Shambhala
Publications Inc.

Meekums, B. (2007) *Dance Movement Therapy in Britain: Pioneers of a profession*, Self-
published on Academia.edu. Reproduced from: http://www.academia.edu/1987077/
DANCE_MOVEMENT_THERAPY_IN_BRITAIN_Pioneers_of_a_profession
[accessed 08 November 2013].

Merleau-Ponty, M. (1968) *The Visible and the Invisible*, trans. A. Lingis, ed. C. Lefort,
Evanston: Northwestern University Press.

Metzl and Riba. (2003) 'Understanding the Symbolic Value of Medications: A Brief
Review' in *Primary Psychiatry*, 10, 7: 45–48.

Miller, J.-A. (1987) 'Préface' in J. Aubert (ed.) *Joyce avec Lacan*, Paris: Navarin Editeur.
Retrieved from: http://www.lacan.com/frameXI1.htm [accessed 17 April 2013].

Nancy, J.-L. (1990) 'Sharing Voices' (Partage des voix)' in L. Ormiston and A. D. Schrift (eds.) *Transforming the Hermeneutic Context: From Nietzsche to Nancy*, New York: SUNY Press, 211–260.

———. (1994) *The Experience of Freedom*, trans. B. McDonald, Stanford: Stanford University Press.

———. (1996) *The Muses*, trans. P. Kamuf, Stanford: Stanford University Press.

———. (2001) *Kiarostami Abbas: The Evidence of Film*, Brussels: Yves Gevaert.

———. (2001a) *Being Singular Plural*, trans. R. Richardson and A. O'Byrne, Stanford: Stanford University Press.

———. (2003) *A Finite Thinking*, trans. S. Parks, Stanford: Stanford University Press.

———. (2005) *The Ground of the Image*, trans. J. Fort, New York: Fordham University Press.

———. (2006) 'The Technique of the Present: On Kawara)' in J.-L. Nancy (ed.) *Multiple Arts: The Muses II*, trans. S. Sparks, Stanford: Stanford University Press, 191–206.

Newton, S. (1996) 'The Spirituality of Abstraction', conference paper: *Interiority, Necessity and Communication in Art*, University of Edinburgh. Reproduced from: http://www.newton-art.com/?page_id=161 [accessed 24 November 2013].

———. (2001) *Painting, Psychoanalysis and Spirituality*, Cambridge: Cambridge University Press.

———. (2008) *Art and Ritual: A Painter's Journey*, London: Ziggurat Books International.

Ogden, T. H. (1999) *The Analytic Third: An Overview*, Northern California Society for Psychoanalytic Psychology. Reproduced from: http://www.psychspace.com/psych/viewnews-795.html [accessed 09 November 2013].

———. (1999a) *Reverie and Interpretation: Sensing Something Human*, London: Karnac Books.

———. (2004) 'On Holding and Containing: Being and Dreaming' in *International Journal of Psychoanalysis*, 85: 1349–1364.

Oppenheim, L. (2005) *A Curious Intimacy: Art and Neuro-psychoanalysis*, London: Routledge.

O'Sullivan, S. (2006) *Art Encounters Deleuze and Guattari: Thought Beyond Representation*, London: Palgrove Macmillan.

Pacey. (1972) *Remedial Art: A Bibliography*, Hatfield: Hertis.

Paterson, M. (2007) *The Senses of Touch: Haptics, Affects and Technologies*, Oxford: Berg Publishers.

Pavlicevi, M. (1997) *Music Therapy in Context: Music, Meaning and Relationship*, London: Jessica Kingsley Publishers.

Plato. (1986) *Phaedrus*, trans. C. J. Rowe, Warminster: Aris & Phillips Ltd.

Polanyi, M. (1958) *Personal Knowledge: Towards a Post Critical Philosophy*, London: Routledge.

———. (1967) *The Tacit Dimension*, New York: Anchor Books.

Pollock, G. (2011) 'Engimas of Research: Psychoanalysis and /as Culture' in *Rigorous Holes: Perspectives on Psychoanalytic Theory in Art and Performance Research*, London: CCW Graduate School, Reproduced from: http://195.194.24.19/qui_screenres-v15.pdf [accessed 26 October 2013].

———. (2013) *After-Images/After-Affects: Trauma and Aesthetic Inscription in the Virtual Feminist Museum*, Manchester: Manchester University Press.

Rabaté, J.-M. (2010) 'Kallos Anti-Bathos? (From Calle to Freud, Lacan, and Back)' in S. Crangle and P. Nicholls (eds.) *On Bathos: Literature, Art, Music*, London: Continuum, 165–182.

Rancière, J. (2002) 'The Aesthetic Revolution and its Outcomes: Emplotments of Autonomy and Hetereonomy' in *New Left Review*, 14: 133–151.

———. (2004) *The Politics of Aesthetics: The Distribution of the Sensible*, trans. G. Rockhill, London: Continuum.

———. (2004a) 'The Janus-Face of Politicized Art: Jacques Rancière in Interview with Gabriel Rockhill' in *The Politics of Aesthetics: The Distribution of the Sensible*, trans. G. Rockhill, London: Continuum, 49–66.

———. (2006) 'Thinking between Disciplines: An Aesthetics of Knowledge' in *Parrhesia*, trans. J. Roffe, 1: 1–12.

———. (2007) 'Le Travail de l'image' in *Multitudes*, 28: 195–210.

———. (2008) 'Aesthetic Separation, Aesthetic Community: Scenes from the Aesthetic Regime of Art' in *Art & Research: A Journal of Ideas, Contexts and Methods*, 2: 1.

———. (2009) *Aesthetics and its Discontents*, trans. S. Corcoran, Cambridge: Polity Press.

———. (2009a) *The Emancipated Spectator*, trans. G. Elliott, London: Verso Books.

———. (2009b) 'Afterword/The Method of Equality: An Answer to Some Questions' in G. Rockhill and P. Watts (eds.) *Jacques Ranciere: History, Politics, Aesthetics*, Durham: Duke University Press, 273–288.

Rannersberger, C. (2011) 'The Sensation of Landscape Painting in Northern Australia' in L. Collins and E. Rush (eds.) *Making Sense: For an Effective Aesthetics*, Oxford: Peter Lang.

Read Johnson, D. (1998) 'On the Therapeutic Action of the Creative Arts Therapies: The Psychodynamic Model' in *The Arts in Psychotherapy*, 25, 2: 85–99.

Reynolds, J. (2007) 'Wounds and Scars: Deleuze on the Time and Ethics of the Event' in *Deleuze Studies*, 1, 2: 144–166.

Riegl, A. (2004) *Historical Grammar of the Visual Arts*, trans. J. E. Jung, New York: Zone Books.

Rolnik (2011) 'Deleuze, Schizoanalysis' in *e-flux journal*. 23. Reproduced from: http://www.e-flux.com/journal/deleuze-schizoanalyst/ [accessed 21 November 2013].

Rothwell, N. (2008) 'Caroline Rannersberger; Landscapes of Delight and Disquiet', exhibition catalogue, Dominik Mersch Gallery, Sydney, New South Wales, Australia.

Ruddy, R. and D. Milnes, (2005) 'Art Therapy for Schizophrenia or Schizophrenia-like Illnesses', in *Cochrane Database of Systematic Reviews*, 4: 1–25.

Sabatino, Charles J. (2007) 'A Heideggerian Reflection on the Prospects of Technology' in *Janus Head*, 10, 1, Reproduced from: http://www.janushead.org/10-1/Sabatino.pdf [accessed 01 May 2012].

Sass, L. A. (1994) *The Paradoxes of Delusion: Wittgenstein, Schreber, and the Schizophrenic Mind*, Ithaca, NY: Cornell University Press.

Sauvageot, A. (2007) *Sophie Calle. L 'art caméléon*, Paris: Presses universitaires de France.

Schade, S. (ed.) (2013) *Vera Frenkel*, Berlin: Hatie Cantz.

Schaverien, J. (1992) *The Revealing Image: Analytical Art Psychotherapy in Theory and Practice*, London: Routledge.

——. (1995) *Desire and the Female Therapist: Engendered Gazes in Psychotherapy and Art Therapy*, London: Routledge.

—— and K. Killick (eds.) (1997) *Art, Psychotherapy and Psychosis*, New York: Routledge.

Schreber, D. P. (1988 [1903]) *Memoirs of My Nervous Illness*, trans. and eds. I. Macalpine and R. Hunter, Harvard: Harvard University Press.

Searle, A. (2002) 'It's a date!' in *The Guardian*, Tuesday 3 December 2002.

Segal H. (1952) 'A Psycho-Analytical Approach to Aesthetics' in *International Journal of Psychoanalysis* 33: 196–207.

——. (1986) 'The Curative Factors in Psychoanalysis' and 'A Psycho-Analytic Approach to Aesthetics' in *The Work of Hanna Segal: A Kleinian Approach to Clinical Practice*, Washington, DC: Jason Aronson, Incorporated, 69–80; 185–205.

Sellars, J. (1999) 'The Point of View of the Cosmos: Deleuze, Romanticism, Stoicism' in *Pli*, 8: 1–24.

Simondon, G. (1958) *Du Mode d'existence des objets techniques*, Paris: Aubier.

——. (1989) *L'Individuation psychique et collective*, Paris: Aubier.

——. (2006) *L'Individuation à la lumière des notions de forme et d'information*, Grenoble: Editions Jérôme Millon.

Skrebowski, L. (2005) 'Dismantling the Self: Deleuze, Stoicism and Spiritual Exercises', in *Stoicism: Fate, Uncertainty, Persistence*, Reproduced from: http://www.londoncon-sortium.com/wp-content/uploads/2007/02/skrebowskistoicsessay.pdf [accessed 09 November 2013].

Slack, J. D. (2005) 'Logic of sensation' in C. J. Stivale (ed.) *Gilles Deleuze: Key Concepts*, Chesham: Acumen Publishing Limited, 131–140.

Smith, D. W. (2004) 'The Inverse Side of the Structure Žižek on Deleuze on Lacan' in *Criticism*, 46, 4: 635–650.

Smithson, R. (1996) *Robert Smithson: The Collected Writings*, ed. J. Flam, Berkeley and Los Angeles: University of California Press.

Spoerri, E. (1997) *Adolf Wölfli Draftsman, Writer, Poet, Composer*, Ithaca: Cornell University Press.

Stiegler, B. (1994) *La Technique et le temps, tome 1: La Faute d'Épithémée*, Paris: Galilée.

———. (1998) *Technics and Time, 1: The Fault of Epimetheus*, trans. R. Beardsworth and G. Collins, Stanford: Stanford University Press.

———. (2004) *De la misère symbolique 1. L'époque hyperindustrielle*, Paris: Galilée.

———. (2005) *De la misère symbolique 2. La catastrophè du sensible*, Paris: Galilée.

———. (2006) *Réenchanter le monde: La valeur esprit contre le populisme industriel*, Paris: Flammarion.

———. (2009) *Technics and Time, 2: Disorientation*, trans. S. Barker, Stanford: Stanford University Press.

———. (2009a) *Acting Out*, trans. D. Barison, Stanford: Stanford University Press.

———. (2010) *Taking Care of Youth and the Generations*, trans. S. Barker, Stanford: Stanford University Press.

———. (2010a) *Technics and Time, 3: Cinematic Time and the Question of Malaise*, trans. S. Barker, Stanford: Stanford University Press.

———. (2013) *What Makes Life Worth Living: On Pharmacology*, trans. D. Ross, Cambridge: Polity Press.

Stivale, C. J. (1980) 'Gilles Deleuze & Félix Guattari: Schizoanalysis & Literary Discourse' in *SubStance*, 9, 4, 29: 46–57.

Tomaino, C. M. (2009) 'Clinical Application of Music Therapy in Neurological Rehabilitation' in R. Haas and V. Brandes (eds.) *Music that Works: Contributions of Biology, Neurophysiology, Psychology, Sociology, Medicine and Musicology*, Austria: Springer-Verlag/Wien, 211–220.

Tuer, D. (1998) 'Vera Frenkel with Dot Tuer and Clive Robertson; The Story Is Always Partial: A Conversation with Vera Frenkel' in *Art Journal*, 57, 4: 2–14.

———. (2013) 'Beyond the New Media Frame: The Poetics of Absence in Vera Frenkel's *String Games*' in S. Schade (ed.) *Vera Frenkel*, Berlin: Hatje Cantz, 38–63.

Tusa, J. (2003) 'Interview with video artist Bill Viola', aired on BBC Radio 3, Friday 22 August 2003. Reproduced from BBC IPlayer: http://www.bbc.co.uk/programmes/p00njlsw [last accessed 06 December 2013].

Valéry, P. (1931) *Regards sur le monde actuel*, Paris: Librairie Stock, Delamain et Boutelleau.

Waller, D. and A. Gilroy (eds.) (1992) *Art Therapy: A Handbook*, Buckingham: Open University Press.

Whitaker, R. (2010) *Anatomy of an Epidemic: Magic Bullets, Psychiatric Drugs, and the Astonishing Rise of Mental Illness in America*, New York: Crown Publishers.

Whitaker, P. (2012) 'The Art Therapy Assemblage' in H. Burt (ed.) *Art Therapy and Postmodernism: Creative Healing Through a Prism*, London: Jessica Kingsley Publishers, 344–386.

WHO. (1992) *The ICD Classification of Mental and Behavioural Disorders: Clinical descriptions and diagnostic guidelines*, Geneva: World Health Organization, 325–332.

Wilhelm, R. (1981) *Sigmund Freud*, Cambridge: Cambridge University Press.

Williams, J. (2009) *Gilles Deleuze's Logic of Sense: A Critical Introduction and Guide*, Edinburgh: University Press.

Wilson, E. (2012) *Love, Mortality and the Moving Image*, Basingstone, Hampshire: Palgrave Macmillan.

Winnicott, D. W. (1956) 'Primary Maternal Preoccupation' in D. W. Winnicott (ed.) 1975, *Through Paediatrics to Psychoanalysis*, London: Hogarth, 300–305.

———. (1960) 'The Theory of the Parent-Infant Relationship' in *International Journal of Psycho-Analysis*, 41: 585–595.

———. (1986) 'The Concept of the Healthy Individual' in C. Winnicott (ed.) *Home Is Where We Start From*, New York: W.W. Norton.

———. (2005) *Playing and Reality*, London: Routledge.

Žižek, S. (1989) *The Sublime Object of Ideology*, London: Verso.

———. (2004) *Organs without Bodies: On Deleuze and Consequences*, London and New York: Routledge.

Index

Note: The letter 'n' following locators refers to notes